d the University
City, where he is
nd Massachusetts,
where he is senior lectu. College and adjunct
curator of Latin American art at the Davis Museum. Oles's research
focuses on twentieth-century Mexican art and US–Mexican cultural
interchange. He has written on Frida Kahlo's early paintings, murals
by José Clemente Orozco and Isamu Noguchi, political prints of the
1930s, and the pop surrealism of Pedro Friedeberg, among other
topics. His previous publications include *South of the Border: Mexico
in the American Imagination 1914–1947* (1993), *Helen Levitt: Mexico
City* (1997), and *Agustín Lazo* (2009).

Thames & Hudson world of art

This famous series provides the widest available range of
illustrated books on art in all its aspects.

To find out about all our publications, including
other titles in the World of Art series, please visit
thamesandhudsonusa.com.

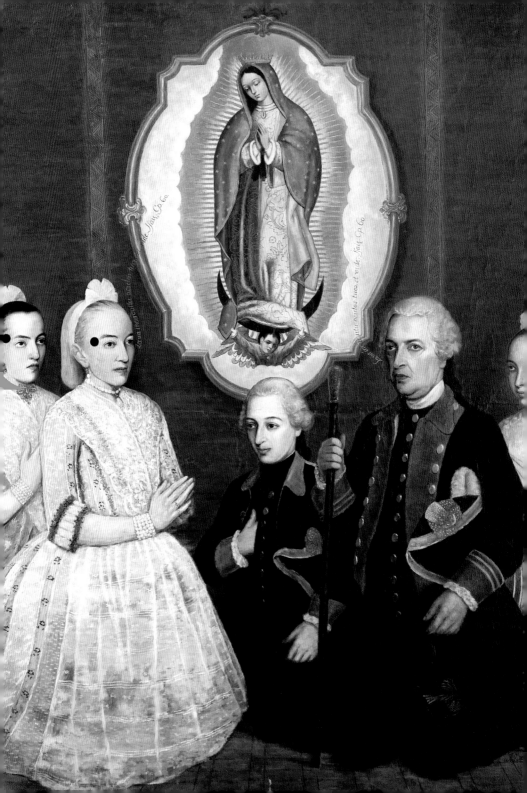

James Oles

Art and Architecture in Mexico

275 illustrations, 248 in color

Thames & Hudson world of art

Copyright © 2013 Thames & Hudson Ltd, London
Text copyright © 2013 James Oles

First published in 2013 in paperback in the United States of America by
Thames & Hudson Inc., 500 Fifth Avenue, New York, New York 10110

thamesandhudsonusa.com

Library of Congress Catalog Card Number
2012947934

ISBN 978-0-500-20406-1

Printed and bound in China by Everbest

Frontispiece:
Unidentified artist, *Family of the
Conde de Peñasco with the Virgin of
Guadalupe, c.* 1780 (see page 124).

Contents

Acalli

xochitl

çecloya

Aquexot

Teçineuh

Temich

xocoyol

xomimitl

tenochtitlan

xuinitzin

acatotl

colhuacan. pueblo.

tenayucan. pueblo

Introduction

In Mexico City sometime around 1541, Spanish authorities asked an indigenous *tlacuilo* (or scribe) to copy a pre-Conquest manuscript that told the history of the Aztecs (or, as they called themselves, the Mexica). One image he drew was a stylized map of Tenochtitlan, the Aztec capital, which had fallen to the conquistadors two decades earlier. Although painting on European paper, the scribe generally followed indigenous aesthetic traditions: the imagery, outlined in black and filled with solid color, is arranged symbolically to form an ideal cosmogram rather than a topographic view. Western pictorial conventions that emphasize depth, such as *chiaroscuro* and perspective, are absent, with one exception: the central element—an eagle perched atop a prickly pear cactus (or *nopal*) growing from a rock, the native hieroglyph for Tenochtitlan—is shaded to give it greater visual emphasis. Here, the tlacuilo took an aesthetic leap into the Renaissance.

The Codex Mendoza is a primary source of information on Aztec civilization, but when closely examined as a work of visual art it reveals other equally important stories, whether or not they were intended by the native scribe and his patrons. The explanatory glosses in European script remind us that visual images, though appreciable on their own, often require textual translations to be understood by new audiences; at the top of the sheet, the inscription of one previous owner—the cosmographer of the French king Henri II—further reminds us that images themselves are objects, each with its own physical history. This survey of Mexican art uses image, text, and history to unpack the meanings of some 275 paintings, sculptures, prints, photographs, monuments, and buildings, considered both as individual objects and as visual indices of the social, cultural, and political events that have shaped Mexico over the past five centuries (for details, see the timeline on page 410).

I. Defining Mexican Art and Architecture

"Mexico" and "Mexican" are terms that may seem self-evident, but that have not always meant what they mean today. For the

1 Unidentified artist, *Foundation of Tenochtitlan*, frontispiece to the Codex Mendoza, *c.* 1541.

This image alludes to the foundation of the Aztec capital in 1325. The city's canals form a perfect X-shape oriented to the four cardinal directions. To the left of the eagle, one seated man is identified as the leader or *tlatoani* (or speaker) by a speech scroll in front of his mouth; the border includes the dates of his rule. Two scenes related to the conquest of nearby cities are shown below.

Aztecs, "Mexico" referred primarily to their capital, "the place of the Mexica people." After 1521, it was applied to the Spanish capital, built on the Aztec foundations of Tenochtitlan; only following Independence in 1821 was the term appropriated for the entire nation (officially known as the United Mexican States). At its greatest extent, the Viceroyalty of New Spain included the Caribbean islands, the Philippines, California and the US Southwest, and most of Central America. Although this book focuses on art produced within the much-reduced boundaries of present-day Mexico, it necessarily includes works found beyond them, from an eighteenth-century mission church near Tucson, Arizona, to a shoebox exhibited at the Venice Biennale in 1993.

As the geographic territory called "Mexico" contracted over time (due to changes in colonial administration and the loss of territory to the United States in the mid-nineteenth century), so the definition of "Mexican" expanded to encompass far more than just the Aztec people, as white residents, who had once seen themselves as "*americanos*" or "*indianos*" (residents of the Indies), as well as a varied mixed-race population, were converted into citizens of an independent country. For much of the period discussed in this book, however, a vast majority of the inhabitants of Mexico—the rural and urban poor, descendants of African slaves, women, and especially indigenous peoples—was largely excluded from mainstream political, economic, and, most relevant for this book, artistic institutions. There were some notable exceptions, of course, including several indigenous painters and sculptors who achieved success in the viceregal period. Nevertheless, because this book focuses on painting, sculpture, and architecture generally produced by or for elites in urban centers (a point I address in the following section), artists from many subaltern groups situated outside hegemonic power structures figure more prominently in the later chapters, which cover a time when the rights of citizenship—and thus, the ability to triumph in the art world—were being slowly but steadily extended to include more diverse social and racial classes, as well as women.

One of the main theses of this book is that the visual arts—including media not analyzed here, such as folk arts and cinema—have long been essential to this expanding definition of *mexicanidad*, or what it means to be "Mexican," whether as

a marker of national or personal identity. Notwithstanding the traditional adage that "Mexicans are born, not made," identity is not a matter of genetics or destiny but rather a construction, imposed from outside and shaped from within. By guiding religious belief, imagining history, asserting political position, and evoking social class, racial categories, and gender roles, the visual arts have played a fundamental role in this construction, for better or worse. In particular, this book shows how images specific to a particular city or region—not only the eagle-and-cactus toponym, but also Zapotec palaces, the Virgin of Guadalupe, and the *china poblana*, to cite just a few examples—became subsumed within a single nationalist iconographic system, which often served to mask continuing cultural, ethnic, and social diversity. At the same time, however, close analysis of works of art illuminates the very processes of identity construction, helping to expose the reasons behind them, as well as their ramifications.

Numerous previous writers, foremost among them the poet and critic Octavio Paz, have sought to find continuity across the long trajectory of Mexican visual culture. For Paz, Mexican history, including its art, emerged from "clashes and reconciliations between two principles." These included the oppositions of pagan vs. Christian, Indian vs. European, and Mexico vs. the United States; but Paz's list might be extended to include an almost infinite array of binaries, including rural vs. urban, local vs. international, figuration vs. abstraction, devout vs. secular, Liberal vs. Conservative, Left vs. Right. All are helpful at different moments in understanding the forces that have shaped the production and interpretation of Mexican art and architecture since the Conquest, but each on its own is insufficient to address such a complex topic.

Perhaps the most important and persistent of these oppositions is the confrontation of indigenous and Spanish traditions, sometimes said to be resolved (Paz would have said "mediated") through *mestizaje*, a term long employed by scholars, anthropologists, and political theorists to summarize the complex process of racial and cultural blending. The frontispiece of the Codex Mendoza, for example, reveals the intersection of two aesthetic systems that shaped much art and architecture produced in Mexico. But this metaphor, though pervasive and helpful, is also too limiting. From the start Mexican art developed within global and multi-ethnic networks,

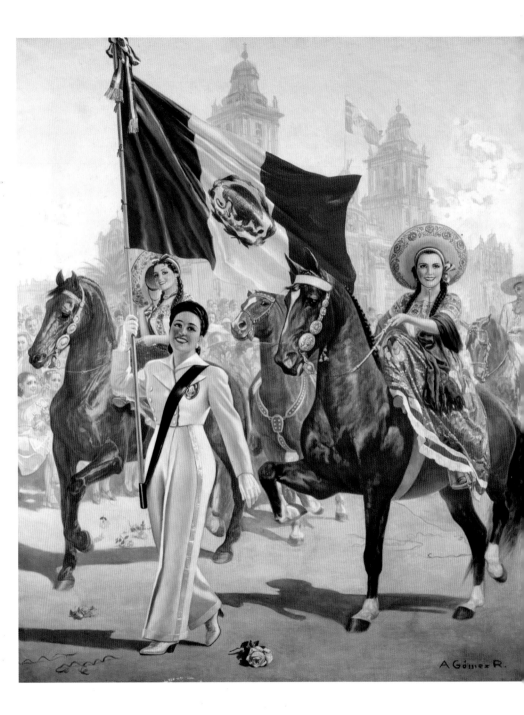

This painting shows participants in the military parade held on November 20, commemorating the start of the Mexican Revolution. The flagbearer and riders dressed as *chinas poblanas*—a national archetype originally associated with Puebla—march in front of the Mexico City Cathedral. The image was originally intended for reproduction on a mass-produced calendar.

shaped not only by Aztec tlacuilos and Sevillian painters, but also by African slaves and Filipino merchants, Flemish artists and Mudéjar artisans, as well as by travelers and residents from elsewhere in Europe and the United States. To encompass this cultural diversity, we might shift our focus from mestizaje to the more inclusive concept of hybridity. Indeed, Mexican art and architecture is especially compelling, innovative, and distinctive where this hybridity is at its most rich and multifaceted, revealing the impact of different visual sources, makers, patrons, and audiences, all bringing unique cultural perspectives to a particular work. Sometimes this hybridity was apparent to people at the time; sometimes it was not: in all cases, discussions of hybridity (or mestizaje, for that matter) are as informed by our own contemporary values and concerns as by visual and historical evidence, further complicating attempts to disentangle the intersecting cross-cultural threads that shaped so much Mexican art.

Other alternative and overlapping categories further connect artists and works from across the centuries. Some of these are artistic genres or media, including portraiture, landscape, murals, and commemorative monuments. Others are thematic: modernization and urban life, devotional icons (whether religious, nationalist, or Communist), women and motherhood, Indians and workers, heroes and allegories, appropriations and citations. Two themes—the indigenous past and institutional patronage—merit particular attention, for they distinguish Mexican art and architecture specifically from that produced elsewhere, including the United States and most other Latin American nations.

Throughout Mexican history, the weight of the indigenous past has remained paramount, shaping Mexican visual arts directly (through the forces of hybridization discussed above) but also rhetorically. Despite a diverse array of civilizations, from the Huichol of the north to the Maya of the south, artists and intellectuals in Mexico privileged the Aztecs and other indigenous cultures of the Valley of Mexico, the locus of power both before and after the Conquest. Spanish viceroys and Mexican politicians sought to justify their authority through direct connections to this Aztec past, often expressed in paintings and public monuments; pre-Hispanic civilizations, including the Maya, were also idealized as "American" equivalents to the Classical civilizations of Europe. Tragically,

however, highlighting the grandeur of the past frequently relegated living Indians to the shadows.

The development of Mexican art and architecture has been shaped by institutional patrons since the early colonial period, in part because divergent religious, cultural, and political factions—despite disagreements—shared a belief that the visual arts were an essential tool, first in establishing a new Spanish and Catholic regime, and later in creating a stable and coherent nation state. Although there have always been private commissions, and artists who have worked outside the official system, powerful religious, political, and educational institutions have long sponsored and controlled the production of art and architecture in Mexico: from the archbishops and viceroys of the colonial period to the first formal art school in the Americas (the Academia Real de San Carlos, founded in 1785) to government ministries (most famously, the Secretaría de Educación Pública or Ministry of Public Education, hereafter the SEP) and federal cultural agencies established after the Mexican Revolution, with their attendant museums, libraries, and schools. Only in the 1980s did this centralized system weaken appreciably, allowing for the emergence of alternative spaces and an increasingly engaged private sector.

The generic terms "Indian" (*indio*) and "indigenous" (*indígena*) are used interchangeably in this text: though the former is inaccurate and was often used with condescension, and the latter more objective and favored in recent scholarship, both terms are outsider constructions that conceal cultural diversity. Readers are reminded of the fluid and evolving nature of all such labels: race existed on social, physical, and legal levels, and—for individuals and society as a whole—was frequently tied to lifestyle, marriage, profession, and social class. Since New Spain was legally a kingdom within the Spanish empire rather than a colony, the words "viceregal" and "Novohispanic" (a neologism meaning "New Spanish") have been adopted here to describe the art and architecture of the period between 1521 and 1821. The word "American" is used in a continental sense, with "US" referring specifically to the United States. Some words for localized products—*rebozo* or *pulque*, for example—or such markers of identity as *criollo*, *peninsular*, *mestizo*, and *casta*, are left in the original Spanish, in order to preserve precise meanings that can be lost or confused in translation.

Just as we must be sensitive to local terminology, we must also be careful when using imported art historical categories in our analysis of Mexican painting, sculpture, and architecture. The present survey narrates a history of *Western* art—what historian Mauricio Tenorio-Trillo has called "the forgotten side of the West"—but even those works of art and architecture that adhered most closely to European precedents were never the result of servile copying. Instead, they should be seen as part of a process of selection, interpretation, invention, and re-contextualization, in each case determined by particular local circumstances and patrons as well as international models. Yet although I avoid simply shoehorning Mexico's visual arts into preexisting stylistic categories, mainly established for European art, such terms as "Baroque" or "surrealist" often help frame the narrative, and permit fruitful cross-cultural comparisons.

II. Structuring Mexican Art and Architecture

The bibliography in this book (page 411) suggests just how much new scholarship has appeared since Justino Fernández's *A Guide to Mexican Art* (1969), the most recent single-author survey of the subject in English. This study not only extends Fernández's coverage forward in time, it also incorporates works, artists, and ideas that have come to light as art historians in Mexico and abroad have moved beyond the familiar narratives, dug into archives, looked closely at well-known images and uncovered others previously lost, examined visual culture from fresh theoretical perspectives, and addressed ever more complex, interdisciplinary topics, ranging from commercial exchange with Asia to the state's manipulation of public architecture in the 1950s. Based on discoveries and insights of numerous colleagues, the present volume seeks to synthesize this exciting new material, introducing some of it to English-speaking readers for the first time. Numerous topics remain still to be mapped, however, and many key figures require renewed attention; a single book or article can radically reorient scholarship at any moment.

I began the project by drafting a working list of exemplary paintings, sculptures, buildings, prints, and photographs, a difficult process that was nonetheless facilitated by years of teaching. Images were chosen for overlapping reasons, including

their formal and iconographic complexity, relationship to works discussed elsewhere in the book, and connections to key aspects of Mexico's cultural, social, and political history. Many have formed part of a canon already evolving by the 1930s, while others, less familiar even to specialists, allow me to bring once marginalized works into the fold. Some—the Mexico City Cathedral or Diego Rivera's murals of the 1920s in the SEP, for example—are complex masterworks, created by collaborative teams over many years; these works are likely to prompt multiple interpretations, and are impossible to illustrate fully. Yet others are small, seemingly minor, and often overlooked objects with more pointed meanings. Rather than an all-inclusive encyclopedic approach that would have shown the maximum number of artists, themes, and works, the more limited selection here places greater attention on individual objects and their creators.

The book is structured chronologically, with ten principal chapters followed by a final chapter dedicated to works of contemporary art, the historical importance of which remains in flux. Although my focus is narrating a history of *art*, rather than using art to tell *history*, many of the featured works do address broader cultural or political forces, which often remain relevant in our own time. Thus, a humble daguerreotype made by a US artist around 1847—one of the first wartime photographs ever created—can be seen as a predecessor of a genre that overwhelms our media-driven world today. Of necessity, this survey features certain aspects of Mexico's cultural history more than others, even if contemporaries would have seen things differently—for example, Miguel Cabrera's eighteenth-century *casta* paintings are treated in greater detail than his religious paintings, although he himself would certainly have privileged the latter.

Finally, two caveats. First, as a specialist in the twentieth century, my goal is to expand our understanding of modern art beyond long-held clichés; although there have been recent and excellent summaries of viceregal and contemporary art, there have been no comparably thorough overviews of nineteenth- or twentieth-century art in English. Thus, this book is weighted towards the present: the first three chapters examine almost three centuries of Novohispanic art and architecture; the last five, dedicated to the post-Revolutionary period, span less than a century. This is not to say that any one

epoch was more important than another, but rather to signal the accelerated diversity that marked the visual arts in Mexico after the mid-nineteenth century, as it did elsewhere in the world.

A second caveat relates again to my title, which defines "art and architecture" somewhat narrowly: to understand fully the entire history of visual culture in post-Conquest Mexico, especially as regards the role of women and subaltern groups for much of the period covered here, readers will have to supplement this text with others that examine traditional folk arts; elite decorative arts, such as furniture, ceramics, and textiles; theater design; public parks and urban planning; advertising and graphic design; parades and festivals; and especially cinema and video. While there are occasional references to key critics and literary figures, this book features little discussion of art criticism or historiography, though both were crucial to the development of artists and architects. It bears emphasis that this is not the history, but rather a history of Mexican art and architecture.

A still from a video made in 1999 by Francis Alÿs (a Belgian-born artist resident in Mexico since 1986) shows the vast space of the main plaza of Mexico City, known as the Zócalo, on a sunny day in May, one of the hottest times of the year. In the background, the Palacio Nacional—a much-modified colonial structure built on the ruins of the residence of Aztec emperor Moctezuma II (r. 1502–20)—frames the scene. Alÿs's video shows people taking shelter in the shadow of the enormous flagpole set in the center of the treeless space, slowly adjusting their collective position as the shadow—like the mark of a sundial—shifts over a twelve-hour period. The flagpole, a sign of exaggerated patriotism planted at the political heart of the nation, is set near the location where—according to tradition—the Aztecs saw an eagle land on a cactus, the omen that became the symbol of their capital, as commemorated in the Codex Mendoza.

A subtle and poetic work of conceptual art, Alÿs's video references a key connecting thread in this survey: the close relationship between Mexican visual arts and the particular history of Mexico City. The story told in this book begins and ends near this great plaza, despite attention to other cities and regions, and to the work of Mexican artists abroad. The video can also be read as a meditation on how the nation—or

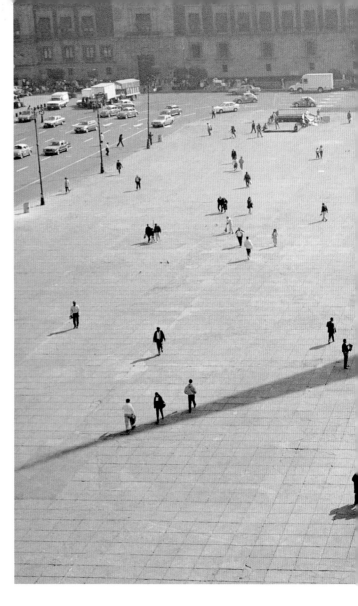

3 Francis Alÿs (in collaboration with Rafael Ortega), still from *Zócalo, May 22, 1999*, 1999.

patriotism more generally, here represented by the barely visible flag on which the Aztec hieroglyph is proudly featured—shelters its citizenry, protecting them from the harshness of the open space. Yet that protection comes at a cost: these citizens follow the shadow like sheep, and though they might benefit from its narrow haven they are left out of the light. In this sense, Alÿs's *Zócalo, May 22, 1999* might stand as an emblem of my goal in this book; just as his critical perspective as an artist

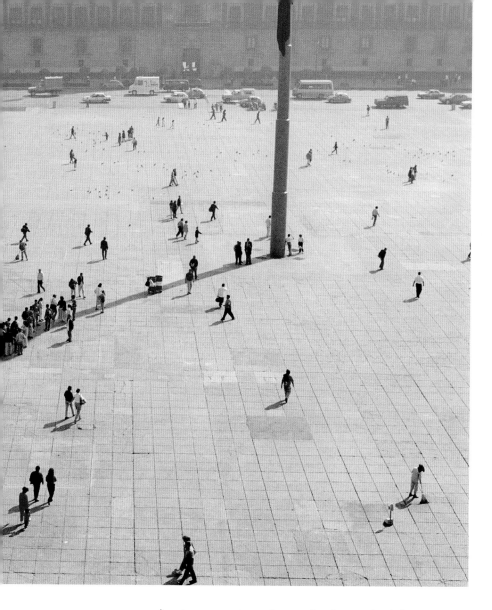

directs our gaze towards a previously unnoticed phenomenon at the heart of Mexico City, my aim as an art historian is to offer new insights into the meanings and messages of Mexican art and architecture, while scrutinizing the nationalist standards that have long shaded previous scholarship. There is much to discover, for the density and diversity of Mexico's aesthetic traditions—sustained over five centuries and marked by visual delight at every turn—are almost unrivaled by any other place.

Chapter 1 Conquest and Negotiation (1520–1600)

In February 1519, fifteen years after he had arrived from Spain to make his fortune in the Caribbean, Hernán Cortés (1485–1547) set off from Cuba as leader of the third Spanish expedition to the American mainland, searching for far greater riches. Just over two years later, in August 1521, his army of some five hundred men, allied with a vast indigenous force, conquered Tenochtitlan, the capital of the Aztecs (or the Mexica, as they were also known)—one of the largest cities in the world, with a population of more than 150,000. Territories beyond the direct control of the Aztecs—among them, present-day Michoacán, the Yucatán, and Guatemala—resisted for longer, though by the mid-sixteenth century the densest indigenous populations were pacified and converted to Christianity.

Charles V, King of Spain and Holy Roman Emperor (r. 1519–56), charged three mendicant orders with this massive conversion effort: three Franciscans arrived in 1523, followed by a group of twelve (intentionally symbolic of the apostles) in 1524; the first twelve Dominicans arrived in 1526; and the first seven Augustinians in 1533. Although protected initially by the República de Indios, a juridical system that treated indigenous populations separately from the colonizers, the native peoples were brutally incorporated into new economic structures, for example the *encomienda*, a semi-feudal institution that gave the Spaniards rights to Indian labor.

In the newly conquered territories, indigenous and European forms of art were initially at war, to use a metaphor coined by the historian Serge Gruzinski. The Conquest—a clash of completely different world views as well as a military undertaking—entailed not only the political and economic transformation of the former Aztec empire but also unleashed one of the most terrible iconoclastic campaigns in history. Buildings, sculptures, feathered costumes, pictorial manuscripts, and untold objects of exceptional beauty were all destroyed as evidence of pagan beliefs. Nevertheless, a few defiant Indians hid or even continued to make prohibited images well into the seventeenth century, especially in remote areas; some ceremonial objects, such as wooden drums (*teponaztlis* and

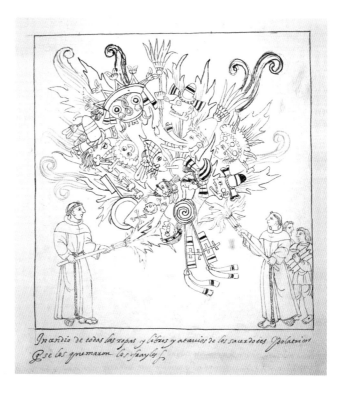

4 Unidentified artist, *Burning the clothes and books and costumes of the priests*, from Diego Muñoz Camargo, *Description of the City and Province of Tlaxcala*, c. 1581–84.

In this drawing by an anonymous indigenous artist, from one of the most important pictorial accounts of the Conquest, two Franciscan friars set aflame materials they associated with pagan divinities. To the right, native boys bring wood to feed the bonfire.

huehuetls), were used in indigenous communities until much later (see fig. 54 on pages 90–91).

And yet from the confrontation between these two civilizations, each with its own rich and multifarious material culture, new forms of art emerged in workshops, schools, and secular and religious spaces in the former Tenochtitlan (now renamed Mexico City) and across the "colony" (legally it was part of the Crown of Castile, and it was known after 1535 as the Viceroyalty of New Spain). In fact, this period was one of tremendous creativity and innovation, notwithstanding the tragedies that followed the European invasion; in particular, a series of devastating epidemics created a demographic crisis for indigenous peoples by the end of the sixteenth century. The great art of the early colonial period was mainly sponsored by *caciques*—indigenous rulers, many of whom hailed from the elite (the *principales*), and who maintained some degree of power in the new regime—or by the European friars. The latter erected hundreds of mission complexes across New Spain between 1530 and 1580, some of which are among the

most extraordinary works of art created anywhere in the sixteenth century. Two artistic systems, each with its own complex symbolism, met and merged in many early post-Conquest works; meanings related to political affiliation or religious belief often shifted according to the audience, Spaniard or Indian. From churches to manuscripts, these works not only provided a foundation for the next five centuries of artistic production, but also anticipated the globalized and hybridized cultures of our own twenty-first century.

I. New Images, Old Techniques

In the early colonial period there was an immediate and desperate need for new images, both religious and political. The practical conquistadors had brought very few works of art with them—though on arriving on the mainland Cortés gave Christian images to local elites, and the Spanish substituted religious prints for indigenous deities in some temples during their march towards Tenochtitlan. None of these works apparently survives. The Virgin of Los Remedios and another sculpture known as the Virgen Conquistadora, now in Puebla, are both said to have been brought to Mexico by the first Spaniards; in fact these are later images, given a mythical genealogy in the 1580s by indigenous elites who wanted to demonstrate that they had been allies of the conquerors.

The task of creating art for the new order fell primarily into the hands of the Franciscans, who had taken initial responsibility for the education (or re-education) of Indians. By 1559, after the major conversions were already over, more than half of the 580 mendicant friars in New Spain were Franciscans. They sought to create an ideal society far from the corruption of Europe, though they ascribed to two contradictory mindsets. Most, in accordance with medieval traditions, held to the messianic belief that the disclosure of the New World would facilitate the complete evangelization of the world's populations and thus lead to the Second Coming; other more elite friars were inspired by the humanism of Erasmus and Thomas More. Among this latter group was Pedro de Gante (1479?–1572), a highly educated Flemish friar (and a relative of Charles V) who was one of the first three Franciscans to arrive in Mexico, and one of the most influential figures in the history of early colonial art.

Although it was mostly demolished in the nineteenth century, the administrative center of the Franciscans in Mexico City was originally an enormous complex. On a site formerly occupied by Moctezuma's aviary and imperial workshops for stone carving, gold, and featherwork, the Franciscans established a chapel for the Indians. It was known as San José de los Naturales, an expression of Saint Joseph's fatherly patronage of the Indians (or "local ones"). This chapel was also the site of a school, founded by Pedro de Gante, where Aztec boys were taught manual arts and crafts, from shoemaking and embroidery to plasterwork and carpentry, practical skills that were useful to the new colonial order. At the more prestigious Colegio Imperial de Santa Cruz at the nearby Franciscan monastery of Santiago Tlatelolco, established in 1536, indigenous students—generally the sons of elite families— were trained in the liberal arts and theology (some noble girls also received a Franciscan education).

At San José de los Naturales and Santa Cruz de Tlatelolco (the competitive Augustinians would establish a school at Tiripitío, Michoacán, in 1540; the Dominicans founded a school of their own in Yanhuitlán, Oaxaca, around the same time) the friars formed a legion of builders, carvers, painters, gilders, featherworkers, and metalsmiths who would produce, under Spanish supervision, many of the most important works of art to come out of sixteenth-century Mexico. These schools formed artists and artisans who were independent of the system of workshops and guilds that was well established by mid-century, and that was controlled by the European artists who had immigrated to the viceroyalty.

In many works produced in this early period we find a rich blend of Spanish and indigenous cultures. This hybridization mirrored what was gradually taking place in racial terms (and that echoed what had taken place previously, while Spain was under Muslim rule). Racial blending occurred from the beginning of the Conquest, a result not only of sexual violence but also of complicity: to preserve their power, Indian elites married their daughters to Spaniards, an arrangement from which the latter also benefited. As early as the 1530s, New Spain already had a sizeable number of residents of mixed racial background; these would increase over the following centuries to become the majority population in Mexico. Simultaneously, cross-cultural blending took place across all aspects of society:

5 Bishop's miter, c. 1550.

This stunning miter may have been made at San José de los Naturales; it was deposited at El Escorial by the Spanish king Philip II in 1576. Framed by tiny images of the apostles and Church fathers is a scene of the Crucifixion, and, at the top, the Last Judgment.

6 School of San José de los Naturales, *Mass of Saint Gregory*, 1539.

The Latin inscription on this feather mosaic reads: "Made for Pope Paul III in Mexico, the great city of the Indies, during the governorship of Don Diego [de Alvarado Huanitzin], under the supervision of the Minorite Pedro de Gante, in 1539."

from agriculture and food preparation, clothing, music, and dance, to language and the naming of people and places. It occurred in politics: to control the far larger indigenous population the relatively small number of whites relied on caciques, rulers who preserved pre-Conquest structures of governance. It even took place in religion, where absolute orthodoxy was often impossible as the Franciscans (in particular) experimented with using native ideas and symbols to facilitate conversion.

The Spanish schools educated students in stone carving and architecture, since a vast building campaign was underway. Painters were trained to cover the walls of new buildings with murals, and to copy or create manuscripts to further evangelization, root out lingering idolatry, and preserve traditional knowledge. These crafts mostly entailed European techniques and imported metal tools and materials, such as rag paper. Two indigenous artistic traditions were recognized as particularly useful, however: feather mosaic and cornstalk-paste sculpture. In the pre-Conquest period, tropical bird feathers (mainly from parrots and hummingbirds) were used for major ceremonial paraphernalia, which was among the mostly highly prized of art forms. Cortés himself recognized this, sending more than one hundred examples back to Europe in 1522. Few pre-Conquest examples survive; the most famous is the so-called Headdress of Moctezuma, now in Vienna.

At San José de los Naturales and Tiripitío, *amantecas* (feather artists) were retrained to create new images for the new religion. Artists sewed and tied feathers, but more commonly they hardened them with paste and then trimmed and glued them onto a pattern sketched on a paper support, or directly onto a religious print they had been asked to embellish. Surviving sixteenth-century examples include finely detailed bishops' miters with biblical scenes, portable altars, and images of Jesus and other holy figures. Some appear to have been designed so that the feathers'

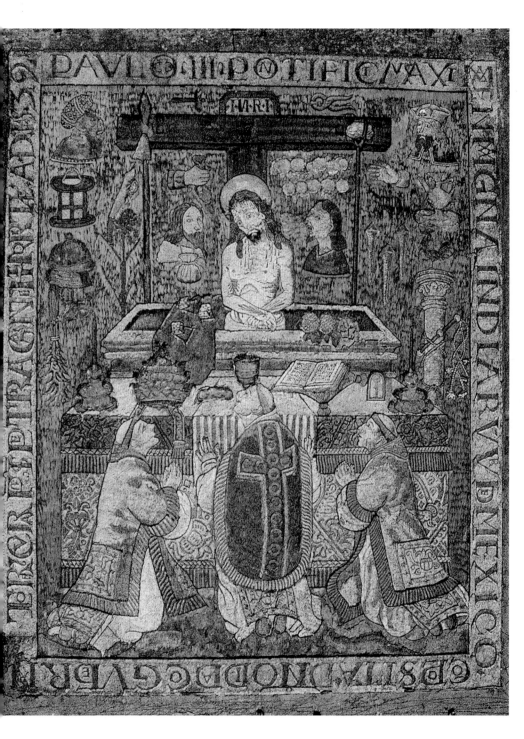

iridescence (believed by the Indians to contain a sacred force) animated the figure when a supplicant knelt in prayer, a sort of early form of kinetic art. The craft survived well into the nineteenth century, though for more secular purposes.

Some of these luxury objects were protected for centuries in trunks in European churches and castles, allowing the feathers to preserve their brilliant colors. The mosaic image of the Mass of Saint Gregory is one of the finest surviving examples. Pope Gregory the Great kneels before an altar and receives a vision of Christ and the symbols of the Passion. Though based on a Flemish engraving of around 1500, the amanteca eliminated complex architectural details while including subtle patterns in the men's robes and on the altar cloth that seem more indigenous than Spanish. The earliest dated work of Mexican art, this was a high-prestige gift— like the tribute payments in featherwork made to the Aztec imperial authorities before the Conquest—intended for a Pope who, in 1537, had issued a bull affirming the Indians' rationality and humanity, and the right of the mendicant orders to administer the sacraments to them.

The friars were also intrigued by lightweight "idols" made using cornstalk-paste. Although no pagan images in this technique survive, early mendicant workshops created Christian images using the same method: an armature of cornstalks and paper was covered with a sort of plaster— made from the whitish heart of the cornstalk, certain orchids, maguey fiber, and a natural glue—and then gessoed and painted. While a similar technique for casting lightweight sculptures made from paper and paste was employed in Europe, dozens of cornstalk-paste figures of Jesus and other saints were exported to Spain, where they were donated to churches and highly coveted for use in religious processions. Typically weighing less than fifty pounds, they were far more portable than wooden sculptures.

In the sixteenth century the tolerance of pre-Conquest cultural forms also cemented relationships between colonial authorities and indigenous communities. This is evident in early markers of political authority: a surviving stone rendition of the coat of arms (dating from 1551) for the city of Texcoco places Nahuatl glyphs within a European armorial shield; similar images once visible in Mexico City are now long lost. One of the most fascinating examples is a stone relief on the facade

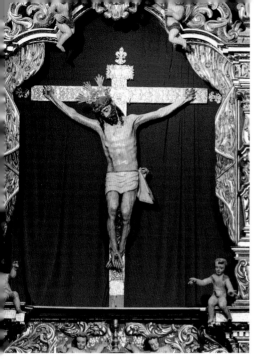

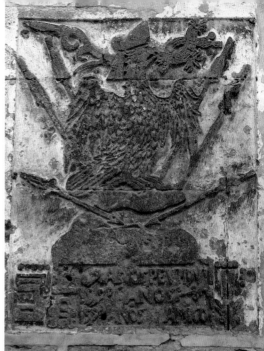

of the Franciscan church in Tecamachalco, made late in the sixteenth century. Dates—perhaps related to the completion of the building—are written in both the Nahuatl and Spanish (Arabic) systems: 5 House (1589) and 7 Reed (1591). More remarkable, however, is the wholly indigenous eagle, wearing the royal diadem of the Aztec emperor and issuing forth from its beak the Aztec hieroglyph for *atl-tlachinolli*, or warfare.

Pre-Conquest toponyms—glyphs that name particular towns—appear on several other sixteenth-century church facades (at Acolman and Tlalnepantla, for example) and in mural programs (Malinalco); they bolstered the friars' ties to the local community, and to the caciques who had often sponsored the buildings and murals. The strange thing about the Tecamachalco relief is that it does not show the local toponym, but rather includes an explicit reference to Tenochtitlan (page 7). By the 1580s, apparently, the provincial elites in this remote town were expressly demonstrating their allegiance not to the defeated Aztecs but to their former capital, now the seat of the viceroyalty. This would not be the last time that the Aztec eagle would be retranslated for political ends.

Stone sculptures (such as the Tecamachalco relief) that show evidence of cultural hybridity have been called

"Indo-Christian" or *tequitqui* (from an Aztec term for "tribute") by modern historians. These hybrid forms are particularly common on sixteenth-century religious structures as well as on baptismal fonts—though sometimes the citations are not obvious, nor would they necessarily have been seen as jarring or strange at the time. In fact, although indigenous artists created them it is not always clear what these tequitqui objects tell us about the indigenous mindset. In some cases, we may be seeing the result of artists unconsciously doing things the way they had always been done, or just provincial versions of European images found in printed books. In other cases, however, we are surely seeing signs of accommodation and negotiation, or even tactical acts of visual resistance to colonial dominance. For example, the plant forms carved on some church portals and *posa* chapels may refer to Aztec-period poems or "flower songs," or to psychotropic plants used in past rituals; decorative bands of circles might recall hieroglyphs meaning "preciousness." Spaniards may have been complicit in these insertions, or might have seen it all as mere decoration; for the indigenous artists, however, no element was incidental or accidental.

While the eagle on the Tecamachalco date stone is pre-Conquest in form and meaning, other images reveal more clearly the impact of Renaissance aesthetics on indigenous culture. The two systems of representation appear in dialogue, like conversations taking place in the Franciscan schools over humanist texts. A case in point is a startling portrayal of the storm god Tlaloc, painted in the late sixteenth century by an artist in the city of Texcoco. The deity's traditional attributes— such as his blue mask with goggle eye—are rendered flat, in accordance with the pre-Conquest manuscript paintings the artist likely used as a source. The body of the god, however, reveals the painter's adoption of chiaroscuro effects, and a contrapposto stance probably derived from prints of the Apollo Belvedere, a widely illustrated Roman sculpture. This is a graphic melding of two pagan deities.

In fact, no Aztec art form survived the Conquest better than manuscript painting: this is evident primarily in books and maps, which are important as works of art, as examples of visual and intellectual hybridity, and as irreplaceable sources of historical and cultural information. In Mexico City, after an initial period of tremendous destruction (only fifteen or so

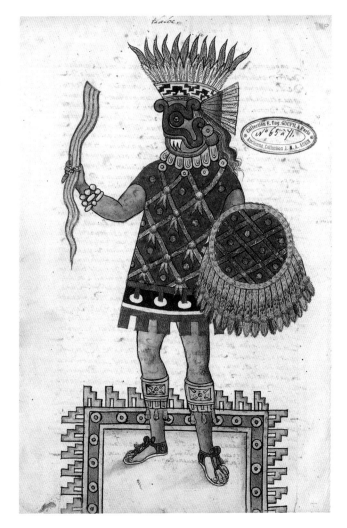

9 Unidentified artist, *Tlaloc*, from the Codex Ixtlilxochitl, *c.* 1582.

The images in this codex may have been owned by Fernando de Alva Ixtlilxochitl (1568?–1648), a mestizo historian who was the grandson of the last independent ruler of the city of Texcoco. Other drawings show Alva Ixtlilxochitl's ancestors as part of an extended attempt to reclaim rightful privileges.

pre-Conquest manuscripts survive from Central Mexico and Oaxaca), the Spanish recognized that native information, as preserved in pictorial books, had important economic and political—as well as spiritual and genealogical—value. Maps told of property rights, tribute rolls told of sources of wealth in different regions, and even "pagan" religious accounts could be mined in order better to understand and search out continuing heresy. At Tlatelolco, the Franciscan friar Bernardino de Sahagún (*c.* 1499–1590) worked with native informants to record the information and knowledge disappearing with every epidemic and every lost generation.

Among the most visually and intellectually complex post-Conquest manuscripts, known generally as codices, are the Codex Mendoza (c. 1541; the frontispiece is discussed in the introduction to this book) and Sahagún's *General History of the Things of New Spain* (also known as the Florentine Codex), produced at the Colegio de Santa Cruz in Tlatelolco. (Since the authors of these "books" are often multiple or anonymous, the titles generally refer to patrons, owners, or libraries.) Unlike traditional indigenous screen-fold manuscripts painted on deer hide or bark paper (*amate*), these two examples use imported paper and were bound as European books. Like the surviving feather mosaics, most sixteenth-century codices are now found in European collections, which testifies to their intended audience, as well as to a history of looting and antiquarian competition for information about the New World.

Unlike the Codex Mendoza, the Florentine Codex was a wholly new production. Beginning in the late 1550s and continuing over the next two decades, Sahagún worked closely with a team of indigenous artists and scribes, as well as native informants, to create this illustrated ethnographic compendium covering all aspects of Aztec culture: from religious beliefs to moral philosophy, and from natural history to the Conquest itself. The production of the manuscript, numbering more than 2,000 folios (or 4,000 pages), took so long that some scribes (22 different hands have been detected) died during the process, probably from disease. Images, generally framed to resemble woodcuts in a printed book, are inserted into the hand-written pages, with the left column in Spanish and the right in Nahuatl, though the texts are not fully equivalent. Sahagún faced enormous obstacles, and his collaborative endeavor was not published in the period; in the late 1570s, Philip II (r. 1556–98) banned all writing that preserved Indian customs, forcing Sahagún's project to come to a halt.

A page from Book Nine of the Florentine Codex, which discusses merchants and craftsmen, includes depictions of featherworking; typically, the page separates text and image according to European conventions. An amanteca is shown in various stages of producing feather mosaics. Like many of the drawings in the Florentine Codex, the images are as bilingual as the accompanying text. The architecture contains clear Renaissance elements, but adjacent to an image of a saint in the lower scene is an eye-shaped Nahuatl glyph, signifying

10 Unidentified artist, *Featherworkers*, from the Florentine Codex, c. 1579.

The Nahuatl text of this massive project was ready by around 1555, when Sahagún had finally acquired enough precious European paper for his scribes. The shorter Spanish translations and 2,686 illustrations took longer to complete; in 1579 the book was hastily finished and sent to Spain.

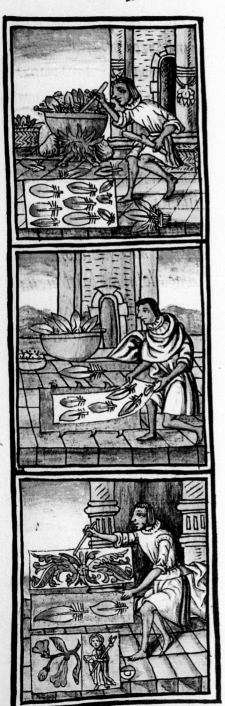

quechol: iehoatl ipe pech mochioa,
incan ienoie iiala pachio, tlauhque
chol, anoço tla tla pa lpalli ihuitl,
auh intoztli ipe pech mochioa incoz
tlapalli ihuitl, çannoie quimope
pechtia intozcuicuil, inihuitl in
motenehoa coztlapalli, çan mopa,
mocozticapa, mocozpa tleco icucic:
ipan quaqualaca in tlapalli, çacatlas
calli, tlaxxocotl monamictia: auh
çatepan motequisquiuia, inicoac in
omotequisquiui, inicomocencauh,
iniizquicac icac tlapepech totl, ini
huitlaoatzalli: inienouian omote
tecac, omoçacoaz, im ipan ichcatl
mepan tlacuilolli, çatepan mocoleoa.
Auh inicoac centetl momana: oa
paltontli ipan moçaloa cc amatl,
occeppa ipan micuiloa in omocui
cuic machiotl, intlacui tuitl o
mochiuh: iehoatl ipan iecaui ini
huitlachioalli, ipan mocençaloa
inihuitl oapalli, aço suchitlacui
lolli, aço quillacuilolli, anoço itla
tlaixiptlaiotl inmochioaz, inaço
quenami tlamachtli, intlauelitta
lli. Inicoac omiculo, inomotli

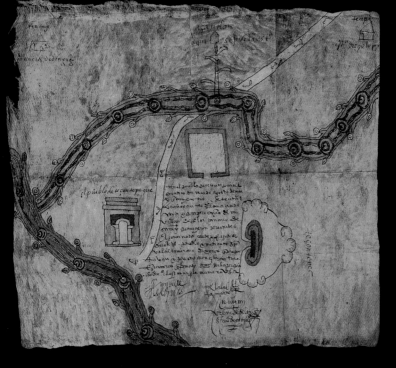

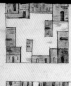
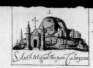

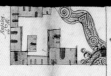

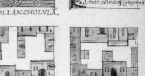

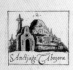
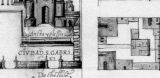
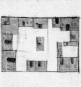

11 Unidentified artist,
Map of Tezontepec, 1571.

In this map, painted on bark paper, the artist resorted to an almost wholly pre-Conquest system of representation: the symbolic rather than topographical rendition of space; the whirlpools in the two rivers; the road marked with footprints; and the pink mountain glyph (*altepetl*) to the right. Indians sometimes used archaic styles to convince Spanish authorities that documents were older—and thus more reliable—than they actually were.

12 Unidentified artist,
Map of Cholula, 1581.

The enormous but ruined pyramid of Cholula bursts out of the confines of the Spanish grid at the upper right. The trumpet on top is a sign of glorious victory— evidence that the city's caciques were allied with the Spanish conquerors, as at Tecamachalco.

iridescence. The artist reveals a rudimentary understanding of perspective, evident in the tiled floor and the distant mountains, yet takes liberties by flattening the mosaics out towards the picture plane, allowing viewers to see them more clearly.

Indigenous artists were also busy painting maps designed to assert their elite status, or to defend traditional land rights against new settlers avid for fertile territory. These maps are of two principal types. Some, like the *Map of Tezontepec* of 1571, were produced within communities in applications to the viceroy for land grants. Executed on more traditional supports, such as bark paper or cloth (the latter were known as *lienzos*), some maps remained jealously guarded by their communities for centuries, used to defend land rights in a legal system that valued such documents above oral testimony.

Other maps were sent to Spain as part of the *Relaciones Geográficas*, which were responses to royal questionnaires issued by Phillip II in 1577–78 and 1584 eliciting detailed information on his American possessions, though most were ultimately of little practical use. One of the finest is the *Map of Cholula* from 1581. As was typical, the map centers attention on a church, in this case the Franciscan mission complex. The map reveals the central plaza and a rigid grid of streets imposed by the Spanish. The sharply observant artist pays attention to key details and there is an attempt at illusionism; although there are lurking signs of an indigenous hand, it is less evident than on the map produced in Tezontepec. Each subsidiary church is accompanied by a mountain, but since Cholula is flat, these are not topographic features but rather Nahuatl glyphs signifying *altepetl*, or community. The most visually pre-Hispanic feature is the great pyramid, shown in the upper right as Tollan, a sacred "place of reeds," and marked by another *altepetl* as well as swirling eddies in the rivers and springs, rendered much like the rivers in the *Map of Tezontepec*.

II. The Art of Evangelization: Architecture and Sculpture

There are almost no surviving sixteenth-century buildings in the center of Mexico City, other than the much-modified cloister of the Hospital de Jesús (founded by Cortés in 1524 as the Hospital de la Purísima Concepción) and part of the back of the Cathedral (c. 1580–90). Devastating floods and urban

renovation projects have destroyed nearly all traces of the days of the conquistadors. For insight into the architectural achievements of this period we must turn to mission complexes located in smaller cities and towns across the country, including a few in towns now subsumed by the capital's urban sprawl.

In his account of the early colonial period, Fray Gerónimo de Mendieta (1525–1604) asked the rhetorical question, "Who built the many churches and monasteries that the friars have in the New World, if not the Indians with their own hands and sweat, with as much determination and joy as if they were building houses for themselves and their children?" These building campaigns were supervised by amateur friar-architects armed with architectural treatises, or (less frequently) by a European master or journeyman mason who was contracted for the job. They relied on indigenous laborers, whose ranks were often seriously depleted by disease (in fact, some large churches were built for the very reason that a plague had hit, as an act of penance). Caciques often willingly participated in the endeavor: they donated the land for the buildings and funded their construction, sometimes increasing the size of churches or commissioning more ornate interior decorations to compete with neighboring towns. Yet working conditions were harsh; in 1605 ten indigenous painters from Tlatelolco brought suit against the prior Fray Juan de Torquemada, stating that they had been underpaid, forced to work on Sundays and holidays, and subjected to corporal punishment.

Between about 1530 and the 1570s, some three hundred mission complexes (or "houses") were built across New Spain, in addition to the orders' monasteries and administrative centers in Mexico City. These foundations were in direct engagement with the surrounding communities, rather than places of spiritual retreat closed off from contact with the outside world. Some of the earliest mission churches were adobe basilicas with thatched roofs and open facades, but these were later torn down and replaced by far grander structures. The surviving mission churches, many dating from the 1550s, represent a continuation of the sturdy Gothic churches built a century before in Spain during the Reconquista (the retaking of the Iberian Peninsula from the Moors), as their tracery vaulting often attests (page 40). They lack aisles or side-chapels and include a choir above the front entrance, resting on a vault that spans the entire nave. Thick walls of adobe brick and

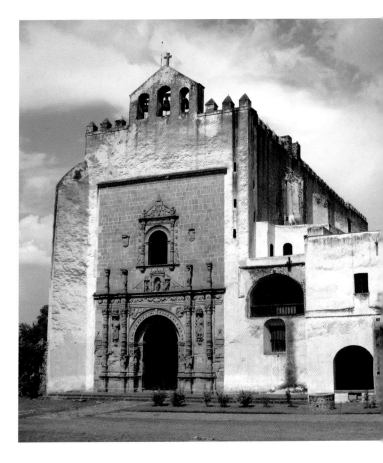

13 Church of San Agustín, Acolman (Mexico), facade completed 1560.

Displays of food and ornamental garlands on the portals of churches like this one at Acolman symbolized the spiritual feast provided by the new religion. For indigenous audiences, however, they may have recalled ritual offerings from the pre-Conquest period.

rammed-earth construction were faced with cut masonry, sometimes reusing stone from demolished pre-Hispanic structures; heavy buttresses defended the walls from frequent earthquakes. Although many churches included structural support for one or two bell towers, those visible today are almost always later additions.

Unlike churches in Europe generally, not all of these buildings face west; their orientation was often determined by the alignment of pre-Conquest pyramids or platforms, on which they were constructed for practical as well as symbolic purposes. As is typical of much Novohispanic architecture, style is commonly evident on exterior surfaces rather than in forms or spaces. Mission church facades in Oaxtepec and Yecapixtla include Gothic rose windows, which were already out of date in much of Europe by the 1550s; others, as in San

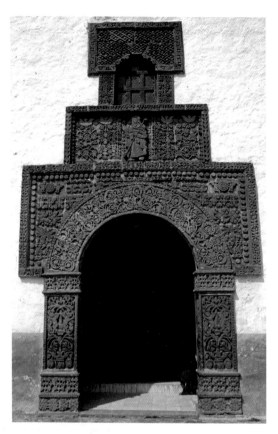

14 Church of Santiago, Angahuan (Michoacán), portal, mid-sixteenth century.

Agustín Acolman (1555–60), reveal a sophisticated understanding of Classical forms. The entrance at Acolman is basically a delicate triumphal arch, with carved renditions of fruits and plates of food (including a whole roast pig) on the curving bands above the doorway. Niches containing statues of Saints Peter and Paul are surrounded by further Classical citations: fluted half-columns, garlands, and friezes. Although originally this refined style would have been called "*a lo romano*," it is sometimes termed "Plateresque," given its resemblance to ornamental Spanish silverwork of the period. Possibly designed by the Spanish architect Claudio de Arciniega (*c.* 1527–1593), this exquisite facade was an assertion of up-to-date Renaissance sophistication in a truly reborn world.

That a wide array of visual options was employed for these churches becomes apparent when comparing the cool reserve of Acolman to the noisy patterns on the facade of Santiago Angahuan, a smaller church in a more remote region. Classicism is present in the arched entryway and stylized acanthus-leaf borders, but the emphasis is on overall pattern rather than Classical or religious details: even the image of Santiago seems lost. The ornament here may reference Moorish plasterwork, and the horizontal rectangles around the door and window could be derived from the *alfiz*, a key element in Arab architecture from southern Spain. The decorative motifs contained within the stacked geometric forms, however, are derived from typographic ornaments and the borders of printed books, carved on separate blocks and later assembled in the manner of tiles. As at Acolman, the relief sculpture attracts attention, drawing the faithful into the church—but here with fewer intellectual demands placed on the viewer.

Apart from the facade, the remaining exterior walls of the missions were merely plastered, or the rough stonework even left exposed. The crenellations and merlons set along the roofline of some churches, as well as on adjacent walls, were not defensive: they symbolized the spiritual militarism of the religious orders, and referenced the protective walls of the Temple of Jerusalem. Some mission churches include an ornate lateral entrance on the north side, used only on special occasions; at Franciscan establishments these are sometimes called the *Porciúncula*, referring to a chapel in Assisi, Italy, where Saint Francis lived and founded his order (page 66). Passage through such a gateway surely had powerful spiritual meaning, though the precise function remains unclear (it may have related to the granting of indulgences). In Huaquechula, the lateral portal on the church of San Martín includes images of Christ in Majesty above flanking images of Peter and Paul, but compared to those on the facade of Acolman the figures here

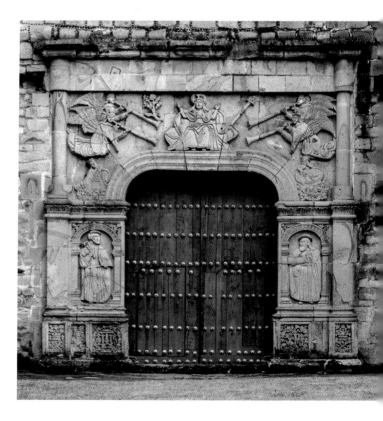

15 Church of San Martín, Huaquechula (Puebla), Porciúncula, before 1570.

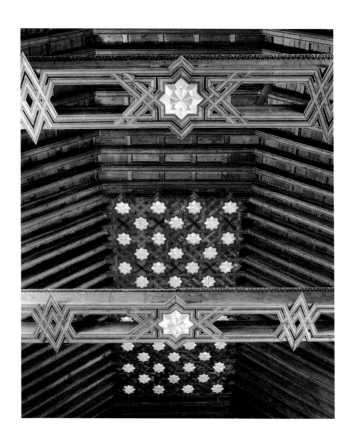

16 Ceiling of the cathedral of La Asunción (Tlaxcala), late sixteenth century or early seventeenth century.

Although the building it shelters was completed in 1564, this wooden ceiling was erected later, perhaps even in the early seventeenth century. The church, originally dedicated to San Francisco as one of the first four Franciscan houses established in Mexico, was rededicated to the Virgin Mary when it was elevated to the rank of cathedral in 1945.

are flat and distorted. The designs were apparently adopted from woodcuts by indigenous sculptors somewhat unfamiliar with three-dimensional modes of representation: like many early colonial sculptural reliefs, they appear pasted on rather than integrated with the architecture, not unlike the carvings on some monumental Aztec sculptures.

In the church itself, the apse was frequently covered with elegant rib vaults resting on side piers. Often ornamental rather than structural, perhaps these vaults were intended to recall the grandeur of Gothic cathedrals. In the early years, the remainder of the roof was wooden, covered in thatch. These initial roofs either burned or were replaced, although a few still remain intact, including the extraordinary Mudéjar ceiling (a Moorish-style construction known as an *alfarje*) in the early Franciscan church in Tlaxcala. It is rendered in resistant cedar in a technique known as *carpintería de lo blanco*, which consists of a puzzle-like assemblage of parts without the use of nails.

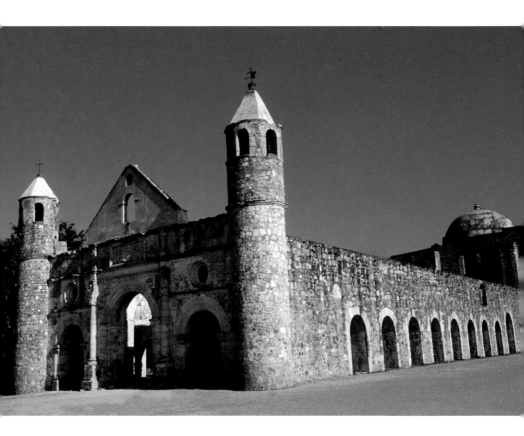

17 Church of Santiago Apóstol, Cuilapan (Oaxaca), 1550s.

The basilica church at Cuilapan lost its roof during the Mexican Revolution (1910–20) and suffered additional damage in an earthquake in 1931. Even in its ruined state, however, it remains one of the most captivating buildings of sixteenth-century Mexico. As at Tecamachalco, a date stone includes years (1555 and 1568) written in Arabic numerals and local glyphs, but it is unclear whether they refer to the construction of the church.

Here is one of the strongest visual reminders of the impact of Moorish culture in New Spain.

If the majority of the mission churches consist of Gothic, Plateresque, or Mudéjar design elements attached to simple boxes, an important but lesser-known subgroup reveals more experimental Renaissance planning. In Pátzcuaro, Bishop Vasco de Quiroga (c. 1470–1565) envisioned a vast church in which five naves, arranged in a star-like pattern, met at a central sanctuary (this utopian project never advanced beyond the first nave). Other early basilicas, such as the Dominican church at Cuilapan, were designed as expedient ways to house large congregations under a broad roof; indeed, the basilica here is actually subsidiary to the (unfinished) main church, and the lateral walls were originally left open to allow Mass to be heard by a greater number of Indians. Even more refined are the Franciscan churches at Tecali (1569) and Zacatlán de las Manzanas (1560s), both possibly by the same architect. If not

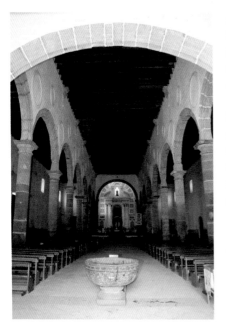

18 Church of San Pedro and San Pablo, Zacatlán de las Manzanas (Puebla), 1562–67.

quite as rigorous in their forms as San Lorenzo in Florence, such churches reveal a passionate attempt to connect the clarity, perfection, and humanism of the Renaissance with the evangelical efforts of missionaries in New Spain.

From the early colonial period onwards, Mexican churches included large wooden altarpieces known as *retablos*, which were placed along the sides of the nave and in the apse. Combining architectural, sculptural, and painted elements, and generally gilded, the earliest retablos closely followed Renaissance canons: clearly delineated tiers or stories were marked horizontally by entablatures and vertically by columns, often topped with a pediment containing an image of God the Father. These enormous wooden constructions represented major expenditures at a time when sculpture was far more valuable than painting. They were created in parts by members of the painters' (including gilders) and sculptors' guilds in Mexico City workshops (the guilds are discussed in greater detail in chapter 2). Once completed, the retablos were shipped off to be assembled *in situ*, their construction sometimes overseen by architects.

As styles changed, and local friars or priests sought to bring their churches up to date, the retablos were far easier to change than the architecture itself. Older versions might be sold to poorer congregations, or their valuable parts reused in new constructions. For this reason, only three Renaissance retablos remain intact today: those in Cuauhtinchan (originally commissioned for the church of San Francisco in Puebla), Huejotzingo, and Xochimilco; the latter dates to c. 1605, and has the purest lines of the three. Each is a massive shimmering construction that fills the apse, as much an architectural wall as a work of art. Along with mural painting, retablos were the chief visual carriers of spiritual information within the church building.

The subject matter of the retablos was carefully controlled and standardized. Declarations by the first (1555) and third (1585) Mexican Provincial Councils—each based on the findings of the Council of Trent (1545–63), the Catholic Church's response to the rise of Protestantism and the dangers of

heresy—give us a sense of the concerns of early colonial leaders about Indian artistry. One statement is worth quoting at length:

Since we desire to remove from the Church of God all things which are the cause or occasion of impiety. . . and which can cause error in simple Persons, such as are abuses in painting and indecency in Images, and because in these parts it is more suitable than elsewhere to take care, because all the Indians who want to, without distinction, paint Images, and without knowing how to paint well nor knowing what they are doing. . . . Therefore, sancto aprobante concilio, we rule and order that no Spaniard nor Indian shall paint Images nor Altarpieces in any Church. . . nor sell an Image, unless such Painter has first been examined and given a license to paint. . . and that the Images so painted should be first examined and taxed by our Judges . . . and we order that our Visitadores who inspect churches and pious places, should see and examine well the Stories and Images which have been painted up to this time, and should have removed those which they find apocryphal, bad, or indecently painted.

The creation of the retablos was also subject to specific contractual provisions typical of a legalistic society. In the surviving contract of 1584 for the Huejotzingo retablo, the town's caciques agreed to provide the Flemish-born painter Simón Pereyns (c. 1530–1589) and sculptor Pedro de Requena with a team that included three local carpenters, three assistants to grind gesso, two male servants, and two female cooks; they were also to supply hay, firewood, charcoal, and corn, and pay a total of seven thousand gold pesos for the completed work (the day wage for a skilled laborer was not even one silver peso; unskilled workers received far less). The contract further specified that the retablo be taller and wider than that of a rival village, detailed the precise number of columns, and stated that the identity and location of sculptures and paintings be "in the manner that the guardian friar and the Indians desire." Pereyns then subcontracted work to Andrés de Concha, a leading Spanish artist who had arrived in New Spain in 1568, and others, including an Indian gilder from Mexico City named Marcos de San Pedro. Although colonial laws generally restricted such tasks to white master-craftsmen, there were not enough of them to do all of this work and so the rules had to be relaxed.

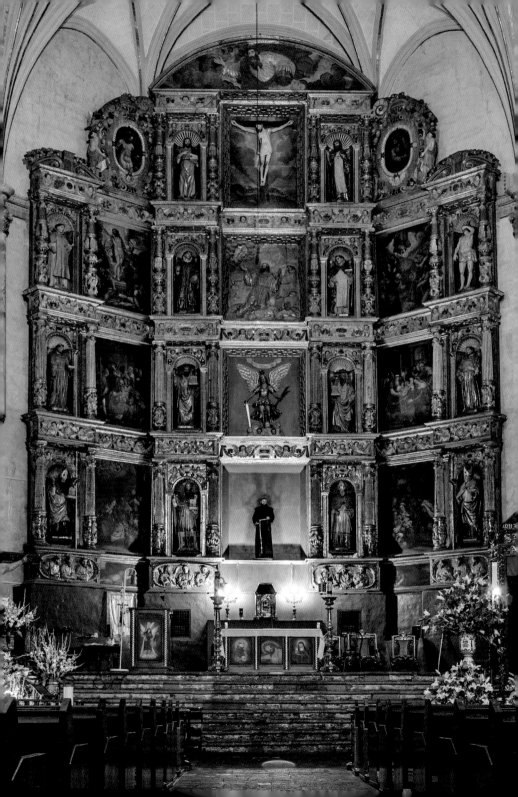

19 Simón Pereyns, Andrés de Concha, Pedro de Requena and assistants, main retablo, 1584–88. Church of San Miguel, Huejotzingo (Puebla).

Concha collaborated with Pereyns on other projects, including a retablo for the Dominican monastery at Teposcolula (Oaxaca). The patrons refused to pay the agreed fee when that wooden construction ended up being too narrow for the intended space, but the problem was eventually resolved.

The close involvement of the local indigenous elites in the construction of the Huejotzingo altarpiece reminds us that just as Indian laborers worked for colonial authorities, so leading European artists could be hired by Indians, even in rather distant towns, including Huejotzingo or Yanhuitlán (Oaxaca). Wealthy indigenous caciques, who still controlled land and laborers, could afford the very best, including painters like Pereyns. They even commissioned portraits of themselves: in the center of the Xochimilco retablo, angels extend Saint Bernardino's cloak to protect the indigenous patrons in the foreground, dressed in clothing that combines native and European elements.

Monasteries themselves were two-story structures that surrounded a cloister, generally placed on the protected south side of the church and accessed by an open portico and waiting area called the *portería*, sometimes used for instruction, hearing confession, performing baptisms and marriage, and even ministering to the sick. Communal spaces for the friars were located on the lower level, with the friars' cells upstairs.

20 Unidentified artist, *Saint Bernardino and Indian Patrons*, panel on main retablo, c. 1605. Church of San Bernardino de Siena, Xochimilco, Mexico City.

Employing a convention also seen in images of the Virgin Mary, the anonymous sculptor—probably from Xochimilco—shows Saint Bernardino sheltering congregants under his robe, with the assistance of two angels. The relief reveals the impact of leading Sevillian sculptors, whose work was exported to New Spain.

A crucial feature of these monastic complexes was the large open plaza in front of the church, surrounded by a low wall. Now generally termed the *atrio* (or atrium), but at the time called the *patio*, these open spaces must have resonated with the plazas in pre-Hispanic cities, as well as the courtyards in front of former mosques in Spain. These courtyards had a primarily practical purpose: before the 1570s, when indigenous populations remained high, they could accommodate the entire congregation, which was able to attend Mass conducted from an open chapel (originally known as the *capilla de indios*). Indians were allowed inside the mission church only after baptism and when the friars were convinced that their recent converts

21 Diego de Valadés, ideal mission patio from *Rhetorica Christiana* (Perugia, 1579).

Diego de Valadés studied at the Colegio de Santa Cruz, where he was named secretary to Pedro de Gante. Although his parentage is not certain, he might have been a mestizo; if so, he entered the Franciscan order despite a regulation of 1555 prohibiting the ordination of Indians, blacks, or mestizos.

understood the basics of Christianity. Some patios measured as much as 400 or 500 feet on each side, and could hold up to 40,000 congregants. One of the most spectacular surviving examples, dating from 1561, almost overwhelms the Franciscan church at Izamal (Yucatán). The size of this arcaded court was surely determined by the Maya platform it rests on.

In 1579, while in Italy, the Mexican-born friar Diego de Valadés (1533–after 1582) published his *Rhetorica Christiana*; this treatise about the evangelization effort drew on his personal experience (and was the first book published in Europe by a Mexican author). One print shows an ideal patio, possibly based on the one in the Franciscan complex in Mexico City. In the center, a group of friars, led by Saint Francis, carry a model of the Church of God. Walkways lined by trees lead to posa chapels (the name indicates that they are places to "pause") in the four corners; congregants stopped to pray at these structures, the upkeep of which was the responsibility of religious confraternities. With their domed or peaked roofs, the chapels recalled the mandatory *ciborium* (canopy) that protected the altar and symbolized heaven. The most beautiful surviving examples are at Calpan and Huejotzingo, in Puebla, where some of the carvings have been directly linked to European woodcuts. There is some evidence that these reliefs were originally brightly painted.

Valadés's engraving shows various activities taking place simultaneously in the patio. Alongside marriage and burial, there is a small image labeled *Discunt omnia* ("they discuss all things"), showing Pedro de Gante himself lecturing to seated Indians (identified clearly by their robes, tied at the shoulder in a pronounced knot) using pictures that have been painted on easily transportable and stored "church cloths" (*sargas*). As the accompanying text states: "Because the Indians lack letters, it was necessary to teach them by means of some illustrations; for this the preacher demonstrates the mysteries of our redemption with a pointer." None of these painted cloths survives, but they may have been similar to the Testerian catechisms, rebus-like pictorial books made for

22 Posa chapel dedicated to San Miguel, Calpan (Puebla), c. 1555.

The image of the Last Judgment on the east side of this chapel has been traced to a German woodcut that originally appeared in the Nuremberg Chronicle (1498), and that was reproduced in many subsequent books, including the *Flos sanctorum*, a volume in all Franciscan libraries. The papal tiara atop the pyramidal roof refers to Saint Peter.

elite converts (including one now in Madrid that bears the signature of Pedro de Gante), which blend European and native systems of representation, a strategy widely tolerated in the early years of the Conquest.

Far more permanent, yet similar in function to the illustrated sargas and catechisms, are the monumental atrial crosses that stood in the center of the patio. Early versions were made from wood, but a decree of 1539 stated they should be lower and made of stone to avoid attracting lightning. One cross from near Mexico City (made around 1550) is typical of the best of these spectacular sculptures. Spread over the entire surface, symbols of the Passion served as an educational tool, and a reminder for those who already knew the story. The crown of thorns and draped cloth imitate real objects that may have been placed on simpler wooden versions, especially around Easter time. Jesus's body is unified with the cross, as if it is just emerging from the stone. In the early evangelization period some Spaniards feared that graphic and public images of Christ's sacrificed body might resonate too strongly with pagan human sacrifice, but the wounds here are nevertheless shown in morbid splendor. Although the iconography is fully Christian, the distribution of symbols across the surface and the emphasis on a story of sacrifice might have struck a chord with new converts who remembered old idols and the ways they had been made. Some crosses have obsidian inlaid at the center, a material the Aztecs associated with vital forces and the sun. The crosses may even have recalled cosmic trees: set at the center of a courtyard, with posa chapels at each cardinal point, the atrial cross would thus have anchored a cosmogram as perfect as the one in the frontispiece of the Codex Mendoza (page 6). As in other examples of early colonial art, these sculptures emitted simultaneous sacred messages to different audiences.

Although mendicant friars had preached to crowds in the open air back in Europe, the open chapel evolved because according to Church doctrine, Mass had to be

23 Unidentified artist, atrial cross, c. 1550.

This monumental cross was formerly located in front of the Capilla de Indios at Tepeyac; the hill above this long-destroyed structure is now famous as the site of the appearance of the Virgin of Guadalupe. The original base of the cross has been lost.

24 Open chapel, church of San Juan Bautista, Teposcolula (Oaxaca), c. 1561–75.

Teposcolula's prosperity (the town was made wealthy through the production of silk and cochineal) financed an altarpiece by Pereyns and Concha (1578), and this elegant open chapel. The central altar—flanked by two transverse aisles—is surmounted by a complex yet elegant hexagonal vault, supported by prominent buttresses that are spread apart to facilitate the sightlines of worshipers.

25 Capilla Real, Cholula (Puebla), 1560s.

The Capilla Real and the adjacent Franciscan church and monastery of San Gabriel were built on the site of a pre-Hispanic temple and plaza. The Capilla Real was originally covered with nine long barrel vaults, an ambitious engineering experiment that failed when they collapsed in 1581. The current roof, consisting of forty-nine domes, dates to the seventeenth and eighteenth centuries.

celebrated under a covered space. Although some chapels, like the one at Acolman, are cave-like openings in the main facade of the mission complex, others stand apart, even more elaborate than the main church, since the very reason for the entire complex was the evangelization of the indigenous masses. At Teposcolula, the two-story chapel (with separate choirs for boys and girls) is an ornate Renaissance structure, yet further proof of the sophistication of cacique patrons far from Mexico City. At Actopan, the vast barrel vault of the open chapel—covered in murals showing scenes from the Old Testament and the gaping jaws of hell—provided an ideal space for didactic instruction at a scale that astounds us even today.

Another eccentric building is the Capilla Real or "Royal Chapel" (a sign that it had been granted special privileges rather than an indication of use), built to the north of the

Franciscan mission church of San Gabriel (and visible on the *Relación Geográfica* map of 1581, page 30) in the once-great indigenous city of Cholula. The nine-by-seven-bay plan has been traced to numerous sources, from an influential architectural treatise by the Italian Mannerist architect Sebastiano Serlio to the seven-nave interior of San José de los Naturales in Mexico City—itself perhaps derived from the hypostyled mosques of southern Spain, most notably the Mezquita in Córdoba. As at the basilica in Cuilapan, the front was originally left open; the structure reached out conceptually to the enormous Indian congregation that was not able to fit into the main church.

III. The Art of Evangelization: Mural Painting

Extraordinary mural programs were painted in the church naves and monasteries of the mission complexes between about 1535 and 1585, a half-century of relative permissiveness in terms of iconographic choices and cultural blending. The generally anonymous mural painters in this early period were probably all indigenous; many trained in the conventual schools in Mexico City and Tiripitío. At some monasteries—Malinalco, for example—we find evidence of formal and iconographic correspondences between murals and contemporary manuscript paintings, indicating that a number of artists (who thought of themselves as tlacuilos, or scribes) worked in both media, which they considered equivalent systems of communication. The overall programs, however, were directed by local friars, and the murals should probably be seen as the result of collaboration.

The indigenous artists used European techniques, including dry fresco (*fresco secco*) and tempera, but also continued certain pre-Hispanic practices, such as pigment manufacture and the burnishing of painted walls with polished stones. Most were rendered in black and white, partly because many of the images, both figural and decorative, were based directly on woodcuts from printed books. It may also have been a matter of economics: black pigments are easily obtained from carbon, and artists were thus able to cover vast areas of walls in both the public and private spaces of the monastic complex in a relatively short period of time. This is why one finds so many illusionistic coffered vaults, painted rather than three-dimensional, as in the open chapel of Actopan. Color was used

sparingly, and may have carried some pre-Conquest meanings; blue, for example, signified fertility.

Some early secular murals (dated 1536) survive in the Caja de Agua, part of a water-circulation system near the Colegio de Santa Cruz de Tlatelolco. Other more historical scenes were commissioned in Tlaxcala by indigenous rulers to demonstrate their contribution to the Conquest—as allies of the Spanish against a common Aztec enemy—and their continuing allegiance in the post-Conquest era. Long-lost murals painted in Tlaxcala's Cabildo (the seat of the indigenous municipal council) in the late 1550s were partly recorded in drawings in the *Description of the City and Province of Tlaxcala*, written by the mestizo chronicler Diego Muñoz Camargo (*c.* 1529–1599) (page 19). A version of that manuscript was given to Philip II in response to the *Relaciones Geográficas* questionnaires, but another remained in Tlaxcala, where, in poor condition by the eighteenth century, it was copied again onto a large cloth known as the *Lienzo de Tlaxcala*. The story of this one mural cycle reminds us that so much early colonial visual culture survives only through copies, partial translations, and frequent misunderstandings.

Surviving murals in the monasteries are difficult to date, and their overlapping thematic programs were subject to the local taste of individual friars. As in Europe, murals in the conventual spaces served to inspire the brothers to prayer and contemplation. As a rule, the four ends (or *testerae*) of the cloister were decorated on both levels with large narrative scenes of the Life of Jesus placed above narrow altars; these were used in devotional walks as stations for meditation or prayer. Similarly, at stairwells, and in other spaces where friars had to turn a corner or pause, one finds images of Calvary— including skulls or whole skeletons that prompted a brief meditation on mortality. The walls often include painted Plateresque columns and ornamental borders filled with dolphins, cherubs, and acanthus leaves: these secular design elements were generally created using templates. Latin prayers form decorative bands along the upper walls. Some scribes may have inserted pre-Conquest imagery into the murals, including references to *pulque* (the fermented sap of the maguey cactus) and corn cults, nearby landscapes with cosmic significance, or calendrical counts. Other murals reveal a keen understanding of Flemish Mannerism: one of the finest and best-preserved mural

26 Unidentified artist, *Lamentation, c.* 1556. Cloister, monastery of San Andrés, Epazoyucan (Hidalgo).

At Epazoyucan, images of Jesus's Passion, set in four indented niches placed at the ends of the ground floor of the cloister, still captivate viewers. They were originally painted black and white; scholars remain uncertain when the color was added.

programs is found in the cloister at Epazoyucan (Hidalgo), where brightly colored scenes of Christ Carrying the Cross, the Lamentation, Ecce Homo, and the Dormition of the Virgin were closely based on European sources.

Not surprisingly, the murals frequently glorify religious philosophers and monastic leaders, and illustrate key events in the genealogy and history of the orders. Murals in Huejotzingo commemorate the arrival of a group of twelve Franciscans in June 1524. At Actopan, life-size portraits of the Doctors of the Church, as well as saints associated with the Augustinian order, are stacked up in the stairwell. At the nearby monastery in Atotonilco el Grande, the same space includes portraits of the Classical philosophers Socrates, Plato, Aristotle, Pythagoras, Seneca, and Cicero, similar to illustrations in an edition of Aristotle published in Paris in 1542, proof of the profound humanistic impulse that some friars embraced. These figures not only affirmed that history stood behind the mendicant orders and their spiritual goals, but also provided virtual companionship, since few friars were usually in residence.

Like the gilded retablos, the murals located inside church naves—as well as the porterías and open chapels—though painted by indigenous hands, were powerful public assertions of the new order. It is less clear to what extent the murals elsewhere in the monasteries were seen by anyone other than the friars and their servants. Some privileged Indians may have had access to the lower cloister. One of the earliest known Novohispanic portraits, located at the foot of the staircase in Actopan, shows two local caciques (who donated land, labor, and money for the mission) praying alongside the prior Fray Martín de Acevedo. We know precious little about how they or other indigenous people experienced or understood any of

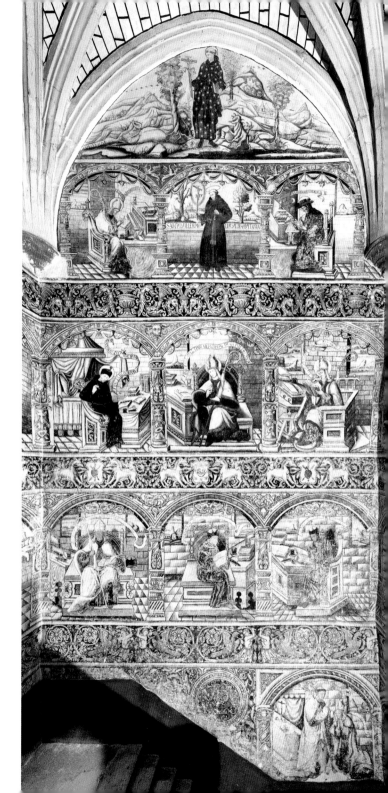

27 Unidentified artist, *Doctors and Saints*, *c.* 1574. Stairwell, monastery of San Nicolás, Actopan (Hidalgo).

28 Unidentified artist, *Portraits of Fray Martín de Acevedo, Don Juan Inica Actopa, and Don Pedro Izcuicuitlapilco, c.* 1574. Stairwell, monastery of San Nicolás, Actopan (Hidalgo).

these murals, though one imagines the tlacuilos themselves felt pride in the results.

Scenes of the Last Judgment and references to the Apocalypse are also common in both sculptural and mural decorations. On one level, such fearsome images reminded indigenous converts as well as the friars of the dangers of sin. But they also revealed the tensions and anxieties of the age. The discovery of America, the conversion of the Indians, and the devastating plagues were all seen as part of a turbulent onslaught of historical events, including the Crusades and the Reconquista, which seemed to augur the end of time predicted by the Book of Revelation. The Franciscans were particularly influenced in this regard by the mystic teachings of the twelfth-century monk Joachim of Fiore. Frightening images of hell often accompany scenes of the Last Judgment: in the open chapel of Actopan a fanged monster's mouth opens to show brutal scenes of diabolic torture, including cannibalism, derived from illustrations in Valadés's *Rhetorica Christiana*.

One of the most important of these apocalyptic cycles was painted by an indigenous artist (or artists) in the Franciscan church at Tecamachalco. Dated 1562 in a Nahuatl inscription, this is less a mural than a unique installation that bursts forth on the low ceiling of the under-choir as one enters the church: twenty-eight richly colored biblical scenes, rendered in tempera on separate oval canvases, were pasted onto sheets of amate paper glued between the vaults. The Franciscans certainly chose the subjects: an inner ring includes events from Genesis

and the Book of Ezekiel, while an outer ring shows scenes from the Revelation of Saint John. Scholars have traced these images to woodcuts in mid-sixteenth-century bibles published in Lyon, though those rather crude prints were derived from others by such artists as Dürer and Holbein. At the same time, the amate support and subtle visual references to pre-Conquest imagery—the eddies in the water surrounding Noah's Ark, for example—place these works within a denser web of ideas, images, and influences that converged in a once-prosperous town now off the beaten track.

Of the surviving mural programs from sixteenth-century Mexico, none is more visually exciting than the "battle scenes" that frame the nave of the mission church in the frontier town of Ixmiquilpan. Now surviving only as fragments, the murals, which preserve their original color, originally consisted of a band about 6½ feet high. Swirling acanthus leaves serve as pedestals for warriors dressed as jaguar and coyote knights wielding obsidian-edged clubs (*macuahuitls*), who fight centaurs and semi-nude figures carrying bows and arrows. Despite the prominent Classical motifs, pre-Conquest iconography—including speech scrolls, shields, and trophy heads—predominates. In fact, the Ixmiquilpan murals resonate more with battle scenes in pre-Hispanic murals—such as those at Bonampak and Cacaxtla—or the images of gladiatorial combat shown in the Codex Diego Durán of the 1570s, than with any known mural cycles in other mission churches.

The deeper meaning of the Ixmiquilpan cycle is not clear, although it is likely that the scenes were based on actual theatrical performances held in the area, versions of the Dances of Moors and Christians that originated in Spain during the Reconquista. One theory holds that the murals show the local Otomí (who had already converted to Christianity) fighting pagan Chichimecs (who continued to resist the Spaniards), thus confirming the congregation's support of the brutal and genocidal Guerra Chichimeca of the second half of the sixteenth century. Another suggests that the murals allude to Aztec war songs, and that the victors should be seen as warriors of the Sun, uprooting forces of darkness from a flowery Christian heaven. Either way, this multivalent mural cycle spoke to the timeworn theme of Good versus Evil and was thus acceptable to the Augustinians—notwithstanding its obvious pre-Hispanic references.

29 Unidentified artist, *Scenes from the Old Testament and the Book of Revelation*, 1562. Church of Nuestra Señora de la Asunción, Tecamachalco (Puebla).

The famous paintings at Tecamachalco were long attributed to a documented indigenous scribe named Juan Gerson, though their authorship is now in question.

The conventual murals had very little impact on subsequent artists, since almost all were whitewashed over by the end of the century. In some cases, they may have been visible only for a decade or less. By the 1580s, the secular clergy had increased its authority over New Spain and its arts, and was suspicious of mendicant experiments of all types. In the wake of the Council of Trent, when the Catholic Church sought to reassert orthodoxy, many of the murals—inspired as they were by humanism, Northern European prints, and even pre-Conquest culture—were now suspect, and the fact that Indians had been involved in their creation only increased the concerns of the

censors. Not until the discovery and (sometimes overly zealous) restoration of these great mural cycles in the post-Revolutionary period would they truly enter the canon as one of the great achievements in the history of art in the Americas.

Even if the regulations required by the Council of Trent had been more tolerant, however, there were not so many people around to view these works by the end of the sixteenth century. Uncontrollable epidemics had pummeled New Spain almost every two decades following the Conquest, with particularly devastating results for the missions. Some indigenous populations fell by as much as 90 per cent. Though missionaries, now including Jesuits, continued their work to the north, in Central Mexico the evangelization of the Indians was complete. The depopulation of rural Mexico, the increase in the *peninsular* (Spaniards born in Europe), *criollo* (whites born in New Spain), and mestizo populations, and the growing power of the secular clergy meant that the art of the next centuries, with relatively few exceptions, would be produced in the booming cities. Indigenous aesthetics and meanings would become increasingly rare, as fewer and fewer people survived with any memory of how things had once been.

30 Unidentified artist, *Battle Scene*, c. 1569–72. Church of San Miguel, Ixmiquilpan (Hidalgo).

In this fragment from the frieze that once ran along both sides of the nave of the church, a warrior dressed in a coyote costume seems to step out of a fruit-filled urn supported by acanthus leaves. Bearing a round shield but holding no weapons of his own, he grabs his captive by the hair, a pre-Hispanic sign of domination.

Chapter 2 Art for the New Cities (1550–1700)

In the first century after the Conquest, the emergence of
Mexico City as an ordered and "civilized" capital—built over
the ruins of Tenochtitlan—became a great source of satisfaction
for the criollo elite—many of whom were direct descendants
of the conquistadors—as well as transplanted peninsulares. In
La grandeza mexicana (*Mexican Grandeur*, 1604), the poet and
theologian Bernardo de Balbuena (born in Spain, but raised in
Mexico) called Mexico City the "center of perfection [and]
hinge of the world." New Spain's growing prosperity—built on
mining, agriculture, and international trade—and the increasing
power of the viceregal court and ecclesiastical leaders created
new patronage networks for architectural and artistic projects.

Mexico City dominated art production at the close of the
sixteenth century, although Puebla (the second-largest city in
New Spain) became the innovative center in the first half of the
seventeenth century, after terrible floods made Mexico City
almost uninhabitable, at least for a time. Along with other
skilled tradesmen, the painters, sculptors, and architects—
initially all were immigrants but over time they were
increasingly Mexican-born—worked according to familiar
European models. Artistic education, production, and
distribution, though supervised by the Church, were by the
end of the sixteenth century fully controlled by the various
professional guilds, primarily based in Mexico City. Since the
art and architecture in Spain at this time was itself eclectic, it
should be of no surprise to find a similar complexity in Mexico.
Indeed, Novohispanic painting, sculpture, and architectural
forms were caught in a dense transatlantic web of copying,
adapting, recycling, and transforming, a framework that often
makes tracing specific sources elusive.

Images from Spain and Flanders poured into the Americas
along with all sorts of luxury goods; a booming trade in prints
kept Novohispanic artists relatively well informed about new
trends, while ensuring their religious iconography conformed
to doctrinal requirements. But, if they were somewhat
conservative relative to leading artistic centers in Spain or Italy,
the achievements of Mexican painters, sculptors, and architects

in the seventeenth century were nonetheless stunning. Such artworks are evidence of the steady rise of a local cultural tradition with its own dynamic internal forces, as well as an engagement with outside sources. Artists in New Spain, like other influential figures in colonial society, were both dependent and rebellious: they operated in a broader culture that relied on imitation, while also seeking—at least at the highest echelons of the profession—to be innovative and imaginative, the intellectual equals of their European colleagues.

Despite the preponderance of religious painting created through the patronage of bishops and secular (or non-monastic) clergy, by the end of the seventeenth century we find a rise in the production of non-religious images, spurred on by the demands of the viceroy's court. Some of these works reveal an increasing sense of local pride, or *criollismo*, built on new fortunes. Although the more transient peninsulares occupied the highest political and ecclesiastical offices and dominated commercial trade, generation after generation of criollos controlled the Church and university, and made fortunes in mining and agriculture. Art provided a key means to assert their political legitimacy and defend hard-won prerogatives. Not surprisingly, this burgeoning criollismo would lead to an interest in foundational tales and other histories that would be crucial in the later formation of a distinct national identity. The Spaniards and criollos did not monopolize the art market, however; some elite Indians also commissioned works as assertions of their own political and cultural status.

I. Civic and Domestic Architecture

Several of the cities of New Spain occupied new spaces: Puebla, for example, was founded in 1531 near—but not atop—the defeated pre-Hispanic centers of Cholula and Huejotzingo. In fact, the name itself means a new "populated place," distinct from an older settlement, or *pueblo*. Spaniards inhabited the heart of Puebla (indigenous laborers were marginalized across the river), where the rigid grid—the streets were uniformly 14½ yards wide—was based more on the military encampments of the Reconquista than on abstract Renaissance concepts. Other important Spanish cities included Oaxaca (originally named Antequera, and founded in 1529), Guadalajara, and Mérida (both founded in 1542). But the single most

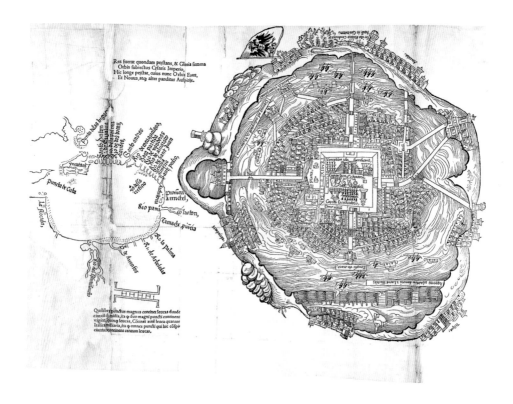

Res fuerat quondam prstans, & Gloria summa
Orbis subiectus Cæsaris Imperio,
Hic longe prstat, cuius nunc Orbis Eous,
Et Nouus, atq; alter panditur Auspicijs.

Quiliberpunctus magnus continet leucas duode
cim cū dimidia, ita q̃ duo magni puncti continent
viginti quinq̃ leucas, Cœtiuet vnū leuca quatuor
Italicamiliaria, ita q̃ omnes puncti qui hic cōspi
ciuntur continent centum leucas.

31 Unidentified artist, *Map of Tenochtitlan and the Gulf of Mexico*, 1524.

This map features a square plaza with ceremonial buildings in the Aztec capital. One, identified as the "Temple of Sacrifice," is clearly the twin pyramid known today as the Templo Mayor. Other rather accurate details include a representation of Moctezuma's aviary and several raised causeways connecting the island to the lakeshore.

important place in New Spain, as it had been before the arrival of the Spanish, was Mexico City itself.

Although they had admired Tenochtitlan, the conquistadors quickly pursued the destruction of the indigenous city, already underway during their final campaign against the Aztecs. The first *traza* or urban plan of 1523–24 was drawn up by Alonso García Bravo (1490–1561), a soldier who had arrived in the New World in 1513, joining Cortés's invasion force in 1519. García Bravo followed the city's preexisting grid and orientation, but, in accordance with Renaissance ideas, straightened and widened the streets to facilitate control and allow more sunlight to penetrate the blocks. The Spaniards filled in many canals, but left the main causeways intact; these roads—known as *calzadas*—still carry traffic today. Although they occupied some Mexica palaces, they used the principal temples as quarries. The gridded central area, also called the *traza*, was reserved for whites, who numbered between 12,000 and 15,000 by the end of the century; the larger indigenous population, which fluctuated because of epidemics, occupied four separate neighborhoods (*parcialidades*), located on somewhat swampier ground.

32 Unidentified artist, *Plan of the Plaza Mayor, Mexico City*, 1563.

In this drawing Mexico City's first Cathedral seems dwarfed by the enormous civic buildings that surround it. The outlined rectangle to the right of the Cathedral is the foundation of the new Cathedral—the cornerstone of which had just been laid the previous year.

The earliest European depiction of Mexico City is a woodcut published in 1524 to accompany a Latin translation of Cortés's letters to Charles V. Probably created by a German engraver in Nuremberg working from Spanish texts and at least one indigenous map, the architectural forms in the scene are European, but certain details can be traced to pre-Conquest mapmaking conventions. For example, the enormous bay to the left of the city is not based on a real geographic feature, but rather seems to be a misreading of a mountain glyph (*altepetl*), resembling the one on the *Map of Tezontepec* (page 30). There are no images showing the city under reconstruction, however, though some illustrations in Sahagún's Florentine Codex (page 28) and other early sources depict Indian masons at work.

A plan from 1563 of Mexico City's Plaza Mayor (renamed the Zócalo in the nineteenth century) already demonstrates a rational urbanism well in effect. The plaza includes a small and quite primitive Cathedral to the north, and a canal, dating from the pre-Conquest period, to the south. The first building of the Real y Pontificia Universidad de México (Royal and Pontifical University of Mexico), established in 1553, stands behind the

Cathedral. Soon after the Conquest, Cortés replaced the two large palaces of Moctezuma that framed the new plaza to the west and east with rusticated, fortress-like buildings with medieval and Renaissance details.

The structure to the east, originally Moctezuma's Casas Nuevas ("new houses"), eventually became the home of the viceroy, though it was called the Real Palacio (Royal Palace) and functioned as the principal administrative building in New Spain. The building was partly destroyed by a riot in 1692, and has been much modified over the centuries; it was renamed the Palacio Nacional after Independence. Commercial endeavors were established in surrounding arcades, and on the south side of the plaza, the colonists constructed the Ayuntamiento (city hall), which included a jail, mint, granary, and further portals for merchants.

From the beginning, then, the Plaza Mayor concentrated the forces of Church, Crown, and commerce in the sacred space once reserved for Aztec ceremonial life, reminding us that from the start New Spain was controlled at all levels by a centralized system. After the replacement of the First and Second Audiencias—rather unwieldy royal committees initially charged with governing the new territories—with the first viceroy, Antonio de Mendoza, in 1535, the king had an official representative in the Americas whose body literally substituted for his own. No Spanish monarch ever visited his New World possessions, but he was symbolically present in processions marking the viceroy's arrival and other formal acts pertaining to

his rule, often commemorated by ephemeral triumphal arches. Sculptural reliefs showing the Habsburg coat of arms indicated royal patronage of key religious and secular buildings, including the Real Palacio and Cathedral.

No early civic or domestic buildings remain in the center of Mexico City, but we can get some sense of the aesthetics of these lost structures by turning to surviving examples in the provinces. In Cuernavaca, the Palacio de Cortés—perhaps begun in the late 1520s—preserves the blocky crenellated walls and open Renaissance arcades (one of which now shelters a mural painted in 1930 by Diego Rivera) common to many early civil constructions. Far more ornate is the Mannerist facade of the Casa de Montejo in Mérida (1549), built by the

33 Palacio de Cortés, Cuernavaca (Morelos), sixteenth century.

34 Casa de Montejo, Mérida (Yucatán), facade dated 1549.

son of one of the chief conquistadors. The classicizing relief decorations—recalling those at Acolman (page 34)—include possible portrait busts of the first owner and his wife, mythological figures, and quirky animals. Above the window, the Montejo coat of arms is flanked by gigantic statues of Spanish halberdiers who tower above hairy "wild men" wielding rustic clubs: symbols of victory over uncivilized or pagan forces, according to medieval Spanish traditions, these sculptures also evoke the ongoing and brutal conquest of the local Maya.

Thus, like the carved portals of the finest mission churches, the facades of early civic buildings in New Spain were designed to communicate Renaissance sophistication, as well as martial power and royal or aristocratic authority. The interiors were sparsely furnished, and few records of what they looked like survive. The Real Palacio in Mexico City included a Hall of Royal

Accord—a sort of European throne room—where a copy of Titian's *Equestrian Portrait of Charles V*, other royal portraits by Alonso Sánchez Coello, and paintings of the viceroys were displayed. Imported tapestries and worked-leather wall hangings decorated the Palacio de Cortés and the Real Palacio, though these were costly imports that few could afford.

Some secular buildings were decorated with less expensive wall paintings. Though much restored, two rooms in the Casa del Deán in Puebla—frescoed with secular murals around 1590—are among the few sixteenth-century domestic spaces that preserve any of their original decoration. In one room, against a vaguely Flemish landscape of small villages, a mounted and blindfolded figure representing Judaism leads a parade of mounted sibyls, ancient oracles described by Ovid and other Classical writers. The other room, decorated by a different artist, includes renditions of five of Petrarch's *Triumphs*. Derived from a series of Flemish prints by Maarten van Heemskerck from 1565, a suite of allegorical chariots drawn by horses, deer, or unicorns represents the victories of Time, Death, Love, Chastity, and Fame. (The sixth Triumph, Faith, was either not included or does not survive.) Such works were a public testimony to the patron's sophisticated Classical learning and humanism, despite Church censorship. We know nothing of the painters of these murals, though inventive ornamental borders (sometimes called "grotesques") in both rooms reveal evidence of an indigenous hand, particularly in the presence of speech scrolls and native animals associated with pre-Hispanic vices and virtues.

II. Immigrant Masters and the Emergence of a Local Style

35 Unidentified artist, *Triumph of Love, c.* 1590. Casa del Deán, Puebla.

Tomás de la Plaza, dean of Puebla Cathedral from 1564 to 1589, commissioned murals for his house based on Petrarch's *Triumphs*, which narrate humanity's victories over earthly passions. After centuries hidden by whitewash, the murals in this much-altered building were rediscovered in 1953.

Compared to Naples or Seville, patronage of the arts in New Spain in the first century after the Conquest was often limited, work conditions more restrictive, and concerns about orthodoxy more severe. These factors, as well as geographic distance, meant that Novohispanic painters and sculptors were generally more concerned than their leading European counterparts with moral and doctrinal matters than formal or stylistic innovations. Many of their local patrons were newly wealthy: they were descended from non-aristocratic families and were not particularly well educated, making them rather conservative as well. Thus, one finds relatively little value

placed on certain refined skills—such as anatomy and perspective—and a suspicion of intellectually grounded invention, which elsewhere had come to define success, especially in the artistic centers of Italy.

The vast majority of paintings, sculptures, and prints produced throughout the viceregal period were religious, and the bishops and regular clergy largely controlled artistic production, serving as arbiters of quality, though there were also secular patrons. During the Counter-Reformation, artistic production was carefully regulated: the Council of Trent—whose findings were well known in Mexico—prohibited images that were indecorous or "unusual," and called for clear visual demonstrations of piety to avoid confusion in the minds of the faithful. One finds a resulting emphasis on the cult of particular saints and devotions, such as the rosary, and the proliferation of exuberant images of miracles as the expression of popular religious fervor.

Although the following discussion focuses on painting, prints were also produced in New Spain (as well as being imported from Europe) beginning soon after the Conquest. Almost no examples from the sixteenth century survive today, outside of those that appeared in books, which were being printed in Mexico City as early as 1539. One exception is a hand-colored woodcut dated 1571 (but made the year before) showing the Virgin of the Rosary, patroness of the Dominicans, created by Juan (or Joan) Ortiz (born c. 1538), a French printmaker who had arrived in New Spain in 1568 as part of the viceroy's entourage. In 1572, Ortiz was hauled before the Inquisition and accused of inaccuracy and heresy because of a short poem that he included as a caption to the print. Among other things, the censors objected to his statement that the rosary beads were "countless." For this mistake, Ortiz was tortured, imprisoned, and fined; fortunately for historians, however, a copy of the print was perfectly preserved in the Inquisition files.

Several leading viceregal painters were better able to triumph despite official restrictions and cultural limitations. They created guilds to defend their practice and promote their fame. Such painters as Juan Correa (c. 1645–1716) founded large workshops, even exporting their works to elsewhere in the Americas and Europe. Yet no Novohispanic artist attained an international reputation until the eighteenth century, nor did

any travel to the Old World to perfect his skills or establish a European career, as did the American painter Benjamin West. Instead, remaining content with economic prosperity at home, they established local lines of influence, often within the same family. At the same time these artists freely digested European models in new and fascinating ways, using imported canvases by Martin de Vos and Francisco de Zurbarán, among others, and—more importantly—etchings and engravings, which were so intensely used that they long ago fell into tatters.

Although numerous indigenous artists were trained in the early conventual schools, they specialized in manuscript and mural painting, traditions with pre-Conquest roots, rather

than working in tempera or oil on canvas. The latter were European skills that, apparently, none of the friars had mastered. The first painters in New Spain to work in these media, therefore, were immigrants who had left Europe to make their fortunes in America (perhaps one trained the artists at Tecamachalco, p. 50).

The first documented painter, Cristóbal de Quesada, arrived in 1538, though no images by him are known. We know that others soon followed, since a Guild of Painters and Gilders was established by 1557. A Guild of Carpenters, Woodcutters, Joiners, and Violin Makers, which included sculptors, was established in 1568; another for Masons, which included architects, followed in 1599. The medieval guild system dominated artistic practice in Mexico until the rise of the Academia de San Carlos, founded in the 1780s as part of the Bourbon reforms intent on modernizing the colonial economy.

In each generation, however, one or two painters were able to break free of guild regulations, generally in their roles as *pintores de cámara* (court artists working for the viceroy) or master painters employed at the Mexico City Cathedral.

In New Spain, these guilds—which regulated quality, training, and commercialization through ordinances approved by municipal governments—not only replicated contemporaneous European practice but also sought to give their members a competitive advantage over indigenous artists. Early commentators noted that the Indians were adept at quickly mastering new trades (such as goldsmithing), sometimes by spying on Spanish masters who zealously guarded their secrets, and then underselling them.

By controlling who could become an apprentice, and how those

37 Simón Pereyns, *Saint Christopher with the Christ Child*, 1588.

Saint Christopher was of particular interest to the Spanish, who saw their laborious efforts to carry Christianity across the Atlantic reflected in the story of this giant who carried the infant Jesus across a river. Monumental frescoed representations of Saint Christopher appeared in many early churches, including Tlatelolco, Xochimilco, and Yanhuitlan.

apprentices would be trained, the painters' guild promoted a closed system that encouraged the transmission of professional skills—and therefore financial prosperity—within families. The first ordinances of the painters' guild implied that Indians could become masters, but new regulations approved in 1568 forbade them from creating images of saints, and from selling what works they *were* allowed to paint to Spaniards, favoring instead guild members. In practical terms, however, the production and sale of paintings, sculptures, retablos, and other crafts was much more fluid. Elite white artists generally received the major commissions from ecclesiastical and political elites, but a large class of artisans—many of whom were Indian or mestizo—produced thousands of images and objects for lower echelons of consumers.

Late sixteenth-century painting in New Spain was dominated by three Europeans: the Flemish artist Simón Pereyns (arrived 1566), the Sevillian Andrés de Concha (arrived 1568, d. 1612) and the Basque Baltasar de Echave Orio (c. 1558–c. 1623). Echave Orio founded a dynasty of painters that passed on skills from master to pupil (often from father to son) in an unbroken chain that would lead to the most important artist of the mid-eighteenth century, Miguel Cabrera. From the beginning, these painters maintained workshops in Mexico City but also took commissions in more remote mission churches; Pereyns and Concha, as we have seen, collaborated on retablos for Teposcolula (1578) and Huejotzingo (1584–88).

Pereyns is a particularly fascinating figure. He trained in Antwerp and moved around Europe before arriving in Mexico City in 1566 in the entourage of the new viceroy Gastón de Peralta as the first of several pintores de cámara. Pereyns decorated the Real Palacio with battle scenes; he too was hauled before the Inquisition on a charge of heresy—apparently denounced by a jealous competitor—though he managed successfully to defend his activities. One of the earliest dated paintings in New Spain is his *Saint Christopher* of 1588, commissioned for an altarpiece in the Mexico City Cathedral.

These three artists all practiced a style that has been called "Reformed Mannerism," with elements drawn from Spain, Flanders, and Southern Italy, and which balanced a late-Renaissance fascination with distorting space and elongating the human body with Counter-Reformation demands that painting provide clear, direct, and inspirational messages. These

characteristics are also evident in the work of Alonso Vázquez (d. 1607), an artist who had a successful career in Seville before leaving for Mexico in 1603 to accompany the new viceroy.

Though he finished few works in New Spain before his death, Vázquez reminds us that in art and architecture, as in other areas, Seville would have a deep and lasting impact in New Spain. His influence colors Echave Orio's elegant *Vision of Saint Francis* (1609), a large canvas that originally formed part of the main retablo at Santiago Tlatelolco. The next generation of artists included a Spanish-born Dominican friar named Alonso López de Herrera (c. 1580–c. 1675), whose archaic style revealed his own provincial origins, and the Novohispanic painter Luis Juárez (c. 1585–1639), who used the Mannerist paintings of Echave Orio as models.

After around 1640, one finds greater naturalism in Mexican painting, despite a lingering dependence by some artists on Mannerist styles of the sixteenth century. Artists in New Spain remained much indebted to Sevillian painters, many of whom created work specifically for the American market, including Zurbarán, though his direct impact may sometimes be overstated by art historians. Increasingly crucial was the Flemish master Peter Paul Rubens, whose work was much collected by the Spanish court in the 1630s. This vigorous and naturalistic style, which sometimes includes more dramatic *chiaroscuro* devices, is evident in the refined religious compositions of José Juárez (1617–1661), the son of Luis Juárez, and José's student, Baltasar de Echave Rioja (1632–1682).

José Juárez, the finest painter of mid-seventeenth-century Mexico, created religious images that perfectly answered the

38 Baltasar de Echave Orio, *The Vision of Saint Francis at the Porziuncola*, 1609.

According to legend, Saint Francis had a vision of Jesus and Mary at the Porziuncola (the Spanish is Porciúncula), a small church outside Assisi, Italy. They granted his request that those who entered the Porziuncola be pardoned their sins. The story was widely disseminated during the Counter-Reformation to undermine Protestant attacks on the granting of indulgences.

Counter-Reformation call for "decency," that is, works that were not only spiritually correct but also opulent and inspirational. Juárez's painting of the child martyrs Justus and Pastor, for instance, emphasizes triumph and heroism over suffering, which reflected current doctrinal requirements. Some elements were inspired by Flemish engravings, and the canvas reveals at least an indirect impact of Zurbarán in its finely crafted surfaces, interest in psychology, and complex architectural framework. A work such as this may have drawn from many sources, but it was wholly new: Juárez sometimes signed his works "ynbentor," asserting that he was an "inventor," not a copyist.

39 José Juárez, *Saints Justus and Pastor*, 1653.

Justus and Pastor were early Christian martyrs beheaded in AD 304 outside the present-day city of Alcalá de Henares, Spain. In 1567 the Pope ordered their bones be returned to Alcalá. The ornate procession of their remains through decorated cities and past triumphal arches is perhaps alluded to here, by the flowers thrown on the ground and the archways that open on to subsidiary scenes.

One of the most compelling images from seventeenth-century Mexico is a canvas by the Sevillian artist Sebastián López de Arteaga (1610–1652), who emigrated from Spain around 1640. *The Incredulity of Saint Thomas* depicts the saint gently touching the wound in Jesus's side, while the other apostles look on; the dramatic lighting effects seem directly inspired by the tenebrism of Caravaggio, who depicted the same theme in 1600–1601. López de Arteaga's rendition, however, is less naturalistic and more eclectic, drawing on a variety of Sevillian sources, including paintings by the young Diego Velázquez. López apparently found little market for his innovations in New Spain, however, and quickly abandoned

40 Sebastián López de Arteaga,
The Incredulity of Saint Thomas,
c. 1643.

41 Baltasar de Echave Rioja, *The Adoration of the Magi*, 1659.

After his father's death, the twelve-year-old Echave Rioja joined the workshop of José Juárez. Besides the use of European models, such as Rubens, he relied on his teacher: here he copied the standing king on the far right almost exactly from a composition by Juárez (1655), though he gave the man's face a more naturalistic expression.

tenebrism for the more colorful and brightly lit style of such artists as José Juárez: contrary to what we might expect, the newly arrived artist was forced to adjust his work to appeal to his Mexican patrons.

That the work of Rubens would be influential in this period is not surprising, given his popularity in Madrid and the fact that his compositions circulated widely in the form of engravings as well as paintings on copper. Significantly, Flemish publishers (then subject to Spanish rule) enjoyed a near-monopoly on sales of books and prints to New Spain. Some details in Echave Rioja's *Adoration of the Magi*, like his later murals for the sacristy in the Puebla Cathedral, reflect the impact of prints after Rubens, which were given to the artist by his patrons as specific models. Other elements show his familiarity with paintings of

42 Francisco Becerra, Juan Gómez de Trasmonte, and others, Cathedral, Puebla, 1575–1768.

After arriving from Spain in 1640, Bishop Juan de Palafox y Mendoza directed Puebla's wealth towards the completion of the cathedral, dedicated to the Virgin of the Immaculate Conception. Palafox is also famous for founding the first public library in the Americas (1646), an institution that still exists today.

the same theme by Zurbarán, though Echave Rioja arranged the figures and their costumes in original ways. Echave Rioja triumphed as painter-in-charge at the Mexico City Cathedral, a powerful position held by many of the leading viceregal artists.

III. From Herreran Severity to Baroque Exuberance

In the seventeenth century the Indian population of New Spain began to grow after its nadir around 1600; the white population also increased, and society overall was becoming more racially diverse. Though the Church continued to play a key role in patronage, projects were frequently directed and funded by wealthy individuals, both peninsulares and criollos. Religious activities in the cities were now increasingly focused on meeting the needs of urban Spanish and *casta* (mixed-race) populations, rather than on evangelization, although some missions

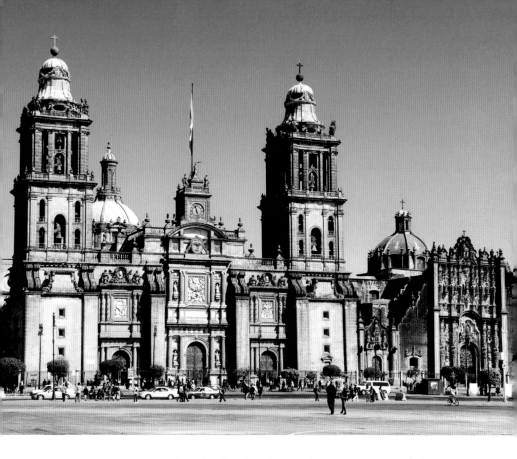

43 Claudio de Arciniega and others, Cathedral, Mexico City, 1573–1817.

The Mexico City Cathedral was named the seat of the archbishop in 1546, and thus attained the status of "Metropolitan Cathedral." The sculptural relief in the center of the facade of the present building shows its patron, the Virgin of the Assumption.

continued to function along trade routes that extended far to the north into what was called *Tierra Adentro*, including the Pueblos of New Mexico. A diversity of patrons meant that architectural forms, such as the convents founded for new orders of nuns, would be far less standardized than in the previous century.

In both Mexico City and Puebla, the earliest cathedrals—finished in the 1530s—were three-aisled basilicas with *ramadas* (thatched wooden roofs) that had been quickly constructed to hold large congregations. Finer cathedrals were planned for both cities by mid-century: the one in Mexico City was based on a plan of 1562 by Claudio de Arciniega and inspired by the new cathedral of Jaén in Spain; in Puebla, the new cathedral was begun in 1575 after a plan by architect Francisco Becerra (1545–1605). But while colonists in Mérida were able to fund and complete their own cathedral by 1598, in the two greatest cities of the viceroyalty the building campaigns advanced erratically.

Setbacks included changing administrations and architects, funding problems, and—in Mexico City—major floods.

Church authorities in Puebla—sensing that they had a competitive advantage—contracted Juan Gómez de Trasmonte (died c. 1647), who had been involved in the construction of the Mexico City Cathedral, to modify Becerra's plan in 1634. The elegant vaults inside the Puebla Cathedral were ready by 1649, when the building was dedicated by Bishop Juan de Palafox y Mendoza. The facade was finished in 1664 and the towers, each nearly 200 feet high, were completed in 1678 (north) and 1768 (south). The poblanos had won the race. The old Mexico City Cathedral was torn down prematurely in 1628, for the new building was not ready until the late 1660s (the towers were not finished for another 150 years). The Habsburg coat of arms still survives on the Puebla Cathedral; the one in Mexico City was changed after independence.

The exteriors of both these buildings were shaped by the Counter-Reformation rigor of El Escorial (1563–84), the massive yet hauntingly sober palace and monastery built by architect Juan de Herrera for Philip II just outside Madrid; the Puebla Cathedral reveals this best, with its severe lines, blocky features, and lack of emphasis on surface ornament (other than the large relief panels, which were common on seventeenth-century buildings in Mexico). This sobriety was difficult to maintain for long. While both churches have rather austere interiors, with Doric columns leading to barrel vaults, new altarpieces shaped by Baroque fashions soon began to compete for attention. For example, in Puebla, the Capilla de los Reyes (Chapel of the Kings) of 1646–49, located in the apse of the cathedral, already included the twisting Solomonic columns that would set a trend across New Spain lasting the rest of the century. In fact, notwithstanding the importance of both these cathedrals, the Herreran style is rare in New Spain: the newly rich americanos preferred conspicuous glitz in architecture as well as painting.

Later seventeenth-century architecture is marked by increasingly exuberant decorative programs with rich plays of light and color, theatrical drama, and visual complexity that are all characteristics of the Baroque, though generally applied to facades and other surfaces rather than interior spaces. The conservative plans of buildings in New Spain compared with European examples from the same period might be attributed

to the rigidity of the urban grid and the existence of larger plots for development. But Novohispanic architects also lacked sophisticated patrons and experienced masons, and, fearing earthquakes, tended to play things safe. Despite the continuing importance of indigenous laborers—especially as stone carvers and masons—evidence of pre-Conquest motifs is now absent.

For the most part, church facades and altarpieces of the late seventeenth and early eighteenth centuries preserve the rectilinear architectural framework that had defined the Renaissance period; however, their forms now undulate, and surface ornament seeps into the flat areas above arches and on column bases, as well as column shafts. In a new main altarpiece for Santo Domingo in Puebla (commissioned in 1688, but including re-carved sculptures from an earlier retablo), for example, one finds a denser array of elements—with the painted areas now squeezed out by sculpture—and Solomonic columns, the corkscrew-like forms of which are partly obscured by applied grapevines, as if gilding the lily.

The massive buttress-like facade applied to the front of the church of La Soledad in Oaxaca (c. 1690) was carved from soft, green stone after a design by a local sculptor named Tomás de Sigüenza. Surface decoration expands as one looks upwards to the Virgin of the Immaculate Conception, carved beneath a broken pediment at the pinnacle—a metaphor for the greater splendors to be found as one approaches heaven. This decorative tradition would find its ultimate embodiment on the facade of the parish church in Zacatecas, dating from the mid-eighteenth century, where the shallow vegetal ornament spreads across the columns and entablatures in the manner of an invasive plant.

The most extraordinary manifestations of Baroque ornament in seventeenth century Mexico, however, are to be found in the stucco reliefs that cover the interiors of Dominican churches in Puebla and Oaxaca, as well as in Tlaxcala. The gray facade of Santo Domingo in Puebla (completed in 1611) is actually an example of severe Herreran classicism, but this immediately gives way to a lavish interior, the walls and ceilings of which are decorated in plaster strapwork, painted and gilded to emphasize the overall effect. To the left of the main altar, beyond an iron grille, the lateral Capilla del Rosario takes this plaster decoration to its ultimate level. The narrative paintings depicting the life of the Virgin, enormous beaded rosaries, and

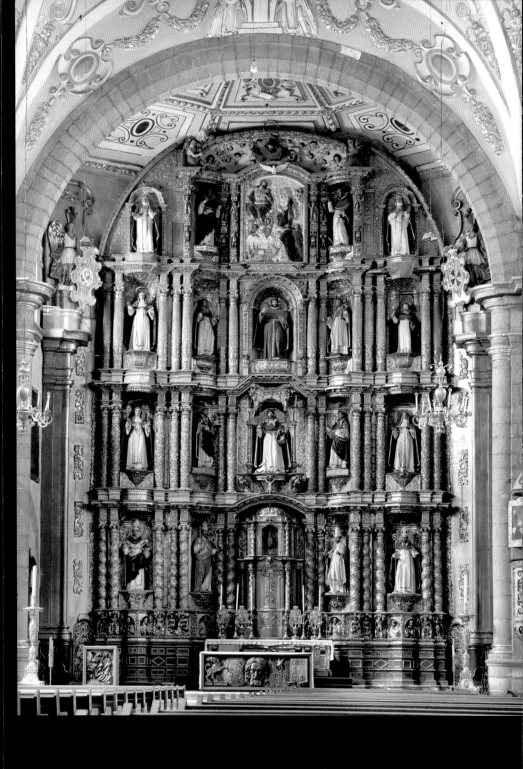

44 Pedro Maldonado and others, main retablo, church of Santo Domingo, Puebla, 1688–90.

In the surviving contract for this altarpiece, the Dominican prior specifically requested that the Mexico City master Pedro Maldonado include decorated Solomonic columns on the first level, and, on the top story, incorporate a relief of the Nativity taken from the previous sixteenth-century retablo.

45 Church of La Soledad, Oaxaca, facade consecrated *c.* 1690.

Oaxaca was particularly prone to earthquakes, and the thick facade of La Soledad was designed to resist seismic activity. This is also the reason for the low towers and stunted profiles of the Oaxaca Cathedral.

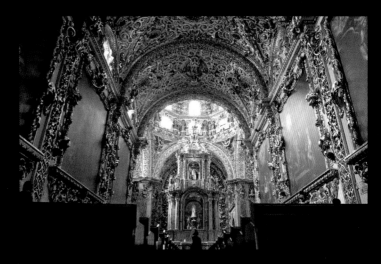

46 Capilla del Rosario, church of Santo Domingo, Puebla, *c.* 1690–1725.

other religious elements may affirm the sacred cult, but the chapel's decoration is largely secular: cherubs, knights, flowers, and fruits erupt within geometric frames derived from the cartouches and strapwork designs in Northern Mannerist pattern books, especially from Flanders.

Although the chapel was probably not finished until sometime around 1725, its consecration in 1690 included a sermon that praised it as the eighth wonder of the world, a clear testimony of local criollo pride. Relatively little is known about the craftsmen, but the first plasterworkers may have arrived from Andalusia, where the style seems to have been developed by Mudéjar artisans working under Spanish control during the Reconquista. The forms of the Capilla del Rosario were copied—and simplified—soon thereafter, by indigenous artists in the marvelous church in Santa María Tonantzintla, just outside Cholula.

The style also spread to Oaxaca: professional craftsmen decorated the whole interior of the Dominican church in Oaxaca in a similar mode, including another ornate rosary chapel and an eye-popping genealogical tree on the under-choir, showing members of Saint Dominic's family emerging like flowers from the swirling branches. In the eighteenth century, ornate plasterwork also migrated to building exteriors—as on the facade of the Sanctuary of the Virgin of Ocotlán in Tlaxcala, and several churches and private homes in Puebla. Although not common in Mexico City, polychromed plasterwork is found in the *camarín* (or changing-room) of the Virgin of Loreto at the Jesuit church in Tepotzotlán, probably dating from the 1730s.

The teeming reliefs in Puebla and Oaxaca find their painted equivalent in the work of Juan Correa and Cristóbal de Villalpando (c. 1649–1714), the two leading artists of the late seventeenth century. While Villalpando was a criollo, Correa was the son of a Spanish doctor and a freed black woman. Both artists maintained large workshops in Mexico City. Given that the Church remained the dominant patron in New Spain, the vast majority of their output consists of religious imagery; both artists, however, were also among the first to produce important secular images, mainly for the viceroy and his circle. Examples include Correa's painted *biombos* (folding screens) and Villalpando's city views and his long-lost scenes depicting the life of Achilles, painted for a triumphal arch

47 Cristobal de Villalpando,
Woman of the Apocalypse,
c. 1685–86.

In the 1680s, Villalpando
decorated the sacristy in the
Mexico City Cathedral (above).
He also painted two equally
prominent spaces in the Puebla
Cathedral: the sacristy and the
cupola above the Capilla de los
Reyes. His vast production could
have been possible only with the
support of a well-organized
workshop.

commemorating the arrival of the duque de Albuquerque as
viceroy in 1702.

While drawing on certain European models, both Correa
and Villalpando created a distinctive—if at times formulaic—
style that harkened back to the strong Mannerist traditions of
the mid-sixteenth century, but that also communicated a sense
of Baroque splendor through a greater use of decorative detail.
Correa tends to be somewhat quieter and more conservative;
Villalpando, however, embraced the theatrical, even turbulent,
aesthetic of the Baroque. The finest pictures by each possess an
almost electrical luminosity, with rich fabrics, swirling trees,

and shiny surfaces that reveal affinities with a neo-Venetian trend then popular in Spain. The warm tonalities of these works were designed to complement the gilded surfaces that dominated church interiors.

Not surprisingly, Correa and Villalpando garnered the most important commissions of their day. Both artists were responsible for the decoration of the enormous side walls of the sacristy in the Mexico City Cathedral, among the most splendid Baroque spaces ever created in New Spain. This

project, begun by Villalpando in 1684 and completed by Correa seven years later, consists of six large mural-like canvases (fresco painting seems to have been neglected in this period, and was not even mentioned in new guild ordinances of 1687) that draw upon a variety of sources, including engravings after Martin de Vos and Rubens; Villalpando's virtuoso brushwork resembles that of the Sevillian painter Juan de Valdés Leal. These energized compositions, laden with decorative details, surrounded the priests with bustling images of Paradise, emphasizing luxurious sensuality as much as triumphant religious doctrine.

In this same period, we find a growing sense of artistic self-identity and professionalization. In 1686, Villalpando became head of the Mexico City painters' guild. New ordinances ratified the following year sought to bring order to an increasingly competitive art market where the old rules were being disregarded; an attempt to exclude Indians from guild membership, however, was rejected by the city government. In his most complex works, Villalpando, like José Juárez, affirmed alongside his signature that he had "invented" the composition, which was an equally self-conscious assertion of artistic virtuosity and originality. Around 1719, just a few years after the deaths of Correa and Villalpando, the new star in the Mexico City art world, Juan Rodríguez Juárez (1675–1728), created what may be the first independent self-portrait in the history of Mexican art, showing himself seated informally before an easel, staring out at the viewer.

Novohispanic religious painting occasionally tells us about daily life in Mexico. Although wills and inventories provide textual lists of the sorts of objects that decorated wealthy homes in this period, we have little visual testimony other than the anachronistic settings of many religious scenes. Correa's *Miracle of the Wedding at Cana* provided the likely criollo patron with evidence of Jesus's approval of marriage and earthly celebrations. But because it transposed the biblical event to a familiar domestic environment, the picture can be mined for information on decorative arts, from the richly set table to the presentation of silver and glass on a stepped sideboard, and even the geometric patterning of the window. Other works of this period highlight the presence of Turkish carpets, mirrors, inlaid furniture, and landscape paintings in viceregal homes. Not until the casta paintings of the mid-eighteenth century (page 116) will we find such eloquent evidence of interior decoration.

48 Juan Correa, *The Miracle of the Wedding at Cana*, 1698.

Correa's painting depicts a famous story from the Book of John. A steward, wearing green, tastes water drawn from the well in the background, and finds it instead to be the finest wine. Primarily a reminder of Jesus's miraculous powers, the painting also testified to its wealthy owner's hospitality.

IV. Creating a History of New Spain

One of the most engaging forms of art to emerge in late seventeenth-century Mexico are elevated urban views, mainly of Mexico City, that are among the earliest independent landscapes produced in New Spain. Several commemorate important political and cultural events, such as the arrival of the new viceroy or religious processions, and include so many figures and activities, related to all social classes and occupations, that they seem like proto-encyclopedic attempts to capture the diversity and wonder of a city in a single perspective. Cristóbal de Villalpando's vista of the Plaza Mayor is one of the first: most of the scene is taken up by the market stalls in the plaza, some in the open air, others in the enclosed Mercado del Parián (Parián Market; destroyed in 1843) erected by the Philippines Traders' Guild and named after the market in Manila. Villalpando emphasizes both the geometric order and commercial dynamism of the capital, including some 1,200 separate figures. Popocatepetl and Ixtaccihuatl, the two volcanoes on the eastern horizon, provide a further sense of place.

Villalpando's cityscape is oriented specifically towards the Real Palacio, showing its southern wing being rebuilt after the so-called Corn Riot of 1692, when rioters, mostly lower-class Indians, torched the city's chief symbol of royal control. Such an image might seem a testimonial of criollo pride in the city, yet panoramic scenes like this—which are frequently found in old European collections—seem to have been produced for Spanish rather than local audiences (Villalpando's was owned by the conde de Galve, who had been viceroy during the riot). Peninsulares would surely have interpreted the scene as proof of the Crown's victory over the mob, evident in the return of social order and prosperity.

Elaborate historical images rarely appeared as independent oil paintings designed for hanging on the wall. Instead, they were displaced onto two of the most distinctive art forms of seventeenth-century New Spain: painted screens known as *biombos* (from the Japanese *byō-bu*, or wind-break) and *enconchados*, paintings that incorporated mother-of-pearl inlay and that were frequently parts of screens or furnishings. Artists apparently had more license for experimentation in these formats, which were both partly derived from artistic prototypes imported from Asia.

The *Não de China*, or Manila Galleon, sailed regularly between Acapulco and the Philippines from 1565 until 1815, bringing a diverse array of coveted luxury objects to the West in exchange for silver. The ships carried ceramics, silk, fans, lacquered trays and boxes, ivory carvings of saints from Goa, embroidered textiles (the famous *mantón de Manila*), and people, among them Asian merchants. The bronze choir screen for the Mexico City Cathedral was designed in the 1720s by the criollo painter Nicolás Rodríguez Juárez (1667–1734), but fabricated in Macao (when it arrived, the dimensions were a bit off and it had to be cut down prior to installation). The trans-Pacific trade had a dramatic impact on the development of Novohispanic art, as well as specialized crafts: the vessel forms and blue-and-white designs of the famous majolica from Puebla, one of the most important regional industries of the time, reveal the local impact of Chinese porcelain.

The first biombos arrived in New Spain from Manila no later than 1610; an ambassador of the Japanese shogun passed through Mexico City in 1614 bearing five pairs of gilded screens, and samurai armor, as an official gift for the viceroy, Luís de Velasco II, the marqués de Salina. Soon, however, the delicate paper screens were replaced by more resilient locally produced versions in oil on canvas, mounted on wooden frames. These typically consist of ten panels, decorated on both sides, and sometimes surrounded by gilded or lacquered framing elements; superimposed golden clouds on some biombos testify to Japanese sources of inspiration. Although they were considered "paintings" in wills and inventories, screens were one of the most important articles of furniture in Novohispanic palaces: they divided up vast rooms, served as elegant backdrops to social events, and protected beds from drafts (pages 114–115). At one reception honoring the viceroy, held in 1640, screens were used to hide performing musicians from the guests.

Although some biombos are purely decorative, many have complex iconographic programs—including allegorical subjects and genre scenes—that resemble those on expensive European tapestries. Uniquely Mexican iconography is present on several screens that pair images of the Conquest of Tenochtitlan on one face with a bird's eye view of Mexico City on the other. The battle scenes show several discrete events and moments, with hundreds of figures, arranged within a turbulent composition labeled to aid a chronological reading. Costume

49 Cristóbal de Villalpando, *View of the Plaza Mayor, c.* 1704.

In 1715 this painting was purchased from an heir of the conde de Galve (viceroy from 1688 to 1696) by the English ambassador to the court of Philip V. The count appears in a carriage in the lower left; yet, because it shows the Mercado del Parián, completed in 1703, it must have been made *after* the viceroy's return to Spain.

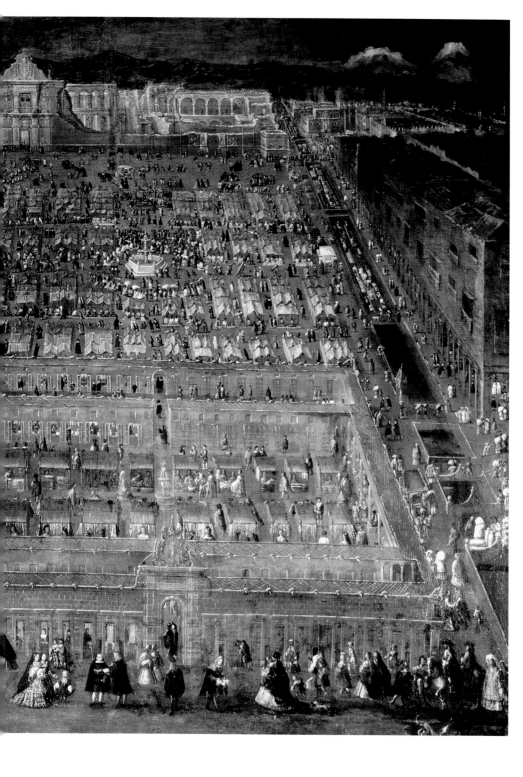

details are generally idealized, though some cultural heirlooms may be shown. Aztec architecture is often misunderstood altogether: palaces are given iron railings and red-tile roofs, and temples become stepped hexagons that do not resemble any pre-Conquest examples. By contrast, on the other side the city's civilized grid, with the Real Palacio placed near the center, symbolizes the stable and well-administered viceregal government.

One famous screen from the workshop of Juan Correa highlights the initial meeting of Cortés and Moctezuma in 1519, which takes place within a stormy lacustrine landscape that seems derived more from Flemish painting than local observation. In this confrontation of equals, Cortés is both a secular and a religious hero: he rides behind the royal standard as the representative of Charles V, and leads the Mercedarian friar Bartolomé de Olmedo as a symbol of the coming power of the mendicant orders. To the left, an enthroned Moctezuma, held aloft on a litter, takes on the trappings of a pagan Roman emperor; Correa may have been inspired by criollo scholars, such as the Jesuit priest Carlos de Sigüenza y Góngora (1645–1700), who found in Aztec civilization an "American" equivalent to Europe's Classical past. The image stresses the meeting of equals, even if we know the ultimate outcome. This is a rhetorical statement, presenting the encounter as a legal diplomatic engagement and thus legitimizing the Spanish as successors to Moctezuma's empire.

The reverse of this particular screen shows not a map of Mexico City but instead an allegorical representation of the entire world. Family groups representing America, Europe, Asia, and Africa were based on French engravings after paintings by Charles LeBrun: instead of showing Louis XIV and his consort,

50 Juan Correa and workshop, *The Encounter of Cortés and Moctezuma*, c. 1683.

The scene shown here may have been understood less as an image from the distant past than as a depiction of a contemporary performance. The Indians in the center perform a *mitote*, a theatrical dance usually staged during the feast of Corpus Christi, which ritually re-enacted Aztec submission to the Spanish.

51 Juan Correa and workshop, *The Four Continents*, c. 1683.

Although they are given the same relative space in the composition, America, Asia, and Africa are represented by generic, albeit regal, figures, while Europe is symbolized by an actual royal family. The composition also favors Spain and Asia, shunting America and Africa to the sides.

52 Miguel González, *Visit of Cortés to the Palace of Moctezuma*, late seventeenth century.

No Spanish pictorial representations of the Conquest exist from the sixteenth century. Such scenes proliferated later, in response to the publication of Bernal Díaz del Castillo's *True History of the Conquest of New Spain* (1632) and Antonio de Solís's *History of the Conquest of Mexico* (1684); the latter went through many subsequent editions.

53 Unidentified artist, *Moctezuma*, c. 1675–1700.

This painting is filled with legal references that would have been obvious to contemporary observers. By giving up his weapons, Moctezuma reveals that he is following the rules of *translatio imperii*, an official transfer of imperial power to Charles V, who would thus become the legitimate ruler of Mexico.

however, Correa featured portraits of the reigning Spanish monarch, Charles II (r. 1665–1700), and his wife Marie Louise of Orléans. Although the figures seem to promenade in the same garden environment, each "continent" is distinguished by local costumes and animals, following Cesare Ripa's influential *Iconologia* of 1593: the alligator and parrot, for example, symbolize America. Although it was produced at a time of waning Spanish power, the image also asserts Spain's continuing authority at the center of trans-oceanic trade routes.

Enconchados were luxurious display objects produced in New Spain and Peru; some two hundred Mexican examples are known, made between 1650 and 1750. They were inspired by imported furniture and decorative arts inlaid with mother of pearl, produced from China to India, but especially by Japanese *nanban* lacquerwares, which were intended for export. As individual works or parts of series (either to be assembled into screens or as discrete objects for display on the wall), enconchados represent religious and historical scenes, from straightforward Virgins to dense compositions with dozens of figures; the shell inlay is generally used for bodies, while the faces and other fine details are rendered in oil paint. Those representing the Conquest of Mexico were influenced by the publication of histories of that event by the former conquistador Bernal Díaz del Castillo (1496–1584) and by the Spanish historian Antonio de Solís (1610–1686). Five series have been identified, of which three include the full set of twenty-four panels; some were divided into two equal sets with scenes of "war" and "peace." Another spectacular series (now in the Library of Congress, Washington, D.C.) shows eight complex battle scenes inspired by European renditions of biblical and Classical wars. The conquistadors are identified as "los nuestros" (our own) in some captions.

The enconchado series divided the dense historical panoramas on the biombos into autonomous, but linked, episodes. One scene, depicting Cortés visiting Moctezuma, was repeated with minor variations on the three complete enconchado series. The two leaders, shown as equal in power to affirm the legality of the Spanish victory, meet in a throne room that includes full-length portraits of previous Aztec emperors, similar to the images of the viceroys in the Real Palacio. Malintzin (known today as Malinche), Cortés's translator and mistress, is the only woman present. The artist

of a set now in Buenos Aires, Miguel González, embellished some of the mother of pearl with paint, but left the Spaniards' armor plain: the opalescent surfaces reflect light like actual steel. This set is decorated on the reverse with images of water birds against a gold background, strikingly similar to lacquer screens by the Japanese artist Ogata Kōrin.

Both the screens and the enconchados seem to have been primarily destined for the viceroys or other high functionaries, either as welcoming or departing gifts. Although they nominally affirmed criollo achievements, the artworks mainly announced the legality of the Spanish Conquest and thus of Habsburg authority. In fact, one of the finest of the Conquest cycles rendered as enconchados (now in the Museo de América in

Madrid) may have been owned by Charles II; perhaps it was a luxurious gift to a weak leader from a sycophant hoping to assure him that all was well in the empire. But all was not well: in 1700, Habsburg rule in Spain would come to an end, signaling a new phase in Mexico's colonial history.

To give further legitimacy to the Spanish Crown's viceregal government, statues of twelve Aztec emperors were placed on a triumphal arch designed by Sigüenza y Góngora (and accompanied by texts by Sor Juana Inés de la Cruz) for the arrival of the marqués de la Laguna as the new viceroy in 1680. Such images gave New Spain its own "Classical past" and indicated that the viceroy and thus the king were part of an unbroken line of rulers that led back to centuries before the Conquest.

Indigenous patrons also used images of the Aztec emperors for rhetorical purposes. One surviving "court" portrait of Moctezuma was commissioned by indigenous caciques for the Tecpan of Tlatelolco, part of a long history of commissioned murals and paintings in these indigenous government buildings. The emperor seems less historic than a performer in a contemporary *mitote*. His costume combines Spanish, Roman, and indigenous elements; his golden *copilli* or Aztec diadem, which shows he conserves his noble status, is embossed with the Habsburg double-headed eagle. Moctezuma relinquishes his arms and crown, and lowers his head in a sign of submission. The painting asserted the grandeur of the past, but also demonstrated continued loyalty to the present Spanish regime.

The historical import of Cortés and Moctezuma notwithstanding, no single image had a greater impact on the history of Mexican art than that of the Virgin of Guadalupe. At once a physical object—painted in the 1550s and copied innumerable times from around 1600 onwards—and a religious icon, the Virgin was believed to be a unique and miraculous relic whose power came from being an *acheiropoieton*: an image made without the use of human hands.

The original version was painted in tempera on linen, probably by a little-known Indian artist named Marcos Cípac de Aquino; perhaps trained by one of the first European immigrant artists in New Spain, he also completed an altarpiece for San José de los Naturales around 1555. This image of the Virgin was made for a small church at Tepeyac—a village to the north of Mexico City where there had formerly been a temple to the Aztec fertility goddess, Tonantzin—dedicated to the Virgin of

Guadalupe, a particularly sacred sculpture located in a shrine in Extremadura, the Spanish region from which many conquistadors (including Cortés) hailed. Marcos's tempera painting soon attracted a devout local following—much to the chagrin of the Franciscans, including Sahagún, who were concerned about the possible idolatrous conflation of Mary and Tonantzin by the recently converted Indians.

Marcos, however, did not depict the cult figure in Extremadura. Rather, his Virgin combined elements of the praying Virgin of the Immaculate Conception and the Virgin of the Rosary (page 63), both of them inspired by the woman of Revelation 12.1 ("clothed with the sun, with the moon under her feet"), with details from images of the Assumption of the Virgin, including the angelic support and clouds. Such images of the Virgin were widely venerated in both Spain and Mexico: she served as a pure intercessor between man and God, and a symbol of maternal love and fertility.

Church authorities and the Jesuits promoted the growing cult, and especially the belief that the original painting granted miracles. This devotion increased in the early seventeenth century: the first known copy, painted by Echave Orio in 1606, indicates that her impact had begun to spread beyond Tepeyac. At some point in the first half of the seventeenth century, there was a crucial conceptual leap. To substantiate the miraculous power of the image, the Indian hand was forgotten in favor of a new explanation: the painting was not a painting after all, but rather the result of a supernatural projection of the Virgin's image onto the cloak of a converted Indian named Juan Diego. According to a story that was first published in 1648, in a short book by the criollo priest Miguel Sánchez, in 1531 the Virgin had appeared in the sky to Juan Diego three times at Tepeyac, before leaving her image on his cloak to take back to the Archbishop, Juan de Zumárraga, as proof of his vision.

Although this tale would seem to indicate that the Virgin—however made—was designed to encourage conversion of the indigenous populations, historical evidence indicates that the painting of the Virgin of Guadalupe was originally the object of criollo rather than indigenous devotion. Her story was one of several recorded in the seventeenth century that emphasized Mary's protection of the "Indian"—that is, American—realm, which displaced the importance previously assigned to Saint Joseph. These accounts were compiled and published by

54 Unidentified artist, *Transfer of the Image of the Virgin of Guadalupe to the First Shrine and the First Miracle, c.* 1653.

Besides attesting to the spiritual power of the Virgin, this painting is a rich source of information on cultural blending. Costumed Indians in both the background and foreground participate in a mitote that involves a mock battle; two play Aztec wooden drums. The wounded man, meanwhile, rests on a fine Turkish carpet.

criollos to strengthen their own local identity rather than foment indigenous devotion. Even the Virgin's dark skin, first mentioned in an account of 1666 (the painting has been much modified and restored, and it is difficult to know precisely what it looked like when first completed) could be seen as a symbol of her "Americanness," just as an Indian family represents the American continent on the screen by Correa.

A new sanctuary was built to house the increasingly popular image of the Virgin, and two enormous history paintings from the 1650s that once framed the entrance, and are now attributed to the workshop of José Juárez, gave visual credence to the power of the Virgin. The more complex of the two scenes depicts events of 1533. Through a window-like opening we see the original image being carried across the lake from

Mexico City to Tepeyac, and a mock battle being performed
between Indian converts and pagan Chichimecs, which recalls
the Ixmiquilpan murals (page 51). In a later episode taking place
inside the church, an Indian wounded during the celebration
is being healed by the Virgin, whose image has been installed
above the altar. Witnesses include Zumárraga and other
Spanish officials, as well as indigenous elites dressed in both
pre- and post-Conquest garb. This retroactive and fictitious
narrative specifically highlighted the Virgin's particular
benevolence towards an Indian, who by the 1650s operated as
a surrogate for the criollo community.

If such history paintings served as public, almost mural-sized
proclamations of the power of the original painting, other
images sought to explain its very existence. José Juárez's *Virgin*

55 José Juárez, *The Virgin of Guadalupe with Apparitions*, 1656.

Documents show that this painting was acquired or perhaps commissioned by Francisca Ruiz de Valdivieso, lady-in-waiting to the duquesa de Albuquerque. She traveled to New Spain when the duke was named viceroy (r. 1653–60). There she became a "humble slave" (as the caption states) to the Virgin of Guadalupe, and entered a convent upon her return to Spain. The painting was probably part of her religious dowry.

of Guadalupe of 1656 is the earliest dated work that shows the original image as part of the apparition narrative. Unlike his earlier depiction of Justus and Pastor (page 67), here Juárez divides up the story without recourse to a naturalistic architectural backdrop. The Virgin in the center, surrounded by a *trompe l'oeil* frame, may have been based on a tracing: to further the copy's sacred power, the inscription below indicates that it had "touched the original." The flanking images of the apparition with explanatory texts are derived from lost paintings Juárez had created based on engravings in Miguel Sánchez's book of 1648. Although the central image remains faithful to the "divine" original, in the lateral scenes Juárez shows the Virgin moving her arms and hands, allowing viewers to relate more directly to Juan Diego's personal vision, in keeping with the dictates of the Counter-Reformation.

The apparition of the Virgin of Guadalupe to an Indian, and the subsequent protection she offered from paganism, floods,

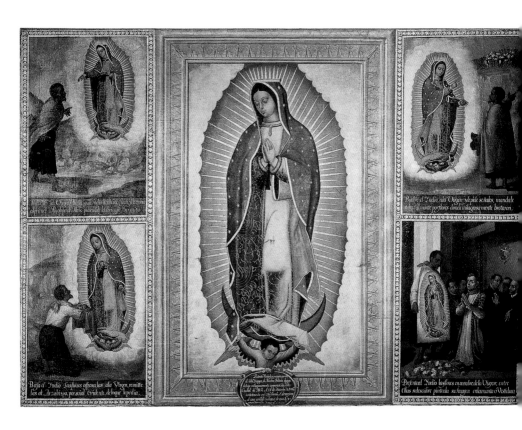

92

and plagues, was a particularly local, even "American" story. It confirmed God's particular blessing of New Spain, elevating the colony above the motherland, and thus the criollos (born in New Spain, just like Juan Diego) above the immigrant peninsulares. For many years, it was said that the original painting was executed on an indigenous *tilma*, or maguey-fiber cloak—rather than the actual (if more prosaic) linen support—which would have made it physically as well as conceptually "Mexican." It would not be until the eighteenth century, however, that the proto-nationalist character of this cult would truly unfold, generating, as we will see, a magnificent avalanche of complex images.

José Juárez's painting of the Virgin of Guadalupe from 1656 is today housed in a Conceptionist convent in Spain. This calls attention to the global circulation of Mexican art from an early period: exotic feather mosaics and practical cornstalk-paste sculptures were sent to Europe (page 22); other objects were brought back to Spain by viceroys, bishops, and peninsular officials (sometimes called "indianos"), and either kept as reminders of the source of their wealth or donated to the church as signs of devotion. Works also traveled south: in 1691, Villalpando was hired to paint a series of canvases on the life of Saint Francis for the Franciscan foundation in Antigua, Guatemala, where it remains today. Leading painters eventually exported paintings farther afield as part of a bustling art trade, though purchasers were more interested in particular cult images (many Mexican paintings of the Virgin of Guadalupe are found in Spanish and South American churches today) than in names; this would change in the eighteenth century, when New Spain's fabulous wealth created the country's first internationally famous artists.

In the seventeenth century, several other indigenous visions were first recorded, and these too generated numerous devotional images. These cults, which surely sought to capitalize on or even compete with the Virgin of Guadalupe's success, include the apparition to Indians of the Lord of Chalma (Señor de Chalma), found in a spring in 1539; the Virgin of Los Remedios (supposedly lost during the Conquest and found in a maguey in 1540); the Virgin of Ocotlán in 1541; and San Miguel del Milagro in 1631. All of these stories were depicted in quasi-history paintings featuring humble indigenous protagonists. For Tlaxcalan caciques, the apparitions of the Virgin of Ocotlán and

56 Unidentified artist,
San Felipe de Jesús, c. 1680.

According to period accounts,
San Felipe de Jesús was bound to
a cross and pierced with three
lances. In this sculpture, two
penetrate his body to form an
additional cross, while the third
is evoked by the wound in his
chest, seen through an opening
in the cloak.

San Miguel—in their territory—formed part of an ongoing attempt to assert their independent status and privileges, especially in relation to Mexico City, which "owned" the Virgin of Guadalupe. But these stories and the images they generated served the criollos as well: time and time again, divine forces had blessed this particular land, confirmed the Christian devotion of the largest sector of the colonial population, and thus dispelled lingering peninsular doubts about New Spain's level of civilization. If the criollos had not actually seen these visions, they surely profited by living in the same cosmographic space.

Criollos also promoted several hagiographic tales concerning hermits and other religious figures, including the Pueblan bishop Juan de Palafox y Mendoza and, not surprisingly, the first criollo saint, San Felipe de Jesús. After leaving for the Philippines to make his fortune, Mexico City-born Felipe de las Casas (1572–1597) entered a branch of the Franciscan order that required the friars to go barefoot, and wear coarse robes and rope belts. On his return to Mexico to be ordained, he was shipwrecked off the coast of Japan and crucified at Nagasaki with other Spanish friars as well as recent Japanese converts. Soon thereafter, murals depicting this event were painted in the nave of the Franciscan church in Cuernavaca; several decades after his beatification in 1627, a new altarpiece was erected in his honor in the Mexico City Cathedral, with a sculpture of the saint placed in its center.

The image of San Felipe is carved and decorated in the round, since it would have been taken down and used in processions outside the church. Unlike most religious sculptures of the period, in which poses are relatively static, the artist gives this figure a sense of dramatic movement, with echoes of Zurbarán's *Saint Serapion* (1628). San Felipe's arms are outstretched in reference to his martyrdom by three lances, a gesture reinforced by the crossed weapons. The head leans

back, but the face is calm: this idealized rather than expressive gaze is typical of Novohispanic images of martyrs. His friar's robe, opened to reveal the wound on his chest, was rendered in the elegant and labor-intensive *estofado* technique, surely by a specialized artisan: layers of gold leaf and paint were placed on the sculpture, then scraped away and punched to create the brocade patterns. Though here the glittering surfaces seem to contradict Felipe's vows of poverty, the image provided public testimony of the spiritual and material wealth of the criollo elite, now embodied by one of their own.

Despite the extraordinary workmanship of the figure of San Felipe, the artist's name has been lost. Sculptors, formed in a guild separate from the painters, were in fact prominent figures in the Novohispanic art world. Among the earliest names recorded is that of Salvador de Ocampo (c. 1665–1732), an indigenous carver who created the magnificent choir stalls for the church of San Agustín in Mexico City, one of the most important sculptural projects of the day.

57 Salvador de Ocampo and workshop, *The Sacrifice of Isaac*, 1701–2.

Ocampo based several scenes in the San Agustín choir stalls on engravings by Matthäus Merian, published in a Lutheran bible supplied by the friars. In 1861, the stalls were removed; they were eventually installed in the Escuela Nacional Preparatoria, located in the former Jesuit Colegio de San Ildefonso.

In New Spain, sculpture was generally far more expensive than painting, in part because each work required finer materials (such as gold) and a variety of skills—carving, painting, gilding—and therefore a large team of qualified artisans. Gilding also had to be done speedily in the dry months, which further increased costs. For his work in the sacristy of the Mexico City Cathedral, sculptor and gilder Miguel de Velasco was paid 4,000 pesos, ten times what Villalpando received for one of his enormous canvases in the same space. Important sculpture workshops also emerged on the fringes of New Spain, in Guatemala and Santa Fe, in present-day New Mexico. In fact, the survival of the Santa Fe workshops well into the nineteenth century reveals the long-term and widespread impact of Mexico's viceregal art traditions, which began with the arrival of a few Spanish immigrants and continued with carvers and painters who were citizens of the United States.

Chapter 3　Baroque Splendor under the Bourbons (1700–1810)

In 1700, Habsburg rule in Spain passed to a branch of the Bourbon family of France. The resulting War of the Spanish Succession meant the loss of Spain's territories in Flanders and southern Italy, and thus royal attention was increasingly focused on the Crown's possessions in the New World. After a period of relative neglect, the Bourbons launched a reorganization of administrative, commercial, and military structures that would have profound ramifications in New Spain.

At first the so-called Bourbon Reforms were gradual, but viceroys appointed under Charles III (r. 1759–88) and Charles IV (r. 1788–1808) pushed harder, seeking to increase efficiency in the collection of royal revenues, streamline trade and commerce, strengthen the colonial administration, and increase military security. Tensions and resentment would arise as the Spanish monarchs reasserted peninsular control over a local elite that had become accustomed to operating rather autonomously.

The economic stability resulting from the reforms, however, benefited not only the Crown and the peninsulares but also the aristocratic criollos, who were made enormously wealthy through silver mining and agriculture. Increasingly eager to demonstrate their status, the richest residents of New Spain sponsored an unprecedented outburst of artistic creativity, from gloriously ostentatious church facades and residential palaces to gilded retablos and historical and religious scenes that strengthened criollo identity.

58 Gerónimo de Balbás, Altar de los Reyes, 1718–37. Cathedral, Mexico City.

Carved and gilded in a workshop and assembled on site, the massive Altar de los Reyes curves inwards, like a cave. As in the Capilla del Rosario in Puebla, this altarpiece creates a wondrous and overwhelming environment that recalls the artificial grottoes in Mannerist gardens, filled with imitation stalactites and enriched with sculptures.

I. Late Baroque Religious Architecture

Surely no manifestation of eighteenth-century Novohispanic visual culture has been more widely discussed, or even imitated, than the late Baroque churches built in New Spain between 1750 and 1780. As in previous centuries, architects expressed stylistic innovation on retablos and building facades, now of an unrivalled visual complexity; they rarely modified the basic Latin-cross plan of the church itself. Funded largely by criollo fortunes, the most ornate buildings—located in Mexico

City as well as provincial capitals and mining centers—came to embody a truly "national" style. Their ornamental flourishes would also find new life in the Spanish colonial revival style of the early twentieth century, from the Panama-California Exposition in San Diego's Balboa Park (1915) to houses in Los Angeles and Mexico City.

Mid-eighteenth-century architecture in Mexico emphasizes richly carved surfaces, dramatic color contrasts, and plays of light and shadow. While the altarpieces and facades of the previous century retained a respect for Classical language and structure, from the 1740s onwards things are almost never what they seem on church facades and their interior retablos. Instead, one finds an increasing distortion of forms and rejection of clarity, as well as a transmutation of materials: columns become trapezoidal and even disappear, gilded wood is made to look like draped cloth, and painted limestone appears as variegated marble. All these elements fed the Baroque period's delight in intellectual intricacy and bizarre illusions.

Heavily ornamented eighteenth-century facades are sometimes called Churrigueresque, since they were partly inspired by designs created by the Churriguera family, architects who worked in Madrid and Salamanca in the late seventeenth century. The Mexican designers, however, went far beyond anything the Churrigueras had imagined; some of their inventions, even in religious settings, approach the ornamental freedom and lightness of the French Rococo. This new style energized surfaces—sometimes eliding the boundaries between nature and artifice—and provided an escape from mundane realities, while evidencing the conspicuous consumption of wealthy patrons.

In New Spain, this elaborate and even capricious style was launched by two immigrants from Seville, Gerónimo de Balbás (d. 1748) and Lorenzo Rodríguez (1701–1774). Both were great innovators, favored by the ecclesiastical hierarchy, but they were also forced to endure the irritation of their criollo colleagues, who were annoyed that prestigious and profitable commissions were being given yet again to peninsulares. They lived in a period of increasing professionalization of the architectural practice: in 1736 and 1746 new proposals to revise the guild ordinances of 1599 sought to elevate the architect's social and economic position. Architects improved standards for construction and materials, and—in anticipation of

modern-day building codes—claimed the right to inspect buildings to make sure they were being erected correctly. Criollos and peninsulares joined in an attempt to bar non-whites (other than caciques) from entering the guild, but the viceregal government forced them to leave apprenticeships open to Indians, though not to blacks or mulattoes (any caste, however, could participate in the actual building process). As with the criollo–peninsular rivalry, these exclusionary measures—which benefited the most skilled craftsmen—were an unabashed attempt to limit competition.

With his reputation set by the retablo he completed in 1709 for the sacramental chapel of the cathedral in Seville, Balbás was sent to Mexico City in 1718 with a commission to build a new retablo for the Capilla de los Reyes, located in the apse behind the main altar in the cathedral. This was a massive project for an important religious and political space, glorifying royal patronage of the Church. It involved a team of sculptors, painters, and gilders, as well as carpenters and other assistants; the ambitious work was not finished until 1737. The retablo was unlike anything previously seen in New Spain: a dense array of columns, garlands, and overlapping geometric and organic forms fill the curved apse, creating a golden wall without obvious architectural supports. The faceted surfaces refracted candlelight in myriad directions, hinting at the iconography of the sculptures and paintings and heightening the sense of mystery.

The monumental columns on either side of the central medallion (Juan Rodríguez Juárez's *Adoration of the Magi*), which look somewhat like inverted obelisks, are known as *estípites*, a distinctive architectural form used by the Churrigueras in Spain. The estípite is a tapering rectangular column that approximates an ideal human body: the small head (or "capital") expands out to broad shoulders and then back to a narrow waist and legs. It is based on the Greco-Roman herm, a sculptural element reinterpreted by such Mannerist designers as the German Wendel Dietterlin. Set between the estípites are niche-pilasters (or *interestípites*), flatter elements with spaces to hold sculptures. Just as the twisting Solomonic column set the fashion for altarpieces and facades in the previous century, so the estípite defined the new style, as introduced by Balbás, and it appeared on nearly all major religious buildings until the 1790s.

As a foretaste of the modernizing tendencies that would accelerate after mid-century, Balbás's contract specified that the sculptures were to be painted to resemble lifelike "Roman-style" sculptures and then partially gilded—rather than using the estofado technique (page 95), a decision that must have angered criollo specialists in this labor-intensive craft. Nevertheless, sponsored by the Crown, the Altar de los Reyes (Altar of the Kings) was a political as well as religious monument that was as influential as the new clothing styles being introduced at the same time by the Bourbon viceroys and their entourage. Novohispanic architects were forced to modernize their own practice, and by mid-century the estípite was *de rigueur* on altarpieces and church facades. Not only did it allow architects greater inventive freedom than traditional columns, but also, ironically, though the style had roots from Galicia to Madrid to Andalusia, and had been introduced by a peninsular, criollo patrons came to associate it with their own local identity.

The first architect to bring Balbás's innovations to a building exterior was Lorenzo Rodríguez, and by doing so he radically transformed the visual impact of Mexican church facades for the next half century. Although he arrived as a fully trained architect from Cadiz in 1731, criollo competitors prevented him from earning a major commission until 1749, when he was asked to design a new sacramental chapel and parish church for Mexico City. Set against the eastern flank of the Cathedral, the Sagrario Metropolitano asserts its stylistic independence next to that vast behemoth (page 71). The building plan, a simple Greek cross set within a square, might have been inspired by the central plan for the Sanctuary of Guadalupe of 1709—designed by the prolific eighteenth-century architect Pedro de Arrieta (d. 1738)—although there were prototypes in Spain and in the design books of Serlio. But what makes the Sagrario so arresting is its facade, on which intricately carved areas of gray *chiluca*, a rather soft sedimentary stone, are surrounded by flat fields of blood-red *tezontle*, a porous volcanic rock. Already present on Arrieta's Sanctuary, this vivid color contrast would become common in Mexico City buildings of the later eighteenth century.

The most extraordinary features of the Sagrario are the two principal entrances, retablo-facades that originally would have introduced churchgoers to what they would discover

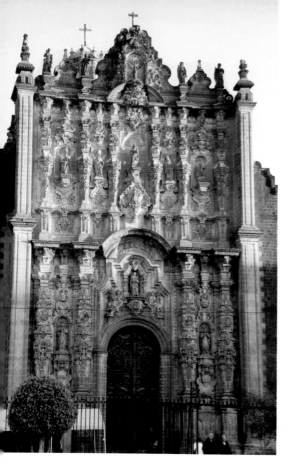

59 Lorenzo Rodríguez, Sagrario Metropolitano, Mexico City, 1749–68.

After arriving in Mexico, the Spanish-born Rodríguez was scorned by local architects—one of whom called him "wine from another climate"—in part because they feared competition. Yet Rodríguez won the commission to design the Sagrario, a project of tremendous interest to the local criollos, no doubt because the church authorities were themselves peninsulares.

inside (the interior is now much modified). Each facade consists of two stories so packed with estípites, niche-pilasters, and sculptures that there remains little sense of architectural structure. Though there is a religious logic to the sculptural program, Rodríguez emphasized the overall visual impact with forms radiating upwards, contorting moldings and cornices, reaching towards the heavens. Unlike the sixteenth-century facade at Acolman (page 33), where the ornament seems applied to the flat wall, here the effect is of a thickly embroidered and bejeweled textile that entirely covers the surface. As if to remind us that a building's skin is as fashionable and superficial as an embroidered frock coat or dress, Rodríguez allows the tezontle scrim to cascade down at the corners, only then revealing the actual structure behind. The overall effect resembles a ceremonial tent.

Like Balbás's retablo for the Capilla de los Reyes, the Sagrario was a prominent stylistic marker with an enormous influence; a contemporary account describes younger architects sketching it on site as it went up. Numerous facades and retablos mirrored it all over Mexico: from the Santísima Trinidad, just a few blocks away, to the Jesuit church and seminary of San Francisco Javier in Tepotzotlán, a seventeenth-century building updated in the early 1760s with a spectacular facade, to churches in wealthy northern cities—San Luis Potosí, Aguascalientes, Durango, and Saltillo. Although much ink has been spilled to put the names of architects and other artists and craftsmen to these buildings, evidently they were collective endeavors with numerous masters working in different media.

As in Brazil, where the Baroque churches paid for by gold extracted in Minas Gerais form a compelling group, the profits of silver in Mexico stimulated artistic creativity. Mining centers

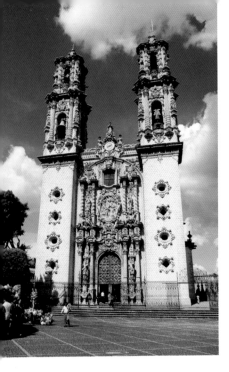

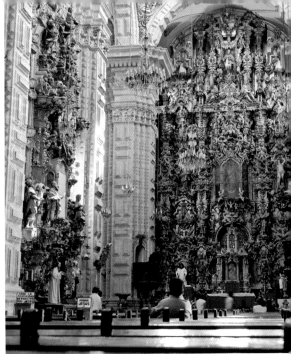

60 Cayetano de Sigüenza, church of Santa Prisca and San Sebastián, Taxco (Guerrero), 1751–58.

It is often difficult to ascribe viceregal churches to specific authors; a notarized contract between Borda and the little-known architect Cayetano de Sigüenza may indicate the latter was primarily responsible for the building, though others may have been involved in the final design. The tall towers echo those in the town of Écija, in Andalusia.

rebounded in New Spain after a depression in the previous century; the Bourbon monarchy relied on New World silver, and their reforms were designed to promote investment and improved technology in the industry. Mining capitals now had the funds to allow major constructions, among them the parish church (later the cathedral) of Zacatecas (1718–82); the church of La Valenciana (1765–88), just outside Guanajuato; and the parish church of Santa Prisca and San Sebastián in Taxco (1751–58), perhaps the most photographed church in the country after the Mexico City Cathedral.

As with La Valenciana, Santa Prisca was a divine offering financed by a staggering fortune. The patron, José de la Borda, a Franco-Spanish miner who had immigrated to New Spain in 1716, hired a criollo architect, Cayetano de Sigüenza (c. 1714–1778), and engaged Isidoro Vicente Balbás (d. 1783), the adopted Mexican-born son of Gerónimo, to create altarpieces for the ornate interior. As in many Novohispanic buildings of this period—and unlike much Baroque and Rococo design elsewhere—there is an emphasis on symmetry on the facade and in the nave, where identical retablos face each other across the aisle. The two towers, with explosive estípites and columns set far above the severe bases, resemble flaming torches. The

61 Church of Santa Prisca and San Sebastián, Taxco, interior with retablos by Isidoro Vicente Balbás, 1753–55.

Gilded baroque altarpieces, each dedicated to a particular holy figure, were not only carriers of religious information but also visually complex and intriguing objects that delighted Novohispanic viewers. At night, candles placed on protruding metal candelabra would have reflected off mirrors, glass, and gold, seeming to animate the carved reliefs.

facade's clearly articulated structure, with Solomonic columns on the second story, maintains Baroque elements while acknowledging changing fashions in Europe: the church was informed by the order and clarity promoted by French neoclassicism but is not neoclassical in and of itself. Sculpted allusions to draperies, canopies, and lambrequins abound, and the vibrating elements on the pilasters and altarpieces recall the starched and pleated fabric that rich men like Borda wore.

As part of the campaign to protect their American interests, the Bourbons promoted the settlement and development of the northern frontier of New Spain. Missionaries (including the Jesuits) and settlers—defended by small contingents of soldiers—created sophisticated outposts, bringing with them architectural ideas, paintings, and sculptures that provided a direct connection to the metropolitan centers they had left behind. In the Pueblos of what is now New Mexico, missionaries built generally simple structures: their bold yet unornamented geometric forms are as solid as the surrounding mesas. More elaborate churches were constructed in richer areas settled mostly by criollos and Spaniards, from Texas to Upper California. The Franciscan mission of San Antonio de Valero (1744), later known as the Alamo, is the most famous of these—though for its historical significance more than for its architecture.

Located in the sparsely populated Sonora desert outside present-day Tucson, San Xavier del Bac was one of the most richly ornamented mission churches built in what is today the United States. The Jesuits were originally responsible for converting the Tohono O'odham (Desert People), formerly known as the Papagos or Pimas, who still occupy the surrounding reservation. When the Jesuits were expelled in 1767, San Xavier was taken over by the Franciscans. On the present church, completed in 1797, thick adobe walls—now eye-blindingly whitewashed—frame a decorative facade that evokes the Sagrario or perhaps some church or altarpiece in Querétaro; the architect, a master mason named Ignacio Gaona, was from that city, though the laborers were local Indians. The exterior reliefs may have been as richly painted as the altarpieces inside, carved from brick in the absence of local supplies of wood, remain today.

Although simple in comparison to the major churches in cities to the south, San Xavier del Bac re-creates their dramatic

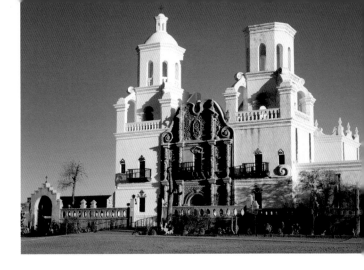

62 Church of San Xavier del Bac, near Tucson, Arizona, 1783–97.

Although the mission at San Xavier del Bac was founded by the famous Jesuit Eusebio Kino, construction of this church began decades after his death. The facade, carved from reddish sandstone, includes spindly estípites and bold volutes, repeated at the base of the towers.

Baroque splendor on the northern frontier. The friars did this not wholly for their own purposes, however; a Spanish official writing in 1804 explained that the "reason for this ornate church at this last outpost of the frontier is not only to congregate Christian Pimas of the San Xavier village, but also to attract by its sheer beauty the unconverted Papagos and Gila Pimas beyond the frontier." Thus, San Xavier del Bac continued the legacy begun in the 1530s of using art and architecture to impress as well as to instruct.

They may have been far from Mexico City, but the missions in the present-day United States formed part of extensive trade networks that facilitated the transmission of art and crafts (Navajo blankets, for example, have their origins in Tlaxcalan *sarapes*). Indeed, though we often think of trade as fundamentally occurring along an east–west axis (Manila to Puebla to Seville), there were also north–south movements. Following earlier exchanges with Guatemala, in which painting went south and sculpture north, the eighteenth century saw an expansion of Novohispanic exports to Central and South America: mahogany furniture was traded to Venezuela, and paintings by José de Páez (1720–1790?) were specifically requested by patrons from the Caribbean to Peru, as well as in the Canary Islands and Spain. Mexican art also moved northward, inspiring local copies and schools. The Sanctuary of Guadalupe in Santa Fe, New Mexico, still exhibits a huge retablo on canvas by José de Alcíbar (active 1751–1803), dated 1783, that was painted in Mexico City, rolled up, and shipped north on the back of a mule.

63 Church of San José de la Laguna, Laguna Pueblo, New Mexico, c. 1699.

64 Laguna Santero, main retablo, c. 1808. Church of San José de la Laguna, Laguna Pueblo, New Mexico.

The main retablo in the church of San José de la Laguna is ascribed to an unnamed artist known as the Laguna Santero (or "saint-maker"), active in New Mexico between 1796 and 1808. Saint Joseph occupies the center of the retablo, flanked by Saint Barbara and Saint John Nepomuceno; above them, the Holy Trinity is framed by Baroque scrolls. A painted animal-hide canopy on the ceiling includes indigenous symbols.

The San José de la Laguna mission in New Mexico was founded in 1699, just after an unsuccessful Indian revolt against the Spanish; the patronage of Saint Joseph recalled his longstanding importance as a fatherly protector of indigenous peoples, and connected this rather modest outpost back to the grand San José de los Naturales in Mexico City. The retablo (known locally as a *reredos*) was carved from native pine and

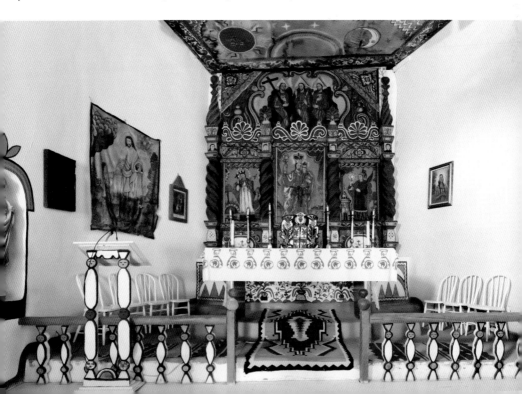

65 Plan of the Capilla del Pocito, from the *Gazeta de México* (November 27, 1791).

The *Gazeta de México* (1784–1809), edited by José Antonio de Alzate y Ramírez, was a bi-weekly publication that provided local and international news. For the residents of New Spain it was an important source of information on science and technology, as well as "good taste" in art and architecture.

66 Francisco Antonio de Guerrero y Torres, Capilla del Pocito, 1777–91. Villa de Guadalupe, Mexico City.

Due to its innovative design, a plan for the Capilla del Pocito was published in the period. The architect, however, modified the final structure, changing the circular rotunda shown in the plan into a more Baroque oval, set on a right angle to the chapel's main axis.

painted by an anonymous Mexican artist who had moved north in the 1790s, where he was commissioned by a criollo merchant to create altar screens for several indigenous communities. The artist's use of twisting Solomonic columns may demonstrate his familiarity with the facades of such churches as Santa Prisca. In this same period, a school of painting emerged in Santa Fe, the richest settlement in what is today the US Southwest; these artists generally depicted simplified saints on wooden panels, since canvas was an expensive trade good.

Although the conservative Latin-cross plan was standard across New Spain, from San Xavier del Bac to small towns in Oaxaca, a few Mexico City churches of the late eighteenth century have more experimental and engaging plans. These include the oval layout of the destroyed church of Santa Brígida (1740–45), set parallel to the street, and the convent church of La Enseñanza (1772–78), its elegant facade with curving side walls pulled back a few feet from the noisy and polluted public way in the manner of a dainty aristocrat. Like Santa Prisca, La Enseñanza has a wonderfully theatrical and well-preserved interior.

La Enseñanza was probably built by Francisco Antonio de Guerrero y Torres (1727–1792), the most important architect of the late eighteenth century; he was named *maestro mayor* (foreman) of both the Cathedral and Real Palacio in Mexico City. His most captivating religious building is the Capilla del Pocito, or Chapel of the Little Well. It was located on the site of a spring that was said to have miraculously emerged to reveal the precise site of the fourth apparition of the Virgin of Guadalupe to Juan Diego (page 89), an anecdote first published in *Zodiaco mariano* (1755) by the Jesuit Juan Antonio de Oviedo. As in the apparition tale of San Miguel del Milagro in Tlaxcala, the spring was associated with the purity and clarity of the Indian's vision, and with the sanctifying properties of holy water.

The Capilla del Pocito was donated as an act of charity by the architect (who was born in Tepeyac), and by the masons, stonecutters, and painters involved. The ground plan appears to have been partly derived from a Roman church illustrated by Serlio, while also reflecting the European tradition of building

circular baptisteries. The star-like windows and the zigzagging tiles on the upper story and three domes, as well as the playful movement of the roofline (as at the Sagrario), make this one of the most precious and fully realized Baroque monuments in Mexico.

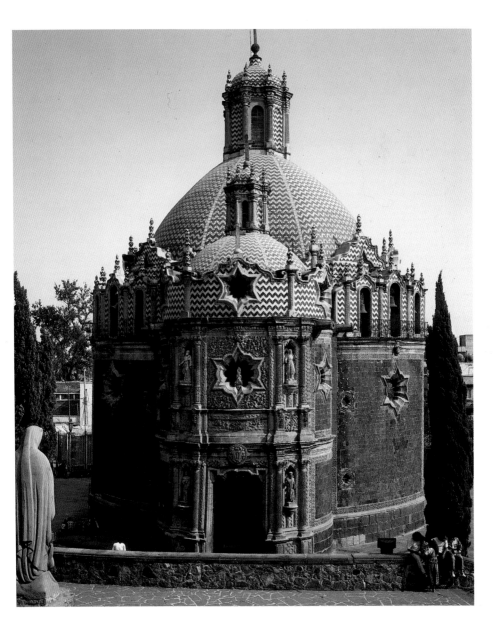

67 Attributed to Juan Antonio del Prado, *Visit of the Viceroy to the Mexico City Cathedral, c.* 1757–68.

Though the viceroy may seem lost in the crowd, this painting asserts his control over such social and economic diversity. The point of view is from the roof of the Real Palacio, directly in line with a gilded iron column bearing a statue of Ferdinand VI, erected in 1747 but removed by viceroy Revillagigedo in 1789.

II. The City of Palaces

Enriched by trade, by the late eighteenth century Mexico City had become the largest city in the Americas, with an ethnically diverse population of more than 130,000—making it about four times larger than Philadelphia at that time. Many of the most costly Bourbon infrastructure projects were centered on the capital, including streetlights, pavements, and a failed attempt to build a city wall to control the entry of people and goods. The Real Palacio and Cabildo were undergoing extensive renovation and enlargement campaigns, and enormous schools were under construction, among them

the Jesuit Colegio de San Ildefonso (completed in 1749) and the Colegio de las Vizcaínas (1752), funded by the Basque community.

Leading eighteenth-century painters continued to create images for the viceregal court: as the alter ego of the king, the viceroy played a crucial role in the grand festivals and processions that revealed the theatricality, ostentation, didacticism, and splendor typical of the Baroque. A famous scene apparently shows the visit to the Cathedral by the viceroy (perhaps Agustín de Ahumada y Villalón, marqués de las Amarillas, r. 1755–60), on the day after the annual arrival of the mail from Spain, when a Mass for the king's health was given. Though the distance from the Real Palacio to the Cathedral is only a hundred or so yards, this was an occasion for a ceremonial display of court hierarchy; some spectators jockey for position while others ignore the grand event altogether.

As in Villalpando's earlier canvas (page 82), the procession is subsumed by the dynamic economic activity of the plaza, where open-air vendors and those with booths in the Mercado del Parián offer everything from mundane fruits and vegetables to luxury goods from Asia. The painting provides an inventory of social classes and professions, from African coachmen to Indian women in loose, embroidered blouses (*huipils*) to high-ranking jurists and priests; there are even two men with knives defending a woman from a robber. The size of these figures is greatly exaggerated in relation to the architectural space, making them easier to read.

As displayed in public galleries in the Real Palacio, portraits of the viceroys were rhetorical statements of political authority more than records of their personal appearance. There were no dedicated portraitists in New Spain, but artists (or their workshops) took on commissions as part of their commercial practice, or had official responsibilities in the viceregal court as the pintor de cámara of the moment. One of the finest of all Novohispanic portraits is that of the duque de Linares (the second Bourbon viceroy) by Juan Rodríguez Juárez, the leading artist in the colony at the start of the eighteenth century. The duke's wig and shiny blue velvet coat were an ostentatious and influential display of the latest French fashions; the red heels indicated that he had been presented at court. The dark tonality and formal pose, however, relate more closely to Spanish court portraits of the previous century.

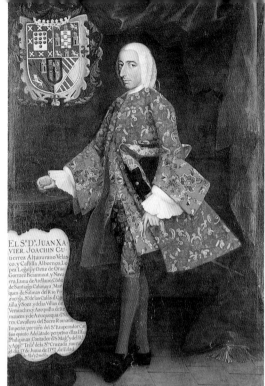

El Sᴿ Dⁿ JUAN XA-
VIER. JOACHIN GU-
tierrez Altamirano Velas-
co. y Castilla Albornos Lo-
pez Legal̃py Ortiz de Orna
Gorraez Beaumont y Nava
rra Luna de Arellano, Code
de Santiago Calimaya, Mar
ques de Salinas del Rio Piſu-
erga, Sᵉ delas Casas de Ca-
tilla y Soza y delas Villas de
Verninches y Azequilla dete
manos y de Azuquequa (Na-
res Cavallero del Sacro Romano
Imperio por uno del Sᵗ Emperador Car
los quinto Adelãtado perpetuo dlasIſlas
Philipinas, Contador de S Mag.y del Ra
y Apᵗᵒ Tribˡ dela Sᵗ Cruzada, murio
el dia 17 de Junio de 1752, de Edad de
81ᵒᵖᵃᵒᶠ⁴

68 Juan Rodríguez Juárez,
Fernando de Alencastre, Duque de Linares, c. 1711–16.

The viceroy's social and political position is underscored by his coat of arms, placed discreetly on the curtain, and the text attached to a plinth on the right, which provides a resume of his career up to and including his tenure in New Spain (r. 1710–16).

69 Miguel Cabrera, *Don Juan Xavier Joaquín Gutiérrez, Conde de Santiago Calimaya,* 1752.

The full name of the subject, spelled out on the shield, testifies to his lineage as a member of one of the oldest criollo families, with ties to Spain, Mexico, and the Philippines. Sometimes wills required descendants to take on all these names to preserve privileges.

This composition would be repeated throughout the century in representations of rich criollos. In the portrait of Don Juan Xavier Joaquín Gutiérrez by Miguel Cabrera (1695–1768), the aristocrat's coat of arms and genealogy are gaudy and artificial, as if pasted onto the canvas. Clocks or watches, which appear in both portraits, not only stood for the efficient use of time but also symbolized the transitory nature of human life. Don Juan's stiff embroidered coat—either Asian or made in Mexico in imitation of Asian textiles—conceals his body. Typically, such portraits provide no evidence of interior life or personality; only later in the century would the sitter's psychology emerge from the shadows.

About forty eighteenth-century palaces (known as *casas solas*) survive in Mexico City. Though a few of these grand houses may have conquistador-era foundations, nothing from the earliest period is visible today; the great flood of 1629–35 destroyed many sixteenth-century buildings. A rapid increase in wealth led to a construction boom after around 1720, and over the course of the century palaces grew larger and more ornate: some had more than fifty rooms to house extended families

and their servants. These public markers of wealth were the primary residences for such wealthy criollos as Don Juan; the architecture of their distant rural haciendas, however, tended to be rather modest until later in the nineteenth century. When the elite abandoned the old downtown in the nineteenth century for new suburbs beyond the Alameda—a park once on the fringes of the city—these enormous homes were divided up into apartments (*vecindades*) or warehouses. Their interiors have all been modified, though arcaded patios, iron railings, tile work, fountains, and decorative sculptures often survive in even the most run-down buildings as echoes of a glorious past.

Guerrero y Torres built two grand houses for Miguel de Berrio y Zaldívar, a criollo who had made a fortune in mining, ranching, wool production, and other commercial activities, and who was named the marqués del Jaral de Berrio by Charles III in 1774. The most opulent was the three-story Casa del Marqués del Jaral de Berrio he gave to his daughter at the time of her marriage, located a stone's throw from the monastery of San Francisco.

As we have seen, architects in New Spain were generally conservative in terms of building plans, even more so when the house had to fit within the rigid urban grid. The Casa del Marqués del Jaral de Berrio, like most of its type, is partly modeled on Andalusian (and thus Moorish) models: a grand entrance opens on to a *zaguán* or passageway that leads to the main patio; typically, the secondary service patio is set farther to the rear of the property. The ground floor was rented out to shopkeepers and artisans; none of the city's privileged citizens wanted to live too close to the crowds and filth of the street.

Though fashionable on churches, estípites were rarely used on domestic buildings. Instead, architects created fanciful Baroque compositions, as here, where two wild men—echoing those on the Casa de Montejo in Mérida (page 59)—stand above unrestrained volutes and a broken pediment. Pilasters and window frames are covered with ornamental details, such as basket weaves and meanders, yet their exuberance is kept in check by flat areas of red tezontle. Just across the street, but far more colorful, is the tile-covered facade of the Casa del Conde del Valle de Orizaba (1750s), built by a family with connections to Puebla, where the glazed ceramic tiles were manufactured and their placement on facades was far more common (page 182). In both buildings, clear horizontals and verticals

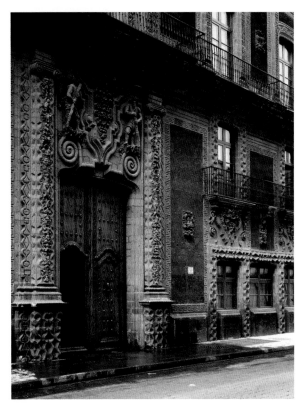

70 Francisco Antonio de Guerrero y Torres, Casa del Marqués del Jaral de Berrio (Palacio de Iturbide), Mexico City, 1784.

From 1821 to 1823 this palace was occupied by Agustín de Iturbide, briefly ruler of the newly independent nation. It was later converted into a hotel; now a museum, it is still popularly known as the Palacio de Iturbide. This detail shows the intricate stone carving around the doorway and windows of the ground floor; the entire facade is difficult to appreciate from the narrow street.

dominate: this emphasis on architectural structure and thus practicality and stability, rather than ethereal spirituality, reflected the commercial mindsets of their owners.

After the facade, the patio was the next principal place to demonstrate the patron's sophistication to arriving visitors: for the Casa del Marqués del Jaral de Berrio, Guerrero y Torres contrasted a delicate arcade with the solidity of the building's walls; above the columns, small portrait heads recall those in a Renaissance palace. The extraordinary patio of Don Miguel's own residence, the Casa de los Condes de San Mateo de Valparaíso (1769–72), was an even greater virtuoso display of the architect's mathematical skills and familiarity with leading architectural treatises: broad intersecting arches awed viewers, and the intricate double stairway recalled Bramante's version of 1512 in the Vatican. Though expensive and tricky to build, these dramatic patios were not just theatrical showpieces: their scale allowed for large carriages to turn around more easily.

Rooms in the Novohispanic palaces tended to be large but sparsely furnished, and were undifferentiated in terms of specific use until late in the century. Furnishings, such as canopied beds, writing desks, and folding screens, could be quite ornate, and revealed diverse cultural origins, from Chippendale design books to Chinese lacquerware. Some wealthy residents had large collections of paintings, local and imported, religious and secular. Two forms of genre painting common in the eighteenth century give us a marvelous sense of what these domestic interiors looked like: casta paintings (discussed below) and ex-votos—devotional paintings that commemorate miraculous salvation from an illness or tragic event, and that were hung in churches as public affirmations of the power of faith. Though

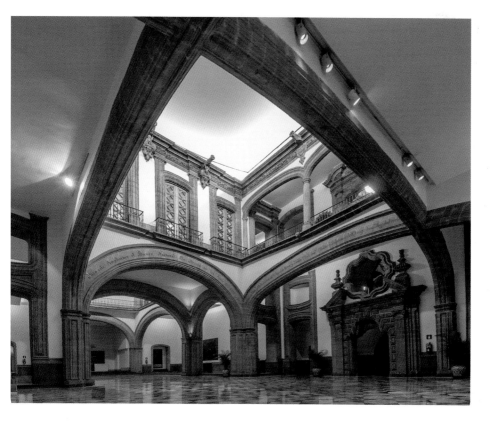

71 Francisco Antonio de Guerrero y Torres, Casa de los Condes de San Mateo de Valparaíso, Mexico City, 1769–72. Interior courtyard.

Now the headquarters of the Banco Nacional de México, this palace has been much restored. The ceiling and floors shown here are not original; as in similar houses, the interior courtyards were originally open to the sky.

based on European precedents, ex-votos were especially popular in New Spain, and continued to be produced in large quantities until the mid-twentieth century.

In an ex-voto commissioned by Josefa Peres Maldonado or her (most probably) criollo family, friars and female family members witness a surgeon performing a radical mastectomy in a well-appointed room. Despite the gruesome subject, the anonymous artist has lavished attention on symbols of wealth: delicately embroidered bedclothes and dresses; the painted or lacquered biombo that serves as a room divider, shielding the bed from drafts and outsiders; religious paintings and statues crowding an altar; the zigzagging lines of a thickly piled wool rug. The fine Rococo headboard, the rocaille border around the explanatory caption, and the loose sleeves and full skirts of the women all indicate the family's adherence to the latest French styles. Long before our era of talk shows and gossip magazines, this was a graphic and public depiction of pain amidst luxury, in which faith temporarily won but, as the text tells us, mortality ultimately triumphed.

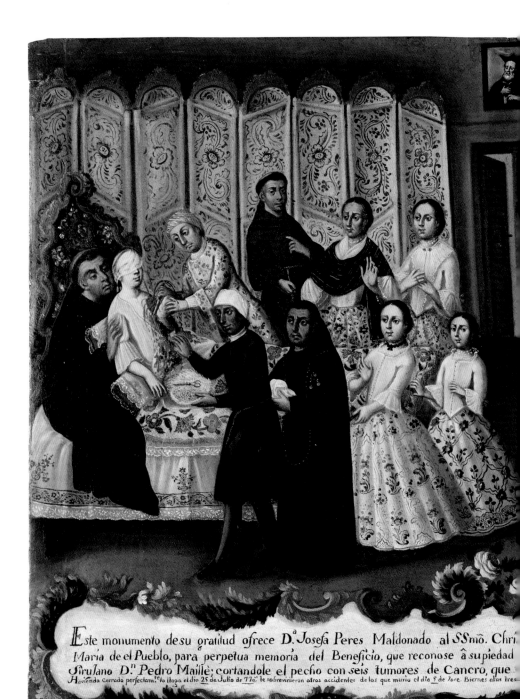

Este monumento de su gratitud ofrece D.ª Josefa Peres Maldonado al SS.mõ. Chri
Maria de el Pueblo, para perpetua memoria del Beneficio, que reconose â su piedad
Sirujano D.ⁿ Pedro Maille; cortandole el pecho con seis tumores de Cancro, que
Haviendo cerrado perfectam.ᵗᵉ la llaga el dia 25 de Julio de 77ª le sobrevinieron otros accidentes de los que murió el dia 9 de 7ore. Biernes a las tres

72 Unidentified artist, *Ex-voto of Josefa Peres Maldonado*, 1777.

This ex-voto may have been painted in one of the wealthy cities of the Bajío, north of Mexico City. The caption identifies the doctor as Don Pedro Maillé, and states that Josefa survived an operation in April 1777 for "six cancerous tumors," but then died in September from "other accidents." In 1938, the French poet André Breton acquired it for his personal collection.

ncino, Venerado en su Y.º de Triana, y âla SS.ma Virgen
acion, que se le hizo el dia 2S de Abril de 1777 a.ºs por el
enprecencia delos S.res y S.ras que se manifiestan eneste lienso,
señales claras de el Patrocinio de esta Sagrada imagen; y desu Salvacion.

III. Casta Painting

One of the most original and revealing artistic genres to emerge in New Spain, the so-called casta paintings have fascinated and perplexed viewers since the eighteenth century. Their origins lie in the history of racial blending that began after the Conquest. Despite early attempts to segregate populations and prevent intermarriage between Spaniards, Indians, and Africans, their mixed-race descendants testified to the inefficacy of colonial laws; by the mid-seventeenth century these people began to form an ever-larger percentage of the population, and interracial marriages increased significantly in the eighteenth century.

The three primary mixed-race categories to be defined socially—referred to collectively as *castas* (or castes)—were given pejorative names: a *mestizo* (mixed one) was the offspring of Spanish and Indian parents; a *mulato* (mulatto, or mule-like hybrid) had Spanish and black parents; and *zambo* (knock-kneed or cross-eyed) was a term used to describe a child with black and Indian parents. As these different groups then married others of "pure" or "mixed" races, new terms were invented to attempt to categorize the results further. Asians, present in the colony from the early seventeenth century but in very limited numbers, remained outside these categories; in art they appear only as minor characters in a few urban panoramas, as in a painting from around 1709 by Manuel de Arellano (active 1691–c. 1722) showing the inauguration of the new Sanctuary for the Virgin of Guadalupe.

Casta paintings represent and rank the mixed unions in visual terms, with explanatory captions to strengthen their didactic function. They were created in two basic formats: single canvases divided up into parts, and series of up to sixteen separate paintings. In either case, each "compartment" or canvas represents an individual family group consisting of parents of two different races or castes, and the offspring of their union. The typical series opens with an Indian and Spanish couple, followed by a sequence of families in which the Spanish heritage is increasingly reduced, ending with a mono-racial family of feathered "Indios mecos," or non-Christian "Chichimecs" from the northern frontier, foreigners who were legally outside the colonial system. The inclusion of local landscapes and customs, as well as tropical fruits and particular

73 Luis de Mena, *Casta Painting with Virgin of Guadalupe*, c. 1750.

This painting by a little-known artist compresses the diverse landscapes, citizens, and products of New Spain into a single space. Flanking the image of the Virgin of Guadalupe are scenes showing indigenous dancers at her shrine and wealthy citizens promenading along the Canal de la Viga. Below the castes, a still-life of seventeen mostly native fruits includes avocados and prickly pears.

crafts, also carefully labeled, emphasized the particular Novohispanic context of the subjects. At least one hundred whole or partial sets survive, made between around 1710 and 1810. Their demise at the end of the colonial period should not be surprising: the use of casta terminology in legal documents was banned in 1822 following Independence.

The casta paintings have their compositional sources in seventeenth-century European prints in which foreign peoples and continental allegories (such as those on Juan Correa's biombo; page 85) appeared as nuclear families, the fundamental unit of the "natural" order. The emphasis on racial blending, however, was wholly original to New Spain. Unlike Luis de Mena's schematic chart, later series of casta paintings—though not "portraits" in the strict sense of the term—often humanize the individual types, placing them within domestic and commercial settings that provide detailed information about daily life at all levels of Novohispanic society. They also represent social groups and professions that had previously not been considered worthy of artistic representation, except as historical characters (the African slave who accompanied Cortés, for example) or as incidental figures in urban views.

The existence of these paintings, alongside legal records and other evidence, might seem to indicate that the residents of New Spain were kept in order by a rigid *sistema de castas* or caste system. Without negating the inherent racism of the casta paintings, nor denying that for many residents of New Spain, ethnic labeling had serious social and economic consequences, the "system" was far more fluid than the images suggest. Besides one's caste, skin color, occupation, wealth, and even place of origin all determined an individual's inherent *calidad* (quality), and thus his or her ultimate economic and social status in Novohispanic society. Rather, casta paintings were fundamental in creating an illusion that there was indeed such a rigid system.

The most compelling of all surviving casta series, and, indeed, one of the greatest secular works ever produced by a Novohispanic artist, was created in 1763 by Miguel Cabrera, who was a mestizo born in Oaxaca. At mid-century, Cabrera and his prolific workshop dominated such rivals as José de Ibarra (1685–1756) and José de Páez, producing rather sweet and bright religious compositions with echoes of Murillo and Tiepolo, as well as portraits for the Novohispanic elite. Cabrera won some of the leading commissions of his day, contributing oil paintings to the gilded retablos in Taxco and Tepotzotlán, and creating important narrative cycles, including thirty-two canvases depicting the life of Saint Ignatius of Loyola for the Jesuit church of La Profesa (1756).

The subjects in Cabrera's only known series of casta paintings are expressive and even emotional. Some figures might

represent individuals Cabrera observed, but others are more likely generic types inspired by seventeenth-century genre painting; we know he owned two such scenes by the Flemish master David Teniers the Younger. Typical of casta series produced after 1760, Cabrera emphasizes differences in clothing, setting, and occupation to show each subject's place in the social hierarchy, especially in the lower echelons, where differences in the parents' skin color are sometimes less evident.

The first image in Cabrera's series (one of eight that show Spanish fathers) sets the family in front of a stall in the Mercado del Parián. The Indian wife and the mestizo daughter wear elaborate costumes with indigenous, European, and Asian elements, made from the same bolts of embroidered cloth they sell. Dressed in a stylish French jacket, the father looks away from the viewer in a pose unique in known casta paintings,

74 Miguel Cabrera, *From Spaniard and Indian, Mestiza*, 1763.

Given Cabrera's mestizo heritage, the body language of the three figures in the painting might have autobiographical references. The girl seems torn between her parents, who pull her in opposite directions. Although her gender and costume associate her more with her mother, she looks ruefully at her father.

75 Miguel Cabrera, *From Castizo and Mestiza, Chamizo*, 1763.

Novohispanic paintings sometimes show prints on display in domestic interiors, even in the homes of the poor. Here the engraving of a urinating figure tacked to the wall—perhaps based on a genre scene by Flemish artist Adriaen Brouwer—serves as a moralizing commentary on the unpleasant habits of the lower classes.

De Caſtiſo,y Meſtiſa, Chamiſo.

heightening the psychological drama. By contrast, the fourteenth image in the series has a gloomy setting. The clothing of the father (identified as a *castizo,* or son of a Spaniard and mestizo) is simple and torn, and the mestizo mother's expression is one of defeat. Although relatively light-skinned, they are shown as lower class: rather than selling fancy textiles, they roll *cigarros,* bundling them in packages of twenty, a tradition with origins in the Maya vigesimal counting system.

Casta images are typically demeaning of the poor, but are often harshest when showing people of African heritage, who were present as both slaves and free workers in New Spain from the early colonial period. Cabrera is actually quite sympathetic in his depiction of blacks, who appear elegantly dressed in two paintings from his cycle. Yet other series are brutally racist, implying that domestic violence and misery

result when one of the spouses is African. In fact, the sistema de castas privileged Indians—who had been granted special status since the Conquest—at the expense of Africans: laws permitted a mestizo to revert to Spanish status after several generations of intermarriage with whites, but black ancestry was a social burden that could never be "purified." Mulatto citizens, however, were sometimes able to attain positions of social privilege: examples of this include the painters Juan Correa, Tomás de Sosa (c. 1655–1716), and José de Ibarra.

If casta paintings are neither objective documents nor scientific charts, how were they understood by contemporary audiences? Their varied meanings shifted over time, but in general, by structuring and labeling the diverse residents of New Spain, the casta series implied control over a complex reality, assuaging the anxieties of the white minority concerned with social or political unrest brought on by racial diversity. Both peninsular authorities and criollo elites would have taken pride in the paintings' presentation of New Spain as a rich, culturally distinct, and ordered society, though for different reasons. Criollos in particular saw the casta paintings as successful ripostes to the French naturalist the Comte de Buffon and others who had written of the racial and thus moral "debasement" of those born in the Americas. The images of colonists busily at work surely reminded Bourbon reformers of the colony's economic prosperity. Casta paintings were commissioned or owned by several viceroys: on their return to Spain they served as souvenirs of the exotic world they had left behind.

IV. Icons of Criollo Devotion

The modernizing, secularizing, and absolutist spirit behind the Bourbon Reforms threatened the economic and political power of indigenous and criollo elites, and religious institutions. It also triggered the production of increasing numbers of devotional images, such as those honoring the Virgen de la Luz, often in direct response to official peninsular censorship. Canvases showing the miraculous apparitions in Tlaxcala of the Virgin of Ocotlán and San Miguel del Milagro—as well as scenes of the baptism of four Tlaxcalan lords during the Conquest—served later in the eighteenth century as part of a struggle to preserve native prerogatives. Indigenous rights—guaranteed by Spanish

law because those same lords had allied with Cortés to help defeat the Aztecs, and blessed by those heavenly appearances—were being specifically threatened by Bourbon administrators seeking to extend royal power.

If the messages of some earlier historical images (such as Villalpando's view of the Plaza Mayor, pages 82–83) remained ambiguous—dependent on whether viewers were peninsulares or criollos—assertions of criollismo became far more explicit in the second half of the eighteenth century, exacerbated by the Bourbon Reforms, and in particular the expulsion in 1767 of the Jesuits, an order that had been responsible for the education of criollo elites. Mural-sized paintings in the Capilla de la Cruz de los Talabarteros (Chapel of the Cross of the Saddlers' Guild), erected in 1752, praised Cortés as the founder of a new faith in New Spain, and his criollo descendants as inheritors of a promised land. The chapel (demolished after Independence) stood to the west of the Mexico City Cathedral, precisely where the eagle was said to have landed on the cactus in 1325, and thus tied the criollos directly to the foundation of Tenochtitlan (page 6). As each new viceroy passed this building on his ceremonial and legal entrance into the city, he was forcibly reminded of the historical and religious prestige of the criollos he had come to govern.

In the eighteenth century, criollo devotion to the Virgin of Guadalupe was increasingly confirmed: in 1737 she was named patroness of Mexico City, and, in 1746, of the entire viceroyalty of New Spain. In 1752, Miguel Cabrera was invited by ecclesiastical leaders to examine the original image, the authenticity of which some peninsulares (including chronicler Juan Bautista Muñoz and scientist José Ignacio Bartolache) had questioned; in a 1756 publication, Cabrera countered that the painting was an "American wonder" that could only have been produced by divine means. Meanwhile, in 1754, a Jesuit who had returned from Mexico gave Pope Benedict XIV an image of the Virgin of Guadalupe painted by Cabrera, part of a successful campaign to have the Vatican officially confirm the Virgin's patronage of New Spain. In his response, the Pope quoted Psalm 147.20: *Non fecit taliter omni nationi* ("He has done this for no other nation"). For some criollos, this juridical and rhetorical statement strengthened their emergent sense of being members of a "nation" connected to but ultimately distinct from Spain.

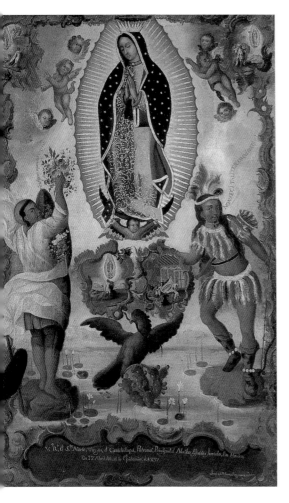

76 José Ribera y Argomanis, *The Virgin of Guadalupe*, 1778.

In Aztec renditions, the eagle in the toponym for Tenochtitlan had nothing in its mouth or cried out the glyph for war (page 25). In the early colonial period, it was increasingly shown with a snake in its mouth. For some, this prefigured the Conquest: the divine eagle—also a Habsburg symbol—represented victory over Satan. The toponym was appropriated as a national icon after Independence.

As José Juárez had done in his version of 1656 (page 92), artists continued to replicate the divine original exactly; Cabrera apparently made a stencil or tracing to assist this process. They sometimes surrounded the original iconic image with wreaths of roses or vignettes illustrating the story of Juan Diego, but also used it in more political compositions that show the Virgin of Guadalupe as a marker of Novohispanic identity. For example, in Luis de Mena's casta painting (page 117), she forms an integral part of a multi-tiered system in which the Virgin, the land, the people, and the fruits of the colony are all equally "American."

In José Ribera's rhetorical allegory of 1778, the familiar apparition narrative has been compressed into tiny cartouches; attention is given instead to two Indians standing on miniature islands in a shallow lake. Having set aside his pilgrim's hat and staff, Juan Diego offers the Virgin roses, representing the devotion of indigenous converts. Carrying a bow and quiver, the feather-covered Indian symbolizes the unconverted nomadic "mecos" of the northern frontier; though he turns away from the Virgin, the Latin phrase he speaks indicates religious but also legal submission. The Virgin hovers above the eagle perched on a cactus, the symbol of Mexico City, equally confirming her spiritual and juridical authority over the colony and, by implication, the special status of those who lived there.

Other paintings of this period show criollo subjects paying homage to the Virgin of Guadalupe. In one anonymous portrait, Francisco de Mora y Luna, conde de Nuestra Señora de Guadalupe de Peñasco, and his family kneel beneath a framed image of the Virgin, a painting within a painting. Even more so

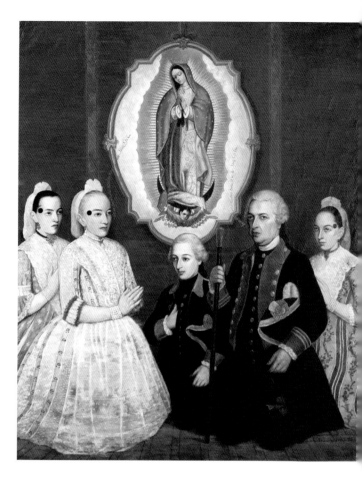

77 Unidentified artist, *Family of the Conde de Peñasco with the Virgin of Guadalupe, c. 1780.*

The subjects here wear expensive costumes that confirm their place at the pinnacle of Novohispanic society. The women sport fashionable *chiqueadores*: artificial beauty spots of velvet or tortoiseshell, glued to their temples.

than in Ribera's image, the Virgin of Guadalupe serves here as an explicit symbol of criollo pride, even of a nascent patriotic spirit. During the struggle for Independence that began in 1810, both royalists and rebels fought under banners bearing the image of the Virgin of Guadalupe; when the criollos eventually triumphed, her nationalist credentials were confirmed.

An important subset of Novohispanic portraits depicts nuns, both as historic figures and as embodiments of criollo devotion. Mexico City alone had twenty convents operated by several orders. Their prosperity derived from complex interdependent economic relationships with criollo families, who funded the convents through donations and paid expensive dowries and endowments to support daughters who had become nuns (all this was usually more than the cost of getting

married). They also paid interest on loans the convents made to finance the families' entrepreneurial endeavors.

Mid-to-late eighteenth-century churches associated with convent schools, such as La Enseñanza (page 106), in Mexico City, and Santa Rosa de Viterbo, in Querétaro, publicly and ostentatiously displayed the wealth of both the convent and its patrons. In the more private spaces, many women found refuge from marriage, but not an escape from luxury—at least for a while. Later in the century ecclesiastical reformers began to crack down on the convents as dens of permissiveness, forcing the nuns to lead more communal and austere lives instead of residing in elegantly decorated apartments.

The most famous nun—indeed, the most famous woman in the history of New Spain, after Cortés's translator, Malinche—was Sor Juana Inés de la Cruz (1651–1695). One of the leading Baroque poets of her day, she was recognized in her lifetime as the "Tenth Muse." At least seven posthumous portraits of Sor Juana survive, and while it is unlikely someone that famous could have avoided posing for a portrait, we cannot be sure that any are true likenesses. In 1750, more than a half-century after her death, Miguel Cabrera portrayed her with an intellectual aura generally reserved for portraits of university or ecclesiastical leaders, all of whom were men. Her Hieronymite habit with blue border, enormous rosary, and badge (escudo de monja) with a scene of the Annunciation on her chest all provide a spiritual identity, but we are drawn more to the volumes of church history, Classical literature, natural science, and medicine that surround her.

Born out of wedlock in a small town at the base of Popocatepetl, Sor Juana had taken her vows in 1669, in part because conventual life was the only arena where a woman of her day could pursue an intellectual career. Despite—or more likely because of—her extraordinary accomplishments, she was publicly humiliated in 1694. Stripped of her material goods and library, she was forced to renounce her passion for the arts and letters by the archbishop of Mexico City, the bishop of Puebla, and her own Jesuit confessor. Whether these three men were motivated by doctrinal rigor, jealousy, or misogyny, the fact that they were all peninsulares surely helped transform Sor Juana into the criollo heroine subsequently depicted by Cabrera, emblematic of all those who had been forced to succumb to Spanish authority.

Sor Juana was a special case. In general, nuns had their portraits made on four different occasions. The convents themselves commissioned portraits of women when they were appointed mother superior, when they founded a new order, or upon their death; these generally remained in the convent. Wealthy families also commissioned portraits when their daughters were about to take their final vows; these were displayed in the home as records of those who would never return. Although some conservative orders preferred images as austere as Francisco de Zurbarán's ascetic saints, such unreformed orders as the Dominican Conceptionists and Hieronymites encouraged portraits of *monjas coronadas*, which commemorate extravagant profession ceremonies, in which women in elaborate costumes were crowned as "brides of Christ." Such portraits glorified the faith and served as a final demonstration of earthly concerns, but also made public the virtue and economic success of the nun's criollo family and the convent she was entering. Many date from late in the eighteenth century, and reveal a criollo rejection of the fashionable "good taste" being introduced by the Bourbons.

These "wedding portraits," partly inspired by images of the flower-bedecked Santa Rosa de Lima, show the nuns participating in a ceremony that had all the theatricality and emotional impact of the Baroque. At a certain moment, the young woman disappeared behind a curtain, then reappeared, prostrate, wearing her new habit. She was then adorned with a large imperial crown covered in flowers made of paper, fabric, or wax, which represented virtue and spiritual supremacy, and laden with other liturgical objects that commemorated her symbolic marriage.

In one image, by Andrés López (active 1763–1811), twenty-five-year-old Sor Pudenciana Josefa Manuela wears a Conceptionist habit partly embroidered with pearls; the richly crafted liturgical elements she carries include an ornamented miniature staff and a sculpture of the infant Jesus, which alludes to her "groom" and also to the child she will never have. Her prominent nun's badge shows the Virgin of the Assumption. Some nuns were given intricately woven palm fronds, or decorated wax candles that could be burned in a final act of vanity. Although it is unclear what happened to the other objects, some of which were surely ephemeral, the nuns conserved their crowns as well as their badges. In the 1990s,

79 Andrés López, *Sor Pudenciana Josefa Manuela del Corazón de María*, 1782.

The text below names the woman's parents, and states that she entered the convent in 1781 as a novice, taking her vows in August of the following year. This painting was acquired in Mexico in 1895 by the American landscape painter Frederic Church.

80 Unidentified artist, *Nun's Badge with Coronation of the Virgin*, c. 1770–90.

Packed into a tiny space, a host of religious figures and angels surrounds the Virgin of the Immaculate Conception, who is being crowned by the Holy Trinity. The scene features two holy nuns, Gertrudis and Teresa, in the lower register. Although the badge is unsigned, its style relates to others by the renowned artist José de Páez.

excavations in the Secretaría de Educación Pública (or SEP), built over Sor Pudenciana's convent, uncovered the burials of several nineteenth-century nuns, some of them still wearing their elegant crowns.

The Bourbon Reforms promoted the expansion of missionary work in uncharted territories in the north of the viceroyalty, through the Colegios de Propaganda Fide. A tragic form of history painting that was fairly common in the eighteenth century consists of idealized portraits of martyred missionaries, most of them Franciscans or (prior to their expulsion) Jesuits. The most extraordinary and monumental

example, based partly on a survivor's account, features two Franciscans martyred in the attempt to convert Apaches in the San Sabá River valley, in central Texas. The bleeding friars flank a landscape in which generic "mecos" attack their primitive mission. These Indians are identified by costume elements as allies of the French, who from their base in New Orleans were then supporting incursions into Spanish territory.

Though the painting recalls the violent Conquest-themed biombos of the previous century (page 81), here the emphasis is on contemporary threats to colonial order. And yet the deeper meaning was probably similar: the painting praised the ongoing task of settlement and conversion while reminding viewers of the tremendous costs, creating new heroes in the process. This fascinating picture unites martyrs associated with both sides of the Atlantic: Fray Joseph, on the right, was born in Navarre; Fray Alonso, though also born in Spain, was taken to Mexico as a child. The mission at San Sabá, and perhaps the

81 Attributed to José de Páez, *Destruction of the Mission of San Sabá in the Province of Texas, c. 1758–65.*

painting as well, was sponsored by Fray Alonso's cousin Pedro Romero de Terreros, the conde de Regla, one of the wealthiest mine-owners in the colony. The painting thus not only heralded a new Franciscan golden age, but was also a public demonstration to the Crown that "American" fortunes were guarding the frontier, and paying for it.

Like the clocks and watches in so many Novohispanic portraits (page 110), images of dead nuns and friars— sometimes elegantly dressed, other times shown decaying in the earth—were reminders for those living in convents and monasteries that one had to pursue a virtuous life before it was too late. Much Baroque art emphasized the transitory aspects of life and the sudden arrival of death. Ex-votos celebrated the subject's salvation but signaled the dangers of disease and accident lurking around every corner (pages 114–15); in other works, dancing skeletons, scenes of hell, and tortured souls in purgatory barely needed an explanation. Leading artists, including Cabrera, designed ornate catafalques, laden with allegories, to be used at the funerals of political and ecclesiastical leaders. Few of these ephemeral constructions survive; a rather simple wooden version from the eighteenth century, used on different occasions,

82 Unidentified artist, *Catafalque of El Carmen*, c. 1760.

The lowest tier of this funerary monument depicts the death of rulers: King, Pope, Cardinal, and Bishop; the next includes Death's victory over Love, Youth, Wealth, and Monastic Life; the third connects Death to Time and the Resurrection; and the poorly preserved top tier apparently referred to Samson's feats of strength.

El Niño D. Josè Manuel. de Cervantes y Velasco, Naciò en 22. de Mayo de 1804. y Murio á 12. de febrero. de 1805. de edad de 8. meses 21 dias.

83 Unidentified artist, *The Child José Manuel de Cervantes y Velasco*, 1805.

Although the text states that the boy died at eight months, the artist has shown him as somewhat older, as if aged to fit the costume. The lace-lined coffin, set against a red damask wall covering, barely accommodates him. His tunic, breastplate, and wings are covered by what are apparently his mother's jewels.

consists of four tiers packed with emblems, skeletons, and admonitory texts, all of which must have echoed equally Baroque funerary orations.

In an age of terrifying child mortality, even among the elites, mortuary portraits of children reminded families of what they had lost, much like the images of daughters who had taken their vows. These paintings were public testimony of the Catholic belief that deceased baptized children, too young to have the faculty of reason, were free of sin and thus gained immediate entrance to heaven. These children were known as *angelitos*, or little angels; some works, like an anonymous painting in which the young boy is sumptuously dressed as the Archangel Michael, show the subjects wearing wings. Far more common in New Spain than in Europe, this painting tradition was later continued by studio photographers, but also reinterpreted in paintings by twentieth-century artists (page 306), testimony to the lasting visual and cultural legacy of the Novohispanic Baroque.

Chapter 4 From Neoclassicism to Romanticism (1750–1850)

In the late eighteenth and early nineteenth centuries, several overlapping forces shaped the arts in New Spain. The Bourbon Reforms, as well as the gradual impact of Enlightenment values—reason, science, progress, and secularization—transformed not only the subjects of art but also the very nature of artistic production. Artists and architects were increasingly influenced by the concept of "ideal beauty," which was derived from great works of the Greco-Roman past. This emergent style, now called neoclassicism but then referred to mainly as an art of *"buen gusto"* or "good taste," gradually spread across the Spanish world, prompted in part by French court fashions and also by Charles III's interest in the excavations at Pompeii and Herculaneum while he ruled from Naples. In Mexico, this aesthetic shift culminated in the 1780s in the foundation of the Academia Real de San Carlos, an art school modeled on the great European academies that would play a dominant role in the history of national art until the early twentieth century.

In New Spain, neoclassicism was fundamentally linked to the monarchy, financed and supported by a narrow sector of aristocrats and viceregal and ecclesiastical authorities, and produced mainly by peninsular rather than criollo artists and architects. The most important neoclassical works, therefore, were public monuments in Mexico City, where royal bureaucrats had the most control. We also find sophisticated manifestations of "good taste" in such wealthy provincial cities as Celaya and Guadalajara. Despite the reforming intentions of the academicians and their allies, Baroque religious images, celebrations, and even environments remained important for a majority of the population, especially the criollos. Overall, however, this period is marked by inescapable transitions: from the Baroque to neoclassicism, from Bourbon absolutism to an independent Republic, from medieval guilds to a modern academic system. It was also a time when the criollos began to promote a new and more scientific vision of their own pre-Hispanic past.

Although Enlightenment ideas were associated with the monarchy, they did ultimately shape the criollos' demands for

self-government. The struggle for Independence (1810–21), however, sent the former viceroyalty into political and economic chaos for the next quarter century. During these desperate times, twenty-two presidents took power and only two finished their terms, and the country lost more than half of its territory to the United States in 1848. After Independence, the seriously underfunded academy fell into disarray, and few artists found patrons for ambitious projects. Yet Mexico was also increasingly open to foreign investment and exploration. From the 1820s on, traveling artist-adventurers—eager to make their reputations in the New World or catering to audiences in Europe and the US—created romantic images of landscapes, ruins, and everyday life, subjects that would increasingly be adopted by Mexican artists by mid-century.

84 José de Alcíbar, *Ministry of Saint Joseph*, c. 1771.

This painting was commissioned for the former church of La Profesa, assigned to the Oratorian order of San Felipe Neri by the king, and renamed in honor of San José after the Jesuits were expelled in 1767.

I. An Art of "Good Taste"

In the mid-eighteenth century one can already find sophisticated references to the Classical past in both religious and secular Novohispanic art, much of it commissioned by wealthy criollos inspired by books that were less carefully controlled by the Inquisition in America than in Spain. In a grand Baroque canvas by José de Alcíbar, Saint Joseph and Jesus appear in the clouds, ministering to figures on the left, while three clerics look on. Among the dense visual references, an Egyptian obelisk stands out, partly derived from an illustration in Athanasius Kircher's *Oedipus Aegyptiacus* (1652–54). Here a symbol of divine illumination and political wisdom, it also recalls commemorative obelisks and pyramids erected in New Spain to celebrate the coronations of Bourbon monarchs. Like much religious oratory of the period, such paintings included coded references not only to esoteric knowledge but also to politics: the scraps of paper

held by the faithful echo petitions for viceregal protection or benevolence, issued by the criollos in a time of rapid change.

The gradual penetration of "good taste" and Enlightenment ideas is even more common in secular imagery, which flourished in the second half of the eighteenth century. Although less prevalent than in Italy or France, landscapes and allegorical scenes are listed in wills and the inventories of aristocratic households, and sometimes appear in paintings of domestic interiors, hung high on the wall in friezes. Though surprisingly few examples survive today, many of these works were probably imported, while others were produced locally, generally by lesser painters, as landscape and still life were considered unworthy genres by such leading artists as Miguel Cabrera. Painted biombos remained important, though they became taller, and were now commonly used to protect the bed (pages 113). Less didactic than those showing scenes of the Conquest, these screens highlight pleasure over politics: some, for example, reference Classical myths and allegories; others

85 Unidentified artist, *Courtship and Leisure on the Terrace of a Country Home*, c. 1750–60.

This screen is one of three that show activities in San Agustín de las Cuevas (today Tlalpan), a town to the south of Mexico City where wealthy residents had country houses. Here couples flirt and play cards; most wear informal clothing, such as the orange *andrín*, derived from a Japanese kimono, worn by the man on the far right.

feature *saraos*, leisurely gatherings that recall the *fêtes galantes* of the French aristocracy.

Decorative programs in public buildings also emphasized the erudite taste and rich intellectual life of privileged elites in Mexico City. Sculptures of Socrates, Plato, Aristotle, and Charles III decorated Ildefonso Iniesta Bejarano's lost facade for the University (1760); allegorical panels attributed to Juan Patricio Morlete Ruiz (1713–1781), featuring Archaeology, Music, History, Navigation, and Physics, were installed in the Turriana Library in the Tridentine Seminary, founded by a cathedral canon and continued by his nephews, all prominent criollo intellectuals. And Miguel Gerónimo Zendejas (1724–1816) created an extraordinary set of wooden doors for a confraternity in Puebla that operated a public pharmacy. Designed to protect archives, as well as glass jars holding herbs and drugs, the doors show portraits of the organization's members alongside allegories of the arts, sciences, and other disciplines, asserting enlightened ideas about medicine, though still tied to religious belief.

86 Miguel Gerónimo Zendejas, cabinet doors, 1797.

These doors were originally installed in the *alacena* (a room used to store and prepare medicines, and for meetings) of the Cofradía de San Nicolás Tolentino, a charitable confraternity. The patron was José Ignacio Rodríguez Alconedo, a pharmacist and botanist whose brother José Luis was a painter and silversmith. Both were arrested, apparently for insurrection, by the viceregal authorities in 1808. Zendejas was a rebel too: his subjects were partly inspired by Diderot's *Encyclopedia* (1751–72), a book prohibited by the Inquisition.

87 Antonio Pérez de Aguilar, *Painter's Cupboard*, 1769.

The upper shelf in this picture includes symbols of painting: a sculpture used as a model, a palette, and brushes. The books may be painters' treatises. These international references are juxtaposed with local ones, such as the copper chocolate pot on the bottom shelf, accompanied by lacquered gourd cups and a mounted coconut shell, all used for drinking the frothy beverage.

Just as members of a Pueblan brotherhood sought to communicate their sophistication to the public, so mid-eighteenth-century artists were asserting a more modern sense of their practice and of the place of the artist within society. The painters' and sculptors' guilds had fallen into decadence in the seventeenth century, allowing unbridled competition by smaller workshops, often run by less skilled mestizo or Indian craftsmen: efforts to revitalize the painters' guild in the 1680s through increased inspections and policing had failed. After learning of the establishment of the Academia de San Fernando in Madrid in 1752, several prestigious Novohispanic painters sought to elevate their professional credentials and obtain similar rights as their peninsular counterparts.

A short-lived "Academy of the most noble and immemorial art of painting" (1753–55), founded by a group of Mexico City painters—led by José de Ibarra and including Miguel Cabrera and Juan Patricio Morlete Ruiz, among others—was designed to systematize and modernize the educational process more than initiate aesthetic reform. The "school" probably consisted of informal gatherings in different workshops, perhaps on a Renaissance model, and operated in parallel rather than in opposition to the guild system. Like the architects before them, these criollo painters emphasized their intellectual status as practitioners of a "liberal art" superior to crafts or trades, paying more attention to signatures and forging alliances with intellectuals. But they also hoped to gain greater economic stability, including freedom from certain tributary obligations

incurred by craftsmen, and more control over production. This latter concern had racial implications in New Spain, where even the best artists were sometimes undersold by Indians or "castas," though by this date, race was less of an issue—Ibarra, we should recall, was himself a mulatto—than quality: the leading painters wanted to distance themselves from the lowly trade in pictures made in "bad taste."

The desire by Novohispanic artists to elevate their social acceptability in elite circles surely frames one of the first recorded still lifes in the history of Mexican art. Painted by a little-known artist of the 1760s, in *trompe l'oeil*, as if it were an actual glass-doored cupboard set into the wall of a dining room or kitchen, the composition resembles seventeenth-century German and Netherlandish models the artist could have known from copies or reproductions. His version, however, avoids overtly Baroque drama or illusionistic tricks in favor of carefully ordered classification. Like a miniature cabinet of curiosities, the picture elevates objects related to art, literature, and music, all clustered on the top shelf; items related to food and drink are placed on the two lower ones. The variety of surfaces and textures reveals the painter's talent in representation, while the mix of local and imported goods (including a Chinese porcelain

plate) may have signaled the owner's prosperity and perhaps even participation in international trade networks.

II. The Academia de San Carlos

These tentative attempts to reform art production both visually and economically were confirmed and institutionalized with the establishment of the Academia Real de San Carlos in the 1780s. The school's origins, however, are to be found more generally in the ongoing Bourbon Reforms. As part of the modernization of the colonial economy—including improved administration and increased royal control—in 1778 the Crown sent Gerónimo Antonio Gil (1731–1798), an experienced die-cutter and engraver, to New Spain to improve the design of coinage produced at the Royal Mint. This was not just a matter of updating old doubloons with new portraits: Spanish coins, as well as engraved prints and official documents, circulated internationally, and the Bourbons recognized that these media provided the perfect opportunity to reveal Spain's "modernity" and thus equality with leading nations. If Gil's most practical task was redesigning coins, as an artist his most important work was the production of silver and bronze medals commissioned by the viceregal and municipal governments as commemorative devices, as awards for merit, and as gifts to Indians in Florida and Louisiana.

Like his contemporaries in painting and architecture, Gil was of a generation of engravers who also sought to raise their profession to a "liberal art." He arrived in New Spain with twenty-four boxes of books, prints, plaster reliefs, medals, tools, and a camera obscura, specifically charged to set up a school of engraving. Student enrollment soon exceeded all expectations, and so, together with the director of the Mint and the viceroy, Gil sought the king's patronage for a more ambitious school of painting, sculpture, and engraving, the "three noble arts:" the Academia Real de San Carlos was eventually confirmed by a decree of 1783; official statutes modeled on those of the Academia de San Fernando in Madrid were issued in 1785. Soon thereafter, the school moved out of the Mint into the former Hospital del Amor de Dios, a stone's throw away.

Like the academies in Madrid and Valencia, the Academia de San Carlos garnered enthusiastic royal patronage for economic

as well as aesthetic reasons. The new educational institution would benefit the regime as much as improvements to the colonial infrastructure, from roads and canals to mines. Like other state monopolies, including those on tobacco and playing cards, the rigidly hierarchical academic system allowed greater control over production and so promoted Spanish mercantile interests. Well-educated, up-to-date craftsmen, trained independently of the criollo-run guilds, would create luxury goods for a domestic market, thus increasing tax revenues otherwise lost to foreign imports. Because the urban fabric and silver production were of key economic interest to the colonial authorities, San Carlos soon dominated architecture and silversmithing. Other guilds exercised relative freedom, however, since even the most hard-nosed monopolist recognized that the craftsmen trained at the academy would be insufficient in number to meet demand in the colony as a whole.

Given preexisting criollo attempts to professionalize the artistic workplace and produce art of "good taste," the foundation of San Carlos cannot be seen as a mere imposition of peninsular or Bourbon ideas on backward "Americans." Nevertheless, by controlling all major public commissions in the colony, the school accelerated the aesthetic shift towards neoclassicism, increasing dependence on metropolitan centers at the expense of local artists and traditions. Gil and other peninsulares, as well as some criollos, associated New Spain's Baroque facades and altarpieces—still being produced by guild members—with an outdated style and economic system, and, even worse, with religious obscurantism. Gil himself believed that guild artists—however prosperous—would be unable to lead the coming transformation, since they lacked preparation in anatomy and perspective and relied on prints and older paintings rather than Classical models. Not surprisingly, the criollos who were being pushed aside resented all of this, and sometimes dug in their heels to resist the new fashions and rules.

The governance and academic structure of the Academia de San Carlos mirrored the rigid hierarchies of Viceregal society, including the privileging of peninsulares over criollos. The institution was initially funded by the Crown, by Mexico City and other municipal governments, and by powerful business and mining interests dominated by peninsulares. Although instruction was in the hands of the professors, the school was

administered by a Board of Governors that generally reflected the current political group in power. Tensions emerged over whether San Carlos was primarily intended for the support of artisans or of academicians; in the long run the latter won out.

The curriculum, based entirely on European models and outlined in the royal statutes, consisted of five main subjects: painting, sculpture, and architecture were ultimately privileged, but there were also classes in relief and metal plate engraving, and mathematics. Gil also promoted the rigorous study of perspective, anatomy, and geometry: students were assigned historical and biblical texts, and studied specialized treatises by Vitruvius, Dürer, Serlio, Palomino, Mengs, and other masters.

Drawing was the foundational discipline, and was covered in a series of courses or stages adopted from the European academies. Students first copied faculty drawings or prints, then made their own drawings from plaster casts of Classical or Renaissance monuments that epitomized the new aesthetic ideals. In the third course, they drew from live and exclusively male models, and in the fourth, they studied techniques of shadowing, modeling, and drapery. After attaining proficiency in these courses, students were divided by specialization. Those in painting, for example, would then be required to copy canvases by "good" artists (generally present and former teachers) that hung in the academy's gallery. In order to obtain the prestigious and rarely granted title "Academician of Merit," painters and sculptors would conclude their coursework by creating an original large-scale composition on an assigned historical or religious topic; these works were usually donated to the school.

The foundations of academic practice in this period—from royal paternalism to the emphasis on drawing from antique models—are present in a flattering image of the viceroy at the time of the academy's conception, Don Matías de Gálvez y Gallardo (r. 1783–84). As in many portraits of leaders, the man gestures outward, but where we might expect to find a desk or battle scene, two street urchins carry drawing materials towards a salon "enlightened" by a chandelier. Beyond, two students sketch the Borghese Gladiator, part of a major shipment of plaster casts sent to Mexico in 1791 on orders from Gil. The poverty of the students is exaggerated, implying that "Americans" are ragged children soon to be elevated by the benevolence of the Crown, and also reminding us that most wealthy criollo families viewed art-making as a trade to be

88 Andrés López, *Don Matías de Gálvez y Gallardo, Vice-Protector of the Academia de San Carlos,* c. 1791.

Matías de Gálvez served in the Spanish colonial regime in the Canary Islands and Guatemala before arriving in Mexico City as viceroy in 1783; he died the following year. Because the painting shows a plaster cast shipped to New Spain in 1791, the portrait is certainly posthumous. It is probably based on the same artist's half-length portrait of the viceroy, commissioned for a gallery in the Real Palacio around 1784.

practiced by the working classes rather than an endeavor worthy of their sons.

In this early phase, students generally entered San Carlos at around twelve to sixteen years old. Most were *discípulos supernumerarios* (non-regular students), who enrolled for no fixed period and were training to become craftsmen in one of the guilds. Many of these students, who often studied at night, were mestizo or indigenous. Far more prestigious, and generally more talented and ambitious, were the *discípulos numerarios* (regular students, some of whom were *pensionados*, or scholarship holders), who were on a fixed twelve-year track towards a professional career. Although these latter students were generally white, four of the sixteen scholarships granted annually were reserved by statute for full-blooded Indians. Women were not allowed to take classes as regular students until 1888, and then, as in academies elsewhere, were prohibited from drawing from nude models.

Just as it grew from European roots, this academic system perpetuated itself across the country, as students moved on to provincial cities, founding local academies in Puebla, Querétaro, and Guadalajara, modeled on their alma mater. Although specific rules and courses changed over time, the emphasis on drawing from Classical models, the privileging of European over Mexican teachers, and demands by government officials and eventually art critics that the school create didactic works for the education of an ever-broader citizenry, would remain fixed for the next hundred or so years. The Academia de San Carlos remained the most important art school in Mexico until well into the twentieth century; its history is marked by important changes, including to its official name: it survives today as the Escuela Nacional de Artes Plásticas (ENAP), part of the Universidad Nacional Autónoma de México (UNAM).

Although the first teachers Gil hired were leading criollo artists, including José de Alcíbar, Andrés López, and sculptor Santiago Sandoval, his intention from the start was to staff the academy with highly qualified Spaniards such as himself. This attempt had a rocky start (one talented engraver was jealously held back by the Crown; a professor of painting soon quit and returned to Spain), but eventually three academicians took positions as directors in their respective disciplines: José Joaquín Fabregat (1748–1807) arrived in 1788 to take charge of print engraving; Manuel Tolsá (1757–1816) in 1791 to teach sculpture;

89 Gerónimo Antonio Gil, medal commemorating Charles III, 1789.

On this medal an allegory of Spain, accompanied by a child dressed as an Indian symbolizing New Spain, mourns atop the idealized tomb of Charles III. His portrait appears on the obverse. The inscriptions celebrate the king for "reviving the noble arts" by founding the Academia de San Carlos, and suggest that the academy's members will love Charles in death as in life.

and Rafael Ximeno y Planes (1759–1825) in 1796 to teach painting. These three Valencian artists had all studied at San Fernando in Madrid, where the director—it is no coincidence—was also a *valenciano*. All three would create important works in the colony, earning a reputation they might never have attained at home.

From the 1780s until Independence, the most important works of art and architecture produced at San Carlos were assertions of royal authority and benevolence, designed for Mexico City as symbols not only of progress and modernization but also of political and moral values. Gil created elegant neoclassical medals bearing royal busts and allegorical scenes that commemorate historic events, including the king's patronage of new civic institutions. On a far vaster scale, Tolsá's *Equestrian Monument to Charles IV*, known affectionately as the *Caballito* (little horse), was a public affirmation of royal power, commissioned in 1795 by the viceroy—Miguel de la Grua, the marqués de Branciforte—who was the brother-in-law of Manuel Godoy, prime minister to Charles IV. After the marqués was accused of corruption, he appealed to the court for permission to erect this statue at his own cost; he actually raised more funds than were needed for its completion, making a hefty profit.

The triumphant sculpture is based on European precedents Tolsá knew from Madrid and beyond, including François Girardon's equestrian portrait of Louis XIV (1699) in Paris: both kings wear the garb of a Roman emperor. In Tolsá's slightly more austere version, the horse tramples a quiver as a sign of the king's domination over the Indians. Unlike Girardon's sculpture, or an image of George III (1770) that once stood in New York City—both of which were melted down in the heat of revolution—the Caballito was defended as an aesthetic achievement after Independence (a fallen eagle symbolizing the Conquest of Mexico, originally placed under the horse's rear leg, was removed by angry criollos in 1823). Nevertheless, Republican ideals required that the statue be exiled to the patio of the University in 1824, only returning to public view in 1852.

90 Manuel Tolsá, *Equestrian Monument to Charles IV*, commissioned 1795, completed 1803.

Although he was commissioned to make this sculpture in 1795, Manuel Tolsá was not able to find enough bronze until 1802. Assisted in the casting by bellmakers, he needed an additional 14 months to detail and polish the 27-ton monument. In this image from the early 1880s, US photographer William Henry Jackson (1843–1942) shows the sculpture on the Paseo de Bucareli, where it stood from 1852 to 1979.

Mexico City was gradually transformed by viceregal projects designed to improve the city's efficiency and profitability. The second conde de Revillagigedo (r. 1789–94) removed street vendors, created new administrative districts (*cuarteles*), added streetlights, and even limited excessive church-bell ringing, but his most ambitious project was the reconstruction of Mexico City's Plaza Mayor. The peninsular academicians—few in number and with a shared cultural vision—worked in tight collaboration on this and other attempts to secularize and regularize the Baroque capital.

Revillagigedo's successor, the marqués de Branciforte, commissioned an ambitious decorative program for the newly cleared plaza. José Antonio González Velázquez (d. 1810), director of architecture at the Academia de San Carlos since 1783, designed an oval balustrade, with openings to the four cardinal points, to frame and protect Tolsá's monument (because the bronze sculpture was not ready for the inauguration in 1796, a temporary wooden version, covered with gilded plaster, was erected in its stead). González Velázquez was clearly inspired by prints showing Michelangelo's design for the Piazza del Campidoglio in Rome, which placed the bronze equestrian statue of Roman emperor Marcus Aurelius at the center of a similar radiating pavement.

Fabregat's engraving of the plaza, made in 1797, was clearly intended to glorify the king and the ongoing Bourbon Reforms, as well as publicize the viceroy's achievement—even at the cost of accuracy. The chaotic heart of the colonial city has been purged of commercial enterprise and pedestrians, and of participatory celebrations, although a few Indians appear to the right. Because the Mercado del Parián occupied the western half, the balustrade was located in the southeast quarter of the plaza; the print, however, creates the illusion that Charles IV occupies the center of a much larger oval in the middle of the Plaza Mayor, staring directly at his palace. At the time, copies of the print were sold to raise money for orphaned girls, but it became more widely known after a version appeared in Alexander von Humboldt's *Views of the Cordilleras* (1810) and thus, like Gil's coins and medals, proclaimed Bourbon sophistication and political control to an international audience.

91 José Joaquín Fabregat (after a drawing by Rafael Ximeno y Planes), *View of the Plaza of Mexico City*, 1797.

The inscription reads, in part, "View of the plaza of Mexico City, newly adorned for the equestrian statue of our august reigning monarch, Charles IV, placed there on December 9, 1796, the birthday of the queen, our lady María Luisa de Borbón, his beloved wife." Like the monument itself, the print was also sponsored by the viceroy.

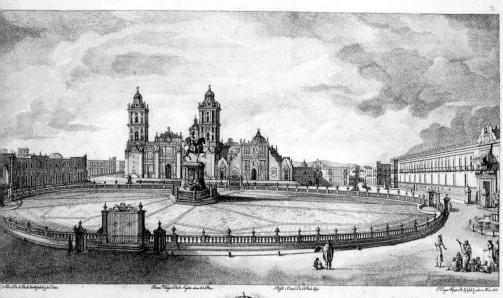

VISTA DE LA PLAZA DE MEXICO, NUEVAMENTE ADORNADA, PARA LA ESTATUA EQUESTRE DE NUESTRO AUGUSTO MONARCA REYNANTE.

92 Rafael Ximeno y Planes, *Portrait of José Maria Rodallega*, c. 1800.

In 1789, viceroy Revillagigedo required that apprentice silversmiths take drawing classes at San Carlos. Rodallega was already a master, recognized for his swirling Rococo designs, so was not subject to the rule. Yet this portrait—in which he shows himself working on a neoclassical censer—might have been a public demonstration that he too had embraced the new style.

Along with images of the viceroys, paintings (or copies) of royal portraits by court artists Anton Raphael Mengs and Mariano Salvador Maella were displayed in public buildings as markers of authority and the new style. Rafael Ximeno y Planes also produced several fine neoclassical portraits, including those depicting Gil, Tolsá, Humboldt, and the criollo silversmith José María Rodallega (1741–1812), caught in the act of chasing an ornate gold censer. Both the portraitist and his subject embrace the new style, which is evident in the wreathed medallions on the censer as well as the plaster casts and print on the wall. The relaxed pose, open-necked shirt, and lack of wig reveal an informality and directness distinct from previous colonial portraiture, resonating more with John Singleton Copley's famous image of Paul Revere finishing a teapot, from 1768.

Like the renovated Plaza Mayor, the Academia Real de San Carlos, and the Jardín Botánico (a botanical garden established in the patio of the Real Palacio in 1787 but never fully completed), the new Real Colegio Metálico (Royal College of Metals) also embodied the efficiency and modernity promoted by the Bourbon Reforms. As the leading provider of revenues in the colony, mining had long been a key concern of the Spanish Crown, and by the 1770s the Bourbons focused on increasing administrative and technical efficiency after a period of relative neglect. A new mining code of 1783 included a call for a school to train engineers, geologists, and surveyors. In 1797 Tolsá was commissioned to design the new institution, and in 1809 he invited Ximeno y Planes to decorate the college chapel. Their collaboration reminds us of the broader interrelationship between these two royal schools: mining interests helped finance San Carlos, which itself trained engineers in mathematics and drafting.

The gray facade of Tolsá's school, now known as the Palacio de Minería (Palace of Mining), emphasizes symmetry and Classical order, rejecting the Rococo patterns and color contrasts of the nearby churches and palaces, including those recently completed by Guerrero y Torres (page 112). The building is more elaborate than the government buildings being built in the new United States, many of which strove for a more

austere "Greek" effect. In fact, Tolsá's streamlined and classicized Baroque style—evident in such details as the broken pediments and the rhythmic play of light and shadow—was inspired by absolutist rather than democratic monuments, most directly Charles III's palace at Caserta (1751–74) and the Casa de la Aduana Real (Royal Customs House) in Valencia (1758), which Tolsá would have known and admired. The architect emphasized monumentality over utility: he lavished attention on the grand staircase but left the classrooms rather small.

Tolsá's other major buildings include similarly dramatic palaces for sophisticated criollos, among them the Palacio del Marqués del Apartado (1795–1805), which included a suite of rooms remodeled for Ferdinand VII (r. 1808, 1813–33), should he have ever decided to travel to Mexico. Tolsá had few followers, however, and major architectural commissions were rare from 1820 until the 1870s; the only important neoclassical edifice built in the capital in this period was the Gran Teatro de Santa Anna (1842–44, demolished 1901) by Lorenzo de la Hidalga (1810–1872).

After completing frescoes in the Cathedral (1809–10; destroyed by fire in 1967), Ximeno y Planes finished two large paintings on canvas for the ceiling of the chapel in the Palacio de Minería: one was a fairly pedestrian Assumption of the Virgin, but the other, *The Miracle of the Little Well*, signals the elevation of history painting from decorative media, such as biombos and enconchados, to the privileged realm of the public mural. Ximeno's carefully ordered composition refers to the same miracle of 1531 that was commemorated by Guerrero y Torres's Capilla del Pocito (page 107). Juan Diego, highlighted in red, gestures to Archbishop Zumárraga, while Indians and Spaniards look on in amazement. In the racial allegory to the left, a Spaniard on the carriage stands above a seated Indian who seems to step on the back of a black slave, recalling the hierarchies of earlier casta paintings. The Virgin of Guadalupe looks down benevolently from above, blessing all social classes.

The mural reveals the peninsular artist's familiarity with Mengs and ceiling designs by Tiepolo, and perhaps Goya's tapestries showing popular types, though this work is a bit more sober and static. On one level, his choice of subject resonated with the building's function—since students in the school learned about controlling water resources—but Ximeno was also working at a moment when the legitimacy of the

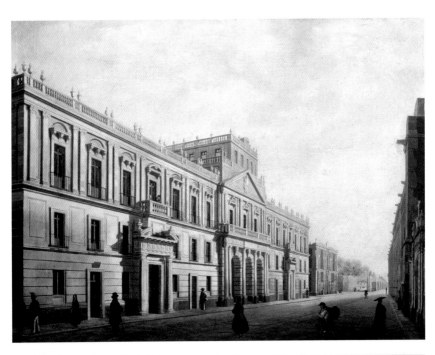

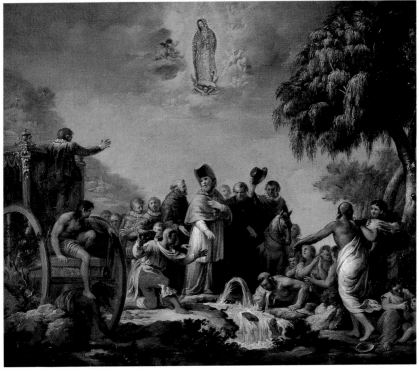

93 Manuel Tolsá, Palacio de Minería, Mexico City, 1797–1813.

This painting, by the Italian set designer and landscape artist Pietro Gualdi, is one of the earliest images of Manuel Tolsá's Palacio de Minería. Gualdi emphasized the building's crisp lines, solid color, and rational composition, all bathed in sunlight. The pedestrians, including a water carrier and a priest, provide a sense of scale and local context.

94 Rafael Ximeno y Planes, *Miracle of the Little Well*, 1809.

Ximeno y Planes was commissioned to decorate the ceiling of the chapel in the Palacio de Minería in 1809. The colors and composition of the final mural, rendered in tempera and completed in 1813, vary little from this preliminary version.

viceregal government was shaken by Napoleon's imprisonment of Ferdinand VII. Ximeno chose an innovative subject recorded by a local Jesuit historian that affirmed the religious importance of the Virgin of Guadalupe. If Juan Diego kneels before the archbishop as a sign of "American" fealty, the image is far less royalist than Tolsá's monument to Charles IV. Though working in a building that testified to Bourbon largesse, Ximeno was playing here to a criollo as well as peninsular audience, perhaps out of sympathy with their cause, or perhaps because he sensed the way the wind was blowing. His mural of the same year for the church of Santa Teresa, also painted after the outbreak of the War of Independence, depicted an uprising of Indians against Spaniards. The first major history paintings of nineteenth-century Mexico thus highlighted local and political concerns that would shape public art throughout the ensuing decades.

The stylistic transformation promoted at San Carlos extended to religious architecture, though the rejection of Baroque forms antagonized criollo guilds and patrons. In fact, the academicians attempted to supervise all architectural projects, ruling that new buildings should have neither images of saints nor "superimposed projections," and ordering that gilded wooden retablos be replaced by neoclassical versions in plastered wood or stone. Many Novohispanic masterpieces, including Gerónimo de Balbás's tabernacle for the Mexico City Cathedral, were destroyed in this stylistic rampage, and we are lucky the interiors of such churches as La Enseñanza survived. Even the facades of some buildings were updated: in 1787, Mexican architect José Damián Ortiz de Castro (1750–1793) received a commission to remodel the cathedral towers, cupola, and interior in the new style; after his death, Tolsá completed the project, adding balustrades and sculptures and modifying the cupola to unify the facade (page 71). The imposition of neoclassical "good taste" is also apparent in the few new religious monuments of this period, including the church of Loreto (Ignacio Castera and José Agustín Paz, 1807–16) in Mexico City, and Tolsá's design of 1803 for a large hospital and orphanage complex in Guadalajara, later known as the Hospicio Cabañas, the location where José Clemente Orozco painted a grand mural cycle in the late 1930s (page 291).

Several important neoclassical buildings of the late viceregal period were built in the prosperous communities of the agricultural zone known as the Bajío, north of the capital. Here,

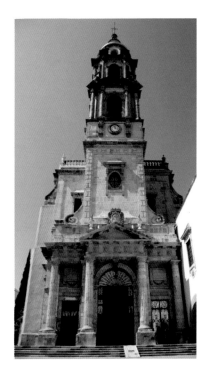

95 Francisco Eduardo Tresguerras, church of Nuestra Señora del Carmen, Celaya (Guanajuato), 1802–7.

Though he seems to have been largely self-taught, Tresguerras was a great polymath, working as an architect, sculptor, painter, engraver, hydraulic engineer, musician, composer, and poet. He wrote and illustrated what might be the first artist's autobiography written in the Americas, known in manuscript form as "The True Dream" (1796).

"good taste" was more a reflection of the enlightened values of wealthy criollo landowners than an expression of royal patronage. The leading architect in this region was Francisco Eduardo Tresguerras (1759–1833). A vocal critic of the "bad taste" of Baroque excess, Tresguerras designed houses, bridges, and fountains, and, after a fire, completely rebuilt Celaya's church of El Carmen, adding a rather severe Doric entrance portico to the base of a single central tower, and redoing the entire interior. Although not an anti-royalist, he later converted a column he had erected in honor of Charles IV in Celaya's main plaza into a monument commemorating the War of Independence.

One of the last viceregal symbols of "good taste" was the Alhóndiga de Granaditas (1797–1809), the civic granary in Guanajuato, designed by José del Mazo y Avilés. Mexico's Independence movement began here, in the wealthy Bajío: on the night of September 15–16, 1810, Father Miguel Hidalgo launched the rebellion at the nearby town of Dolores under the banner of the Virgin of Guadalupe, the only symbol shared across geographic, economic, and racial lines. Less than a year later, Hidalgo's head, and those of three other rebellious leaders, would be placed in cages and hung from the four corners of the Alhóndiga, staining the neoclassical monument with the consequences of revolt.

III. Independence and its Aftermath

Not until 1821, when various factions united under Agustín de Iturbide's Plan de Iguala, leading to the resignation of the last viceroy, was Independence finally achieved. Yet subsequent political instability—brought on by violent struggles for control between opposing forces in the two decades after Independence, and exacerbated by a post-colonial economic collapse—meant that commissions for major public monuments were few. The Academia de San Carlos was plagued by debt, although the government sent three students on scholarships to Europe in 1825. Meanwhile, politicians, historians, and intellectuals grappled with defining the role of the indigenous and colonial past for the new Republic, and with forging a new

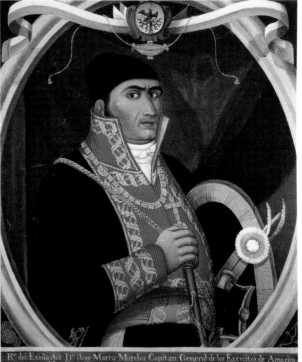

96 Unidentified artist, *José María Morelos*, 1812.

This image was painted during Morelos's occupation of Oaxaca, and is traditionally ascribed to an indigenous artist. The awkward shading of the face and hands betrays the artist's lack of academic training.

Rᵗᵒ del Exmo. Sõr Dⁿ Jose Maria Morelos Capitan General de los Exercitos de America Vocal de su Suprema Junta y Con quitadur del Rumbo del Sud

national identity that would be modern yet connected to tradition, American yet still Spanish. The decision to call the country the United *Mexican* States and to adopt the eagle-and-nopal as the national seal underscored the continuing centrality of Mexico City and its Aztec legacy, but was also the last act of the criollos, who now, as if semantically erasing three centuries of colonial rule, had converted themselves from *New Spaniards* into *Mexicans*. As for the Indians, though newly made citizens they would be generally excluded from this nation-building enterprise until much later.

Most Independence-period political imagery was produced entirely outside San Carlos, much of it in the form of engravings and woodcuts, either anonymous or made by amateurs, that circulated in pamphlets, satirical broadsides, and almanacs. Such images were inconspicuous, easily produced, and provided immediate commentary on rapidly changing events. There are no confirmed life portraits of Hidalgo, but a formal portrait of José María Morelos, the more radical leader of Independence after Hidalgo's execution, shows the "captain general of the armies of America" dressed in an elaborately embroidered

uniform (which he wore only on this occasion). Unlike the portrait of Rodallega, Morelos is surrounded by framing elements and symbols—the proto-national coat-of-arms, banners, and explanatory caption—that situate the portrait stylistically between past and future. What is most modern here is the leader's obvious mixed-race identity.

Several portraits and historical scenes commemorate the brief reign of Agustín de Iturbide, a royalist who had joined forces with the rebels late in the game. After his appointment as Constitutional Emperor of Mexico in 1822, Iturbide adopted the trappings of monarchy in official state images—completely opposite to his republican counterparts in the United States. One densely populated allegory shows Iturbide being crowned in the cathedral in 1822 by Hercules and Mexico, which is represented as a woman wearing an amalgam of indigenous and imperial garb (a longstanding symbol of New Spain). Minerva looks on, History records the events, a Mexican eagle mauls

97 José Ignacio Paz, *Allegory of the Coronation of Iturbide I*, 1822.

Iturbide was crowned on July 21, 1822, but he abdicated in March 1823 and was executed in May 1824. His brief reign left little time to commission art. Not much is known about the artist, who ran a painting school.

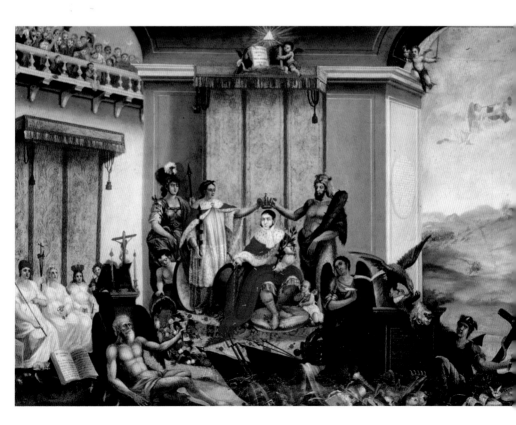

the Spanish lion, and Love deposits the hearts of the faithful. Religious figures are pushed to the margins and a crowd applauds from the balcony, belying the Emperor's anti-democratic rule. Though appropriating Napoleonic iconography to give Iturbide's ephemeral regime greater legitimacy, this rather small and awkward painting unintentionally revealed the pathetic difference between the two leaders.

From the time of Independence, Mexican politics was shaped by bitter fights between two principal political factions (initially associated with different branches of Freemasonry) that would long compete for control of the country. One group (Scottish Rite masons, eventually known as the Conservatives) represented a continuation of royal and peninsular interests; based largely in Mexico City, they believed a powerful centralized and protectionist government, in league with the Church and military, was the only bulwark against chaos. The others (York Rite masons, later the Liberals) were the nominal heirs of the rebellious criollos. Federalists who more readily embraced change, they tended to be small landowners, businessmen, and bureaucrats, often from the provinces, who sought to defeat the old order through anti-clericalism and laissez-faire economics. Much of the art produced over the next decades, especially paintings and sculpture created at the Academia de San Carlos, can be fully understood only through the lens of this political situation.

The proposals for commemorative art in the 1830s and 1840s, though limited, sought to elevate the *insurgentes* (the leaders of the struggle for Independence) as founders of the nation, within a less imperial framework. This creation of a national pantheon was no easy task, given ongoing political quarrels between federalists and centralists. A few life-size renditions of Hidalgo and other leaders survive from this period, perhaps created for commemorative galleries in government spaces. One particularly important project was a funerary monument—supported by politician and historian Carlos María de Bustamante and commissioned by the congress of the State of Mexico—to honor Morelos at Ecatepec, on the exact site where he had been shot.

The artist selected to design this monument was Pedro Patiño Ixtolinque (1774–1834), Tolsá's leading student, who in 1826 had been named director general of the Academia de San Carlos, and was then working on the main altarpiece for the

Sagrario Metropolitano. Patiño Ixtolinque was an intriguing figure, and his early career provides insight into how racial status was negotiated in the late colonial period. The son of a Spanish father and mestiza mother, he was apparently able to attain one of the academy's scholarships reserved for "pure New Spanish Indians," not because of his racial background, but because his father had claims—notwithstanding his own race—as cacique of Coyoacán, a post formerly held by Indians and that gave his son certain "Indian" rights. In an ironic turn, Patiño Ixtolinque's application to become an Academician of Merit in 1817 was contested since that privilege was reserved, by statute, for those who were "Spanish." The Board of Directors ultimately approved his application, arguing that "Spanish" simply meant "not a foreigner."

Patiño Ixtolinque's unfinished monument included freestanding allegories of America and Liberty flanking a central element, apparently an urn holding Morelos's ashes and decorated with his bust. The melancholy pose of America, leaning against the grave of her liberator, draws on Greco-Roman representations of Amazons. The sculpture also partakes of the long tradition—seen in Correa's painted screen (page 84)—of representing the continent through figures wearing feathers and carrying bows and arrows. Such imaginary individuals, derived partly from sixteenth-century European representations of Brazilians, are further related to Novohispanic images of "heathen" Chichimecs, as in José Ribera's Virgin of Guadalupe (page 123). The inverted quiver, with Zapotec decoration, symbolizes defeat, but also recalls the inverted torches that signify death on other neoclassical monuments, and that were "tasteful" replacements for the skeletons common in the Baroque era (page 130).

Although no drawings exist for this project, it may have been inspired by funerary allegories, such as one published in 1823 to accompany a Congressional decree moving the ashes of the insurgentes to the Mexico City Cathedral (similar prints were made in the US showing women mourning at George Washington's tomb after his death in 1799). For symbolic and economic reasons, Patiño Ixtolinque used blocks of coarse alabaster (piedra de villerías) that had formerly served as the base of the Caballito.

From 1833 through much of the 1840s, as the Conservative general Antonio López de Santa Anna sought haltingly to bring

98 Pedro Patiño Ixtolinque, *America*, 1830.

Patiño Ixtolinque is said to have created a death mask of Morelos after the general's execution in 1815. A few years later, he was given the prestigious commission to create a monument to the general, partly because of his correct political stance during the conflict.

99 Unidentified artist, *Gen. Wool and Staff, Calle Real to South*, 1847–48.

In this fragile and unique photographic image, US troops pause on a street in Saltillo, while a local citizen peers out from behind a window grille. It is one of twelve Mexican War daguerreotypes discovered in 1927; another group of thirty-eight was found in a Connecticut barn in 1981.

100 Ferdinand Bastin (artist) and Julio Michaud (publisher), *The Heroic Defense of the City of Monterrey against the North American Army*, 1850.

Testimony to the complicated circulation of lithographic images in the nineteenth century, this print, made in Paris and showing a battle held on September 23, 1846, was actually based on an earlier print that had been published in New York in late 1846 by Sarony & Major. For the Mexican market, the artist beefed up the Mexican troops, eliminated a US flag, and showed the US forces as younger and weaker.

stability to Mexico, several artists arrived from Europe eager to earn commissions, taking advantage of the weakness of the academy. The Catalan painter Carlos Paris (1808–1860), for example, did several official portraits of Santa Anna, and created one of the only large-scale history paintings of this period (lost, but known from an oil sketch), commemorating Santa Anna's victory over the Spanish at the Battle of Pueblo Viejo (1829). But that same general was, of course, unable to halt the United States' invasion in 1846, or to prevent the loss of a vast swath of the national territory two years later. These events deflated any idea that the independent Republic would fully inherit the grandeur of New Spain.

Apart from a few minor prints published in almanacs and short-lived magazines, no images of the War of American Intervention (1846–48) were created by Mexican artists; instead, the war was recorded by the victors, or those working for them. At least twenty official artists accompanied the US army; others, including several daguerreotypists, simply followed the troops, and created the earliest war photographs. Although technical limitations prevented them from recording the actual battles or any "live" events, the photographers captured troops in formation, took portraits of officers and images of their graves, and made pictures of local landmarks and citizens as expensive souvenirs for officers and their families back home. Other foreigners working in Mexico, including the German artist Karl Nebel (1805–1855) and the US painter James Walker (1818–1889), created images of battles and genre scenes to be reproduced as lithographs; these were published separately or in portfolios by such New York firms as

Currier & Ives and Sarony & Major. Only after 1848 did Mexican printers issue war-themed lithographs for a domestic audience, sometimes modifying previously published compositions to increase the impression of resistance and bravery shown by those on the Mexican side.

IV. Scientific Expeditions and Romantic Travelers

In the decades leading up to Independence, and well into the nineteenth century, artists revealed an increasing fascination with the Mexican landscape, as well its ancient citizens and modern inhabitants. The Bourbon monarchs had encouraged the scientific exploration of New Spain, part of their wide-ranging attempt better to understand and thus profit from their American possessions. Whereas casta paintings are pseudo-scientific racial charts, other artists in the late colonial period were engaged in more rational and practical pursuits, including mapping and surveying projects. They also illustrated reports on scientific, anthropological, and archaeological discoveries. Many were the result of a questionnaire issued to colonial authorities by Charles III in 1777, much in the tradition of the *Relaciones Geográficas* of the late sixteenth century (page 31). During the reign of Charles IV, the Royal Botanical Expedition (1787–1803) and the Political and Scientific Expedition (1789–94) surveyed territories and gathered specimens for the royal collection in Madrid. Artists from the Academia de San Carlos participated officially on both of these ventures, though the reports were never published, mainly because of the crisis brought on by the Napoleonic invasion of Spain.

Early historical accounts and reports on Mexico's pre-Hispanic cities were largely the product of criollo historians and scientists, including José Antonio de Alzate y Ramírez (1737–1799; see page 106), who explored the ruins of Xochicalco in 1777 and 1784, and the Jesuit Francisco Javier Clavijero (1731–1787), author of the influential *Historia antigua de México* (1780–81). In 1792, astronomer Antonio de León y Gama (1735–1802) published an analysis of the Sun Stone and Coatlicue, two Aztec monuments found during Revillagigedo's reconstruction of the Plaza Mayor in 1790, which launched the study of Mexican antiquities that continues to the present day. These pioneering endeavors were partly shaped by a criollo desire to glorify the pre-Hispanic civilizations of New Spain

101 José Luciano Castañeda, *Palace Facade at Mitla*, 1824.

Unlike many pre-Hispanic ruins, the Zapotec palaces at Mitla (a site in Oaxaca) remained relatively well preserved, and were especially famous for their geometric mosaic reliefs. These abstract forms frequently reappear in so-called "Aztec revival" or neo-Aztec paintings and buildings from later in the nineteenth century. This is a later copy of a drawing that Castañeda originally produced during the expedition of 1805–9.

as greater than anything found in the English or French colonies in America. Idealized descriptions of pre-Conquest civilizations also served to rebut eighteenth-century European scientists and philosophers, such as the Comte de Buffon, who criticized the Americas as a place of "degeneracy," an idea especially upsetting to criollo elites.

One of the last of the Bourbon-sponsored ventures was the Royal Antiquarian Expedition (1805–9) led by Guillermo Dupaix, which intended "to give an idea of the taste and perfection that the natives achieved in the Arts." Artist José Luciano Castañeda (1774–c. 1834) accompanied Dupaix, and, on first examination, his drawings seem crude distortions of the actual ruins we see today. But his misinterpretations cannot be due simply to a lack of skill, nor to the problem all artists face when they seek to represent a culture no one has represented before. Trained at San Carlos to view Classical and Renaissance monuments as the epitome of aesthetic achievement, Castañeda classicized what he saw: despite bits of vegetation, the clean and crisp lines helped equate such American ruins with such ancient structures as the Parthenon. Castañeda's images of building exteriors isolated in the manner of botanical specimens provide little context, though scales stress their scientific value.

Circulating widely in copies and reproductions throughout the century, these illustrations set a model for the pioneering photo-documentary campaign of the French photographer Désiré Charnay (begun in 1857) and many who followed him.

Because the Spanish jealously guarded their American possessions, few foreigners were able to visit New Spain during the viceregal period. Then, in 1799, Charles IV granted the German naturalist Alexander von Humboldt (1769–1859) a passport to travel through Spain's American colonies, in part because his mining expertise was thought useful to ongoing needs to reform that industry. Humboldt's illustrated accounts, published in various editions beginning in 1808, built on the enlightened scholarship of criollo historians and the drawings of such artists as Castañeda. Humboldt reached an international audience eager for scientific, cultural, economic, and political information on territories barely known outside the Hispanic world. His observations on everything from volcanoes to Aztec sculpture not only set a high standard for accuracy, but also dramatized the exotic, inspiring dozens of travelers who followed once entry restrictions were lifted after Independence.

The most widely circulated images produced in this period were lithographs, a technique introduced to Mexico by Claudio Linati (1790–1832), an Italian said to have studied under the French painter Jacques-Louis David. An avowed anti-monarchist, Linati saw the Mexican Republic as a place for political escape but also as a business opportunity; in 1825 he attained a government license to import the first lithographic equipment to Mexico, benefiting from laws permitting greater freedom of the press. Linati's venture was not commercially successful; he returned to Europe the following year—leaving the press behind—armed with watercolors that he converted into forty-eight lithographs released as an album in 1828. Like the casta paintings of the previous century, but with less concern for racial categorization, these illustrations of local costumes, customs, and heroes (including Moctezuma and Hidalgo) were designed for a European audience; there is no evidence they circulated in Mexico at the time.

Linati's most intriguing images depict local Mexican "types," anonymous individuals representing particular rural and urban costumes or occupations. The most emblematic are the *tehuana* (a woman from Tehuantepec wearing a lacy headdress)

102 Claudio Linati, *Extraction of Pulque from the Maguey*, 1828.

Shown here, the tlachiquero uses a dried gourd to extract sap from the heart of the maguey, later to be transferred to barrels and converted into a fermented drink known as pulque. Widely consumed by the working class, this pre-Hispanic beverage became a source of tremendous wealth to producers in the later nineteenth century.

COSTUMES MEXICAINS.

Extraction du Pulque du Maguey(Aloes) au moyen d'une longue Calebasse avec laquelle on l'aspire.

and the *tlachiquero*, whose activity more than costume marks him as distinctively Mexican: both figures would become clichés of national identity in subsequent decades. Like Castañeda's ruins, Linati's types are isolated on the page as if they are specimens. Such images highlighted Mexico's exotic difference and economic underdevelopment, revealing a new nation ripe for modernization and (European) investment.

The traveler-artists who arrived in Mexico after Linati came mainly from Europe, and formed an eclectic group, ranging from professionals to amateurs, political exiles to fortune-seekers. Many benefited from greater commercial exchange and new image-making technologies. While the German Johann Moritz Rugendas (1802–1858) and the French Baron Jean-Baptiste-Louis Gros (1793–1870) focused on landscape and genre painting, others, such as the British entrepreneur William Bullock (c. 1773–1849) and the Franco-Czech explorer Count Jean Frédéric de Waldeck (1766–1875), were larger-than-life characters whose interests extended far beyond aesthetics to include mining, ethnography, and archaeology. Some were such avid collectors of pre-Hispanic art that they inspired early calls for laws protecting the nation's cultural patrimony. Few took up

permanent residency, but their visual records of Mexico's people, customs, ruins, and natural landscapes were vastly influential in forging an image of the country—first for audiences abroad and then, gradually, within Mexico itself.

Whether depicting Mexico's unspoiled wilderness or ancient ruins, traveler-artists tended to combine objective scientific concerns with subjective emotion, using images both to inform the mind and move the soul. Many were shaped by eighteenth-century theories of the sublime, articulated by such European writers as Edmund Burke and Emmanuel Kant. One of the pioneers in this regard was the English painter Daniel Thomas Egerton (1797–1842), who arrived in Mexico in 1831. Along with Baron Gros, Egerton helped introduce Romantic aesthetics to Mexico; in fact, as a student back in London he had excelled in copying the works of J. M. W. Turner.

In the 1830s, Egerton and Gros climbed both Popocatepetl and Ixtaccihuatl. In a small canvas showing the summit of the latter, perhaps based on sketches produced on site, direct observation is combined with awe-inspiring drama. Egerton does not use the volcano as an identifying topographical marker, or set it against a space marked by human occupation, as did Villalpando (page 80); instead, he focuses on effects of light and

103 Daniel Thomas Egerton, *Gust of Wind on the Summit, Ixtaccihuatl,* c. 1834.

Egerton traveled to Mexico in 1831, prompted by an exhibition of Mexican art at William Bullock's Egyptian Hall on Piccadilly Circus, and encouraged by his brother, who made a fortune in Texas real estate. He was murdered in a town just outside Mexico City in 1842.

atmosphere seen from a rather close range. In this perfect example of theories of the sublime, the overwhelming scale of the peak dwarfs the tiny mountaineers, who nonetheless testify to man's unstoppable will to dominate nature.

Mexico's pre-Hispanic ruins were even more compelling subjects for visitors, and their images tend to record scientific information with an emphasis on sublime impact rather than documentation. Unlike participants in the Bourbon-sponsored expeditions, these traveler-artists operated as private adventurers—sometimes with diplomatic passports—who often had political or commercial as well as artistic goals. Whereas Castañeda had been shaped by the academicians' neoclassical biases, the British artist Frederick Catherwood (1799–1854) was at once more accurate and more romantic, emphasizing the irregularity and mystery of ruined cities. Like many travelers, he had roamed the world, working in Egypt and the Holy Land before joining American diplomat and writer John Lloyd Stephens (1805–1852) on two trips to Mexico and Central America.

In 1839, on their first trip to survey Maya ruins, Catherwood used a camera lucida to depict the buildings accurately; on his return in 1841, he brought a daguerreotype camera, and was one of the first explorers to photograph archaeological sites, though unfortunately his images were lost in a fire in New York in 1842. Catherwood's book illustrations and more elegant lithographs, however, reveal his aesthetic approach. He set buildings and sculptures in context, heightening the drama and difficulty of his endeavor. For example, beneath a careful rendition of a stucco mask on a Maya pyramid at Izamal, Catherwood inserted a narrative episode that gives a sense of scale. The expedition's naturalist and a Maya guide confront the looming face at night; like them, we are awed by evidence of a lost civilization overrun by nature, even frightened by the lurking jaguar. Stephens and Catherwood's best-selling accounts introduced the Maya to millions of readers. Especially in the US and England, this great (and, as people then thought, priestly and pacific) civilization would come to rival all other pre-Conquest peoples, although in subsequent decades, nationalist Mexicans continued to privilege Aztec history in their monuments and art.

104 Frederick Catherwood, *Colossal Head at Izamal*, 1844.

The large mask on the side of this ruined Maya temple at Izamal, a town in the northern Yucatán, no longer survives. Catherwood's rendition reminds us that many works of art—however idealized or romanticized—nonetheless provide valuable historical information for archaeologists working today.

Chapter 5 National Identity: History, Landscape, Citizens (1840–80)

The loss of territory to the United States in 1848 created a crisis of confidence in Mexico, exacerbating internal tensions. Conservatives believed that republicanism was ineffective in a nation with authoritarian structures inherited from the colonial period, and supported greater centralized power at the expense of popular interests. Liberals, on the other hand, attributed the defeat to the fact that Mexico was not yet enough *like* the United States, economic and social progress having been stymied by the greatest legacy of colonialism, namely the over-concentration of land and power, particularly in the hands of the Catholic Church.

Liberal ascendancy in the 1850s led to the Constitution of 1857, followed by the Reform Laws under president Benito Juárez that severely limited the power of the Church. Lands held by corporate entities were converted into private property, secularizing the vast tracts owned by the Church throughout the country. The Reform Laws were bitterly resisted by Conservatives, who ultimately supported a military intervention by Napoleon III and the installation of the ill-fated Maximilian von Habsburg as Emperor of Mexico (r. 1864–67).

With Juárez's return to power in 1867, the Republic was restored. This marked a crucial shift to a new and more secular order and a time of greater social mobility, in which mestizos and Indians (such as Juárez himself) played a more important role in politics and culture. Diverse political visions eventually coalesced around a shared national project based on federally controlled education, increased economic development and foreign investment, and the idea that scientific reasoning could solve all social ills (a political philosophy known as positivism). The election of General Porfirio Díaz in 1877 would lead to an extended period of stability until the outbreak of Revolution in 1910.

These ongoing political tensions are essential to understanding artistic production in Mexico from 1840 to 1920, the period covered here and in the following chapter. Liberals and Conservatives alike believed that the arts could help create a necessary shared sentiment among the citizenry and lead to

105 Juan Cordero, *The Sculptors Tomás Pérez and Felipe Valero*, 1847.

Cordero, Pérez, and Valero all studied in Rome, where this portrait was painted. Dressed in protective leather smocks, the two young men, shown modeling a clay bust of Homer, are mestizos; this is not surprising, since sculptors often came from a lower socio-economic class.

the national unity that might bring Mexico out of crisis; they disagreed, however, on whether the roots of that identity were to be found before or after the Spanish Conquest. Beginning in 1843, the Academia de San Carlos garnered greater financial and political support from both parties. There, artists continued to produce private luxury objects, such as portraits; more importantly—through periodic painting and sculpture exhibitions, public buildings, and commemorative monuments—the academicians helped define Mexican identity.

History painting was the privileged academic genre in this period, but by the 1850s landscape and genre painting gained prominence within San Carlos and beyond. By mid-century we find a rise in patronage in provincial cities, where painters produced portraits, still lifes, and scenes of daily life for a prosperous local bourgeoisie. Avoiding the grand historical themes that preoccupied urban elites, intellectuals, and government officials, these artists would be lauded in the post-Revolutionary period precisely for their apparently non-academic and thus more "authentic" national character.

I. The Revitalization of the Academy

During the nineteenth century, Liberals and Conservatives sought increasing federal control over education, and thus art production. In 1843, Antonio López de Santa Anna revitalized the Academia de San Carlos by turning income from the National Lottery (established in 1770) over to the school. This allowed the Board of Governors to hire new professors from Europe, and to modernize the curriculum. Aesthetically and politically conservative, they looked to the Academy of Saint Luke in Rome, where the Nazarene movement, known for its idealized style and profoundly Christian sensibility, then reigned supreme.

Selected in part because they spoke Spanish, two Catalan graduates of the Roman academy—Pelegrín Clavé (1810–1880) and Manuel Vilar (1812–1860)—arrived in 1846 to take up the

directorships of painting and sculpture, respectively. Two Italians further enriched the faculty: Eugenio Landesio (1810–1879) arrived to teach landscape painting in 1855, and Javier Cavallari (1809–1896) to teach architecture in 1856. The school was also finally able to purchase the building it had rented for decades, embellished with Cavallari's neo-Florentine facade in the 1860s. Exhibitions were held regularly from 1848 until the late 1880s; acquisitions were made for the galleries of San Carlos; and six scholarships were established for study abroad, first in Rome, and, after 1870, in Paris.

The Academia de San Carlos was neither an autonomous art school supporting personal creativity nor a rigidly controlled agency creating state propaganda, hovering instead between these two poles. Each succeeding government sought to control the institution, privileging one artist over another, demanding oaths of loyalty, and using prestigious commissions to shape public debate. If San Carlos received better funding and broader critical attention than museums, scientific societies, and other schools, this was in recognition of its dominant role in generating visual images of nationhood— despite nascent patronage from private intellectuals and regional governments.

No form of art was more privileged within the academic system, nor better served the cause of nation building, than history painting. These complex multi-figured compositions proved mastery of the varied academic skills: talent in drawing, from drapery to the human form; fluency in the manipulation of color and texture to create illusionistic effects; and an ability to create a convincing and dramatic story, evident in the lighting, poses, and gestures, as well as "accurate" costumes and props. Like plays and novels, these paintings—generally large in scale and presented at public exhibitions that were heatedly discussed in the press—performed a powerful discursive and moralistic function, celebrating national myths and heroes while simultaneously alluding to contemporary events or issues, including race, gender, and class. An extended caption typically accompanied their public presentation, ensuring audience familiarity with the subject.

Just as it had during the viceroyalty, history painting served as an engine of political and cultural legitimization, now in the service of Mexico rather than Spain. At mid-century, Clavé dominated the curriculum, and promoted biblical narratives as

subjects for his students. Unlike Novohispanic religious paintings, these academic canvases featured Old rather than New Testament scenes, since their purpose was not devotional but rather to provide severe moral lessons embraced by the ruling Conservatives.

The Babylonian Captivity by Joaquín Ramírez (c. 1839–1866) depicts a chosen people exiled from their home, mournfully framed by a weeping willow. The actors' idealized forms and exaggerated gestures—which today might remind us of silent films—are typical of academic painting in many countries at this time. Such pictures might be easily dismissed as having nothing to do with Mexico, yet almost all were intended by the artists—and so understood by critics and the educated public—as allegories of contemporary politics. Ramírez apparently selected this rarely depicted story because it resonated with a nation that had lost much of its territory to the United States, and, from the Conservatives' perspective, with a Church that had been "captured" by the ascendant Liberal state.

For more than two decades, Clavé and his students—including Ramírez—enforced the clarity and idealization of the Nazarenes. After Clavé's departure for Europe in 1868, however, his successor José Salomé Pina (1830–1909), who had

106 Joaquín Ramírez, *The Babylonian Captivity*, 1858.

Internecine conflicts between the Kingdoms of Judah and Israel led to the fall of Jerusalem and the subjugation of the Jews by Babylon. When exhibited at the Academia de San Carlos, this picture was accompanied by a caption that directed viewers to sympathize with the suffering figures who "lament their loss of liberty, destruction of their homeland, [and] ruin of their temple."

returned home in 1869 after fourteen years abroad, introduced new aesthetic currents associated with realism. Compositions became darker, bloodier, and more erotic, and genre paintings and scenes of Mexican history more common. The stylistic shift is clear if we compare the crisp *Oath of Brutus* (1857) by Felipe Santiago Gutiérrez (1824–1904) to the gloomy *Death of Marat* (1875) by Santiago Rebull (1829–1902). These pictures also reveal different ideas about the purpose of art: whereas Gutiérrez exalted high morals and proper gender roles in a Roman setting, Rebull acknowledged the nastier consequences of political conflict in his reference to the French Revolution (and showed the woman as aggressor rather than victim). Pina and Rebull would direct the way painting was taught at San Carlos until the early twentieth century, ultimately hindering the development of an avant-garde practice.

II. Imagining Mexican History

As well as being inspired by biblical and mythological scenes, and stories drawn from European history and literature, artists at the Academia de San Carlos were increasingly drawn to narratives directly pertinent to Mexico. The earliest of these dealt with the history of Columbus and his Spanish patrons, Ferdinand and Isabella. For many intellectuals, national history began with Columbus, even if he never touched foot on Mexican soil. This paralleled the promotion of Columbian mythology in the United States: the textual sources for Mexican painters included books by US writers Washington Irving and William Prescott, as well as the French author Alphonse de Lamartine. In Mexico, Columbus's connection to Spain was emphasized, since Conservatives considered the introduction of Christianity and European culture as fundamental to national identity.

In 1850, while in Rome, Juan Cordero (1824–1884) painted the first of these Columbian-themed pictures—*Columbus at the Court of the Catholic Kings*—perhaps inspired by Delacroix's treatment of the same topic at the Villa de San Donato in Florence. As required by the Academia de San Carlos, which had granted him a fellowship, he shipped the canvas home as proof of his accomplishments. Cordero's mastery of the academic discipline was evident in every detail, but the picture also impressed critics in Rome and Mexico City because his

109 Juan Cordero, *Columbus at the Court of the Catholic Kings*, 1850.

angle—the great adventurer financed by the Catholic Kings brings God to the New World—appealed to both Conservatives and romantics. For elites back home, the painting further confirmed European cultural hegemony, historically as well as aesthetically.

Unlike most contemporary images of the same scene, however, Cordero showed the explorer presenting three Indians to the court, along with other gifts brought from the Caribbean. On one level, this offering parallels Cordero's own painting, given as "tribute" to his alma mater. The kneeling figure in profile has also been interpreted as a self-portrait: whether

or not this is true, the Indians do display "American" humility vis-à-vis European authority. Cordero himself showed far less submissiveness upon returning to Mexico; convinced he was the equal of any Spaniard, he sought to become director of San Carlos in 1853 and was frustrated when Clavé remained in power. Embittered, Cordero turned to portraiture and murals, working generally outside the privileged academic system.

The first work to deal exclusively with Mexico's pre-Hispanic past within the Academia de San Carlos was created by the professor of sculpture, Manuel Vilar. Designed as a public monument to be cast in bronze, *Tlahuicole* commemorates a Tlaxcalan warrior captured by the Aztecs. Rather than accept

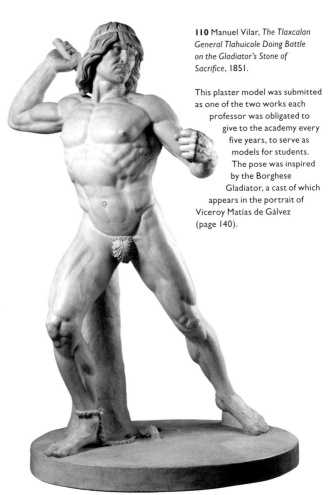

110 Manuel Vilar, *The Tlaxcalan General Tlahuicole Doing Battle on the Gladiator's Stone of Sacrifice*, 1851.

This plaster model was submitted as one of the two works each professor was obligated to give to the academy every five years, to serve as models for students. The pose was inspired by the Borghese Gladiator, a cast of which appears in the portrait of Viceroy Matías de Gálvez (page 140).

clemency, the warrior chose an honorable death in gladiatorial combat. Vilar confirmed the importance of Classical male beauty within the academic system, but he also used historical sources and, given the specific features of the face, an actual Indian may have posed for him. The sculpture anticipates themes common to academic images of Indians for the remainder of the century: it emphasizes a historical (dead) subject over a contemporary (living) one; it privileges the cultures of Central Mexico, thus ratifying the authority of the ruling elites in Mexico City; and it inserts the violent indigenous past into a classicizing aesthetic language, thus "civilizing the barbarian" (in the same way that such words as "pyramid" and "stela" classicized pre-Hispanic ruins).

Vilar probably intended *Tlahuicole*, like his sculptures of Moctezuma, Malinche, and Iturbide, to appeal to Conservative patrons, although none of these plaster models were cast in bronze at the time. In the case of *Tlahuicole*, perhaps this angry, powerful, and almost naked indigenous male body had no place in the public sphere—especially at a time of Indian uprisings in the north and in the Yucatán—even if he were a symbol of republican virtue and resistance to foreign intervention. But it was mainly a result of the disastrous economy and lack of political consensus; in fact, almost no major public monuments were raised in Mexico until the 1870s. A victory column honoring Santa Anna in the Plaza Mayor, designed in 1843 by the Spanish-born architect Lorenzo de la Hidalga, never got any higher than the plinth (*zócalo*), though it did change forever how residents referred to that great public square.

The turbulent history of mid-nineteenth-century Mexico was best illustrated outside the San Carlos, by the political caricaturists who flourished after 1861 when the return of the Liberals to power brought greater freedom of the press. In the 1840s, following Claudio Linati (page 158), several French and Mexican entrepreneurs established lithographic workshops in Mexico City, producing prints for books and literary magazines, and, occasionally, more elegant portfolios for an external as well as internal market. Though the audience for such publications remained small—given low literacy rates and their relatively expensive cost—the lithographic technique eventually increased the dissemination of visual imagery across all social classes.

Of the dozens of illustrated satirical journals in this period, one of the few that survived for more than a few issues was *La*

111 Constantino Escalante, *The Fifth of May*, from *La Orquesta*, vol. 3, no. 7 (May 21, 1862).

In this parody of the French invasion of Mexico, General Charles de Lorencez urges three of his Zouaves forward, but sharp maguey spines hold them back. Although they were defeated at Puebla on May 5, 1862, the French went on to capture Mexico City in June of the following year.

LA ORQUESTA Nº 7. TOMO III.

EL 5 DE MAYO.
—— Porque esa tropa no avanza?
—— Se ha atorado en un maguey.

Orquesta (The Orchestra, 1861–77). Edited until his death by cartoonist Constantino Escalante (1836–1868), the publication took a less partisan approach to current events, notwithstanding the Liberal credentials of its director. Although Escalante had exhibited paintings at San Carlos, like most caricaturists he challenged the Conservative view of art as expressing noble virtues. Instead, inspired by such French satirists as Honoré Daumier and J. J. Grandville, Escalante and his colleagues (including Santiago Hernández and José María Villasana) depicted subjects thought unworthy by the academicians. Drawn rapidly on the stone as if from life, their allegories and parodies generally reference specific political debates easily forgotten with the passage of time, though others address the more lasting effects of urban modernization, such as the arrival of streetcars and the railway.

In May 1864, Maximilian von Habsburg and his wife Carlota landed at Veracruz as Emperor and Empress of Mexico, installed through the imperialist designs of Napoleon III, in league with prominent Conservatives hoping to reverse the tide of Liberal reforms. Their assumption of power was possible—at least for the moment—only because the United States was distracted by a civil war of its own. Prints and photographs were circulated to publicize the couple's arrival along a route that

112 Jean-Adolphe Beaucé, *The Delegation of Kickapoo Indians Visits Emperor Maximilian*, 1865.

The visit of the Kickapoos in December 1864 was widely reported in the press. This painting, by an artist assigned to the French expeditionary force in Mexico, was shipped with other personal belongings back to Europe after Maximilian's death.

was framed by triumphal arches, recalling those that had honored the viceroys in previous centuries.

Maximilian used the arts to legitimize his venture, attempting—unsuccessfully—to reconcile Liberal and Conservative factions. He found Clavé's Nazarene style formally outdated; instead he commissioned Santiago Rebull and his students at the renamed Academia Imperial de San Carlos to create more robust, life-size portraits of the leaders of Independence (Liberal and Conservative heroes alike) for a salon in the Palacio Nacional used for court ceremonies. Eager to form a national *imaginaire*, Maximilian was profoundly interested in Mexico's ancient civilizations: he moved the Museo Nacional (founded in 1825 at the University) to the Palacio Nacional in 1865, and then to the former Mint in 1866. He also dreamt of urban reforms. Apart from extensive

renovations that changed the former summer house of the viceroy in Chapultepec (later used as the Colegio Militar) into his official residence, and the layout of a grand diagonal boulevard, known as the Paseo de la Emperatriz, to link the colonial center to that residence (now known as the Castillo de Chapultepec), Maximilian's plans for the transformation of Mexico City were as ephemeral as the triumphal arches he first passed through.

Although Maximilian and Carlota wear formal court dress in several official portraits, in photographs and the few history paintings that commemorated their reign they often appeared as haute-bourgeois citizens, downplaying the imperialist ambitions behind their rule. A work by French artist Jean-Adolphe Beaucé (1818–1875) shows Kickapoos from northern Mexico—dressed as feathered "savages" somewhat in the tradition of US novelist James Fenimore Cooper (whose books Maximilian read)—appealing for the restitution of lands appropriated by the Liberal government. This official image testifies to Maximilian's sympathy for indigenous groups, though the diplomatic negotiation takes place beneath a portrait of his ancestor Charles V, tying the Austrian's legitimacy to the Spanish colonial enterprise launched in 1519.

Maximilian's bourgeois clothing, now riddled with bullets, appears in photographs that circulated widely after his execution in June 1867, after the retreat of the French army and the victory of the Liberals under Juárez. Though no photographers were allowed to portray the execution itself, an enterprising François

113 François Aubert, *The Shirt of the Emperor, Worn during His Execution*, 1867.

François Aubert moved to Mexico City in 1854, where he learned to be a photographer and then took over his teacher's studio. He later developed a profitable business creating portraits of wealthy Conservatives who were close to the Imperial court.

Aubert (1829–1906) raced to Querétaro, taking portraits of the firing squad and photographing the Emperor's bloodied clothes as if they were sacred relics. These images may have been permitted by a Liberal official who expected that photographic veracity would trump speculation that Maximilian had survived. Copies soon reached Édouard Manet in Paris, who changed his painting of the execution after seeing he had got the costumes wrong. For Conservatives and many Europeans, Aubert's pictures simply confirmed Mexico's barbarism. In the ensuing decades, Mexican artists and intellectuals would struggle to counter that image with representations of the nation's ancient civilizations and modern sophistication.

After 1867, San Carlos—now officially known as the Escuela Nacional de Bellas Artes (ENBA)—was placed under the control of the Ministry of Justice and Public Instruction as part of a Liberal push for greater control over education. During the Restored Republic (1867–76), Liberal intellectuals—including Ignacio Ramírez, a mestizo, and Ignacio M. Altamirano, a full-blooded Indian like Juárez—played an important role in promoting history painting as part of a wider political campaign to heal the wounds caused by the French intervention, reduce partisanship and strengthen national unity and pride, and dispel European stereotypes of Mexico as backward and uncivilized. Accelerated modernization, particularly the secularization of Mexican society and the impact of new technologies—the railway and telegraph, for example—only increased the need for a shared set of myths and rituals rooted in a secure and increasingly distant past.

Mexico's pre-Hispanic history emerged as a major theme for academic painters in the 1860s and 70s, even if the shift was gradual. As signaled by Vilar's *Tlahuicole*, this past was predominantly that of the Toltec and Aztec civilizations of Central Mexico: there was far less interest in the ancient history of Oaxaca or the Yucatán, even if elements drawn from Mixtec and Maya cultures were subsumed within the cultural *bricolage* sometimes referred to as "neo-Aztec." Rather than turn to ancient Greece or Rome, Mexican painters and their Liberal patrons forged an indigenous "classicism," equating the Aztecs with the great civilizations of the Old World. By extension, these Liberals took a dim view of the Conquest.

The earliest of these Aztec *grandes machines*, to use the French term for large history paintings, were commissioned by

Felipe Sánchez Solís (1816–1882), a Liberal lawyer from Toluca, who, like Juárez and Altamirano, had risen from an indigenous background to the heights of Mexican society. To highlight his "noble ancestry" and distance himself from lower-class Indians, Sánchez Solís designed a room decorated in the "Aztec taste" for his house in downtown Mexico City. Inaugurated in 1875, the space juxtaposed academic paintings—among them, *The Discovery of Pulque*, by José Obregón (1832–1902), and *The Senate of Tlaxcala*, by Rodrigo Gutiérrez (1848–1903)—with codices and pre-Hispanic artifacts, including an obsidian mirror. This private museum housed the meetings of a literary salon known as the Sociedad Nezahualcóyotl, but also announced Sánchez Solís's Liberal credentials, political ambitions, and even economic interests.

The paintings show fictive re-creations of pre-Hispanic tales based loosely on historical sources, presented in the manner of theatrical performances on stages decorated with the same eclectic mix of cultural forms one would have then seen in the displays at the Museo Nacional. Both also have dense, overlapping meanings that reached beyond the ostensible subject, and that resonated with the patron and the wider public. In particular, these works highlighted the brilliance of indigenous civilizations before the Spanish Conquest—a glory that Sánchez Solís hoped to appropriate to himself.

In *The Discovery of Pulque*, a beautiful young woman named Xochitl, accompanied by her parents, presents a bowl of pulque (the fermented drink that she has supposedly just invented) to the Toltec ruler of Tula, Tecpancaltzin, her future husband. Perhaps Sánchez Solís selected the theme because his wife hailed from a family of hacienda-owners who profited from the production of pulque. The painting proposes a left-to-right reading: nature is subservient to culture, barbarism gives way to civilization, and workers benefit the aristocrat. Even more revealing is that the princess's skin tone is lighter than the king's. As a couple, they reverse the *español* and *india* pairing of casta painting, instead mimicking Sánchez Solís's own situation, since his wife—like Juárez's—was white. The painting thus allegorizes the need for Indian assimilation through *mestizaje*, which was more tolerated in provincial areas (such as the State of Mexico or Oaxaca) than in Mexico City, where racial hierarchies were more entrenched.

114 José Obregón, *The Discovery of Pulque*, 1869.

While Obregón employed gentle forms and warm colors that harken back to Clavé, Gutiérrez adopts the realism that was to typify Mexican history painting after 1870, though his depictions were still far from any archaeological "truth." His painting of 1875 shows Tlaxcalan nobles debating whether to join the Spanish forces against the Aztec empire in 1519. Like Obregón's throne room, the "senate chamber" shown here is culturally inaccurate, but functions as a European framework that elevates the indigenous actors and makes the alien more familiar. The picture clearly refers to the dangers of disunity, and of betraying one's nation through alliances with foreign invaders, but could also be read as a reference to Sánchez Solís's own senatorial ambitions.

Mexico's colonial past played a less constructive role in forging national identity in this period. For many Liberals, the viceroyalty represented a period of domination by Church and

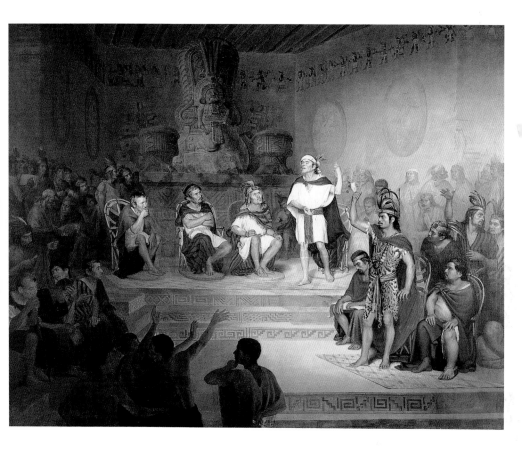

115 Rodrigo Gutiérrez, *The Senate of Tlaxcala*, 1875.

The Discovery of Pulque and *The Senate of Tlaxcala* were acquired by the Academia de San Carlos after the death of their patron, the indigenous lawyer Felipe Sánchez Solís. They were later exhibited at the world's fairs in Paris (1889) and Chicago (1893); originally intended to reinforce one man's personal identity, they had now been co-opted by the state as evidence of national identity.

Crown, and—notwithstanding the unavoidable legacy of those three centuries—was easily bracketed off between an idealized pre-Conquest era and an equally idealized Republican present. In history painting, scenes related to the colonial period thus depict either criollo heroes, such as Sor Juana Inés de la Cruz, or focus on the brutality of the Conquest itself.

In a life-sized portrayal by Félix Parra (1845–1919) of Bartolomé de las Casas, the Dominican known for his vocal defense of indigenous rights stands stiffly in front of a half-ruined Aztec temple with ornamentation—a fertility goddess to the left, and a fallen column to the right—that echoes the gender of the indigenous couple at his feet. Metaphorically, the woman embraces Christian civilization, just as contemporary Indians were expected to accept state-sponsored education aimed at assimilation, and become engaged, productive citizens. Far from being pro-Indian, many Liberals believed that contemporary

indigenous culture needed to be broken. Thus, the dead "husband" is at once a bloodied martyr to the brutality of the invaders and a necessary sacrifice symbolizing greater societal forces. His absence will now allow the indigenous "wife" to forge new allegiances and—ultimately—generate whiter, and more culturally European, descendants.

III. The Meanings of Landscape

In the second half of the nineteenth century urban and rural landscapes emerged as crucial markers of Mexican identity. The volcanoes and views of Mexico City had confirmed criollo pride since the late viceregal period, and such travelers as Egerton (page 160) and Catherwood had foregrounded the sublime power of mountains and ruins (pages 162–63). It is only with the establishment of landscape painting as an independent discipline in the Academia de San Carlos, however, that it began to be seen as a genre equivalent—at least in the eyes of its practitioners—to long-glorified history painting.

After Independence, the first landscapes produced for an internal rather than foreign market were mainly images of Mexico City. In 1838, the Italian set designer and painter Pietro Gualdi (1808–1857) arrived in Veracruz with a traveling opera company; discovering an untapped market, he remained in the country for thirteen years before moving on to New Orleans. While in Mexico City, Gualdi created precise renditions of major monuments (page 149) and urban spaces that are not about exotic strangeness but instead emphasize the capital's grandeur and order. Some were issued as lithographs in a portfolio of 1841 titled *Monumentos de México*. As in Fabregat's engraving of the Plaza Mayor of 1797 (page 145), the city's bustling population is barely visible. The earliest surviving photographs of Mexico are also images of architectural monuments; they may have been taken in January 1840 by a French engraver who imported one of the first daguerreotype cameras in late 1839.

No information on his formal education survives, but Mexican printmaker Casimiro Castro (1826–1889) may have trained under Gualdi, who taught classes in perspective at the Academia de San Carlos. Although he illustrated books and magazines, Castro's greatest project—and one of the finest lithographic albums of its day—was *México y sus alrededores*

C. Castro del y lit. Lit de V Debray México, Portal del Coliseo Viejo Propiedad del Editor

MORELOS SQUARE. PLAZA DE MORELOS. PLACE DE MORELOS.
Formerly Guardiola Square. Antigua Plazuela de Guardiola Ancienne Place de Guardiola.

117 Casimiro Castro, *Plaza de Morelos*, from *México y sus alrededores* (Mexico City, c. 1865).

In his prints, Castro filled the streets with citizens of all social classes: from troops to itinerant vendors to promenading members of the rising middle class that was his primary audience. Antonio Piatti's statue of Morelos (1860) was installed by Maximilian in 1865 next to the former Casa del Conde del Valle de Orizaba. It has since been moved.

(Mexico and Its Surroundings), first published in Mexico City in 1855–56. This luxurious publication was released in several editions through the late 1860s, with the plates modified to reflect the current political situation (for example, prints showing the French invasion were included in editions published during the reign of Maximilian). Castro drew his scenes using such modern tools as binoculars and photographs, and even rode in a hot air balloon to achieve hitherto unseen vistas, though the city remained mainly colonial in terms of infrastructure. *México y sus alrededores* was sent to Europe as a gift to Maximilian to give him a sense of the country he was about to govern. In fact, such albums and their progeny (including twentieth-century photobooks) privileged image over text, and shaped a vision of Mexico for ever-wider audiences at home and abroad both by what was included and what was left out.

It was one thing for set designers and commercial lithographers to produce images glorifying the city, but quite another to claim that landscape had a place in the academy equal to that of history painting. The traditional rankings of pictorial genres were already eroding in Europe by 1855, however, when the Academia de San Carlos brought Eugenio Landesio to Mexico to inaugurate the position of professor of landscape.

An extremely influential teacher, Landesio had developed a schematic and analytical approach to landscape painting based on two major categories: location (permanent features, such as mountains, trees, and water) and episode (narrative features, involving animals and people). His published theories contradicted traditional academic prejudices that landscape artists (such as Castro and Gualdi) replicated what they saw before them, whereas history painters invented dramatic events from the past that they had obviously never witnessed. Landesio wanted viewers to recognize that great landscapes required the same mastery of observational skills and the same level of creative imagination as history painting, and could thus carry similar moral and historical messages.

Landesio's grandest canvases, including views of haciendas and mines commissioned by foreign investors and local patrons, put his theories into practice. Each constituent part—from the clouds to the smallest worker—was treated separately, in the open air or the studio, and later incorporated into a final

118 Eugenio Landesio, *Hacienda de Colón*, 1858.

The Hacienda de Colón, located near Izúcar de Matamoros in the state of Puebla, was dedicated to the production of sugar. The owner, architect Lorenzo de la Hidalga, commissioned this painting. When exhibited at San Carlos, the painter's detailed description specified the diverse events taking place, such as the "laborers [on the rooftop] enjoying the lunch brought to them by the women."

picture that was at once accurate and idealized. Just as the historical figures rendered by Clavé's students (page 167) combined proper anatomy with unblemished features, so Landesio depicts the complex buildings of the Hacienda de Colón with a perfect command of perspective and then casts the walls in the warm light of the sun, a discursive invention designed to ennoble the proto-industrial complex.

Landesio encouraged his students to produce landscapes with historical scenes: *The Foundation of Tenochtitlan* (1863) by Luis Coto (1830–1891), for example, was an early example of Aztec-themed painting, and was acquired by Maximilian for his personal collection. But Landesio's most important protégé was José María Velasco (1840–1912), who would dominate landscape painting in Mexico after his teacher's departure in 1877 and become the first Mexican artist to achieve an international reputation (and enter US collections). The great polymath of nineteenth-century academic practice, Velasco had studied mathematics, geology, and surveying before continuing on to the Academia de San Carlos. He also took courses in zoology and botany at Mexico City's medical school, wrote and illustrated scientific tracts, and created prints and murals for the Museo Nacional and the Instituto Geológico de México. Far more than Landesio or any of his other students, Velasco would combine objective science and poetic invention in the service of nationalism.

Much of Velasco's work attempts to resolve the tensions between tradition and modernity, or nature and technology, that shaped many nations, including Mexico, in the latter half of the nineteenth century. In the 1860s, under the influence of Landesio, Velasco's landscapes often included fairly obvious allusions to historical or contemporary events. Reminiscent of Hubert Robert's depictions of Parisian churches demolished after the French Revolution, Velasco's oil sketch of the ruined church of San Bernardo documents the destruction of colonial buildings in the wake of the Reform Laws of the late 1850s, opening up urban real estate to private investment. But the golden light shining towards the former altar, and the cathedral towers looming in the background, underscore a moral message consonant with Velasco's relatively conservative beliefs: human change is inevitable, but the authority of God is constant.

The mid-century assault on churches, monasteries, and convents resulted in the removal of many colonial paintings to

119 José María Velasco, *Church of San Bernardo*, 1861.

The secularization and destruction of Church property in the former colonial traza (page 56) led to a gradual transformation of the center. Commercial investment increased, but elite white families gradually began to move west, eventually to new suburbs.

the picture galleries at San Carlos, embraced by conservative directors less as stylistic models for copying than as proof of the grandeur of the nation's colonial past. This gradual "museification" of Mexico's viceregal art and architecture ran parallel to the secularization of religious monuments: for example, the seventeenth-century church of San Agustín was transformed into the Biblioteca Nacional (inaugurated in 1884). Today many of Mexico City's most important cultural institutions occupy former churches or stand on the sites of convents and monasteries torn down in the 1860s.

Beginning around 1873, Velasco broadened his vision, turning from specific anecdotes to comprehensive views of the Valley of Mexico seen from ever-higher elevations to the north of the city. In the most famous version, painted in 1877, strong diagonals and intense contrasts between light and dark direct our attention towards the Villa de Guadalupe at the base of the hill in the middle ground, and then, with the Calzada de Guadalupe serving as an arrow, straight to Mexico City; the two volcanoes appear in the far distance. Whereas Landesio's system had required that landscape artists (following a tradition

120 José María Velasco, *Valley of Mexico Seen from Santa Isabel Hill*, 1877.

Like many artists of his time, Velasco copied his paintings for collectors: most copies were smaller, with only minor modifications. He reproduced this work seven times. Two were purchased by František Kaska, a Czech pharmacist who had accompanied the French army to Mexico in 1865. Kaska gave one to Pope Leo XIII and it remains in the Vatican Museum today.

established by French painter Claude Lorrain) conserve some fixed area in the foreground to situate the episode, here the foreground drops away, leaving the viewer almost in mid-air; the lack of framing devices furthers the sense of an unlimited, almost God-like, perspective.

Velasco's scientific knowledge is evident throughout, from the rock formations to the plants and atmospheric effects, all based on plein-air sketches. He even used binoculars to ensure that each detail was perfectly accurate. For Velasco, however, the ultimate truths in such a landscape were spiritual. Echoing John Ruskin, he wrote in his autobiography that "The artist has to behold nature, the works of God, always as a disciple, never as a professor."

But this is also a profoundly patriotic painting. Velasco heightened the centrality of the capital by suppressing outlying towns and settlements, and included, somewhat subtly, a reference to the Mexican national arms: an eagle with a bird (rather than a snake) in its mouth, silhouetted against a dark outcrop, flies away from the prominent cactus to the left. As in Ribera's rendition of the Virgin of Guadalupe from almost a century before (page 123), but with everything tied together in a far more realistic scene, Velasco's painting shows that divine forces bless Mexico City—the capital of the Aztecs, of the viceroyalty, and of the modern Republic, and site of the Palacio Nacional where Porfirio Díaz had just assumed the office of president. The landscape asserts a centralist ideology, which echoes that of the political regime that would last until 1911.

By subsuming within its frame all historical narratives and simultaneously confirming the glory of the new president, Velasco's view of the Valley of Mexico supplanted the specificity of any particular narrative, asserting landscape's superiority as a genre over history painting. His composition was also arguably less partisan, since Liberals and Conservatives alike could rally around the national flag. It was also better at communicating Mexican grandeur to foreign audiences, since there was no need to know any historical text. Of all his academic colleagues, Velasco attained the most fame through exhibitions of his work in world's fairs from Philadelphia to Paris, and was the first nineteenth-century painter to be elevated in the post-Revolutionary period as an exemplar of nationalism. His paintings remain beloved today for providing a nostalgic reminder of the marvelous environment that has since been invaded by an urban sprawl now impossible to erase.

Though his views of the Valley of Mexico tended to suppress signs of modernity, as part of his positivist vision Velasco actually embraced technological change. This is evident in several depictions of the British-owned railway line connecting Mexico City and Veracruz, a great engineering feat inaugurated in 1873. In one painting, a major bridge seems higher and more delicate than it was in reality; lush tropical vegetation is deployed to cover the scars of deforestation that appear in contemporary photographs. Thus, while showing man's technological conquest over nature, Velasco highlights the peaceful coexistence of technology *within* nature, as well as affirming Mexico as a land open to foreign investment and

121 José María Velasco, *Curved Bridge of the Mexican Railway in the Metlac Ravine*, 1881.

All of Velasco's railway-themed landscapes, including some where puffs of steam from the engine are barely visible in the distance, underscore the industry's crucial role in Mexico's economic development. In the same years Velasco was painting the British-owned Mexican Railway line, William Henry Jackson photographed the US-owned Mexican Central Railway, which ran north to Ciudad Juárez.

development. One can also interpret his railway images as allegories of centralization, since all lines led to the capital. The irony of choosing a foreign-owned and engineered railway to make a statement about national identity was not lost on contemporary cartoonists, who used the train as a symbol of a government headed down the wrong track.

IV. *Portraiture and* Costumbrismo

Of course, Mexican identity was not just a product of historical texts and geographic spaces, it was also a function of citizenship—not only who was legally Mexican, but also who in particular represented "Mexicanness." As elsewhere, images of Mexicans in the nineteenth century fall into two basic artistic categories, both with their roots in the viceregal period: portraits of specific individuals, and genre scenes depicting generalized types. Whatever their personal politics or patriotism, the Mexican subjects of formal portraiture—first in paintings, and then, more democratically, in photographs—

envisioned themselves much like their counterparts in Europe and the US, using similar conventions of pose and dress. Only in the twentieth century would these works be reinterpreted as essentially "Mexican." An entirely different operation governs the representation of workers and servants who appear as "types" rather than individuals: they did not commission their own images (those in prints and paintings may not have even existed as actual people), but were instead imagined and manipulated by Mexican elites, usually in the cities, as avatars of national identity.

Throughout the 1870s, portraitists from the Academia de San Carlos, as well as a few enterprising visitors from abroad, dominated the Mexico City market. The French painter Édouard Pingret (1788–1875), then Pelegrín Clavé and Juan Cordero, obtained the most prestigious commissions, and their works were sometimes included in annual exhibitions. Some portraitists in the provinces—José María Estrada (c. 1810–1862) in Guadalajara, for example—operated stable and profitable businesses over decades; others, generally self-taught, traveled from town to town, and remain anonymous today. Works by the provincial artists were unseen and thus unacknowledged in Mexico City.

The work of Estrada best represents provincial portraiture of the time. Notwithstanding his studies at the local Academia de Bellas Artes, he posed his subjects stiffly against blank backgrounds; identity is expressed more through costume and attributes than facial features, and old-fashioned inscriptions recall the genealogical information required by colonial patrons (page 110). Estrada also received commissions for post-mortem images, giving more emphasis to the deceased's face— usually shown as if sleeping—than did viceregal artists (page 131). By the 1840s, the spread of photographic studios across the country—first making fragile and expensive daguerreotypes, and then ever cheaper tintypes and paper prints—would gradually but inevitably put most painter-portraitists out of business.

122 José María Estrada, *Portrait of Manuela Gutiérrez*, 1838.

Although this girl (identified in the caption as only one-and-a-half years old) goes barefoot and wears a shift appropriate to her age, her doll symbolizes a future role as mother; the toy-like poodle is a timeworn reference to fidelity. The coral jewelry, perhaps made by Estrada himself, was thought to ward off evil. This painting was formerly in the collection of the Guadalajara-born artist Roberto Montenegro.

Manuela Gutierrez, retratada de un año y cuatro meses de edad el 4 de Octubre de 1838.

123 Hermenegildo Bustos, *Self-Portrait*, 1891.

Bustos's work was unknown outside his hometown until the 1930s. Inscriptions on the reverse of this self-portrait, including a seemingly autobiographical statement that he was an "Indian," were added by an early collector to exaggerate the painter's nationalist credentials. It may be that the red text on the front is apocryphal as well.

One artist who managed to garner commissions well after the emergence of photography was Hermenegildo Bustos (1832–1907), who worked in and around the town of Purísima del Rincón, Guanajuato. Making a living from painting alone was apparently difficult: Estrada was also a silversmith, but Bustos had an even more eclectic career as a farmer, carpenter, church sacristan, and ice-cream maker. Like Velasco, albeit on a smaller scale, Bustos communicated both his belief in God and a fascination with science. Though he was mainly a portraitist, his output included religious scenes and ex-votos, as well as precise still lifes and records of astronomical phenomena. Bustos may have had some professional training in the city of León, yet he signed several works as *aficionado*, or amateur, perhaps to assert his independence. His assured self-portrait of 1891, however—an anomaly in nineteenth-century provincial practice—belies this modest rejection of professional status.

Bustos depicted family members as well as the residents of his community, including tradespeople, hacienda administrators, and their wives and children. He took an honest, almost cartographic approach to the faces of his sitters: in a town where everyone knew everyone, perhaps flattering idealization was less effective. His vision may also have been influenced by photography. The oval format of some works resembles the conventions of studio photographers, and one posthumous portrait of 1862 includes an inscription stating it was copied from a daguerreotype. Bustos competed not in price but in his ability to render his subjects on a larger scale and in living color, giving individuals the same sense of prestige and permanence sought by their wealthier counterparts in Mexico City.

In the nineteenth century, genre scenes—like landscapes—gradually emerged as more acceptable subjects, first outside San Carlos and then increasingly within its walls. Ignacio Altamirano, for example, promoted the representation of everyday life (known in Mexico as *costumbrismo*) as an alternative to Classical and religious subject matter. We can trace some of this genre imagery to previous artworks: casta paintings and other secular images of the Bourbon period, such as painted screens and urban views; the sketches, paintings, and

print portfolios of several European travelers, including Linati, Nebel, and Pingret; and even wax figurines, embroidered shawls (*rebozos*), and other folk arts. Yet genre images at mid-century were more closely derived from literary than visual sources, part of a focused attempt after 1848 by Mexican intellectuals to reimagine what made their country unique. Those same elites, who identified deeply with European culture in their own daily lives, simultaneously asserted their distance from that difference: the "truest" Mexicans were apparently to be found downstairs rather than up.

The boom in lithography and photography helped consolidate and categorize these types for a local audience, and the artists and their publishers believed that they were correcting the misperceptions and prejudices of European travelers. This is particularly evident in *Los mexicanos pintados por si mismos* (The Mexicans Depicted By Themselves, 1854–55), which emerged out of Mexico City's rich and interconnected milieu of lithography workshops and literary magazines.

European representations of different popular costumes and occupations date back to the seventeenth century, with more immediate precedents published in London, Paris, and Madrid in the early 1840s. If the European books were often pseudo-scientific and satirical, the Mexican version was more concerned with identity formation. This is clear in both the images, mainly by Hesiquio Iriarte (c. 1824–1903), and the accompanying texts by leading writers of the time.

Los mexicanos pintados por si mismos, originally issued in separate fascicles, included thirty-five different "types:" characters defined by dress, occupation, manner of speech, or social role. Most represented lower- to middle-class occupations familiar to residents of any city (chess-player, seamstress, lamplighter), and even the two rural types (the mule-driver and *ranchero*) might be seen in the capital from time to time. Perhaps expressing the publisher's Liberal bias, the album omitted military and religious figures, members of the upper class, and, most importantly, Indians. Among the few

124 Hesiquio Iriarte, *The China*, from *Los mexicanos pintados por si mismos: Tipos y costumbres nacionales* (Mexico City, 1854–55).

The *china*, often associated with Puebla (thus, *china poblana*), was famous for her bright clothing (partly derived from Asian imports in the colonial period) and her coquettish independence, signaled here by the fact that she is smoking a *cigarro*.

truly local types were the pulque seller and the *china*, the flashily dressed working woman who was free from bourgeois norms. In fact, the publication, with fewer references to exotic difference than Linati's album of 1828 (page 158), emphasized that Mexicans, when they actually viewed themselves, shared more similarities than differences with their counterparts in other world capitals.

About a decade later, photographers Antíoco Cruces and Luis Campa (who operated an important Mexico City studio between 1862 and 1877) replicated the models established by their lithographer-predecessors: now, however, real men and women were being removed from the street to face the camera in the studio. Of the eighty or so "types" issued by the studio as cartes-de-visite, many show uniquely local goods (*petates* [palm mats] and enchiladas) and occupations (the tlachiquero), or menial tasks that emphasize the city's lack of infrastructure (the water-seller). Unlike Iriarte's lithographs, these images emphasize otherness, and cultural and economic distance from the presumed collector. Others show slightly more successful citizens, like the coffee seller who proudly brandishes the national flag on his rectangular coffee urn. This inventory of the lower classes resembles other systems of social control engineered by middle-class bureaucrats (who are entirely absent from the series by Cruces and Campa), including official photographic registries of criminals (begun in Mexico in 1854) and prostitutes (1865). And the specifically local "types" would find endless representation on postcards later in the century, shaping visualizations of Mexican identity well into the next.

Despite the fascination with the visual and literary descriptions of national "types," it took some time for the academicians in Mexico City to accept that even more complicated paintings depicting scenes of daily life had a place in their august bastion of universal truths and high moral principles. In the 1850s, genre paintings were first included in the academy's exhibitions, though only in sections open to non-members, including foreigners and provincial artists, whose pictures were either lent by private collectors or intended for commercial sale. By the late 1860s, however, genre painting was increasingly recognized as an effective and prestigious vehicle for communicating moral and nationalist messages.

The first major genre paintings by Mexican artists were produced in provincial cities, where smaller art academies were

125 Antíoco Cruces and Luis Campa, *Coffee Seller,* c. 1870–75.

Cruces and Campa primarily created portraits, whether of famous citizens, middle-class residents, or working-class "types." They sold around 20,000 copies of their portrait of Benito Juárez after his death in 1872. Most of their works were produced as cartes-de-visite, paper prints pasted to calling-card-sized mounts.

less concerned with imported aesthetic rules, and where bourgeois patrons—many themselves mestizos—were less concerned with social etiquette and severe divisions of race and class than their counterparts in Mexico City. The most sophisticated of these local practitioners was José Agustín Arrieta (1803–1874), an artist who had trained at the local art academy in Puebla, Mexico's second largest city. Like other provincial artists, Arrieta worked in several genres, including religious scenes and portraiture, but was most renowned for his still lifes—many of which show a mix of local and imported goods, as in Pérez de Aguilar's earlier example (page 137)—and *cuadros de costumbres del país* or "pictures of customs of the country." Arrieta showed his work both locally and at the Academia de San Carlos, reaching the attention of mainstream writers and critics, unlike Estrada or Bustos.

Arrieta's tableaux of daily life in Puebla's kitchens, *pulquerías* (taverns selling pulque), and markets are populated by a cast of characters ranging from tatty beggars to flirtatious servants to

126 Agustín Arrieta, *La Sorpreza*, 1850.

Details in this street scene lampoon racial blending. A barefoot woman pulls away from her darker-skinned partner; two dogs fight in the foreground like interracial spouses quarreling in the kitchen in casta images. While the mule (itself a hybrid) brays, the white woman at the left moves out of the scene, aloof, but perhaps not surprised by it all.

pretentious dandies. In *La Sorpreza*, the demure woman to the left—a proxy for the bourgeois viewer-collector—looks towards the messy commercial, social, and even sexual behavior inventoried beneath the ironic sign of a pulquería. Her subtle smile reminds us that at the time critics understood such works as humorous, even satirical. In many of Arrieta's works, women take an active rather than subservient role, rejecting unwanted suitors, controlling the keys to their husbands' happiness, and sometimes staring straight at the viewer, forcing us to acknowledge their lives.

Though his skills in anatomical drawing and perspective were limited by his provincial education, Arrieta was hardly naïve. He drew on a wide variety of sources, from individual types and genre images by such traveler-artists as Pingret, to Spanish and Dutch precedents (Velázquez and Teniers, for example), works he knew from prints and from copies in local collections. Arrieta must have been familiar with eighteenth-century casta paintings, since several pictures (including *La Sorpreza*) allude in a similar fashion to the consequences of racial mixing. But his genre scenes also exude an earthy—even lusty—honesty, and

sympathy for moral weakness, that evidence an easy familiarity with the specific worlds he portrayed.

If Arrieta's paintings propose a certain (male) longing for the relaxed morality of the lower classes, genre painting in Mexico City endorsed stricter codes of behavior, especially for women. Beginning in the 1840s, illustrated women's magazines in Mexico promoted the virtues of domesticity and motherhood, infused with an aura of romanticism that served as a counterpoint to the rugged neoclassicism of the male-dominated academy. As in Europe and the US, Mexican bourgeois women at mid-century were generally confined to the home, engaged in domestic pursuits but leaving the dirty work to those same servants who appear in Arrieta's scenes.

Though modernity restricted women's participation in the public realm, however, ironically it encouraged their education in the private realm, including their pursuit of the arts. In this climate, a few intrepid and talented women—still excluded from taking courses at San Carlos—enrolled in the night classes several prominent artists gave to supplement their income. Many of these female students had some direct contact with the school: Guadalupe Carpio, for example, benefited from the fact that her father, Manuel Carpio, was a well-known poet, professor of anatomy, and member of the academy's board. The most talented showed their work in exhibitions at San Carlos as "outsiders."

Of these "women painters," as they were called, the ones who best proposed an alternative, even proto-feminist, practice were Josefa (1829–?) and Juliana (d. 1852) Sanromán, daughters of a wealthy businessman. We know relatively little about their lives, but they apparently studied under Clavé, whose conservative repertoire of portraits and religious images insulated the sisters from even a whiff of impropriety. Josefa and Juliana created several genre paintings that represent different rooms in the family home; their own biblical scenes and portraits of family members hang from the dark walls, tilting forward as was the custom. Each painting provides evidence of the Sanromán sisters' privileged economic status, cultural sophistication, and religious values, set within the protective boundaries of home and family. Although not explicitly autobiographical, these pictures include probable portraits or self-portraits of the sisters playing the piano, working at an easel, or listening to the priest. As if showing the cast from a romantic play, Josefa's *Convalescence*

127 Josefa Sanromán, *Convalescence*, c. 1854.

In the nineteenth century many genre paintings were purchased by private collectors from exhibitions at San Carlos. Works by women—including Guadalupe Carpio and the Sanromán sisters—were, however, not offered for sale, remaining instead in the hands of the family.

features Juliana as the suffering victim accompanied by her hopeful sisters, the trustworthy doctor, and the distant servant, preparing the invalid's bed. We also know how this story ends: after Juliana's early death, Josefa married her sister's widower and never again exhibited publicly.

The Sanromán sisters anticipate many of the themes addressed by male genre painters in the Academia de San Carlos in the 1870s, after Pina was named director. Manuel Ocaranza (1841–1882) emerged as a leading genre painter in this period; some of his works depict modern life in the streets of the capital, echoing contemporaneous scenes by Édouard Manet and other Impressionists, or genre painters in the US. *Café de la Concordia*, for example, shows a poor boy gazing

128 Manuel Ocaranza, *Café de la Concordia*, 1871.

The Café de la Concordia was located on the Calle de Plateros (today Avenida Madero), in the heart of the city's most elegant shopping district. It was frequented by artists, writers, politicians, and dandies, including the poet and art critic Manuel Gutiérrez Nájera.

129 Alberto Bribiesca, *Moral Education: A Mother Guides Her Daughter to Aid a Mendicant*, 1879.

longingly through the window of a Mexico City restaurant. Ocaranza, Alberto Bribiesca (1856–1909), and other academic colleagues often featured middle- or upper-class women in the home, weighed down by symbols and moral messages. In fact, for the rest of the century, genre painting—because it appealed to the viewer's sensibility and emotion—remained directed more to women than men, who were expected to learn their lessons from history, from military action, and, of course, from the leaders of the country.

More didactic than anything imagined by the Sanromán sisters, Bribiesca's *Moral Education* is also larger in scale than their works, and reveals a greater command of anatomy, obtained by access to life-drawing classes. The picture ties charity to domesticity, twice praising motherhood in the process, and framing it all under an abstraction of the national landscape. The title underscores the idea—widely discussed in the press—that under the Liberals it was mothers rather than "fanatical" priests who were the chief conveyors of Christian virtue. If anything, the angelic figure here stands for the motherland itself, raising her sons and daughters, mestizo or white, to reach ever-higher levels. That would be the chief goal of the regime of Porfirio Díaz. As for the struggling indigenous populations, it would take these quasi-citizens much longer to assume their place on the national stage.

Chapter 6 From the Porfiriato to the Revolution (1880–1920)

In 1877 General Porfirio Díaz was elected president of Mexico. He remained in control for a thirty-four-year period known as the Porfiriato, consolidating the central power of the state, strengthening the capitalist sector, and promoting foreign investment. His authoritarian rule—often at the expense of the largely disenfranchised working-class and indigenous populations—facilitated economic expansion, as once-contentious Liberals and Conservatives united behind the banner of order and progress. The role of the state, including in the cultural sphere, was theorized and justified by a professional and intellectual elite who embraced positivism, and who were known as the *científicos*.

Painting and architecture were better funded now than at any time since Independence, and served to affirm the centralized authority of the regime and the cosmopolitan sophistication of the upper class. Public monuments, buildings, and exhibitions, both in Mexico City and abroad, promoted the nation as a rich site for investment and immigration. Somewhat ironically, given Napoleon III's colonialist intervention in the 1860s, French culture emerged as the undisputed model—at least for those in control.

By the first decade of the twentieth century, urbanization and political corruption caused a crisis of confidence among a younger generation of artists and writers, who rejected positivism in pursuit of aesthetic and spiritual concerns, revealed in works shaped by Symbolism, Art Nouveau, and other avant-garde practices. They eventually located a profound national spirit, or *alma nacional*, in Mexico's traditional culture and the colonial past. Tensions among artists both inside and outside the Escuela Nacional de Bellas Artes (the former Academia de San Carlos) reflected the increasingly chaotic political and economic climate after the outbreak of the Mexican Revolution in November 1910, and Díaz's departure from office in May 1911.

I. Representations of the Indian

During the Porfiriato, the most prominent works of art and architecture resulted from attempts by the nation's elites to

transform Mexico's image in the minds of citizens and the world at large. Several projects of the 1880s and 1890s confirmed that the origins of the nation were to be found in the Aztec empire. Patrons and artists placed particular emphasis on the heroic figure of Cuauhtémoc, the last Aztec emperor (or *tlatoani*), renowned for his resistance to the Spanish invasion. This glorification of the Aztecs, which gave the nation a distinguished past and also reinforced the central authority of the regime, was nothing new; the message, however, had become far more bombastic.

A great city requires great monuments, but when Porfirio Díaz took office in 1877, there were very few indeed. This would change dramatically with the westward expansion of the capital, away from the old colonial center and towards Chapultepec. This shift was set as early as 1852, when the city government placed Tolsá's Caballito (page 144) on the Paseo de Bucareli. Aware of the monument's symbolic power, Maximilian had moved it slightly to face the Paseo de la Emperatriz, the diagonal through the surrounding farmland leading straight to his official residence at Chapultepec.

Known after 1873 as the Paseo de la Reforma (or simply Reforma), this new urban axis offered a blank slate on which to recast Mexican history. The aesthetic embellishment of Reforma, begun under president Lerdo de Tejada (1872–76) and extended by Díaz, was also economic. Over the next decades the city's wealthiest residents and much of the foreign community moved here, to new neighborhoods (known in Mexico as *colonias*, or "colonies"), named after such heroes as Cuauhtémoc and Juárez, which suburbanized former haciendas. Real-estate speculators profited from unbridled development permitted by the lack of a master plan.

In 1877, investor Antonio Escandón erected a monument to Columbus in a traffic circle on the still unpaved Reforma. Designed in Paris by Charles Cordier (1827–1905), it commemorated the inauguration of the Mexico–Veracruz railway. Díaz and Vicente Riva Palacio, his Minister of Economic Development, then asserted control to trump private patronage and promote a more nationalist history. In the traffic circles to the west of Columbus they planned a series of monuments honoring Cuauhtémoc, Hidalgo, and Juárez and the Reform Laws, placing them in a historical lineage that could be experienced by all citizens. (Cortés was present

130 Francisco M. Jiménez and Miguel Noreña, Monument to Cuauhtémoc, Paseo de la Reforma, Mexico City, 1887.

One of the leading commercial photographers in late nineteenth-century Mexico, French-born Abel Briquet (1833–1926) was hired by railway companies and the Díaz government to create commemorative albums. This image was taken soon after the Monument's inauguration, and shows a barely urbanized part of the city.

only indirectly, and portrayed negatively, on the monument dedicated to Cuauhtémoc.)

Engineer Francisco M. Jiménez and sculptor Miguel Noreña (1843–1894) won the competition in 1877 for the Monument to Cuauhtémoc, though it took a decade to complete (the monuments to Hidalgo and Juárez would not be finished until 1910). Like the backdrops in history paintings, Jiménez's base combines Classical and pre-Hispanic elements, including decorative patterns from Mitla, a ruin in Díaz's home state of Oaxaca (page 157). Bronze reliefs showing *Cuauhtémoc Brought Before Cortés*, by Noreña, and *The Torture of Cuauhtémoc*, by Gabriel Guerra (1847–1893), underscore the leader's tragic fate, but Noreña's crowning statue shows the tlatoani as triumphant. The figure is at once familiar yet exotic, civilized yet aggressive. He wears a nominally pre-Hispanic costume, though poses in the manner of a Greco-Roman god; he clutches a scroll with Cortés's (rejected) peace offering in one hand while wielding a spear with the other. The decision to embody the Aztec past in Cuauhtémoc was not surprising. Unlike his predecessor, Moctezuma II, Cuauhtémoc had resisted the invasion and thus served—like Vilar's uncast *Tlahuicole* of 1851 (page 171), and like General Díaz himself—as a paragon of local (indigenous) opposition to foreign intervention.

The other major neo-Aztec monument erected during the Porfiriato (apart from a monument to Juárez in Oaxaca, of 1894) was also meant to embellish a public space frequented by tourists. Beginning in 1876, Mexico participated in almost all the

major world's fairs held in Europe and the United States; in 1889, the Díaz administration invested heavily in the Mexican pavilion for the Exposition Universelle, held in Paris. Participants were asked to build pavilions in a "national" style, and the Ministry of Economic Development funded what became known as the Aztec Palace; one of the larger national pavilions, it was positioned just steps from the Eiffel Tower.

Construction engineer Antonio M. Anza and historian Antonio Peñafiel (1830–1922) won a competition for the design, although their work was mainly confined to the facade; a French firm was responsible for the skeletal iron interior. Like a flashy poster competing among dozens in a travel agency, the Aztec Palace was designed to stand out from the other pavilions, including many that used local forms, such as pagoda roofs, minarets, and Moorish arches. The sloping profiles, central (though non-functional) stairway, and imagery on the stamped zinc panels were partly inspired by Peñafiel's own excavations at Xochicalco, although the crisp lines also recall Castañeda's neoclassical drawing of Mitla. But the main

131 Antonio M. Anza and Antonio Peñafiel, Aztec Palace at the Exposition Universelle, Paris, 1889.

This period photograph shows the recently completed Mexican pavilion with a newly planted cactus garden in front; the main entrance was on the ground level, to the left. The building was destroyed after the fair, but Contreras's bronze panels were shipped back to Mexico. Some were installed on the neo-Aztec Monument to the Race (Luis Lelo de Larrea) in 1940.

decorative program was assuredly Aztec, from the prominent solar disk set over the central portico to the bronze reliefs showing Aztec leaders and gods on Peñafiel's colorful exterior; these were made by Jesús Contreras (1866–1902), a graduate of the Academia de San Carlos then living in Paris.

The dynamic, classicizing poses of the six leaders, including Cuauhtémoc, cast Mexican history in a noble guise. The six deities in more static positions loosely referenced the displays inside the pavilion, which gave visitors commercially useful information on Mexico's resources, industry, and educational system. A section on art and architecture, curated by Velasco, included Gutiérrez's *Senate of Tlaxcala* (page 179) and a model of the new Monument to Cuauhtémoc. These images echoed the historicist exterior, while Velasco's *Valley of Mexico* (page 186), and *Metlac Ravine* (page 188), among other paintings, provided a backdrop to exhibits of natural resources and technology.

The Aztec Palace only seemed exotic; in reality, it was a fully modern building constructed at a time when Beaux-Arts eclecticism allowed architects to dress a frame in any style, and intended as an equal competitor at a world's fair where the goal was to obtain the investments and immigration that would increase economic growth. The building was also part of a sophisticated propaganda campaign to show that Mexico's supposed "barbarism" (whether of the Aztecs or the Liberals who had executed Maximilian) was an illusion: the true Mexico, like the interior of the pavilion, was civilized and prosperous.

In the last two decades of the nineteenth century, the aging professors in the Escuela Nacional de Bellas Artes continued to promote an academic realism in which neoclassical clarity was invested with Baroque effects of color and lighting. Such details as botanical specimens, period costumes, or archaeological references were rendered with ever-greater verisimilitude, while the compositions (whether in painting or sculpture) remained idealized and moralizing, far removed from social, ethnic, or political realities. Painters were immune to the gritty and socially concerned realism of the French painter Gustave Courbet—to say nothing of the formal experimentation of the Impressionists and Post-Impressionists—until just after the turn of the century.

Scenes from Aztec history remained vital in promoting national identity. A competition of 1889, for example, called for painters to represent the foundation of Tenochtitlan, a rather

132 Leandro Izaguirre, *The Torture of Cuauhtémoc*, 1893.

For audiences in Chicago, the story of Cuauhtémoc would have been familiar from the pages of William Prescott's bestselling *The History of the Conquest of Mexico*, published in many editions beginning in 1843. Despite Izaguirre's quest for realism, the throne Cuauhtémoc sits on is carved with Maya glyphs.

bucolic myth of origins that confirmed the centrality of Mexico City. Later in the century, painters depicted more gruesome and dramatic scenes, even showing human sacrifice.

In *The Torture of Cuauhtémoc* by Leandro Izaguirre (1867–1941), the Spanish burn the handsome emperor's feet in an unsuccessful attempt to learn the location of hidden treasure. This story originated after Independence, when it resonated with modern patriots who had similarly resisted the Spanish Crown. Guerra had already addressed the subject on the Monument to Cuauhtémoc, but this mural-sized painting, specially commissioned for the World's Columbian Exposition of 1893, held in Chicago, was intended to thrill international audiences; although sources indicated the event had occurred in a patio, the artist placed it indoors to heighten the drama. Such a melodramatic rendition of Cuauhtémoc might also be seen as a form of state propaganda, meant to distract viewers from an undeniable reality: the Porfirian government hardly needed to be tortured to release the nation's wealth to foreigners.

In 1890, all pre-Hispanic ruins were placed under federal jurisdiction as part of the government's ongoing attempt to control the past and its meanings, and to help create a greater

sense of a nation unified by a specific indigenous past. But whether in paintings, monuments, or museums, the preservation of ancient treasures not only concealed Porfirian economic policy, it also diverted attention from living indigenous populations in the country.

In Indian villages, communal lands (*ejidos*) were subject to privatization under the same Reform Laws that had broken up Church properties in the 1860s. Meanwhile, the rebellious Yaquis and Maya were being decimated through military campaigns or enslaved on haciendas: as if to underscore the distance between artistic fantasies and living realities, one of the displays in the Aztec Palace was the trophy head of an Apache captured by the Mexican army. Even pacific Indian groups were denied access to education, running water, or political power, despite their rights of citizenship.

Notwithstanding limits on the press, political cartoonists prospered during the Porfiriato, which tolerated some—but not all—adverse political commentary. It is here that we find an alternative vision of Mexican history. Some of the main caricaturists—including Daniel Cabrera (1858–1914) and Jesús Martínez Carrión (1860–1906)—studied briefly at the ENBA, but ultimately rejected the academicians' complicity with the regime. Cabrera was the director of *El Hijo del Ahuizote* (1885–1903), the most important illustrated periodical during the Porfiriato, founded in opposition to the conciliatory and pro-development "Liberals" then in office.

After 1889, several images in the magazine exposed the link between nationalist homages to the Aztec past and Díaz's authoritarian rule. In one cartoon, General Bernardo Reyes offers the heart torn from a Yaqui to a false idol whose name conflates Don Porfirio with Huitzilopochtli, the Aztec god of war and human sacrifice, all in the name of "patriotism." The artist here—probably Cabrera or Martínez Carrión, but the image was unsigned for fear of arrest—reasserts the racial heritage that Díaz, a dark-skinned mestizo from Oaxaca, downplayed in his official portraits, but also

133 Unidentified artist, *An Offering to Porfiriopoxtli*, from *El Hijo del Ahuizote*, vol. 15, no. 731 (April 29, 1900).

The name of *El Hijo del Ahuizote* (The Son of the Ahuizote) paid homage to an earlier anti-Díaz publication. The *ahuizote* (from the Nahuatl for water-dog) is an Aztec mythical creature, but the term also refers to an "annoying person" or "pest."

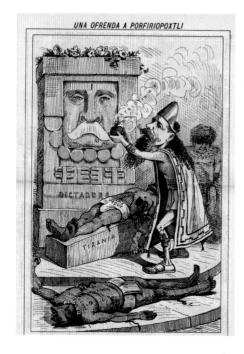

UNA OFRENDA A PORFIRIOPOXTLI

134 José Jara, *The Wake*, 1889.

The setting here is a rural church or chapel: the chipped walls, Baroque painting, and gilded retablo (barely visible to the right) lock the Indians' Catholicism in the past. Jara's painting won a bronze medal at the Exposition Universelle of 1889.

135 Carl Lumholtz, *Felipe, principal maker of idols among the Huichol*, 1890.

The Swedish ethnographer Carl Lumholtz explored mountainous northwestern Mexico from 1890 to 1910, under the sponsorship of the American Museum of Natural History. A version of this photograph was published in his *Unknown Mexico* (1902), a popular travel account.

exposes the cynicism of a nation that destroyed its own Indians while paying homage to its Indian past.

Living indigenous people rarely appeared in official art during the Porfiriato, although José Jara (1867–1939) created a few notable exceptions. The respectful atmosphere of his painting *The Wake*, entitled "Funeral of an Indian" when shown in Paris in 1889, might seem an advance—at least over Beaucé's depiction of exotic "foreigners" (page 174). The monumental quality of the picture asserts the Indians' worthiness as a subject. Yet theirs is a dark world, barely penetrated by light, burdened by Catholicism, marked by a passive acceptance of fate, and even, as one critic said—noting the exposed feet of the corpse—distasteful. Contemporaneous photographs that presumed to anthropological accuracy sometimes made Indians seem timeless residents of a primitive world, confirming the idea that these people were a drag on national progress, wholly separate from the nation. This was especially apparent in the photographic illustrations that accompanied the pioneering studies of rural Mexico by anthropologists Carl Lumholtz (1851–1922) and Frederick Starr (1858–1933).

The existence of a large indigenous population in Mexico, however, could not be denied. The emerging discipline of cultural anthropology would provide a solution to what had long been termed the "Indian problem," with scholars arguing that poverty or other social ills formerly ascribed to immutable racial characteristics were actually determined by political and social factors; these problems, therefore, could be remedied through state interventions, especially in education and increased hygiene. By 1910, such theories were finding increasing support in Mexico through the writings of Franz Boas, director of the Escuela Internacional de Antropología y Etnografía Americana (1916–20), and later, his student Manuel Gamio. As an official policy, *indigenismo*—a positive valorization of indigenous culture—would profoundly shape the arts in the second decade of the twentieth century and beyond.

II. An Imported Modernity

Modernity in Mexico was first and most visibly signaled by the changing face of the capital. Economic prosperity in the late Porfiriato triggered a building boom, as well as urban expansion due to migration from rural areas. These changes further divided the city: neighborhoods with modern infrastructure were increasingly distinct from growing slums, where the mortality rate was twice that of Buenos Aires or Rio de Janeiro. By contrast, the Paseo de la Reforma and new buildings near Alameda Park formed a discontinuous yet shining theatrical set that gave one the illusion of living in a modern city.

The neo-Aztec Monument to Cuauhtémoc was an exotic outlier in a city that ultimately privileged European models for buildings. This should not be surprising, since elite patrons were eager to prove that they were as cosmopolitan as their counterparts in other world capitals. In 1884, José Ramón Ibarrola (1841–1925) designed a neo-Moorish structure inspired by the Alhambra for the New Orleans World Cotton Exposition (it was later reinstalled in Mexico City). But in most state-sponsored painting and architecture at the turn of the century, exoticism gave way to standardized, even international, Beaux-Arts design. At the Paris Exposition of 1900, for example, the same engineer who had built the Aztec Palace created an overblown neoclassical pavilion.

The chief civic buildings of the late Porfiriato were clustered towards the eastern side of the Alameda Park, on lands "liberated" from religious institutions through the Reform Laws. Some new structures outside of this central zone— including a new hospital for the mentally ill, schools, and a geology museum—were designed by Mexican architects, but Europeans were hired for most of the principal buildings, including the Oficina Central de Correos (Central Post Office, 1902–6) and Teatro Nacional (1904–16), both by Adamo Boari (1863–1928); the new Secretaría de Comunicaciones y Obras Públicas (Ministry of Communications and Public Works, 1902–11), designed by Silvio Contri (1856–1933); and an enormous Palacio Legislativo by the French architect Émile Bénard (1844–1929), which never got past the steel frame.

Almost everything about these buildings was imported, except for the cheap labor: US structural engineers were responsible for the foundations and framing; foreign (mainly Italian) sculptors and muralists decorated interiors and exteriors; and precious materials, such as the Carrara marble used for the sculptures and columns on the facade of the Teatro Nacional, or the ornate metal lanterns and stairways forged in Florentine workshops, were brought to Mexico at great expense. (One exception to this European bias was Mauricio de María y Campos's new Cámara de Diputados, or Chamber of Deputies, of 1911, which proudly used Mexican steel for the frame.)

In an orgy of historicism, Boari's Oficina Central de Correos combines elements taken from Spanish Plateresque and Venetian Gothic models; across the street, the Teatro Nacional mixes neo-Baroque Classicism with organic details reminiscent of central European Secessionism. The theater's massing of forms, central dome, projecting statuary, and interior spaces were inspired by Charles Garnier's Paris Opera (1861–75), a symbol of stability and authority during Napoleon III's Second Empire.

Boari adorned the Teatro Nacional with subtle nationalist details, rather like pinning a gold brooch in the shape of the Aztec Sun Stone to the chest of a wealthy Mexican woman dressed by Worth. On the facade, the heads of Aztec coyote and eagle warriors project out from side balconies, and serpents writhe above doorways covered in elegant iron grilles. The fireproof stage curtain is a monumental glass-mosaic landscape featuring the volcanoes Popocatepetl and Ixtaccihuatl, based on a drawing by Boari and fabricated by

136 Guillermo Kahlo, *Teatro Nacional under Construction*, 1911.

Guillermo Kahlo (1871–1941) was a professional photographer particularly skilled in creating crisp shots of architectural exteriors and interiors; he created several luxurious albums for government and corporate patrons. Today he is more famous as the father of Frida Kahlo.

137 Antonio Rivas Mercado, Hacienda de Santa María Tecajete (Hidalgo), 1884.

A pulque boom in the late nineteenth century allowed hacienda owners to renovate their main houses. Like many academic architects of the day, Rivas Mercado could dress a building in any style. Here, the crenellated towers flanking the main entrance are punctuated by decorative yet intimidating gun slots.

Tiffany Studios in New York. Left unfinished during the Revolution, the theater (now renamed the Palacio de Bellas Artes) was completed by Mexican architect Federico Mariscal (1881–1971) in 1934. The up-to-date art deco interior features walls of dark-red and black marble, studded with pre-Columbian masks in polished bronze.

The architectural transformation of Mexico City was echoed in the provinces, from the ornamented Classicism of Oaxaca's Teatro Macedonio Alcalá (1903) to Guanajuato's iron-framed Mercado Hidalgo (1910). Architectural eclecticism can also be found in the facades of pulque haciendas of Central Mexico and the sisal haciendas on the Yucatán, later additions that transformed rather nondescript colonial-era structures into turreted castles, neo-Gothic palaces, and romantic *chateaux*.

The resplendent interiors of the new civic buildings included the first major secular murals painted in Mexico: underscoring the cosmopolitanism of the architecture, allegorical modes were privileged over historical scenes. Given the relative lack of major building campaigns until late in the century, most previous murals in Mexico had been commissioned for religious spaces, including those by Rafael Ximeno y Planes (page 147) and Juan Cordero. Among the rare exceptions were Santiago Rebull's bacchantes—dancing figures rendered in what was called a "Pompeian style"—commissioned by Maximilian for the corridors of the Castillo de Chapultepec in 1865, and Cordero's *The Triumph of Knowledge and Work over Envy and Ignorance* (1874; destroyed 1900), a small mural in the Escuela Nacional Preparatoria (National Preparatory School).

Unlike the *costumbrista* murals on some rural haciendas, these official works barely include Mexican subjects, despite overarching references to national prosperity. For the Palacio de Comunicaciones, which housed the government ministry responsible for railways and telegraph lines, Contri contracted artisans at a famous Florentine firm run by the Coppedè family to create the ornate neo-Renaissance interiors. Oil-on-canvas murals in public areas of the building include inevitable allegories of Peace, Progress, Art, and Labor. Over the grand staircase, a Mexican farmer appears plowing his field; in general, however, the iconography features fair-skinned performers in a Classical arcadia, identical to their counterparts in any number of public buildings in Europe, the US, or South America.

138 Alberto Fuster, *Allegory of Peace*, 1903.

Among Classical gods and allegorical figures—Painting occupies a central position on the stairway—one figure stands out: even without the flag, the woman with hair braided in the indigenous manner and a rebozo draped over her arm is easily identified as Mexico.

139 Saturnino Herrán, *Allegory of Construction*, 1910.

This preparatory oil sketch for the left half of a mural-sized diptych, installed in 1911 in a men's trade school in the capital, is one of the first powerful representations in Mexico of the modern worker. Herrán emphasized the musculature of the healthy laborers, from a man decorating ceramics to another carrying a huge stone.

In the ENBA, Mexican artists also engaged in escapist and even sycophantic fantasies that demonstrated their allegiance with the regime. The most ambitious was surely the *Allegory of Peace* by Alberto Fuster (1870–1922), an assemblage of neoclassical muses and gods crammed onto an enormous canvas. Like the weighted exteriors of the Porfirian buildings, the work embodied cosmopolitanism and ratified the political system; not surprisingly, a group of loyalists, including Enrique Creel, Federico Gamboa, and Joaquín Casasus, purchased it as an official gift for Díaz in honor of the centennial in 1910. "Official" art, however, is rarely monolithic. The twin mural panels by Saturnino Herrán (1887–1918) for the Escuela de Artes y Oficios para Varones (Men's School for Arts and Trades), also allegorized the regime, though here embodied in industrious mestizo craftsmen, framed by scaffolds that represent ongoing construction campaigns, and rendered with bravura brushwork and glowing color. More than Fuster's staid academicism, Herrán's workers signal the direction Mexican artists would follow after the Revolution.

In September 1910, an aged Porfirio Díaz marked the centennial of Mexico's declaration of independence from Spain with a complex spectacle framed by new public buildings, the inauguration of more monuments, diplomatic dinners, and a *Desfile Histórico*, a massive parade with floats and costumed participants representing national history since the Conquest. More money was spent on the parade than on the art exhibitions held in conjunction with the Centennial, of which

140 Antonio Rivas Mercado,
Column of Independence,
Mexico City, 1902–10.

Almost 150 feet high, the
structure consists of a steel frame
covered in stone; the sculptures
are by Enrique Alciati (1858–after
1912), an Italian artist who was
then teaching at the ENBA. In an
earthquake of 1957, the bronze
statue of Victory crashed to
the ground, although it was
later restored.

one featured Spanish painting, another Japanese crafts, and a
third—underfunded but most influential for the future course of
Mexican art—a show of younger Mexican artists at the ENBA.

These events were a last spectacular attempt to validate
the sclerotic regime under the slogans of order and progress,
and to reveal Díaz as the undisputed heir to Independence.
Nowhere was the fiction more evident than in the treatment
of Mexico's impoverished indigenous populations. The parade
included Indians brought in from across the country and dressed
in neo-Aztec and traditional costumes, who marched down
the streets looking as if they had just emerged from academic
paintings. Meanwhile, the poorest urban residents, many of
them indigenous themselves, were either hustled away from
the city center or forced to wear modern "European" dress.

The monumental decoration of Reforma accelerated in the
1890s. A *paseo cívico* (or civic promenade), adorned with two
life-size bronze statues of political or intellectual native sons
from each state, plus Mexico City, was planned for the paved
walkways on each side of the avenue, though only thirty-six
were originally installed. Like a single candle on a birthday
cake, the towering centerpiece of the entire program was the
Column of Independence by architect Antonio Rivas Mercado
(1853–1927), topped by a gilded figure of Winged Victory, and
inspired by similar monuments in Paris and Berlin. Unlike 1843,
when de la Hidalga's project for a column honoring Santa Anna
was truncated, now there were no constraints, political or
economic. Marble sculptures of Independence heroes Morelos,
Nicolás Bravo, Vicente Guerrero, Francisco Javier Mina, and
Hidalgo (elevated above the others), are surrounded on a lower
level by bronze figures of Law, Justice, Peace, and War, as well as
a young boy leading a lion, representing, as Rivas Mercado said at
the inauguration, "the People, strong in war and docile in peace."

Both the column and an equally neoclassical monument—a
white marble hemicycle in Alameda Park, designed by Guillermo
Heredia and honoring Benito Juárez—were ready by September.
Commemorative albums were published and the press trumpeted
the regime's victories; the Mexico City Cathedral and Palacio
Nacional sparkled with thousands of electric lights; and only a
few malcontents grumbled about the vast expense. Ironically,
the celebratory events of September 1910 marked the end of
the Porfirian regime; two months later, Francisco I. Madero
initiated the armed revolt that launched the Mexican Revolution.

III. Modernismo *and the National Soul*

Well before the outbreak of the Revolution, several younger Mexican artists had begun to question the positivist rhetoric and centralized power of the Porfirian regime. This was not so much an oppositional political stance—like that of the cartoonists of *El Hijo del Ahuizote*—as an act of personal resistance to the changes wrought by rapid modernization and industrialization, to the supposed triumph of science over religion, to bourgeois materialism, and to official constructions of national identity.

A similar interrogation of modernity, and turn inwards to more aesthetic concerns, gave rise to Symbolism in France; Arts and Crafts in Britain and the United States; and Art Nouveau in France, Belgium, and Catalonia. In much of the Spanish-speaking world, the movement—which subsumed many of the ideas circulating elsewhere—was known as *modernismo,* a term that asserted one's modern condition even as it challenged the impact of modernization (the word cannot be directly translated, since in English "modernism" implies an aesthetic embrace, rather than rejection, of technology and industrialization.) In Latin America, this was initially a literary phenomenon, launched by the Nicaraguan poet Rubén Darío in 1888 and quickly disseminated through Spanish-language literary magazines.

The *modernistas* stressed subjectivity and spirituality; not surprisingly, modernismo thus describes a state of mind rather than any one stylistic language. In Mexico, younger artists increasingly rebelled against the conservative rules of the Academia. They chose from a variety of avant-garde styles, particularly Symbolism and Post-Impressionism, that might better address their more introspective and emotional concerns, from the pursuit of beauty to the fear of death. These artists were also marked by a radically new sense of self-identity: they increasingly saw themselves as marginalized visionaries rather than confident propagandists.

Modernismo is most evident in the fields of literature and the fine arts, though one can also trace its impact in architecture. Rather than the Beaux-Arts eclecticism of Boari and Contri, the most notable modernista buildings in Mexico City are the delicate Art Nouveau facades by Catalan architects in the new Colonia Roma—laid out in 1904—and the

extraordinary interiors of the Casa Requena (1901–12; later dismantled and moved to Chihuahua), with pansy-shaped chairs and cabinets in the form of spiraling vines, carved by a master named Pomposo after designs by Ramón P. Cantó.

The modernista work of Jesús Contreras emblematizes this profound shift in aesthetic values, and is a key example of the initial phase of modernismo, in which Mexican artists pursued cosmopolitan rather than local themes. After completing the Aztec gods and leaders for the Mexican pavilion in 1889, Contreras returned to Mexico City, where he set up an artistic foundry with government support. There he produced decorative objects, as well as bronze statues installed along Reforma and in several provincial cities. By the end of the 1890s, however, Contreras had turned his back on neoclassical ideals. In works like *Malgré Tout*, he revealed his debts to Auguste Rodin, as is evident in the work's juxtaposition of smooth flesh and rough stone, the eroticized female body, and the open-ended symbolism of the subject itself. (As was typical, Contreras's marble sculptures were generally made by professional stone carvers after his clay originals.)

141 Jesús Contreras, *Malgré Tout*, 1897–98.

Many Mexican sculptures of this period include titles written in French, underscoring the cosmopolitan sophistication of both artist and patron. The phrase here can be translated as "In spite of everything."

For most of the nineteenth century, nude women—whether as live models or artistic subjects—were absent from the Academia de San Carlos. But the modernistas now employed the female body as a site for the metaphoric depiction of personal suffering and moral decadence—in sharp contrast to the upright masculinity of so many militaristic heroes cast in bronze, and also to the angelic housewives and mothers featured in academic genre paintings (page 197) and women's magazines. Rather than a hero or saint, Contreras's *Malgré Tout* depicts an idealized and ahistorical slave who, despite being stripped, shackled, and chained, lifts her head with stoic resistance, allowing the viewer to empathize. Other Rodinesque works by Mexican sculptors of the period lack this moralizing tone. Their sexually charged titles (one is called *After the Orgy*) and revealing poses remind us that such works were not only poetic social metaphors: they titillated privileged male viewers with glimpses of the forbidden.

As we have seen, for much of the nineteenth century, illustrated magazines, such as *La Orquesta* and *El Hijo del Ahuizote*, were as vital as academic paintings in creating visual records of the political and social concerns of Mexico City elites. For the modernistas, magazines became even more crucial arenas for cultural critique. The *Revista Azul* (1894–96), named in honor of an influential book of poems by Rubén Darío, was succeeded by the aptly titled *Revista Moderna* (renamed the *Revista Moderna de México* in 1903), which ran from 1898 to 1911. Edited by Jesús E. Valenzuela, this was the most important publication of the day, running poems by Mexican and Latin American writers alongside translations of Verlaine and Poe. The illustrations, however, were almost exclusively by Mexican artists.

The art editor of the *Revista Moderna* was Julio Ruelas (1870–1907), who had barely attended classes in the ENBA before leaving to study in Karlsruhe, Germany, in the early 1890s. His work relates more to that of the European Symbolists, including Max Klinger and Félicien Rops, than to anything by his Mexican contemporaries. Ruelas produced numerous ink drawings for the *Revista Moderna*, usually small vignettes that echoed rather than illustrated the articles and poems they accompanied. Classical fauns and gods, medieval knights and princesses, courtesans and monks, all inhabit a world that is anti-rational, pre-modern, and definitely not Mexican. Many

drawings explore the psychic frontiers between pleasure and vice, or eroticism and violence. Networks of organic Art Nouveau lines often serve as decorative frames that underscore a sense of entrapment. Ruelas seems to revel in the free depiction of transgressive acts criminalized by bourgeois laws and social norms. Such behavior was tolerable only when hidden—whether in the pages of an elite magazine, or in the brothels on the Calle Cuauhtemotzín in downtown Mexico City.

Ruelas's *The Critic* embodies the modernista self-image of the artist as both visionary and victim. The critic—wearing a top hat and garters, clutching a folded newspaper, and radiating electrical charges or noxious vapors—perches atop a self-portrait of the artist. Neither animal nor human, this perverse little hybrid is a perfect Symbolist metaphor for the tortures artists face when misunderstood by their critics. But Ruelas also asserts his own critical agency, by exposing the hypocrisy (and, perhaps, kinky behavior) of this supposed defender of traditional values. Like Contreras, Ruelas died in his thirties, as if following an established prototype for the suffering *fin-de-siècle* artist. Jesús Luján, a wealthy hacienda owner who was chief patron of the *Revista Moderna*, commissioned one of Contreras's young followers, Arnulfo Domínguez Bello (1886–1948), to sculpt a monument for Ruelas's grave in Montparnasse.

142 Julio Ruelas, *The Critic*, 1906.

Ruelas studied etching and engraving in Paris. His personal prints were independent works of art to be admired for their own sake, unlike earlier Mexican lithographs, which had catalogued types and landscapes in bound portfolios.

If the most critical aesthetic reactions to modernization played out first in the pages of Mexico's literary magazines, reforms taking place in the Escuela Nacional de Bellas Artes would increasingly open the classrooms to more modern approaches to the making of art, eventually breaking the emphasis on drawing established in the 1780s. In 1903, Justo Sierra, the Minister of Public Instruction and Fine Arts, named Antonio Rivas Mercado the first new director in a quarter century. Rivas Mercado renovated the facilities and modernized the curriculum and faculty. One of those he welcomed was Gerardo Murillo (1875–1964). Just back from Rome, Murillo's radical aesthetic and political ideas, including anarchism and syndicalism, were essential to the development of muralism after 1920. (Inspired by the same intellectual milieu that gave birth to Futurism as well as fascism,

however, his ideas turned increasingly reactionary after the 1920s.)

The younger students, encouraged by Murillo and cognizant of the fresh aesthetic ideas circulating in Europe, were increasingly dissatisfied not only with the elderly professors, including Velasco and Rebull, but also with the supposed reformers, Rivas Mercado and his subdirector, the Catalan painter Antonio Fabrés (1854–1938). For the more radical students, Rivas Mercado was a científico closely allied with the regime, while Fabrés practiced an outmoded style that echoed the neo-Baroque realism of Ernest Meissonier. Even though Rivas Mercado and Fabrés fought over personal differences, they had introduced a strict drawing method and reliance on photography that suggested an

143 Germán Gedovius, *Interior of the Sacristy at Tepotzotlán*, 1906.

Gedovius studied in Munich, but by 1903 he was back teaching at the ENBA, where he trained a generation of rather conservative women artists. This painting was a gift to Justo Sierra, the Minister of Public Instruction, affirming the continued bonds between the academic system and the Porfirian regime.

144 Dr. Atl (Gerardo Murillo), *Night*, c. 1911–14.

In 1911, Gerardo Murillo adopted the name Dr. Atl (*atl* means water in Nahuatl), a nationalist and mystical gesture. This print was published with the artist's hymn to the volcano that read, in part, "Out of a vital need, I have sought to replenish my strained muscles in its electric emanations."

outmoded grasp at realism at a time when "realism" seemed irrelevant. These tensions resulted in a strike by the more radical students in 1911, and Rivas Mercado's resignation the following year. For the rest of the decade, in fact, the ENBA would be rattled by the wider political Revolution beyond its walls.

Between 1900 and 1920 one finds increasing stylistic and thematic diversity, both within San Carlos and in works by artists who had trained and practiced outside its domain, including the late Impressionist Joaquín Clausell (1866–1935), and a few painters from Guadalajara: Jorge Enciso (1879–1969), José Luis Figueroa (1896–1985), and Amado de la Cueva (1891–1926), the latter a member of the Centro Bohemio, an important nexus of avant-garde ideas in that city. Painters adopted idiosyncratic styles: some chose Pointillism and other post-Impressionist modes, others selected compositional and stylistic elements inspired by Japonisme, Aestheticism, or Symbolism, later followed by a smattering of Futurism and Expressionism, as if in a free-for-all rush to assimilate decades of European pictorial innovation almost at once. Near the end of his life, even Velasco—who ignored the Impressionism he saw during trips to Paris—created timid Symbolist landscapes showing flocks of sheep, though marked by a religious faith few modernistas shared.

From our vantage point, what seems most important about these diverse works is less their style than their subjects, which, despite a moodiness typical of modernismo, become increasingly nationalist: they locate Mexican culture in rural landscapes, viceregal churches, and traditional customs, all explicitly distinct from the cosmopolitan city. This reflects vocal calls by Mexican intellectuals for paintings with national imagery, such as the volcanoes. Murillo's nocturnal view of Ixtaccihuatl, printed in Paris, is experimental in both form and composition. In the face of the scientific and hyper-nationalist panoramas by Velasco (or in the Teatro Nacional), the only possible response seemed to be the intimate fragment. In later years, Murillo—now known as Dr. Atl—became Mexico's preeminent landscape painter, though his visually spectacular works, rendered in a waxy experimental medium he called Atl Colors, seem somewhat conservative in comparison to his early prints and Futurist-inspired abstractions.

Modernista melancholia also infects numerous paintings of colonial churches, fountains, and patios, almost always shown

abandoned. After being scorned, torn down, and ignored by artists—except Velasco (page 184)—for much of the nineteenth century, the nation's viceregal past was increasingly the subject of study. In the ENBA, Jesús T. Acevedo (1882–1918) and Nicolás Mariscal (1875–1964) encouraged their architecture students to look to the Mexican Baroque as a source of inspiration for a "national" style, though it would take some time for actual buildings to be funded.

For some modernistas, Mexico's "Hispanic" heritage—including the racial and cultural blending forged during the colonial period—provided a potent spiritual alternative to technological anonymity and the hegemony of the United States. In his interiors of secularized Mexican monasteries, Germán Gedovius (1866–1937) used the past to tell of the present. These abandoned rooms of studious friars might allude to the fragility of learning in times of rapid change; rather than nostalgia for a more stable viceregal epoch, they emphasize irretrievable loss.

Of all the painters associated with the Academia de San Carlos, none better expressed the contemporary modernista spirit, nor more clearly laid the foundations for the future of modern Mexican art, than Saturnino Herrán. Born in Aguascalientes, Herrán relocated—as did many ambitious artists—to Mexico City; he entered the ENBA in 1904 but never left for study in Europe. He created an extraordinary body of work during a decade marked by dramatic change, only to die in 1918 at age thirty-one, younger even than Ruelas or Contreras, before the Revolution had run its course. Had he lived, there is little doubt that he would have achieved the fame of his most competitive rival, Diego Rivera (1886–1957).

Herrán's *Legend of the Volcanoes* of 1910 might be considered the last major history painting of nineteenth-century Mexico, or the first great one of the twentieth century. The winning entry in an academic competition that required students to render any subject in a triptych format, the painting fuses diverse genres, including allegory, history, and landscape, deploying the sensual nudes of such sculptors as Contreras in the service of nationalist identity. Unlike Izaguirre's *Cuauhtémoc* (page 203), Herrán's indigenous subjects are not resurrected archaeological heroes denoting political morality, but contemporary symbols infused with universal themes dear to the modernistas: passion, suffering, and tragedy.

145 Saturnino Herrán, *The Legend of the Volcanoes*, 1910.

A translation of the inscription reads: "The legend tells of a white princess who loved an Indian prince with infinite love. Her father, a severe old man, formed his rebellious daughter into a mountain. And the tears of her lover ran unstoppable before the clearly defined peaks that forever would guard the princess's soul."

Herrán portrayed an Aztec myth that explained the origin of the volcanoes in human rather than geological terms. This was a Romeo-and-Juliet tale of a rude warrior and refined princess who were forbidden to marry by the girl's father; after dying in grief they were transformed into mountains, the dormant female (Ixtaccihuatl) forever accompanied by the active male (Popocatepetl). In the painting, the lovers' bodies literally become as green as ice. But Herrán reinterpreted the tragic story using race, rather than social class, as the barrier to union, in order to allude to an equally tragic national narrative: the resolution of the "Indian problem" through cultural and racial mestizaje—which would bring marginalized populations into the political and cultural mainstream—was being thwarted by the "old man" (Díaz). Only five years later, in a mural cycle for the Teatro Nacional (page 229), Herrán took a more optimistic stance.

Y...las lagrimas del amante corrieron
manotables ante la nitida cumbre
que por siempre guardaría el alma de la p...incesa

Herrán was one of the first Mexican artists to represent
urban and rural workers in a sustained manner, neither
romanticizing them nor resorting to moralizing clichés, as
had genre painters in the nineteenth century. By 1910,
younger Mexican painters and sculptors began to depict
Mexico City's lower classes with greater sympathy: in part
reflecting the impact of Fabrés, who had used real workers
as models in the life-drawing classes, and encouraged
students to depict working-class subjects based on direct
observation. The search for national identity in the nation's
workers, indigenous or mestizo, was also much discussed
in the magazine *Savia Moderna* (1906)—its title implied
that "new sap" needed to flow in Mexico's cosmopolitan
literature—and the Ateneo de la Juventud, an association
of writers and artists founded in 1909.

The two other major submissions to the same triptych commission won by Herrán in 1910 featured modern Mexican workers, as did Herrán's murals for the Escuela de Artes y Oficios (page 210). But the decision to focus on local types—including Indians in more traditional dress—in pursuit of the national soul was inspired by artists in Spain, including Joaquín Sorolla y Bastida and Ignacio Zuloaga, whose works had been featured in the exhibition of Spanish painting held during the Centennial. Indeed, the dark atmosphere and loose brushwork of Herrán's *The Offering* are particularly reminiscent of Zuloaga's depictions of the Spanish peasantry. While Mexican artists working abroad—including Diego Rivera, Roberto Montenegro (1885–1968), Alfredo Ramos Martínez (1875–1946), and Angel Zárraga (1886–1946)—depicted muscular Mallorcan fishermen, Andalusian matrons, and devout Breton women as embodiments of honest and earthy "modern" values, it was Saturnino Herrán—and, to a lesser extent, Gedovius and Ramos Martínez—who captured their Mexican counterparts in the years before 1920.

In *The Offering*, one of his most ambitious compositions, Herrán shows a family bringing bundles of *cempasúchil* (marigolds) to market for use in offerings on the Day of the Dead, the first major representation of this Mexican

146 Saturnino Herrán, *The Offering*, 1913.

celebration in painting outside of the still life genre. We seem to be on the banks of the canal, observing the family at close range. Their costumes mark them as mestizos, though the cultural allusions here extend back to the Aztec past. Herrán's urban workers pull and push with force, but his rural figures are generally more stoic, often posing in traditional costumes, sometimes shown as blind or with their eyes closed—not yet the powerful builders of a new regime.

After Rivas Mercado left the ENBA, the government of dictator Victoriano Huerta named Alfredo Ramos Martínez as the new director, following the demands of the students. In 1913 Ramos Martínez set up what he called an Escuela de Pintura al Aire Libre (Open Air Painting School), a sort of satellite classroom in a house near the village of Santa Anita. Herrán may have painted *The Offering* near here; other artists who became prominent in the 1920s, including David Alfaro Siqueiros (1896–1974), worked in Santa Anita, perfecting their Impressionist or post-Impressionist techniques. Santa Anita was more than an anti-academy; it represented a retreat from the congested urban center at a time when the political situation was spinning out of control.

With the fall of Huerta in the summer of 1914, Ramos Martínez was dismissed and his place taken by the far more radical Dr. Atl, though the Revolution would quickly send Atl and his friend José Clemente Orozco (1883–1949) out of the city, leaving San Carlos to fall back into the relatively conservative hands of some older modernistas. But the real protagonists were the workers—peasants and Indians—who would soon appear in Mexico City, not on the walls of painting exhibitions, but armed and angry in the armies of Francisco Villa and Emiliano Zapata.

IV. Art during the Revolution

During the Mexican Revolution (1910–20) the Escuela Nacional de Bellas Artes never fully closed, but the art world was in disarray, with patronage systems disrupted. Most artists observed the war from the sidelines, but a few actually fought in the Revolution; depending on who was in control where and when, an artist might be a political activist or be sent into exile. And of course, many others were living abroad. Because there was no powerful federal government or army to commission

official "war art," the Revolution itself would not be the subject of much painting or sculpture until after the conflict was over. Instead, it was visualized in countless prints, political cartoons, and photographs.

The two leading image-makers of the Revolution, at least from a *post*-Revolutionary perspective, were the printmaker José Guadalupe Posada (1852–1913) and the photographer Agustín Víctor Casasola (1874–1938). Both established their careers during the Porfiriato working for bourgeois pro-Díaz periodicals, both formed part of complex production and distribution networks, and both produced vast numbers of images, generating a discourse based on particulars rather than grand, overarching themes. The two were documentarians engaged with their moment, whose lives and images were later mythologized in the service of national identity.

Around 1888, Posada moved to Mexico City and joined a printer's shop run by editor Antonio Vanegas Arroyo. Posada contributed illustrations to broadsides, chapbooks, and other cheap publications, while others wrote the texts. Partly inspired by Manuel Manilla (1830–1895), his immediate predecessor in the shop, Posada developed a distinctive visual style that reveals some familiarity with European popular prints and even US comic strips. Although he sometimes drew portraits of historical figures and upper-class types in a more representational manner, Posada economized in his depictions of the lower classes, which became his dominant subject, using strong wiry lines and reducing shading effects. In part this may have been practical: Posada had to satisfy his editor's demands for relief prints that could be cheaply and quickly produced, set

147 José Guadalupe Posada, *The Comet of the Century of Independence*, 1899/1910.

The apparition of Halley's Comet in 1910 coincided with the Mexican Centennial. For a broadside issued to mark the occasion, Posada reused two plates he had created in 1899 depicting a different comet. This particular image pokes fun at popular beliefs that the comet's tail would set fire to the city.

148 José Guadalupe Posada, *Calaveras of the Masses, Number 2*, 1910.

This broadside was produced after November 20, 1910, when Francisco I. Madero called for an armed insurrection against the Díaz regime. Madero assumed the presidency of Mexico in October 1911, several months after the resignation of Díaz. He was assassinated during a military coup led by Victoriano Huerta in February 1913.

Pasé por la primavera
Y me llamó la atención
El ver una calavera,
Que trajeron del panteón.
Daba pena y tentación,
Mirar que pelaba el diente
Era el dueño, el patrón;
Oh sin duda el dependiente.

Al otro lado un empeño
Mucha fué la admiración,
Tendido estaba su dueño,
Y con velas el cajón.....
Este que fué empeñero,
Robaba sin compación
Que por amar el dinero;
Calavera es del montón.

Adelante el carnicero
En la mano su morcón,
Mas allá el tocinero;
Con su hediondo chicharrón
Estos pronto se murieron
Y se fueron al panteón,
Calaveras se volvieron;
Calaveras del montón.

En la esquina un pulquero
Tomando de compromiso,
Al otro lado del piso
Le acompaña un jicarero.
Brindo porque le quiero
Decía con amor profundo.....
Hoy calavera es el primero,
Y le acompaña el segundo.

El vicioso zapatero
Que alegre se emborrachó,
Por andar de pendenciero;
Hasta la zuela perdió.
En la calle se pelió
Pues insultava á cualquiera,
Otro como él lo mató
Y ahora ya es calavera.

Han corrido mala suerte
Los ambrientos peluqueros,
Ya se los llevó la muerte;
A tóditos por entero.....
Se volvieron peluqueros
Sentados en un sillón,
Y como estan tan fieras;
Los quemó la cremación.

No corras tanto Madero
Deten un poco tu trote,
Porque con ese galope,
Te volviste narangero.
Ya no corras......detente
Acorta ya tu carrera,
Que te gritará la gente;
¡A que horrible calavera!

Madero, en esta ocasión
Es mucho lo que has corrido
Perdistes ya la razón,
Y en muerte te has convertido.
Ahora tu filiación
La tiene el nuevo partido;
Tu calavera han metido,
Al horno de cremación.

Adonde está tu viveza
Millonario y con dinero,
Alza un poco la cabeza;
Y dale vuelta al tintero,
Te llevan á la prisión
Más corriendo que de prisa,
Ya te volvió ceniza......
El horno de cremación,

De tu roída calavera
No queda ya ni pedazos
Al horno fué la primera,
Y se quemó á tizonasos.
Tu huesamenta hecha trizas
La metieron al montón,
Ahora si que ni cenizas;
Recoje la cremación.

Por valiente el panadero
Y por andar de bribón,
Junto con el biscochero;
Tristes calaveras son...
Lo mismo es el dulcero
Y el que vende macarrón,
Uno y otro parrandero;
Calaveras del montón.

Quiero que sepan mi cuita
Porque el gañote me tuerzo,
Si quieren su propinita
No se olviden de este verso....
El decirlo no quiciera
Pues me duele el corazón,
Pero esta pobre calavera,
Los saluda en el montón....

En todas las fiestecitas
Se debe tener cuidado,
Que los crueles motoristas;
A mucha gente han matado.
Que sigan con sus tonteras
Que los espera el panteón
Todos hechos calaveras
Saliendo de la prisión.

Se acabaron los prensistas
No hay encuadernadores,
Se murieron los cajistas;
Ya no quedan impresores.
Con todos los escritores
Bailando la sandunguera,
Se volvieron calavera
En el panteón de Dolores.

Los toreros como sabios
Sufrieron su revolcón,
Vengó el toro sus agrabios
Los mandó para el panteón.
También á los del expres
Y empleados de papelera
Sin brazos, manos ni pies
Los volvieron calavera.

El mundo va á terminar
Por el cólera enfurecido,
Que sea pues bien venido.
Si nos tiene que tocar.
Pues decirlo no quiciera
Me causa desesperación
Porque tenemos que ser
Calaveras del montón;

Imprenta de Antonio Vanegas Arroyo.—2a. Calle de Santa Teresa, número 43—México 1910.

with type, and sustain large print runs (hence he used zinc etching instead of lithography). Posada was also technologically innovative, using photographic processes to facilitate the production of the zinc plates, and sometimes relying on actual photographs as source material.

But the style also satisfied his public. The Vanegas Arroyo shop was mainly known for "penny sheets," illustrated broadsides with texts, often in ballad form, marketed to a popular audience. Here Posada depicted current events with sensationalist verve, featuring violent crimes and executions, natural disasters, and scientific curiosities, such as a pig born with a man's face. Some prints used skeletons to parody political leaders, social movements, and even the production of broadsides in the Vanegas Arroyo shop; these sheets, known as *calaveras*, drew on a long tradition of producing satirical caricatures for the Day of the Dead. The penny sheets were wildly popular; at a time of high illiteracy rates, they were read aloud to the delight of the crowd, like condensed forms of today's tabloids.

Although Posada sympathized with his working-class audience, he also embraced the order and progress ensured by the Porfirian regime and was highly critical of the outbreak of the Revolution, and of its leaders. In one Day of the Dead sheet, Posada shows the landowner and revolutionary Francisco I. Madero as a false leader, masquerading as a poor peasant, a bottle of firewater from his wealthy family's distillery in hand. The anonymous *corrido*, or ballad, criticizes Madero for "running" too quickly, lamenting at one point that "The world will cease because rage has been unleashed." Given the print's obviously satirical tone, it is surprising that it was reused by the Vanegas Arroyo shop on later pro-Madero broadsides.

Posada died in 1913, before the most terrible events of the Revolution. His prints were rediscovered by the French artist and muralist Jean Charlot (1898–1979) and others in the early 1920s, and republished as the "art" of a working-class hero— a construction that edited out his pro-Díaz imagery and his earlier, less cartoonish lithographs—which transformed him into the ideal precursor of the radical artists of the 1920s and 1930s. Rivera and Orozco would remember having been inspired by Posada as young men in Mexico City; in Rivera's case, this was surely a retrospective invention. Posada also played a posthumous role in the Surrealist movement, when his most bizarre images were embraced by André Breton in the 1930s.

A half-century after the execution of Maximilian, war photography had emerged as a powerful and ubiquitous genre. Apart from World War I, no conflict of the early twentieth century was so extensively photographed as the Mexican Revolution. Technological limitations put restraints on the representation of major battles, but photographers captured every other aspect of the war, from the lighthearted to the grisly: spectators in El Paso watching the fighting across the river in Ciudad Juárez in 1911; US troops posing during the invasion of Veracruz in 1914; the corpse of General Venustiano Carranza—who had been elected president after the Constitutional Convention of 1917—after his assassination in 1920. Some images followed longstanding aesthetic conventions for representing power and conflict; others showed leaders in more candid poses, or featured the dreary everyday life of the troops. Many reminded viewers of war's ever-greater modernity, and increasingly gruesome brutality.

Scores of photographers hailed from the United States, producing images that could be sold to news agencies or printed in the form of postcards for the US forces billeted along the border. Mexican photographers were equally present, whether assigned to newspapers or working as semi-official propagandists for different military caudillos. Of them all, however, Agustín Víctor Casasola emerged in the immediate post-Revolutionary period as *the* photographer of the conflict,

149 Archivo Casasola (Manuel Ramos), *Villa in the Presidential Chair*, 1914.

This image was taken on December 6, 1914, in the Palacio Nacional, soon after a coalition of anti-Huerta forces had taken Mexico City. Revolutionary leaders Tomás Urbina, Francisco Villa, Emiliano Zapata, Otilio Montaño, and Rodolfo Fierro pose under a military painting. A leader of peasants wary of the trappings of power, Zapata famously declined to sit in the presidential chair.

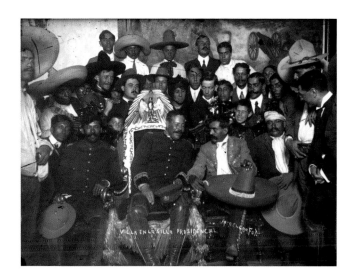

150 Archivo Casasola (Gerónimo Hernández), *Women in the Buenavista Train Station*, 1912.

Given the publication date, we know these women are likely accompanying the federal forces sent to suppress a revolt in the north by one of Madero's early supporters, Pascual Orozco. Their baskets probably include food for the troops. This modern print shows later damage to the glass plate negative.

not least because he had created an archive so vast that it seemed equivalent to the complexity of the Revolution itself.

Like Posada, Casasola was no radical: in 1900 he joined the staff of *El Imparcial* (1896–1914), a pro-Díaz newspaper that promoted sensationalist on-the-street reporting over intellectual arguments, and was the first paper in Mexico to use photoengraving. For *El Imparcial* Casasola depicted official diplomatic and political events, often with Díaz playing a patriarchal role. He was more revolutionary in terms of his profession; in 1911 Casasola founded Mexico's first association of press photographers, and the following year formed the Agencia Mexicana de Información Gráfica, a commercial archive that eventually included some 400,000 negatives by more than 480 photographers, both signed and unattributed, depicting almost every aspect of national life, with a particular emphasis on Mexico City and the Revolution.

Posada produced some 2,000 images, most of them signed or with stylistic quirks that are his alone. But the specific authors of many of the photographs in the Archivo Casasola (as it is now known) have only recently been identified: in some cases, Casasola etched his name on negatives he had purchased

or pirated from others. The majority of photographs in the archive were only published after the war, in Casasola's own multi-volume *Album Histórico Gráfico*, as well as in innumerable history books.

The images preserved in the Archivo Casasola remind us that with the spread of photography, ordinary people increasingly emerged as active participants in the visualization of history. Yet, unmoored from their specific historical context, photographs can be as subject to speculation as the most fictive paintings. For example, one of the most famous images in the archive, taken at Mexico City's train station, shows several women who are often referred to as *soldaderas*, though they are not armed. Published versions of this image usually show only the tense woman on the left, who seems gazing off to an uncertain destiny; the full negative, however, includes more static figures, who acknowledge the photographer's gaze.

Among the more professional artists, David Alfaro Siqueiros served in the Constitutionalist forces in 1914–15, and Francisco Goitia (1882–1960) worked as a staff artist under General Felipe Ángeles in Villa's army. In 1918, both men exhibited scenes of the Revolution in Mexico City, after the worst fighting was over. Dr. Atl was Carranza's Chief of Propaganda, but never depicted the Revolution; Orozco—though unable to serve in the military after losing his left hand in a chemical explosion—created political cartoons about the Revolution for rather reactionary publications in Mexico City, and for the short-lived Carrancista newspaper *La Vanguardia* (1915), in which he, like Posada, critiqued the immorality unleashed by the war.

Saturnino Herrán's response to the political, economic, and spiritual crisis was *Our Gods*, an oil-on-canvas mural (left unfinished at the time of his death) for the lobby of Boari's Teatro Nacional. In this triptych, kneeling Aztecs and Spaniards pay homage to a central icon that melds the Aztec Coatlicue and a Spanish Crucifixion, forging them into a single syncretic deity worshipped by both sides. In terms of its *fin-de-siècle* symbolism, this allegory looks backwards, but the message could not be more contemporary: Herrán's metaphysical call for racial and cultural mestizaje was profoundly inspired by anthropologist Manuel Gamio's book *Forging a Fatherland* of 1916. In the following decade, Rivera, Orozco, and other artists would further unpack and explore the theme of mestizaje in their vast mural cycles.

151 Saturnino Herrán, *Our Gods: Coatlicue Transformed*, 1915–16.

This preparatory drawing for the central panel of Herrán's *Our Gods* triptych represents a synthesis of two religions and two artistic traditions. A monumental sculpture of Coatlicue, the Aztec earth goddess, was a centerpiece of the Museo Nacional; the crucified image of Jesus was taken from Zuloaga's *Christ of Blood* (1911), a paragon of modern Spanish painting.

Though he formally enrolled in the ENBA in 1906, Orozco remained skeptical of its hidebound rules, as is evident in a series of watercolors showing Mexico City brothels that he exhibited in 1916 under the title "The House of Tears." Rendered in a bold, expressionist style, the works are intimate explorations of society's moral depths. They draw on multiple sources, from modernista depictions of women as *femmes fatales* or social parasites, to longstanding bourgeois fears of prostitutes as carriers of disease and national degeneracy, to Orozco's own forays into Mexico City's red-light district. Painted during the bloodiest years of the Revolution, the grimacing whores with masklike faces—sometimes shown stealing money from their clients—stand for the primitive

152 José Clemente Orozco,
The Pimp's Hour, 1913–15.

In 1917 Orozco traveled to San
Francisco in search of work. In his
autobiography, published in 1945,
he recalled that US customs
officials in Laredo, Texas,
confiscated and destroyed some
sixty of his bordello-themed
watercolors, deeming the works
"immoral."

forces unleashed not only by modernization, but also by the
war itself, forces that need to be controlled to avoid chaos.
From this pessimistic stance, perhaps, there was no way out,
and for the next seven years, Orozco abandoned art altogether.

Diego Rivera, whose images of the 1920s would come to
define the Mexican Revolution for international audiences, all
but missed the defining event of his generation. He and Herrán
had been the two most prominent students at San Carlos in
the early 1900s, but Rivera obtained a private scholarship to
study in Europe, and left in 1907 for Madrid and then Paris,
voraciously moving through a host of styles. Although Rivera
returned to Mexico for the Centennial celebrations of
September 1910 and witnessed the fall of Díaz, he left again
for Paris in June 1911 and did not return home until 1921.

Between 1912 and 1917, Rivera emerged as a leading Cubist
painter in the contentious art world of Montparnasse, and was
known for his hard-edged and carefully measured compositions.
One of his largest Cubist pictures, now titled *Zapatista
Landscape*, shows objects assembled on and around a table,
surrounded by the crisp blue sky and volcanoes of the Valley of
Mexico, as if abstracted from the paintings of his teacher, José
María Velasco. The leader of a rural uprising in Morelos that
sought to reclaim communal lands that had been seized by

wealthy landowners, Zapata was widely discussed in the press by 1915. Yet the felt sombrero, rifle, and colorful sarape in the still life may not have originally referenced Zapata, at least not explicitly; at the time, Rivera referred to the picture only as his "Mexican trophy." The current title, which overtly politicizes the subject, seems a retrospective attempt by Rivera to bolster his populist credentials, like his "memories" of watching Posada

at work. After 1917, Rivera abandoned Cubism as part of the "return to order" in French painting. In the early 1920s, now back in Mexico City, Rivera scorned his Cubist pictures as youthful exercises.

More than Rivera, it was a young Guatemalan artist named Carlos Mérida (1891–1984), resident in Mexico City since 1919, who suggested a possible strategy for combining local subjects with cutting-edge abstraction. Mérida had studied in Paris under the Catalan painter Hermen Anglada Camarasa, but had also assimilated a concern for pictorial flatness from Cubism and Constructivism, which for him resonated with the decorative patterns of Maya textiles. In paintings shown in Mexico City in 1920, including *The Little Princess of Ixtanquiqui,* Mérida presented Maya figures dressed in traditional costumes that were at once highly nationalistic and very abstracted. Though Mérida's call for an "American" modernism was influential, few Mexican artists would take such a bold formal path in the 1920s.

In the post-Revolutionary period, most critics, historians, and artists—including Diego Rivera—dismissed the importance of all the history paintings and modernista allegories produced in the late nineteenth century as academic rubbish, irrelevant to the construction of a new post-Revolutionary identity. Though a convenient rhetorical strategy, such assertions belied the fact that the foundations for modern Mexican art were securely established in the decades before 1920. As Orozco famously said, "By 1922 the table was set for mural painting."

153 Diego Rivera, *Zapatista Landscape: The Guerilla*, 1915.

Several of Rivera's paintings from 1915 include nostalgic references to Mexican material culture: a woven sarape, a basket, a traditional chair (*equipal*), and a cigar box with the label "Benito Juárez." The *trompe l'oeil* paper seemingly nailed to the lower right reminded viewers that the picture was just an illusion.

154 Carlos Mérida, *The Little Princess of Ixtanquiqui*, 1919.

Although the reference in the title is obscure, Mérida's images of this period depict rural types in his native Guatemala, especially near Chichicastenango. Maya subjects are relatively rare in modern Mexican art, given the continuing political, economic, and cultural centrality of the capital.

Chapter 7 From Revolution to Renaissance (1920–34)

By 1922, ideas, styles, and subjects circulating in the pre-Revolutionary period had coalesced into a solid foundation for post-Revolutionary Mexican artists. In fact, painters, writers, and other Mexican intellectuals of the early 1920s felt part of a cultural "renaissance" equal in importance to the Italian Quattrocento, popularizing an idea that had been circulating in modernista circles since the early years of the century. Yet the "dinner party" Orozco alluded to was a complex, evolving, and often contentious affair, even if historians and the muralists themselves tried to simplify the story in subsequent decades.

In the 1920s and early 1930s, despite the importance of collective endeavors and unifying manifestos, Mexican artists represented perspectives as diverse as their colleagues in any other art capital. Even muralism, the most public and internationally famous artistic strategy of this period, was a heterogeneous phenomenon marked by distinct styles and themes, and shaped by different patrons and political positions. In later decades, scholars and critics sometimes lumped the art of this period together using such overarching categories as "Mexican Mural Renaissance" or "Mexican School of Painting." (The latter phrase encompasses various figurative artists who emphasized local subject matter well into the 1960s.) However convenient, these terms tend to obscure the very multiplicity of approaches that transformed Mexico City into one of the most innovative centers of modern art anywhere.

The Escuela Nacional de Bellas Artes (after 1929 the Escuela Nacional de Artes Plásticas, or ENAP) lost its monopolistic position after 1917. Equally important training grounds were the scaffolds of the leading muralists, as well as the Escuelas de Pintura al Aire Libre of the 1920s. Artists continued to travel abroad—for both political and artistic reasons—but even for those who remained in Mexico, an ever-wider array of avant-garde ideas and movements now competed for attention. Cultural exchange between the United States and Mexico also surged in the 1920s, with the increasing movement of artists and critics north and south of the border.

I. Muralism in the 1920s

Despite incipient institutional stability signaled by the election of General Álvaro Obregón (1920–24), Mexico emerged from the Revolution economically weak, and politically, socially, and geographically divided. Under Obregón and his successor, Plutarco Elías Calles (1924–28), the Secretaría de Educación Pública (or SEP) became a critical state agency, charged with improving literacy and shaping a new and unified national identity. Obregón increased federal expenditure on education tenfold, allowing his Minister of Public Education, José Vasconcelos (1882–1959), to develop a plan to transform Mexican society through schools, libraries, and the arts.

Vasconcelos was one of several visionaries who brought ideas frustrated during the Porfiriato to fruition in the 1920s. Among these were indigenismo and especially mestizaje, two related concepts that were increasingly seen by artists and intellectuals as essential to the formation of the modern nation. For Vasconcelos, indigenous culture was validated, but mainly as part of a utopian process of cultural assimilation in which each of the world's races—but in particular the Spanish and Indian—would ultimately merge into a single "cosmic race" with unrivaled spiritual and aesthetic power. This theory was, of course, marked by a fundamental racism that privileged the agency of white urban elites; nevertheless, as a metaphor of unity, this amplified definition of mestizaje was of tremendous utility to artists and government leaders in the early 1920s.

As head of the Universidad Nacional (1919–20) and then Minister of Public Education (1920–24), Vasconcelos oversaw institutions housed mainly in secularized colonial buildings downtown; for example, the Escuela Nacional Preparatoria occupied the former Colegio de San Ildefonso. And to the extent that there was an official state architecture (funds for new buildings being quite limited), the chosen style was neo-colonial. This is evident in the new headquarters for the SEP (1921–22), designed by a little-known engineer named Federico Méndez Rivas, which incorporated part of the seventeenth-century convent of La Encarnación and echoed colonial monuments in its open arcades. A model primary school begun during Vasconcelos's administration—the Centro Escolar Benito Juárez in the Colonia Roma—also recalled the colonial past, with carved stonework, tiled roofs and wide patios.

155 Carlos Obregón Santacilia, Centro Escolar Benito Juárez, Mexico City, 1923–25.

When first erected as a showplace in the Colonia Roma, this public school was visible from a great distance; it is now crowded by surrounding buildings. Roberto Montenegro painted murals in the school's Biblioteca Lincoln, inaugurated by Charles Lindbergh in 1927.

Such buildings represented a continuation of nineteenth-century historicism, though now focused on local sources. Unlike the Aztec Revival, however, neo-colonial architecture perfectly embodied the concept of mestizaje, since its forms and materials were based on centuries of cultural blending and adaptions to Mexico's specific environment. Neo-colonial architecture also confirmed Vasconcelos's self-image as heir to the sixteenth-century friars, encouraging parallels between the evangelization of the indigenous population and the Ministry's equally transformative programs. Yet while Vasconcelos would commission didactic images for his buildings, he and his future muralists knew little about the mission frescoes, which remained largely concealed by whitewash.

To decorate the walls of these buildings, Vasconcelos encouraged Diego Rivera and other leading artists then in Europe to return; first, however, he hired modernistas Dr. Atl and Roberto Montenegro to decorate walls in the former church and monastery of San Pedro and San Pablo. The theme of mestizaje is explicit in Montenegro's *Tree of Life*. The flowering branches, populated with birds and jaguars, were directly appropriated from traditional ceramics made in Tonalá, Jalisco, that combined indigenous and European forms and techniques. The toga-clad women (just one wears an

156 Roberto Montenegro, *The Tree of Life*, 1922.

Montenegro's composition occupies the main wall in a deconsecrated church, converted into a Sala de Discusiones Libres, or lecture hall (the building has had several subsequent functions, and is currently a museum). The gold background recalls the gilded wooden retablo that once occupied the space.

indigenous costume) represent the twelve hours or zodiacal signs; they frame a sword-bearing knight, perhaps a stand-in for Vasconcelos. A plaque contains a text provided by Vasconcelos: "Action transcends destiny: Conquer!" Long said to have been taken from Goethe, the phrase appears to be a misquotation, perhaps even a total invention. In any event, it was the perfect slogan for a man who believed his policies would correct centuries of oppression and ignorance.

In the first phase of muralism, a dozen or so painters were working simultaneously, trying to figure out what subjects and

styles were appropriate to modern mural "decorations." In general, Vasconcelos was not pleased with the initial results, among them Rivera's allegorical *Creation* (1922–23) in the Escuela Nacional Preparatoria, the elite public high school that formed part of the Universidad Nacional. Despite tentative references to Mexican culture and mestizaje, they were neither instructional nor clearly modern; in fact, they harkened back to Symbolism, assuming familiarity with esoteric knowledge (Masonic and Rosicrucian symbols, for example). Vasconcelos sent Rivera to the Isthmus of Tehuantepec to rediscover traditional Mexico. In the Preparatoria, meanwhile, several younger muralists were already depicting daily life and national history, as well as learning the technique of *buon fresco*.

Unlike their slightly older colleagues, Ramón Alva de la Canal (1892–1985), Jean Charlot, Fernando Leal (1896–1964), and Fermín Revueltas (1902–1935) had all studied under Ramos Martínez in the Escuela de Pintura al Aire Libre in the rural south of Mexico City, after it reopened in 1920. There they

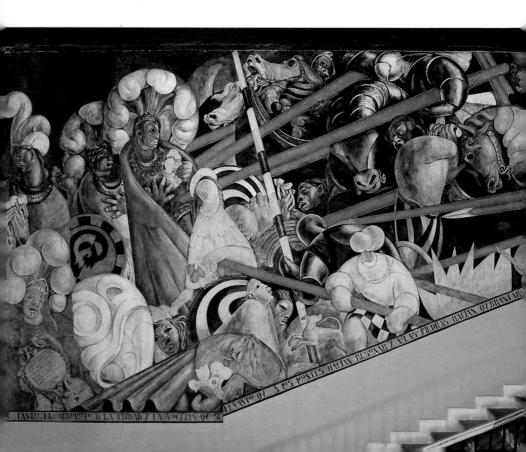

experimented with Post-Impressionist brushwork and Fauvist color, employed in direct engagement with peasant models and local landscapes. Themes related to mestizaje were first addressed in the artists' easel paintings and then adopted in their murals in the Preparatoria, embodied either in past conflict, as in Charlot's *Massacre in the Templo Mayor*, or in present-day popular culture, as in Leal's encaustic mural (1922–23) showing pilgrims and dancers paying homage to the Lord of Chalma, a much-revered statue of the Black Christ. The murals and paintings of these younger artists had a profound influence on Rivera's subsequent development.

In 1932, US writer Anita Brenner baptized Orozco, Rivera, and Siqueiros as "the three great figures of modern Mexican art." Later historians have simply referred to them as *los tres grandes*, though the term obscures other artists that contributed to the development of muralism. Nevertheless, the most prominent mural projects of the 1920s were the multi-paneled cycles by Rivera in the SEP (1923–28) and the Escuela Nacional de Agricultura in Chapingo (1926–27), and by Orozco in the stairwell and corridors of the Escuela Nacional Preparatoria (1923–26). All underwent complicated stylistic and thematic shifts over time. The most ardent theorist of the three, Siqueiros never finished his murals in the stairwell of the Patio Chico of the Preparatoria, though together with Amado de la Cueva he completed a cycle for the Universidad de Guadalajara in 1925, the first modern murals executed outside Mexico City.

These cycles reveal the increasing radicalization of the muralists. Many joined the Mexican Communist Party, and in late 1922 they formed a union—the Sindicato de Obreros Técnicos, Pintores, y Escultores de México (Union of Mexican Technical Workers, Painters, and Sculptors)—to defend their interests. They started a newspaper called *El Machete*, a title that emphasized the idea of art as a weapon for social change. Siqueiros and Xavier Guerrero (1896–1974) contributed didactic illustrations to this publication, which became the official organ of the Mexican Communist Party in 1924. The Sindicato's manifesto of 1923, a blend of *Vasconcelista* and Marxist rhetoric, privileges public "monumental art" over bourgeois easel painting, and extols Mexico's popular and indigenous artistic traditions. By including "technical workers" (the plasterers, carpenters, and others) in their union, and

157 Jean Charlot, *Massacre in the Templo Mayor*, 1922–23.

Charlot's mural draws on the battle scenes of Paolo Uccello, but the feathered headdresses and glittery costumes purposely allude to viceregal representations of the Aztecs, such as those on biombos and enconchados (page 86). He meant the mural to be read symbolically rather than as an attempt at historical accuracy.

158 Xavier Guerrero, *The Bats and Mummies Attempt to Prevent the Development of Revolutionary Painting*, from *El Machete* (July 1–15, 1924).

The rough lines of this woodcut are typical of illustrations in *El Machete*. Guarded by soldiers, a muralist in overalls paints Communist symbols. The vampire bats, representing reactionary forces, allude to attacks the muralists faced while working in the Preparatoria.

wearing overalls, the artists made explicit their own working-class identity.

In his frescoes in the SEP, Rivera sought to unite Mexico's cultural, ethnic, and geographic diversity in a single coherent program covering three floors. The bright colors, crisply outlined figures, exhaustive details, and pleasantly rounded forms would typify his murals for the next three decades. Rivera's sources are many: Giotto was a chief inspiration, but he also used compositional strategies derived from his experience with Cubism.

On the ground floor, the Patio of Labor includes rather tranquil images of traditional industries, like weaving and sugar production. Some panels relate to ongoing political struggles: the embrace of the peasant (*campesino*) and urban worker, miners being searched by foremen, and a martyred peon from a hacienda. In *The New School*, a rural schoolteacher sits outdoors with students of different ages, genders, and social classes—perhaps a reference to the Misiones Culturales (Cultural Missions) of the SEP, which sent out trained urbanites to improve living standards in remote areas. These panels suggest ideal views in the same direction the viewer faces; for example, dusty mountains appear on the north wall, while sugar cane fields appear on the south wall. In the rear courtyard—or Patio of Fiestas—Rivera featured religious and secular celebrations, from the indigenous Yaqui Deer Dance of Sonora to the celebration of the Day of the Dead in a racially diverse, modern Mexico City.

While panels in the first courtyard are linked by the landscapes that run over the inset doorways, Rivera soon began to create denser compositions that cover three or four adjacent panels, or run up the walls in the stairwell. Multiple figures now pack the pictorial space, some even resting against

159 Diego Rivera, *The New School*, 1923.

In this arid northern landscape, the revolutionary soldier symbolizes the military leaders from Sonora then controlling the country, whose benevolent protection ensured agricultural production and education. Not surprisingly, books and learning are recurring themes in Rivera's cycle.

or sitting upon doorframes as if the architectural structures were part of the scene. *Distribution of Land* and *May Day Rally* depict political celebrations that anticipate images of agrarian reform and proletarian revolt elsewhere in the building. Several of these panels include portraits of Rivera's assistants, friends, and even the artist himself.

The top floor consists of a gallery of national martyrs, as well as an extended series of panels framed by *trompe l'oeil* stone archways and connected by a red banner inscribed with the lyrics of two corridos: the first tells of the peasant revolution that had just happened, the second narrates the proletarian revolution yet to come. Many of these panels ennoble the peasantry while overtly critiquing reactionary forces, from US capitalists to bourgeois counter-revolutionaries, including ex-minister Vasconcelos himself. (The culminating image in this cycle is discussed below, page 265.)

Rivera followed a grueling schedule, working on varied mural projects at the same time as well as producing easel paintings and drawings for sale, and also remaining active in political movements. At the Escuela Nacional de Agricultura, he decorated walls in the administration building, housed in the turreted mansion of an expropriated hacienda, and filled the former chapel with a rich program that alludes to the Sistine Chapel. Panels running along the sides equate "natural evolution" (from minerals to fruit trees) with "social revolution" (from oppression to proletarian victory), culminating in a monumental pregnant nude (actually Rivera's then wife, Guadalupe) personifying the Earth, whose body roughly conforms to a map of Mexico. Below her, allegories of Earth, Air, Fire, and Water represent forces harnessed by technology, while a youth symbolizing the future ignites a generator.

Back in the Preparatoria, Orozco took somewhat longer to find a signature style. After painting a series of esoteric allegories—including a blond *Maternity* inspired by Botticelli—he returned to his revolutionary roots, creating several caustic anti-bourgeois and anti-clerical caricatures, and lampooning Justice, Victory, and even God, which incited critical attacks and vandalism. Tensions between the students (who generally hailed from middle- or upper-class families) and the muralists culminated in Vasconcelos's resignation in July 1924 and the dismissal of most of the artists, although Orozco returned in 1926 to finish his cycle.

Orozco also grappled with the theme of mestizaje and the Conquest in his rendition of Cortés and Malinche (the only named historical figures in the cycle), who dominate a sloping ceiling of the main staircase. Their nudity not only reinforced the parallel to innumerable representations of Adam and Eve, but also allowed the artist to highlight differences in skin tone,

160 Diego Rivera, *The Liberated Earth with Natural Forces Controlled by Man* (end wall), 1926–27.

Like Montenegro's *Tree of Life*, this mural occupies a space that formerly housed an altar piece. Here it is the Earth, rather than a religious figure, that blesses faithful students. Carved wooden pews with proletarian symbols, designed by Rivera, fill the meeting hall.

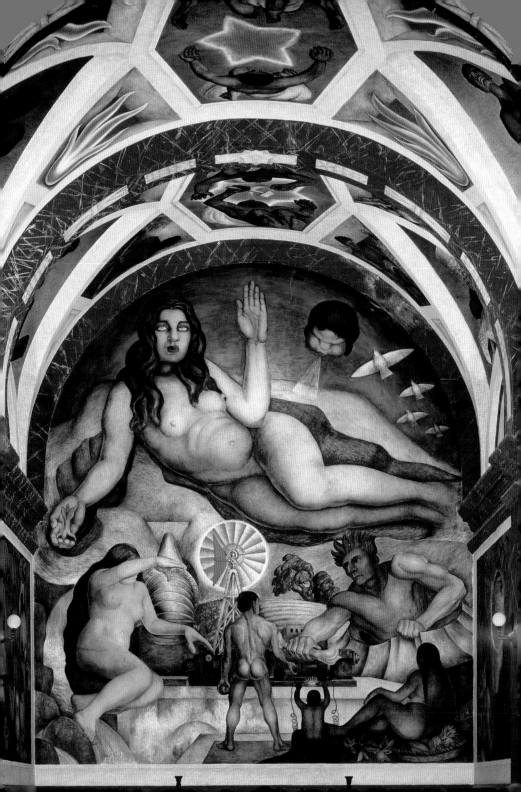

161 José Clemente Orozco, *Cortés and Malinche*, 1924.

In this pseudo-marriage portrait, the conquistador and his mistress clasp hands tenderly, but Cortés seems to be holding Malinche back. The black bunting over their heads is a sign of mourning, but its meaning here is unclear.

162 José Clemente Orozco, *The Trench*, 1926.

The Trench is one of several panels on the ground floor of the former Preparatoria that allude to the Mexican Revolution. Stone archways that run along the corridor frame each scene as a separate composition. In 1931, Orozco reworked this iconic image as an easel painting, now in the collection of New York's Museum of Modern Art.

pointedly clear in their overlapping forms. The gendered construction of race might remind us of the first pair in an eighteenth-century casta series (page 119), though here, the Spaniard and Indian have no offspring. The naked figure below them is surely a direct citation of the dead indigenous "husband" in Parra's *Fray Bartolomé de las Casas* (page 180). Like the nineteenth-century academic painters, Orozco viewed the Conquest as an inevitable if brutal advance towards cultural assimilation; he never idealized Mexico's indigenous populations, past or present.

Compared to Rivera's, Orozco's compositions include fewer figures, use a narrower range of colors, and are rendered with broad energetic strokes. Though there is some visual evidence he was familiar with German Expressionism, Orozco's style was mainly the result of his desire to heighten drama rather than provide detailed information; it might also be partly due to the

difficulty of creating murals with just one hand. The ambiguous messages of many of his panels reflect his brief adoption of anarchist ideas during the Revolution, but even more so his lifelong distrust of all forms of ideology. In *The Trench*, for example, thrusting Baroque vectors create drama and tension, but we are given no indication of what side these peasant soldiers are on. War is memorable, Orozco reminds us, not for its leaders or manifestos, but for its impact on average men and women.

Access to these early murals was somewhat limited, since few of the buildings were open to the general public, although they did reach one specific and highly influential audience: teachers and government bureaucrats, who were charged with transforming all aspects of Mexican society. For many others, reception was indirect, filtered through the press, international publications, and even vaudeville shows, where Rivera was an easy target for humorists. In the long run, however, the impact of these murals was transformational; whether or not they ratified official programs or advocated more radical positions, they had changed the rules about *who* and *what* merited attention in art, as well as life.

II. The Idealization of Rural Life

Mexican easel painting of the 1920s paralleled the widespread "return to order" that shaped French painting immediately after World War I, in which artists sought spiritual recovery in the countryside. After the Mexican Revolution, national values were also located in an idealized rural landscape, and in the festivals, costumes, and material culture of the peasantry. The intellectual roots of this shift are complex, but artists in the 1920s were partly engaging longstanding tropes about the innocence of folk culture, seen in nineteenth-century European art as well as the paintings of Herrán and others in Mexico. This is apparent not only in Rivera's own images, which quickly garnered international attention, but also in the works produced by teachers and students in the arts education programs run by the SEP. That this approach forced a reevaluation of *indigenous* beauty—signaled by a newspaper competition to find the nation's "prettiest Indian woman" in 1921—was not lost on contemporary critics.

Despite a rejection of easel painting in their manifesto of 1924, the muralists relied on the sale of portable paintings and prints to supplement the meager wages they earned on the scaffolds. Many of these works were derived—and in some cases, directly copied—from their frescoes in Mexico City in order to meet the demands of a growing market for modern Mexican art, at the time based principally in the United States. For example, Orozco, who moved to New York in 1927 in search of new patrons and commissions, was encouraged by his dealer, Alma Reed, to create saleable works based on his scenes

163 Diego Rivera, *Flower Day*, 1925.

This painting shows flower vendors celebrating the Friday of Sorrows in the village of Santa Anita, on the outskirts of Mexico City. The masklike faces and the seated poses of the women are derived from Aztec sculpture.

of the Revolution in the Preparatoria; though many were somber and even violent, they found eager buyers at the time.

No artist was more successful than Diego Rivera in shaping a particular image of Mexico—both at home and abroad— through his seemingly endless production of oil paintings, watercolors, and drawings. In general, these works emphasized tranquil and folkloric scenes of everyday life, particularly mothers and children (often his own servants), and flower vendors and other local types, such as the *molendera* (woman grinding corn), who had been featured in genre paintings and photographs since the mid-nineteenth century. In *Flower Day*, the first picture by Rivera to enter a US museum collection, the perfect beauty and symmetry of the forms imbue the work with a sense of timeless elegance: here labor seems effortless and traditions unchanging.

164 Edward Weston, *Tres Ollas de Oaxaca*, 1926.

Weston purchased these black ceramic water jars in the market in Oaxaca, and later photographed them on the roof above his Mexico City apartment. Other more documentary photographs were commissioned by Anita Brenner, for a book eventually published as *Idols Behind Altars* (1929).

A similar aesthetic is apparent in the carefully arranged still lifes taken by the Californian photographer Edward Weston (1886–1958), who lived in Mexico from 1923 to 1926. Such images were deeply informed by official indigenismo: whether physically present or embodied in their handicrafts, the Indian subjects of Rivera and Weston are elevated as powerful nationalist icons, equally "modernized" through the artists' sophisticated manipulation of form. At the same time, however, they seem completely divorced from the contemporary world. Orozco scorned this type of imagery as romanticizing poverty and backwardness; nevertheless, in their very idealization, these images reassured viewers in Mexico and abroad that the peasants behind the Revolution were actually contained and content. Unfortunately, this utopian vision degenerated in the 1940s and 1950s into an overblown and hyper-nationalist kitsch—seen in calendar art, advertising, postcards, even Rivera's later paintings—just as urbanization and industrialization were making such perfect rural scenes harder and harder to find.

In the SEP, Vasconcelos established a drawing and handicrafts section charged with teaching art to tens of thousands of students in primary and industrial schools, as well as teachers' colleges. The first director was Adolfo Best Maugard (1891–1964), who developed a method for teaching drawing based on the patterns found on applied arts, from Aztec potsherds and Greek vases to Mexican crafts. Out of this heterogeneous cultural mix, Best Maugard extracted seven basic linear elements (the spiral, circle, half-circle, "S" motif, and curved, zig-zag, and straight lines) that he believed constituted a universal aesthetic vocabulary, located deep in the human psyche. Students and their teachers used these elements to create decorative, tranquil, and "universal" compositions: in a demonstration drawing by Julio Castellanos (1905–1947), the sole Mexican referent may be the bird on the right, derived from the lacquered gourds of Olinalá, Guerrero.

248

The Best Maugard method was part of a broader interest in revitalizing art through the incorporation of so-called primitive visual languages, shared by many in the avant-garde, but the official name of this program—the Movimiento Pro-Arte Mexicano—signaled that his vision was primarily nationalist. His system proposed the creation of an essentially Mexican art from a synthesis of world cultures, though focusing on local sources that specifically embodied Spanish-Indian mestizaje, with some hint of Asian influence as well. This sat well with Vasconcelos's own concept of the formation of a "cosmic race," as well as ongoing attempts by the regime to forge a shared national culture. Although an official part of the SEP curriculum for only three years, the method provided an alternative to didactic muralism. In the mature work of Castellanos and other teachers, among them Agustín Lazo (1896–1971) and Rufino Tamayo (1899–1991), an emphasis on imagination over observation, and on the poetic over the political, can be traced to the Best Maugard method.

165 Julio Castellanos, *Untitled (Figures and Flowers)*, c. 1922.

The Best Maugard drawing method was codified in a teachers' manual published in 1923. The artist explained how seven "primary elements" could be combined in original compositions using the student's intuition. A translated version of the text went through several US editions, beginning in 1927.

166 Abraham Ángel, *Landscape (The Little Mule)*, 1923.

The painted facade on the left depicts a pulquería named El Vacilón (The Reveller). The murals on these taverns, directed to a mostly illiterate clientele, were heralded in the period as the folk equivalents of the murals sponsored by the Secretaría de Educación Pública.

Early in 1924, artist Manuel Rodríguez Lozano (c. 1895–1971) took over this program and introduced important pedagogic modifications. He encouraged students to study popular paintings, particularly ex-votos, and tap into their emotional and spiritual power. The provincial portraits of such artists as Estrada and Bustos, and the murals on pulquerías, were also now being revaluated; they were seen to embody an authentic national spirit unspoiled by academic training.

Rodríguez Lozano's leading protégé was a teenager named Abraham Ángel Card Valdés (1905–1924). The son of a Scottish mining engineer and a Mexican mother, Abraham Ángel painted portraits and landscapes in Fauvist colors on cheap cardboard; the results are some of the most strikingly innovative modernist works produced in Mexico in this period. In

Landscape (The Little Mule), stylized trees and strong black outlines clearly reveal the impact of the Best Maugard method, though without the transparent flatness. The awkward perspective of the buildings echoes the naïveté of popular paintings, including the town plazas painted on lacquered chests from Michoacán. The final result, however, resonates as much with Henri Matisse's *Joy of Life* (1907) as with any local sources.

Abraham Ángel was also the first of several modern Mexican artists—including Rivera's Otomí assistant, Máximo Pacheco (1907–1992), and, most famously, Rufino Tamayo, whose Zapotec roots were invariably noted by critics—who were constructed as embodiments of Mexican identity not only through their art, but also through their ethnicity and personal identity. Indeed, Abraham Ángel was known simply by his two given names, which elided his Scottish heritage and emphasized his apparently heavenly virtues. More tragically, his vibrant images concealed a rather sordid tale of familial tensions, sexual jealousy, and competition that ended with his probable suicide in 1924, at the age of nineteen. The pressures of being "the greatest artist in America," as Rodríguez Lozano called him, and then suddenly being dropped when his teacher embraced Julio Castellanos as his new protégé and lover, may have been too much to bear.

Another major force in the development of modern Mexican painting was a revitalized network of Escuelas de Pintura al Aire Libre, partly inspired by the progressive pedagogical theories of US educational reformer John Dewey. The system's earlier direct link to the ENAP had faded by 1925, when new Escuelas de Pintura al Aire Libre were established, first in rural towns near Mexico City, and then Guadalajara, Taxco, and other provincial locations, as part of a populist effort to extend arts education to a wide range of citizens. Beginning in 1927, related schools, known as the Centros Populares de Enseñanza Artística Urbana (Popular Centers of Urban Artistic Instruction), were instituted in working-class neighborhoods. That same year, an Escuela Libre de Escultura y Talla Directa (Free School of Sculpture and Direct Carving) was founded in the former monastery of La Merced in downtown Mexico City, with classes in iron- and woodworking, ceramics, smelting, and stone carving. *Forma* (1926–28), the official arts magazine of the SEP, extensively promoted the students' work.

Most students, who were given free materials and faced few entrance restrictions, were children between the ages of nine

and fifteen, although adults could also enroll. All were encouraged to depict their surroundings and traditions with relative freedom from strict academic rules. Paintings ranged from simple landscapes on paper to more sophisticated compositions with multiple figures. Many works reveal a sharp sensitivity to pattern, texture, and color—even if anatomy and perspective are intuitive rather than studied. Luis Lara's genre scene showing different stages in the production of baskets (including soaking them in water) is at once ethnographically accurate and yet compositionally naïve: the three figures seem unnecessarily weighted to the left.

Several women enrolled in these art schools or worked there as teachers, among them Rosario Cabrera (1901–1975). Overall, however, women faced an uphill battle as artists in the 1920s, in part because Revolutionary reforms were directed elsewhere (women did not obtain full suffrage in Mexico until

167 Luis Lara, *The Basket Makers*, 1930.

Almost nothing is known about Luis Lara. The unusually large size of the canvas, surely intended for exhibition, indicates that his talent was recognized by his teacher, Alfredo Ramos Martínez.

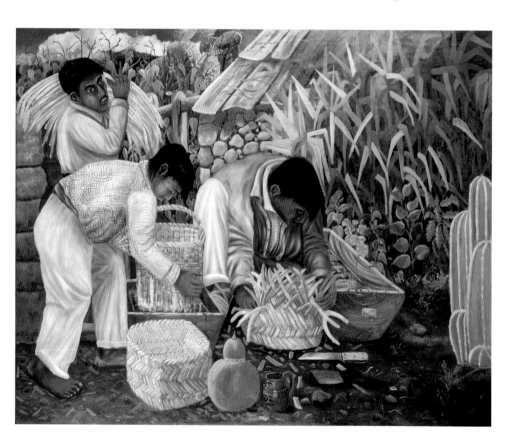

1953). Few sought to participate in the first phase of muralism. Apart from Italian-born photographer Tina Modotti (1896–1942), who had arrived in Mexico with Edward Weston, the most prominent women in the Mexico City art world in the 1920s were writers, not artists: anthropologist Frances Toor (1890–1956), publisher of the magazine *Mexican Folkways* (1925–37), and journalist Anita Brenner (1905–1974).

Among the particularly talented students—all of whom later developed independent careers—were Fernando Castillo (1895–1940), Ramón Cano Manilla (1888–1974), and Mardonio Magaña (1865–1947). Though these and other working-class artists clearly received training, this was downplayed in contemporary publications and exhibitions. Affinities with European modernist currents, such as Expressionism, whether thematic or stylistic, were never attributed to the interventions of the professors. Instead, nationalist promoters highlighted the naïveté and spontaneity of these works as visual proof that a brilliant aesthetic sense was somehow innate to the Mexican soul—however humble one's background. Critics abroad confirmed this belief when work from the Escuelas de Pintura al Aire Libre toured Europe in 1926 to great acclaim. In fact, the images produced in these alternative art schools framed the success of the more "sophisticated" muralists and painters, as if to prove that all strands of modern Mexican art had emerged from the same rich soil.

The children's art programs not only represented the benevolent extension of revolutionary reforms to the masses, but they were also a quintessentially modernist endeavor, through which leading artists found formal and spiritual rejuvenation in the work of their younger or untrained colleagues. In the later 1920s, many artists adopted the flatness, crude anatomy, unpolished craftsmanship, and simplified forms of children's art, but now in sophisticated compositions that only *seem* childlike. This embrace of the "primitive" was also related to the nationalist search for the inner strength of the mestizo, in opposition to racist definitions of mixed races as "degenerate."

Primitivizing strategies are thus apparent in a wide range of works, from woodcuts showing workers and peasants, to paintings by artists who had worked as art teachers. Rufino Tamayo not only taught children but also collected children's art: from the late 1920s on, he created several complicated allegories about the creative process that reveal a keen

Tamayo himself is the subject of this complex, even metaphysical picture. Wearing a child's sailor suit, he paints a large canvas showing a horse. He is surrounded in his cramped studio by muses, including a possible portrait of María Izquierdo, his companion at the time. The original title of the painting was *Pintura infantil*, or "Children's Art."

awareness of European modernism, while adopting the formal directness of Mexico's untrained artists.

III. Inventing a Modern World

The Revolutionary ideals that elevated local landscapes and customs to new heights also stimulated modernizing trends that would eventually threaten those same rural folkways. In their murals of the 1920s, Rivera and Orozco downplayed Mexico City as a subject: even Rivera's *Day of the Dead in the City* emphasized popular culture rather than recognizable monuments. For other artists, however, the city represented an escape from the confining boundaries of tradition. Rather than focusing on what made Mexico culturally and historically distinct from other nations, these artists chose to highlight its similarities and intersections with the modern world, particularly as embodied in new technologies, building types, communication systems, and social conditions.

In part these artists were responding to the changes in the capital triggered by population growth and increased economic stability. Especially in the congested downtown, and the colonias that continued to expand westward, obvious markers of modernity were increasingly easy to find: from automobiles and telephone cables to flappers and vaudeville shows, to pioneering examples of functionalist architecture. This noisy and exciting city was visualized in *Revista de Revistas* and *El Universal Ilustrado*, the cultural supplements of two leading newspapers, as well as the output of a generation of artists working partly, or entirely, in the shadow of the leading muralists.

Two radical manifestos of 1921 influenced a generation of Mexican artists searching for an aesthetic revolution as dramatic as the political one the country had just experienced. These two documents, informed by Futurism and other avant-garde movements, proposed a leap forward in both subject and style. The first was written by Siqueiros and published in Barcelona in May, in the sole issue of *Vida Americana*, an art magazine that he edited. In "Three Appeals for Present-Day Guidance to the Painters and Sculptors of the New American Generation," Siqueiros called on artists to embrace universal rather than national values, expressed through "pure plasticism" rather than superficial illusions. "Let us live our marvelous dynamic age," he wrote, directly echoing Filippo Marinetti.

170 María Izquierdo, *Siesta*, c. 1929–34.

Jean Charlot is generally credited with leading a modern woodcut revival in Mexico in the early 1920s. The medium was popular with teachers and students in the Escuelas de Pintura al Aire Libre; this example by María Izquierdo (1902–1954) seems inspired by a series of roughly carved prints of rural subjects made by Tamayo in the mid-1920s.

The other manifesto, titled *Actual No. 1*, was issued as a broadside in December by the poet Manuel Maples Arce (1898–1981). A rapid-fire assault of estrangement techniques, including Dada wordplay, Futurist outbursts, and moments of stream-of-consciousness, Maples Arce's text appealed to a narrower audience, yet basically elaborated upon the same points as Siqueiros's "Three Appeals," including praise for the machine and a rejection of nationalist art, with some lingering traces of modernismo; even the title, meaning "present-day," seems taken from its predecessor. Maples Arce proposed the foundation of an avant-garde movement in Mexico, which he called *Estridentismo* (roughly translatable as "Stridentism"), emphasizing not the future so much as the boisterous rhetoric that would be necessary to modernize Mexican society, aesthetically, spiritually, and socially.

Estridentismo's impact was belied by the small size of the group that clustered around Maples Arce, including writers Germán List Arzubide (1898–1998) and Arqueles Vela (1899–1977), and artists Ramón Alva de la Canal, Jean Charlot, and Fermín Revueltas. The sculptor Germán Cueto (1893–1975), printmaker Leopoldo Méndez (1902–1969), and Tina Modotti were also closely associated with the movement. The Estridentistas promoted their work through exhibitions and proto-happenings in a Chinese restaurant they called the Café de Nadie (or Nobody's Café), in poetry books with assertively modernist covers, and in such short-lived magazines as *Irradiador* (1923) and *Horizonte* (1926–27), the titles of which communicated their energetic, forward-looking attitude.

In the early 1920s, Estridentista images, mainly watercolors and prints, privileged modern Mexico City: from the cafés that provided intellectual camaraderie, to the bridges, radio towers, and cables that expressed the speed and sound of modern communications, to the factory chimneys in an incipient industrialized landscape. Where Mexico City was not modern enough, artists invented Constructivist buildings that never existed, or streamlined existing ones to make them look more avant-garde. Among the most innovative images by the group were Germán Cueto's brightly colored portrait-masks in cardboard, terracotta, and other materials, which resonate with modernist caricatures by Miguel Covarrubias (1904–1957) and Matías Santoyo (1905–1975), widely published in popular magazines at the time.

171 Fermín Revueltas, *Five Cent Coffee*, c. 1925.

One of the most abstract images produced in Mexico in the 1920s, this synthesis of patrons, advertisements, and furnishings in a restaurant was surely inspired by Rivera's Cubism. This work was owned by Maples Arce: beyond the narrow Estridentista circle, there was almost no market at the time for such avant-garde imagery.

172 Germán Cueto, *Mask of Germán List Arzubide*, c. 1923.

Cueto was one of Mexico's most abstract artists of the 1920s. His early masks resemble those used in carnival celebrations, but later versions in bent copper—created during an extended residence in Paris (1927–1932)—are more reminiscent of Cubist sculpture.

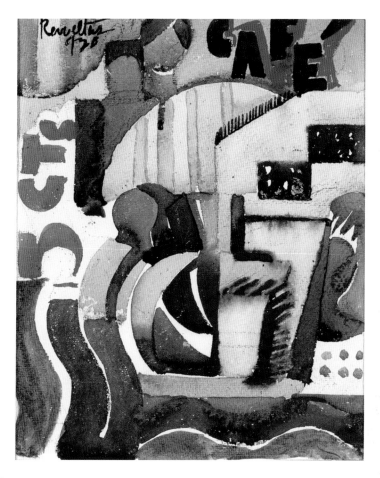

Like the Italian Futurists and the artists associated with the Semana de Arte Moderna in São Paulo, Brazil (1922), the Estridentistas were concerned with national rejuvenation on social as well as aesthetic levels. They also sought to deploy art and poetry to improve the lot of the working class through improved infrastructure and other Revolutionary reforms. Ironically, however, the worker himself is generally either absent or understated in their images. In fact, unlike the Futurists, some of whom leaned towards fascism, Maples Arce and other leading Estridentistas pursued a leftist social agenda, moving to the provincial city of Jalapa, Veracruz, in 1925, to join the administration of the progressive governor Heriberto Jara. Two years later their hopes of creating a utopian society were dashed when Jara was removed from office, and

173 Tina Modotti, *Telegraph Wires*, c. 1925.

Along with Cueto's mask, this photograph was reproduced in List Arzubide's *El movimiento estridentista* (1926), a delightfully opinionated early account. By turning her camera up slightly, Modotti created an image that could be anywhere in the world, and probably avoided more prosaic surroundings.

Estridentismo as a coherent movement faded. Cueto eventually landed in Paris, where he exhibited with the abstract art group Cercle et Carré, founded by French poet Michel Seuphor and the Uruguayan painter Joaquín Torres-García.

Given the urgency of strengthening the nation in the wake of the Revolution, it is not surprising that an aggressive virility dominated most aspects of Mexican politics and culture. Politicians, bureaucrats, and artists alike justified artistic practice with a simple overarching message that emphasized art's utilitarian function as a weapon for social change. But not everyone was a warrior. In the 1920s an important group of artists slowly coalesced around a contrarian position, long held dear by European modernists, that advocated what they called "pure art," or art for art's sake. Or, to cite an epigram by the poet Xavier Villaurrutia (1903–1950), "Painting for everyone as long as everyone is just a few."

Named for a chiefly literary magazine they founded in 1928, the poets known as the *Contemporáneos*, or "contemporary ones," are often said to be a "group without a group," since they signed no manifesto and shared no platform. In opposition to the nationalist agenda of the revolutionary writers and muralists, they emphasized personal rather than collective expression, and forged international contacts with similar literary movements in Lima and Buenos Aires. The Contemporáneos emerged as an oppositional force not so much because of their political views but rather for their resistance to the populist and hyper-masculine discourse of the time. Their "art for art's sake" position would be attacked by Rivera and other leftists as "effeminate" and counter-revolutionary, an argument facilitated because most of the Contemporáneos were gay, though not—except for the poet Salvador Novo (1904–1974)—openly so.

Although the artists associated with the Contemporáneos shared no single style, several avoided the angular post-Cubism of the Estridentistas in favor of a gentle neoclassicism, much inspired by Picasso. The idealized rural subjects of Rodríguez

174 Manuel Álvarez Bravo, *Two Pairs of Legs, c.* 1930.

This image testifies to the new technologies and modes of consumption shaping the modern city. The billboard, which advertises rubber shoe-soles produced by the Euzkadi rubber company, was placed on the side of the Edificio La Nacional, which was under construction at the time.

Lozano and Castellanos are not so distant from those in Rivera's easel paintings of the period. Other compelling works engage directly with the complicated modernity of Mexico City: for example, several paintings by Rufino Tamayo and photographs by Manuel Álvarez Bravo (1902–2002) feature commercial shops, billboards, and urban residents, with an eye to uncanny imagery and strange juxtapositions. Álvarez Bravo adopted the "new vision" introduced to Mexico by Weston and Modotti, but his more poetic titles and ambiguous meanings reveal his early alliance with the Contemporáneos.

Some imagined the city as a stage for living a modern life, rather than a site for utopian dreams. Rodríguez Lozano's portrait of Salvador Novo perfectly embodies the poet's spirit, shared by many of those associated with the Contemporáneos: intimate, edgy, and slightly decadent. Despite the formal influence of children's art, the subject is for mature audiences

175 Manuel Rodríguez Lozano, *Portrait of Salvador Novo*, 1924.

When this portrait was painted, Novo was only twenty years old, just out of the Escuela Nacional Preparatoria, and already cultivating a persona inspired by Oscar Wilde. The automobile, probably a Ford Model T (or *fordcito*), allowed the modern flâneur new possibilities for circulation in the city.

only. Novo, wearing a dressing gown, rides a taxi at night past Boari's Oficina de Correos, cruising an intersection known to insiders as a place for sexual contacts.

Later in the decade, works by the Contemporáneos reveal greater debts to European modernism, whether the contacts were direct or indirect; their magazine reproduced the work of De Chirico, Man Ray, and Miró, though Mexican artists—including the muralists—were favored. After several years in Europe, Agustín Lazo returned to Mexico in 1930 well informed about Surrealism and Italian metaphysical painting. The stage-like settings of his drawings and collages recall the importance of theater in the Contemporáneos circle, most famously the Teatro Ulises, financed by Antonieta Rivas

Mercado, the daughter of the Porfirian architect (page 212). Even more radically avant-garde were the photograms, multiple exposures, and other manipulated photographs created by Emilio Amero (1901–1976) in the late 1920s and early 1930s. Amero lived for a time in New York City: not surprisingly, the most formally experimental Mexican artists of the day were generally those who had spent the most time abroad.

With increasing stability and national prosperity, modern architecture began to rise in Mexico City at the end of the 1920s, slowly bringing to reality the dynamic city the Estridentistas had imagined. A few modern steel-frame structures were erected at the end of the Porfiriato, most notably a towered pavilion purchased in Europe in 1895 and later converted into a natural history museum. The first truly functionalist buildings all date from 1928–29; most were private homes, though José Villagrán García's Tuberculosis Sanatorium hinted at the future embrace of the style by government agencies. More visible, though far chunkier, were the Edificio La Nacional (1930–32) by Manuel Ortiz Monasterio (1887–1967), facing the still-unfinished Teatro Nacional, and the Ermita apartment building (1930) in Tacubaya by Juan Segura (1898–1989). Their thick reinforced concrete walls are pierced by small windows, revealing that same fear of earthquakes that had defined the structure of early colonial churches.

Modern architecture on a domestic scale was reserved mainly for the intellectual elite, despite some tentative experiments with workers' housing. The pioneer in this field was Juan O'Gorman (1905–1982), who designed modernist homes for several leading members of the art world, including Julio Castellanos, Frances Toor, and, most famously, Diego Rivera. Commissioned soon after Rivera's marriage to Frida Kahlo in 1929, and located in the southern suburb of San Ángel, the Rivera-Kahlo complex consists of a smaller residential structure connected by a bridge to a larger public gallery and studio for Rivera; several features cite house-studios in Paris by Le Corbusier. Reflecting budgetary concerns, O'Gorman's houses are more compact than their French counterparts, and the lack of industrial suppliers required greater recourse to handcraft and inventiveness, such as railings made from water pipes.

In a city where traditional housing styles prevailed, modernist buildings associated their patrons—like their counterparts elsewhere—with internationalism, efficiency, and

176 Juan O'Gorman, House-Studio for Diego Rivera and Frida Kahlo, Mexico City, 1930–31.

The blank surfaces and machine-age references of the Rivera-Kahlo complex purposefully rejected the historical allusions of nearby residences, as well as the San Ángel Inn, a former colonial hacienda. By the 1940s, however, starkly modernist and flowery neo-Baroque houses easily coexisted in other prosperous neighborhoods, such as Polanco and the Condesa.

177 Agustín Jiménez, *Untitled*, 1933.

While Manuel Álvarez Bravo took a more purist approach to the medium, other photographers, including Agustín Jiménez (1901–1974) and Emilio Amero, willingly manipulated their negatives in the service of art and politics, as well as advertising. This photomontage was created to promote the Tolteca cement factory.

even factory production, rather than folk traditions or national history. Rivera's studio visually ratified his self-identity as a worker, especially because it was a semi-public space where he received visitors and even tourists shopping for watercolors. In Mexico, however, the interiors and exteriors of these early functionalist houses often included cultural references that mitigated assertions of absolute modernity: rooms were decorated with painted furniture and hand-woven textiles; lots were circumscribed by organ-cactus fences, like those in the countryside; and outside walls were brightly colored. O'Gorman thus adopted the same strategy as painters and muralists, melding avant-garde forms with references to the local.

Mexico's modern architecture—including Rivera's studio and the Edificio La Nacional, as well as roadways, sidewalks, and even park benches—was increasingly cast from concrete, most of it produced by La Tolteca, a British company with a pre-Hispanic name. Although connections between art and commerce were already established during the Porfiriato, corporate patronage became increasingly important in the early 1930s. For business reasons, La Tolteca was a key defender of functionalist architecture against traditionalists who supported the Spanish colonial revival style as more authentically "Mexican." In 1931, the company held a competition in which painters and photographers were asked to represent its Mexico City factory. Though the submissions were blind, O'Gorman won first prize in the painting category; that he happened to be a major client did not raise accusations of favoritism in the press.

IV. Art during the Maximato

The Maximato refers to a six-year period following the assassination of president-elect Álvaro Obregón by a Catholic fanatic in 1928. Three presidents took office in quick succession, but Plutarco Elías Calles, the self-proclaimed *jefe máximo de la Revolución*, retained power at a time of changing economic and political realities. Under his direction, the government abandoned social reforms in order to consolidate state power. To this end, Calles formed the National Revolutionary Party, a powerful political machine that united a spectrum of divergent groups, from workers' unions to the military, and that—under different names—would dominate

178 Diego Rivera, *The Arsenal*, 1928.

This panel alludes to bitter divisions within the Communist Party. On the far left stands Siqueiros, a committed Stalinist. At the far right, Modotti appears with her lover, Cuban Trotskyite Julio Antonio Mella. Shortly after the panel was completed, Mella was assassinated in Mexico City, probably by Stalinist agent Carlos Contreras, who here peeks out at us just above Modotti.

Mexican politics for the next seven decades. Rightward shifts and concerns with political stabilization during this turbulent period, exacerbated by the world economic crisis after 1929, created difficulties for the most radical Mexican artists: some were censored, imprisoned, or exiled, while others, facing few opportunities at home, turned to patrons in the economic powerhouse to the north.

In the late 1920s we find an increased polarization within the Mexican art world. Rivera traveled to the Soviet Union in 1927–28 for the tenth anniversary of the Bolshevik Revolution; Siqueiros joined him in 1928. Although both were disappointed

179 Tina Modotti, *Woman with Flag*, 1928.

Works by Modotti, Xavier Guerrero, and other radical Mexican artists circulated in international leftist journals. This photograph of a woman carrying what is probably a red banner appeared on the cover of *New Masses* in June 1929.

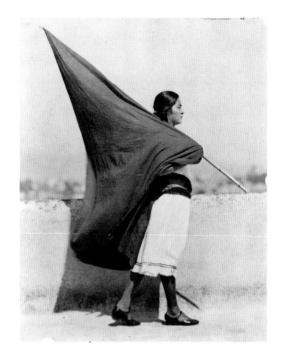

by the conservative aesthetic rules being imposed by Stalin, they returned more committed—at least visually—to a future proletarian revolution, especially apparent in Rivera's later panels in the SEP, such as *The Arsenal*. In this culminating panel of his *Corrido of the Proletarian Revolution*, anonymous workers, accompanied by Frida Kahlo, distribute modern weapons to the peasants: here was yet another declaration of unity between the nation's two most important social groups, and a self-confirming assertion of the primacy of artists and intellectuals in the revolutionary struggle. Meanwhile, in photographs published in *El Machete* and other radical magazines, Modotti distilled the complex discourse of muralism down to its basic elements, inspired by the formalist compositions of her mentor, Edward Weston.

Obregón's assassination triggered virulent debates over the future of revolutionary reforms, and Mexican artists, especially members of the Mexican Communist Party (PCM), now faced greater limitations. In a complex political climate, activists quickly became victims. The government shut down *El Machete* in June 1929 and forced the PCM underground. In 1930, Modotti was sent into exile, and Siqueiros, who had been arrested after

180 David Alfaro Siqueiros, *Proletarian Mother*, 1931.

Without access to expensive canvas, Siqueiros began painting on reused burlap bags. He shaved their fibrous surfaces, covered them with thick gesso, and then laid the paint on thickly: the method approximates fresco painting. He also appreciated the fact that the coarse support reflected the difficult lives of his subjects.

a May Day rally in Mexico City, was confined to Mexico City's Lecumberri Penitentiary before being placed under house arrest in the mining town of Taxco.

Siqueiros painted relatively little in the 1920s, dedicating most of his time to leftist activism, including union organization among mineworkers in Jalisco. Only after he was imprisoned did he turn almost full time to the production of art, first in a series of melancholic scenes showing tortured prisoners and their abandoned families. In Taxco, with limited access to fine-art materials, Siqueiros created several large paintings using rough burlap bags as a support. Although many have darkened with age, these tragic paintings are brutal in both form and subject. In *Proletarian Mother* the figures are practically entombed by surrounding walls; poverty and oppression stifle even basic human tenderness.

Siqueiros's monumental Taxco paintings are far removed from the romanticized canvases of peasant life created by Rivera. These distinct visions of rural Mexico might have been synthesized in "Que Viva México!" (1930–32), an unfinished film by the Soviet director Sergei Eisenstein (1898–1948). Visually and thematically, the project was deeply inspired by the muralists, and (known through several bastardized versions) shaped the subsequent history of Mexican photography and cinema.

The increasingly restrictive political climate offered radical artists fewer commissions and spaces for independent action. Recalling earlier moments of crisis, Ramón Alva de la Canal, Gabriel Fernández Ledesma (1900–1983), Fernando Leal, and Fermín Revueltas joined against the aesthetic and pedagogical conservatism of the Escuela Nacional de Artes Plásticas, where such professors as Gedovius and Izaguirre still held sway. As teachers, they defended the Escuelas de Pintura al Aire Libre—which enrolled students from a wide array of social backgrounds—against accusations that these schools had no long-term purpose. Echoing the aggressive rhetoric of the muralists and Estridentistas, they called their group "¡30-30!,"

after a gauge of rifle used during the Revolution (there were also thirty founding members), and broadcast their position through illustrated manifestos pasted to the walls of buildings at night.

The ¡30-30! movement was far more radical in terms of institutional proposals than aesthetics; many of their works consist of Expressionist woodcuts that depict rural rather than modernist subjects, evidence of their goal to reach a wider public than the Estridentistas or Contemporáneos. Its members, the *treintatreintistas*, also sought to unify the ENAP's various programs into a single progressive and multi-disciplinary center for the training of art-workers, drawn from all social classes, in the service of social reform. Not surprisingly, the older academicians—intent on preserving the idea of art as a profession for a carefully trained few—resisted this utopian project. In their publications, the treintatreintistas advocated new exhibition spaces that would reach broader audiences; they even held an exhibition of prints in a vaudeville tent. Although government censorship forced them to tone down the virulence of their message, they continued to show as a group until April 1930.

In August 1929 Diego Rivera was named director of the ENAP, which was now under the direct control of the SEP; the school's name was changed to the Escuela Central de Artes Plásticas for a brief period. Sympathetic to the treintatreintistas, he advocated a complete overhaul of the curriculum, introducing an apprenticeship system and student self-government, but the attempt faltered; Rivera resigned in

181 Fernando Leal, illustration to *Fifth Treintatreintista Manifesto*, 1928.

This print attacks Manuel Toussaint (identified here as "Monseñor Todos Santos"), then the conservative director of the ENAP and later a prominent historian of colonial art. The ¡30-30! artists were also violently opposed to the Contemporáneos' apolitical "pure art" approach, and publicly attacked their lack of "virility"—as seen here in the effeminate figure to the far left.

May 1930. Under President Emilio Portes Gil, the government engineered the gradual closure of the Escuelas de Pintura al Aire Libre, though a last holdout survived in Taxco until 1937. Some of the more militant artists, still dependent on their federal paychecks, accepted a sort of internal exile by participating in the SEP's Misiones Culturales. Like Modotti, Siqueiros, and several other leading Communists, they were now far from the capital: out of sight, out of mind.

Decreasing official patronage pushed several artists north to the United States, and Orozco was the first of the leading muralists to leave. Soon after finishing his mural cycle in the Escuela Nacional Preparatoria he departed for New York, arriving in December 1927. Jean Charlot followed him the next year. Since the late 1910s, in fact, New York had been an important destination for Mexican artists and intellectuals, including Best Maugard, Covarrubias, composer Carlos Chávez (1899–1978), poet José Juan Tablada (1871–1945), and most famously Marius de Zayas (1880–1961), a caricaturist, dealer, and leading promoter of modern art.

Yet throughout this period of widespread repression there was one artist who continued to work on public murals in Mexico City, insulated in part by his international fame. In 1929, Diego Rivera painted murals for the conference room of Obregón Santacilia's new Secretaría de Salubridad (Ministry of Health, 1926–29), and began the most important project of his career to date: the decoration of three walls in the immense stairwell in the Palacio Nacional, the headquarters of the federal government, which housed the office of the president.

For this project, Rivera took no small subject for his theme. He chose to depict the entire history of Mexico, though the mural visualizes that history mainly in terms of Mexico City, much in the tradition of nineteenth-century history paintings. Indeed, in the middle of the central wall he inserted an image of an eagle perched on the nopal, derived from a relief on the throne of Moctezuma II, discovered in 1926 in the foundation of what had been the tlatoani's Casas Nuevas (page 58). Mestizaje, symbolized by the battle between Aztecs and Spaniards— inspired by Charlot's precedent in the Preparatoria, but here depicted with greater historical accuracy—serves as the foundation for the events above. Overall, however, the work is not meant to be read as a narrative. Instead, it is a turbulent montage of events, documents, average citizens, and leaders,

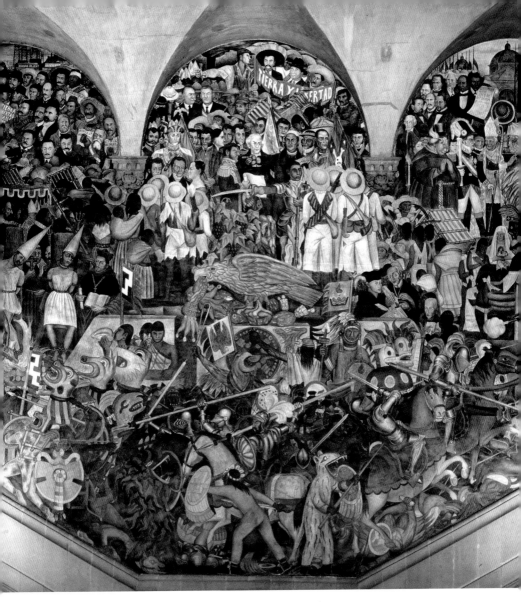

182 Diego Rivera, *Mexico of Yesterday, Today and Tomorrow* (detail), 1929–35.

In the center of the wall, Rivera placed an eagle with the atl-tlachinolli glyph (page 25) in its mouth. The glyph alludes to the battle scene below it, and informed viewers of the origins of the Mexican national emblem.

from Cortés to Maximilian to Calles, in which lifelike details contrast with the spatial impossibility of the overall composition. The mural was designed to impact visitors with a totalizing and awe-inspiring visual display: fireworks more than a textbook.

In the Palacio Nacional, at the top of the central wall, Rivera inserted adjoining portraits of Obregón and Calles, just steps away from Zapata. Although he surely saw this commission as a chance to imprint a Marxist interpretation of

269

history on the national psyche, leading Communists attacked Rivera's complicity with the regime as both muralist and director of the ENAP, and expelled him from the party in September 1929; that Rivera sympathized with Leon Trotsky hardly helped his position. In 1935, when he returned to complete the south wall in the stairwell, Rivera showed present-day political problems—now implicating Calles in an evil network of religious, military, and political forces, and highlighting the threat of fascism. At the very top, Karl Marx

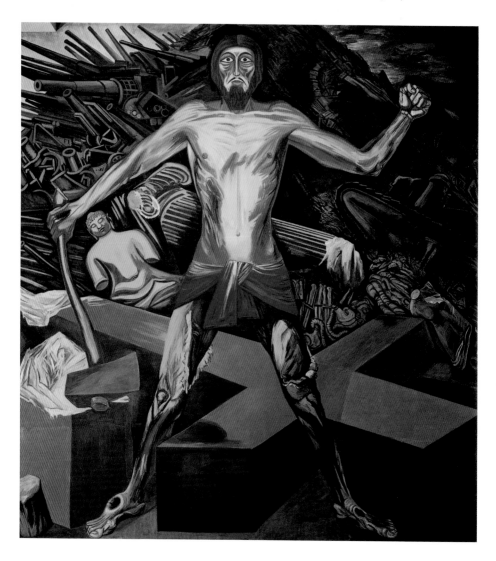

points the way to a socialist utopia. In the 1940s and 50s, Rivera returned once again to the Palacio, now to expand the stairwell mural in a series of panels running along the adjacent corridor; unfortunately, he died before the cycle could be completed.

Following Orozco, Rivera left for the US in 1930, and Siqueiros in 1932; all three were back in Mexico by 1934, when a change in the presidency signaled new opportunities (Rivera and Orozco would return to paint murals in the US in 1940). During the dark economic period that preceded the election of Franklin Delano Roosevelt, these artists worked on over a dozen projects: most were clustered around Los Angeles, San Francisco, and New York City, though the two most extensive and influential were Rivera's murals for the Detroit Institute of Arts and Orozco's cycle at Dartmouth College, in Hanover, New Hampshire. These murals were supported by patrons ranging from art professors to civic boosters to industrialists, and painted for diverse sites, including a private home and a stockbrokers' club; half were painted in centers of higher education. Although the artists developed some of the themes already surveyed in their Mexican murals, their US works were—not surprisingly—shaped by a far more international vision.

Orozco was the first Mexican artist to complete a mural in the US. His *Prometheus* (1930), which looms above the dining hall at Pomona College in Claremont, California, is one of several ancient and modern martyrs, both mythical and historical, that parade through his subsequent (and increasingly formally complex) murals. At the New School for Social Research in New York (1930–31), he depicted Gandhi, Lenin, and the socialist governor of Yucatán, Felipe Carrillo Puerto; at Dartmouth, his *Epic of American Civilization* cycle features the Toltec philosopher-king Quetzalcoatl, Hernán Cortés, Zapata, and finally—brutally—an image of an angry resurrected Jesus who has returned to destroy the symbol of his martyrdom. In these educational institutions, Orozco highlighted visionaries and prophets who were misunderstood by the masses, or sacrificed by reactionary forces unwilling to accept their efforts to transform society; all these men anticipate the ordeals of the modern artist himself.

In Los Angeles in 1932, Siqueiros was finally able to advance ideas about the function and practice of public art he had been developing since his manifesto of 1921. He formed a Bloc of

183 José Clemente Orozco, *Modern Migration of the Spirit*, 1932–34.

This panel from Orozco's *Epic of American Civilization* shows a vengeful Jesus, rendered with an intensity that recalls Spanish Romanesque murals and German Expressionist painting. The pyramidal background is a "trash heap" with broken elements representing the causes of his anger: religion, civilization, and militarism.

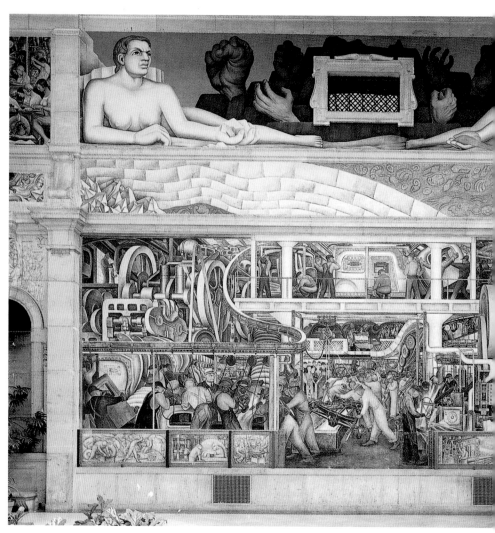

Mural Painters to reinforce his vision of muralism as a collective project, though he would be the undisputed author of the works. His first two murals, *Street Meeting* and *Tropical America*, were both painted on external cement walls using industrial tools, such as the airbrush. Unfortunately, Siqueiros's technical experiments meant that the works began to erode even before their radical subjects were whitewashed over by concerned patrons (*Tropical America* has been partially restored; *Portrait of Present-Day Mexico*, a private commission that survived intact, was relocated to the Santa Barbara Museum of Art in 2002). From this point on, however, Siqueiros would call for modern artists to abandon such antiquated formats as buon fresco and oil painting, associated as they were with authoritarian institutions of the past, and to replace them with modern materials and tools produced by workers and used in factories, in order to create a proletarian art in substance as well as subject matter.

Unlike Orozco and Siqueiros, Diego Rivera did not address any specifically Mexican topics in his US murals of the 1930s; instead, he focused on modern industry and the triumph of the working class. And of the three leading muralists, Rivera initially adopted the least combative subjects. His murals in San Francisco praised local agriculture and industry; those for the courtyard of the Detroit Institute of Arts idealized the triumphs of the machine age, with a focus on the production of the Ford Model A at the River Rouge Plant, then the world's largest factory complex.

It was in New York, when commissioned to paint a mural for the lobby of the RCA Building at the new Rockefeller Center, that he finally took his gloves off. Rivera was asked to

184 David Alfaro Siqueiros, *Tropical America*, 1932.

Tropical America rejects the romantic imagery of travel posters and Maya Revival movie theaters for a more critical view of the ancient past. The crucified indigenous figure, framed by a pyramid with Maya and Inca elements, is about to be rescued by the two revolutionaries at the far right, identified as peasants from Mexico and Peru.

185 Diego Rivera, *Detroit Industry* (south wall), 1932–33.

Though based, like all his work, on careful research, Rivera's image of the assembly line is a montage of various operations seen from a single, impossible, vantage point. The only trace of Mexico here is the stamping-press, recast to resemble Coatlicue, a melding of machine and god that echoes Herrán's allegory of 1915–16 (page 230).

illustrate the specific theme of "Man at the Crossroads Looking With Hope and High Vision to the Choosing of a New and Better Future," which he took as his title. In the mural, he presented the worker-viewer with an unambiguous choice between oppressive war-torn capitalism or idyllic Soviet-style communism. Images of the macro- and microcosmos, Classical statues, and even large television screens (a recent invention of RCA) in the upper register reinforced the message. Rivera was dismissed before he could complete the work, ostensibly because he had included a portrait of Lenin, but perhaps also because the mural challenged the idea that technology (particularly radio and television, over which RCA held a monopoly) was a social good. Rather, Rivera insisted, it depends on who is at the controls. The unfinished fresco was chipped from the wall in February 1934, though Rivera was paid his entire $21,000 fee, a figure that recalls the large sums retablo painters received in the sixteenth century (page 39). Later that year, he painted a modified version of the mural in the newly inaugurated Palacio de Bellas Artes in Mexico City.

Not all Mexican artists working in the US were muralists, of course. Frida Kahlo, who accompanied Rivera to the US after their marriage, created images that not only assert a more intimate approach to art-making (she was surely inspired by the Contemporáneos), but also provide an alternative view of the modern city. In *Henry Ford Hospital*, painted in Detroit, Kahlo shows herself abandoned after a miscarriage; symbols related to the event, such as the anatomical model, medical sterilizer, and lost fetus, are attached to her body by vein-like ribbons. The factory complex on the horizon is lifeless and distant. After the injuries she suffered in a bus accident in 1925 forced her to drop out of the Preparatoria, Kahlo received some training from her father, a photographer and amateur watercolorist (page 209). An astute observer, she absorbed many of the leading trends of the 1920s, including children's art and, from an early point, Surrealism.

Notwithstanding her current fame, Kahlo's personal works paled at the time against Rivera's US murals, which resulted from a complex compromise between an ambitious artist and his equally ambitious patrons. He sought to stake his claim as the great portrayer of the working class in the world's largest economy, and perhaps the leading artist anywhere in the Americas, with a series of high-profile works that (initially)

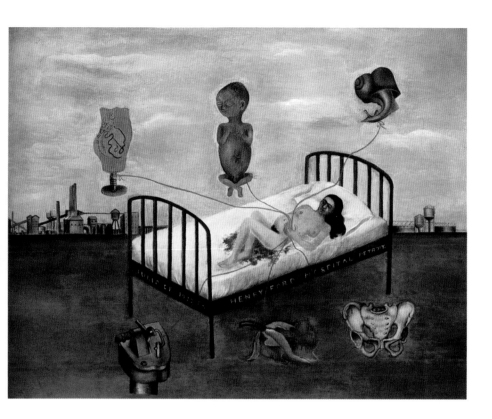

186 Frida Kahlo, *Henry Ford Hospital*, 1932.

This work alludes to traditional ex-votos, which Kahlo and many of her contemporaries collected (pages 114–115). The bed seems lost in the vacant space, though now an exterior landscape rather than a domestic interior. Here the only supernatural power offering salvation is art itself.

downplayed Marxist theory. Indeed, even though Rivera made no effort to hide his radical beliefs—and, in one panel in the Education Ministry, had even lambasted two great capitalists (Henry Ford and John D. Rockefeller) whose sons would later hire him—he garnered major commissions. He was also given a one-man show (1930–31) at the nascent Museum of Modern Art in New York City, only the second artist after Matisse to be so honored. His patrons were willing to take the risk, surely, because Rivera then represented continental America's best response to the artistic dominance of Europe: his civic-minded realism, which adapted modernist formal innovations to nationalist realities, had, as yet, no serious competition in the US.

Emilio Amero, Rufino Tamayo, and other Mexicans later painted murals in the US, but none would be as famous as those produced by Rivera, Orozco, and Siqueiros in the early 1930s. Yet in a country more sensitive to public opinion, these works were frequently attacked for their challenging views on

187 Julio Castellanos, *The Blanket Toss*, 1933.

In this mural, Castellanos politicizes a common children's game: future workers and peasants join together to torment a devil and priest by tossing them on a red blanket. Castellanos places his idealized figures, inspired by Picasso's neoclassicism, at the service of official anti-clericalism.

religion and history; the artists were at times demonized by xenophobic critics and, in a few cases, subjected to more overt acts of censorship than any had faced in Mexico. Their legacy, however, was extensive. The murals triggered a renewed interest in modern fresco painting among US artists, and helped facilitate the emergence of several public art programs under the New Deal agencies of the Roosevelt administration. Although Orozco downplayed his own need for assistants, several young painters, including Ben Shahn, eagerly worked under Siqueiros and Rivera, using this training in subsequent murals. Other US artists were inspired to travel south to see the murals of the 1920s for themselves, and a few even obtained mural commissions in Mexico (page 282). The Mexican murals of the 1930s also provided powerful precedents for the Chicano street art of the 1970s, predictably centered in Los Angeles and San Francisco.

Meanwhile, in Mexico City, a revival of mural painting and public art was underway during the presidency of Abelardo L. Rodríguez (1932–34), in part because the Depression prompted greater social spending in order to ameliorate political and economic tensions. In 1934, the government commissioned

Rivera and Orozco to paint murals for the newly completed Palacio de Bellas Artes; inaugurated a new marketplace in the colonial center that was decorated with more murals (page 282); and decided to transform the abandoned steel frame of Bénard's Palacio Legislativo into a Monument to the Revolution: Carlos Obregón Santacilia's modified triumphal arch, with sculptures by Oliverio Martínez (1901–1938), was inaugurated in 1938.

The SEP again emerged as a center for progressive reforms—now under the direction of socialist lawyer Narciso Bassols—giving modernist architects, especially Juan O'Gorman, a chance to radicalize their practice and use buildings as engines of social change. O'Gorman was named chief architect, and, along with renovating the existing infrastructure, designed several functionalist primary schools for working-class neighborhoods in Mexico City, where they boldly communicated the beneficence of the ruling regime. Bassols called for a "maximum of efficiency at minimum cost," and so O'Gorman created stripped-down factories for education, offering hygienic facilities, sunlit playgrounds, and standardized components scaled to the height of an average child. As in his studio for Rivera (page 262), he used color on the exterior walls; O'Gorman believed that in the Mexican climate, white would damage the eyes of the students. This was new architecture for the new masses, unlike Vasconcelian neo-colonialism (page 235), which recalled an era dominated by the aristocracy and the Church.

At a time when the "tres grandes" were all in the US, O'Gorman commissioned younger artists—some new to mural painting—to decorate the stairwells and corridors of these schools, continuing a policy established in previous educational showplaces, such as the Escuela Primaria Domingo F. Sarmiento (1926–27), with murals by Máximo Pacheco. Although O'Gorman gave the artists—including Castellanos, Jesús Guerrero Galván (1910–1973), and Pablo O'Higgins (1904–1983)—freedom to select their subjects, almost all feature children as protagonists, some in violent scenes that expose the dangers of child labor, the established Church, and the evils of the bourgeoisie. Like the functionalist schools themselves, these murals announce a new phase in revolutionary art, well before the administration of Lázaro Cárdenas shifted the Mexican government to the left after 1935.

Chapter 8 Political Traumas and Personal Dreams (1934–46)

Mexican artists from the mid-1930s until the end of World War II were shaped not only by changing national politics, but also increasingly by an international context impossible to ignore. In December 1934, General Lázaro Cárdenas assumed the presidency, and, although some believed he would be yet another puppet, he eventually broke with Calles, sending the "jefe máximo" into exile. To strengthen his independence, Cárdenas legalized the Communist Party, and forged a powerful alliance of union workers, peasants, soldiers, bureaucrats, and intellectuals within the official political party, renamed the Party of the Mexican Revolution (or PRM) in 1938. After a period of antagonism with the government, and even self-exile, radical artists now enjoyed a much more favorable climate for the production of left-wing imagery.

This spell of intense nationalism and populism culminated in the expropriation of foreign-owned oil companies in March 1938. Though attacked as "communistic" by the right-wing press, Cárdenas's reformist policies, partly designed to foment domestic capitalism, were actually closer in spirit to Roosevelt's New Deal than to the state-controlled economy in Stalin's USSR. But while some might have hoped that his nationalist politics would lead to a resurgence of mural painting, the regime actually privileged more ephemeral media—prints, posters, radio, and film—that had the potential to reach and influence far wider audiences. While some mural commissions emerged outside federal patronage networks, many radical artists joined collectives—the Taller de Gráfica Popular (Workshop of Popular Graphics), for example—where they created images that could swiftly address the pressing concerns of the day. In fact, much Mexican art of this period was profoundly shaped by international politics, especially the rise of military regimes in Europe and Asia, calls for a Popular Front against fascism, and the outbreak of war, first in Spain and then across the globe.

In the later 1930s, the Cárdenas regime slowed the rate of revolutionary change; however, a liberal immigration policy brought a host of new arrivals, fleeing events in Europe. Refugees included Leon Trotsky—who was granted asylum in

188 Jesús Guerrero Galván, *One of the Others, One of Our Own*, 1934, from *Choque*, no. 1 (March 27, 1934).

In this cartoon, the easel painter is associated with André Gide's *Corydon*, a book of 1924 that overtly defended homosexuality. The proletarian artist is inspired by Marx, though in fact his political philosophy actually said little about aesthetic strategies, generating endless controversies in the period.

1936, only to be assassinated by a Stalinist agent in 1940—as well as artists, intellectuals, and even orphaned children from the Spanish Republic, which fell to Franco in 1939. Among them were several leading Surrealists, whose arrival had a dramatic impact on the Mexican art scene. In 1942, under Cárdenas's successor, Manuel Ávila Camacho (1940–46), Mexico joined World War II on the side of the Allies; some sectors profited from the wartime boom. As that conflict drew to a close, the Mexican government turned national attention towards industrial growth and urban development.

I. Radical Artists' Collectives of the 1930s

A cartoon by Jesús Guerrero Galván, published in a leftist magazine in 1934, contrasts an effete easel painter—a caricature of Agustín Lazo—with a hefty worker-muralist, clearly privileging "social art" over "pure art," or art for art's sake, which is seen as over-refined and concerned with personal rather than collective needs. Placed back to back, there seems no possibility for dialogue here, though in actual practice, many artists—including Guerrero Galván himself— moved between the two positions. This cruel satire encapsulates the heated debates that shaped the Mexican art world in the mid-1930s.

In the 1930s and early 1940s most Mexican artists remained committed to figuration, though their conflicting views of the purpose of art denied any sense of a cohesive "Mexican School." Most of the Contemporáneos abstained from dealing with current events, except in loosely metaphoric terms, continuing the emphasis on rather apolitical easel painting. Equally escapist were visiting artists from the US, searching for an imagined utopia south of the border. Books and exhibitions in the United States, especially Anita Brenner's *Idols Behind Altars* (1929) and the "Mexican Arts" show curated by René d'Harnoncourt for the Metropolitan Museum of Art in 1930, began to form a canon that focused on quaint images of rural Mexico—much to the annoyance of Orozco and many on the left. To cater to a growing base of collectors—from the US in particular—the first professional commercial gallery in Mexico City, the Galería de Arte Mexicano, opened in 1935.

For radical artists, the dire domestic and international situation, especially the rise of fascism, required a greater militancy on their part. They initially refused to collaborate with the regime; like their counterparts in Germany, Italy, and the USSR, they sought instead to form part of mass society, to shape civic discourse on a dramatic scale. Rather than work in a lonely studio, they formed collectives and designed murals, prints, and posters for the most public spaces possible—including the street—primarily in support of the working class. Although ultimately independent from the dictates of the Communist International, their images and collective organizations were influenced by external political events, including the call for a Popular Front against fascism in the summer of 1935.

Leftist Mexican artists rejected the "socialist realism" imposed by Stalin in 1932, which required artists to glorify the accomplishments of the Bolshevik Revolution—and especially the figure of Stalin himself—in a conservative academic style. Instead, they argued that the limited pace of post-Revolutionary change in Mexico required greater stylistic freedom in order to challenge the system (in this, they benefited from operating in a less tightly controlled political environment). Yet Rivera and Siqueiros engaged in a virulent debate over the future course of Mexican art in the mid-1930s. Underlying this conflict was a profound and complicated division within the international Left, between the official Communist Party line (which Siqueiros

supported) and the Left Opposition (with which Rivera sympathized), led by Trotsky from exile. Siqueiros was also struggling to compete personally with Rivera's greater critical and financial success, especially in the US.

Although both artists believed in the supremacy of monumental public murals and identified with the working class, Siqueiros attacked Rivera for his "folkloric" content (referring more to his easel paintings than his murals), for his collusion with capitalists, and for his *modus operandi* as an independent creator using such old-fashioned techniques as fresco. Building on his experiences in Los Angeles and Buenos Aires (where he painted a mural in 1933), Siqueiros advocated that murals be produced by collectives, based on a spirit of camaraderie; that they serve the working class rather than the government or bourgeoisie; and that they appropriate the tools of the proletarian worker (such as the airbrush) and methods of mass communication (including photography and cinema) in order to create truly revolutionary art. Even if he himself was often absent from the country, Siqueiros created some of the most innovative works of the period, and his ideas profoundly shaped Mexican art over the next decade.

In the 1930s, Siqueiros's emphasis on collective action influenced the formation of varied alliances and blocs of radical artists, particularly muralists and printmakers. Before the establishment of the Popular Front, these groups were short-lived and sectarian; yet despite their differences, all sought to recapture the spirit of the union the muralists had created in the early 1920s. Among the first were the Liga de Intelectuales Proletarios (League of Proletarian Intellectuals; 1931) and the more influential Liga de Escritores y Artistas Revolucionarios, or LEAR (League of Revolutionary Writers and Artists; 1933–38).

Founded in late 1933 by Leopoldo Méndez, Pablo O'Higgins, Siqueiros, and others, the LEAR was initially a small militant organization affiliated with the still-clandestine PCM. The organizers included radical artists who had been active in the 1920s as well as younger writers and painters who, for the most part, had not participated in the Sindicato; Méndez, a former Estridentista, brought some of the breathless urgency of that movement to this endeavor. In its earliest phase, the LEAR took a confrontational stance to the regime: one of its early slogans was "support for neither Calles nor Cárdenas."

189 Leopoldo Méndez, *How They Try*, 1935.

This broadside shows fascist agitators known as the Gold Shirts (identified by their ARM, or Acción Revolucionaria Mexicanista, buttons) fighting unarmed workers whose banner reads "Down With Capitalist Exploitation." For many on the left, ARM emblematized a grave threat to Revolutionary reforms.

The LEAR's commitment to the class struggle was signaled by the title of its magazine, *Frente a Frente* (Front to Front), which included proletarian literature and political journalism alongside prints and photomontages, some by the German anti-Nazi artist John Heartfield. The members organized lectures, concerts, and sent "cultural brigades" to provincial cities; they held exhibitions and produced prints and posters showing workers victimized by Calles and proto-fascist organizations. Siqueiros helped form an Escuela-Taller de Artes Plásticas (School-Workshop of Visual Arts), which included night classes for urban workers, as well as a collaborative environment for artist-members.

LEAR-affiliated artists also worked on collective mural projects in the Mercado Abelardo L. Rodríguez (1933–35) and Centro Escolar Revolución (1936), both designed by architect Antonio Muñóz (1896–1965), and the Talleres Gráficos de la Nación, a state-owned printing company (1936), all in Mexico City. Some created open-air murals for rural schools, part of the SEP's ongoing Misiones Culturales. Although the Mercado Rodríguez murals were painted in the waning years of the Maximato, and thus took a more oppositional stance, the later projects revealed greater collaboration with the Cárdenas regime. All of these projects brought leftist rhetorical imagery directly to working-class audiences.

Funded by the Mexico City government (a branch of the federal government until 1997), the neo-colonial Mercado Rodríguez was a vast public works project in a downtrodden neighborhood north of the Zócalo. Ten young artists, some of whom had painted murals in the SEP's elementary schools, decorated the stairwells and corridors of the building. These included LEAR members Pablo O'Higgins and Antonio Pujol (1913–1995). The former, who had arrived from San Diego in 1924 to work as an assistant to Rivera, was joined by three other US artists: sisters Marion (1909–1970) and Grace

Greenwood (1902–1979), the first women to paint important frescoes in Mexico; and sculptor Isamu Noguchi (1904–1988), whose horizontal relief covered in tinted cement represented a unique attempt in Mexico to translate didactic muralism into the language of European abstraction.

The city authorities initially requested that the artists depict positive images related to health, hygiene, and food, in praise of the post-Revolutionary regime. But after the LEAR became involved—surreptitiously at first—most of the painters used their walls to emphasize lurking dangers, including poverty and unemployment, the suppression of strikes, and the triple threat of war, fascism, and imperialism. One of the most visually complex murals in the market is Marion Greenwood's *Industrialization of the Countryside*, which exposed how food production and distribution are controlled by capitalist forces to the detriment of the poor. After returning from New York, Rivera was given a supervisory role over the muralists; although his involvement was rather limited, most of the murals, including those by the Greenwoods, were inspired by his style and technique.

After 1936 the LEAR softened its antagonistic position and prospered, expanding beyond the fine arts and literature to

190 Marion Greenwood, *The Industrialization of the Countryside* (detail), 1934–35.

LEAR images frequently showed the necessity for direct, even violent, action. Greenwood's stairwell cycle culminates in a scene that shows striking stevedores fighting police in the port of Tampico. Such an aggressively leftist image would have been impossible in a public building in the US.

include sections dedicated to music, theater, cinema, and photography, and sending delegations to the American Artists' Congress in New York in 1936 and the International Congress of Writers for the Defense of Culture in Valencia in 1937. Membership growth, however, was partly tied to the organization's access to teaching positions in the SEP, a chief source of livelihood for artists, musicians, and writers. Tensions arose between these so-called "opportunists" and the more radical artists, and in late 1937, the organization collapsed.

The Taller de Gráfica Popular was founded by Leopoldo Méndez, Pablo O'Higgins, Luis Arenal (1908–1985), and Raúl Anguiano (1915–2006) in late 1937; Angel Bracho (1911–2005), José Chávez Morado (1909–2002), and Alfredo Zalce (1908–2003) joined soon thereafter to form the core of a membership that would fluctuate over the following decades and include guest members from Mexico and abroad. Although the TGP was initially affiliated with both the LEAR and union leader Vicente Lombardo Toledano's Universidad Obrera (Workers' University), the workshop eventually became independent. With roots in the pages of *El Machete* (page 239) and the ¡30-30! movement (page 267), as well as LEAR broadsides, the TGP was the first organization in Mexico devoted exclusively to the production of radical graphics, considered the most expedient and inexpensive means of communicating pressing social and political issues to a broad popular audience. In the spirit of the Popular Front, not all artists associated with the TGP were Party members, though all were required to take a stance against fascism.

Printmakers in the TGP preferred lithographs and linoleum cuts, which allowed rapid execution, though they occasionally used woodcuts. While Siqueiros later complained that the Taller should have employed more industrial reproductive technologies, such as offset printing, Méndez and others in the TGP believed that fine craftsmanship was essential to effective visual communication. Despite their collective spirit, marked by sessions of mutual- and self-critique, the artists were free to pursue individual styles, ranging from crude expressionism to surrealist playfulness, from bitter caricatures to an idealized figuration that at times approaches the dictates of socialist realism. (In 1940, Soviet critics attacked TGP work as too formally experimental and insufficiently didactic.)

TGP artists appropriated a variety of visual languages from past and present. Their greatest hero was Posada (page 224), though they tended to exaggerate his radical beliefs. Also influential were Orozco's lithographs; prints by such German Expressionists as Käthe Kollwitz and George Grosz; Spanish Civil War posters; and Mexico's own political cartoonists of the late nineteenth century, including Constantino Escalante (page 173) and Daniel Cabrera (page 204). Artists based works on press photography, too, as had Posada decades before. Some images were produced quickly to address issues of the moment, and distributed for free; others were more formally resolved, even elegant, and released in limited editions for sale.

In the early years of the TGP, the most important images, whether issued in portfolios or as separate prints, dealt with the threat of war and fascism. TGP members created images in support of the Spanish Republic (the most important body of visual imagery on the Spanish Civil War produced outside Spain) and the USSR, and condemned Nazi Germany and anti-Semitism. Posters juxtaposed bold and sometimes grisly lithographs with attention-grabbing red typography; they were pasted onto city walls at night. In the spirit of Posada's broadsides and the Estridentista manifestos, these ephemeral works acted as instant murals, allowing the rapid and mass communication of topical information.

The members of the TGP also explored domestic issues, from the effects of urbanization on Mexico's poor (page 314) to the danger of local fascist sympathizers—pro-Franco Spanish shopkeepers, for example. Threats to the radical reforms of the Cárdenas administration were also highlighted: these included TGP exposés of corruption, critiques of the boycott of the Mexican oil industry by the US and England after the 1938 expropriation, and attacks on the power of mass media, especially the conservative newspapers that were the TGP's leading competitors for public attention. As well as generating their own projects, the members of the TGP obtained commissions from labor unions, anti-fascist groups, and even government ministries to make calendars, posters, and broadsides for wide distribution; the group's precarious financial situation was only partially alleviated by membership fees and infrequent payments.

Not all TGP images were negative attacks, of course, but the less combative imagery was often designed for sale to help

91 Pablo O'Higgins, *For Franco*, 1938.

This print attacks members of the pro-fascist Spanish community in Mexico City. A capitalist vulture controls sacks of beans and corn; the shopkeeper raises his prices. Bags of money are stored in the pro-Franco Casino Español. The artist changed his name from Paul Higgins in the late 1920s, around the time he joined the Mexican Communist Party.

192 Leopoldo Méndez, *Professor Juan Martínez Escobar*, 1939.

In 1939, with financing from the SEP, Méndez produced a portfolio of seven lithographs titled *En nombre de Cristo*, condemning the killing of rural schoolteachers by members of the Cristero movement, a peasant uprising against anti-clerical government policies. The print shows a worker pointing at the murderer, his identity revealed as a false mask of Jesus falls from his face.

194 Leopoldo Méndez, *Televicious Calaveras*, 1949.

In the spirit of Posada, the TGP produced calavera sheets around the time of the Day of the Dead. These also included satirical poems on topical issues. Méndez here uses a convention common in art since the nineteenth century: the worker who gazes longingly through a window at the pleasures of bourgeois life (page 197)

193 José Chávez Morado, *Fascism in Latin America*, 1939.

Some of the earliest TGP images were posters advertising a series of anti-fascist lectures held at the Palacio de Bellas Artes, and sponsored by the Liga Pro Cultura Alemana en México, a German émigré group. Here a Nazi crocodile threatens an Aztec statue with a Star of David on its chest.

EL FASCISMO

6ª CONFERENCIA *El Fascismo en Latino-América*

ORADOR
Lic. Ricardo José Zevada

VIERNES 2
DE JUNIO
PALACIO DE
BELLAS ARTES
A LAS 20 HORAS
ENTRADA LIBRE
RADIO
X E F O
Y
X E U Z

LIGA PRO·CULTURA ALEMANA EN MÉXICO

CALAVERAS TELEVISIOSAS
todo por un hoyito

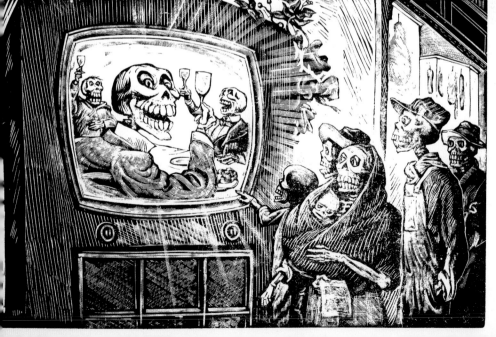

fund other group projects. In 1942, former Bauhaus director Hannes Meyer, then living in exile in Mexico City, was named business manager of the TGP. He established La Estampa Mexicana, an editorial wing that produced high-quality limited-edition portfolios, focusing on rural life and uplifting scenes of the Revolution. These were subjects of greater interest to collectors than brutal anti-fascist attacks, and their sales brought economic stability to the organization; income from *Mexican People* (1946), an album of color lithographs, supported the TGP for an entire year. An even more ambitious endeavor was *Estampas de la Revolución Mexicana* (1947), a portfolio of eighty-five linocuts in which almost all the members of the TGP participated.

In part because of increased cultural exchange between Mexico and the US during the war years, the TGP achieved greater international fame in the 1940s. Some of the founders left, mainly due to political disagreements, while new members—such as Adolfo Mexiac (b. 1927) (page 256), Alberto Beltrán (1923–2002), and US artists Mariana Yampolsky (1925–2002) and Elizabeth Catlett (1915–2012)—reinvigorated the organization with fresh ideas. There were postwar concerns to address, from the trial of US communists Julius and Ethel Rosenberg to the impact of television; Méndez produced some of his greatest works in this period, including linocuts used for the title sequences in nationalist movies directed by Emilio "El Indio" Fernández (1904–1986). Yet the TGP gradually lost its political cohesiveness and relevance. Its decline was assured by 1960, when founders Méndez and O'Higgins, among others, moved on to other projects.

II. Artists at War

Although involved in the LEAR, Siqueiros was too peripatetic to play an extended role in the organization. In early 1936, while in New York for the American Artists' Congress, he founded the Siqueiros Experimental Workshop: A Laboratory of Modern Techniques in Art. In collaboration with LEAR members Luis Arenal and Antonio Pujol, and several younger US artists—including Sande McCoy and his half-brother Jackson Pollock (who mainly watched from the sidelines)— Siqueiros designed posters, banners, floats, and other ephemeral materials for the Communist Party of the USA, as

195 David Alfaro Siqueiros, *Collective Suicide*, 1936.

The title refers to the mass suicide depicted in the lower section of the painting, perhaps of Chichimec warriors during the Conquest. Siqueiros saw the event as broadly parallel to the imminent clash between fascism and capitalism, and the conflagration out of which a new order would emerge.

well as working on dramatic paintings that expressed the urgency of the anti-fascist struggle, and the dangers of working-class complacency. In these latter works, destined for elite patrons familiar with avant-garde strategies, Siqueiros was able to bring the aesthetic and political theories that he had explored in Los Angeles and Buenos Aires into distinct focus.

In such anti-fascist allegories as *Collective Suicide*, Siqueiros employed industrially produced materials, including plywood and fast-drying nitrocellulose lacquers of the type used for airplane and automobile exteriors (Siqueiros sometimes, but not always, used a variety marketed under the trade name Duco). Because these materials were used and manufactured by the working class, he believed artworks that incorporated them were inherently proletarian. Inspired by the Surrealist technique of controlled accidents, he placed wooden panels on the floor, then applied paint with a brush, dripped it from a stick, or poured it directly from the can. Siqueiros also added solvents to create chemical reactions on the surface: the pictures thus embodied violent forces in their very creation.

Finally, representational images were included, by airbrushing over stencils or even painting over pasted-on photographs. Such methods facilitated production, allowing the modern artist to compete with newspapers or radio for wider audiences; the results, however, were unique works of inspired genius rather than anonymous products of an assembly line.

In early 1937 Siqueiros left New York to fight in the Spanish Republican army, abandoning art for direct participation in the war against fascism. The legacy of his Workshop continued into the postwar period, however, particularly in the mature paintings of Pollock, which were partly inspired by Siqueiros's experimental techniques and impassioned urgency, though now—in the context of the Cold War—purified of his explicit political messages.

In the 1930s, the microphone and film projector, rather than the immobile fresco, became the chief tools of propaganda. Already in 1934 the SEP had financed a stirring political film about oppressed Veracruz fishermen—released in 1936 as "The Wave"—created by a US–Mexican team that included Paul Strand (1890–1976) and Fred Zinnemann (1907–1997); the movie was designed to bring the social urgency of muralism to walls (or screens) in communities across the country. Under Cárdenas, a new Departamento Autónomo de Prensa y Propaganda (Autonomous Department of Press and Propaganda) strategically deployed posters, radio, and other media to communicate political messages.

After 1936, muralism was thus played down as an official strategy by the federal government; among the few exceptions was O'Higgins's fresco cycle in a Mexico City elementary school that celebrated the oil expropriation (1939–40). Rivera's re-creation of the destroyed RCA mural in the Palacio de Bellas Artes (1934) and his completion of the stairwell fresco in the Palacio Nacional (1935) were his last federal commissions until 1942. Mural commissions now came increasingly from the private sector, particularly hoteliers seeking to capitalize on the fact that the murals were an essential stop on the booming tourist circuit; from trade unions; and from provincial authorities intent on creating a local cultural "renaissance." Not until the early 1950s would murals—now mainly on exterior walls and relatively tame in terms of subject matter—return to prominence in federal government projects (pages 321–23).

Rivera had explicitly condemned both Hitler and Mussolini in his *Portrait of America* (1933), painted in a Trotskyite school in New York during his Rockefeller Center debacle, but he generally avoided the war as a theme except for a small panel in a later mural executed in San Francisco in 1940. Anti-fascism in the murals by Orozco and Siqueiros of the late 1930s was more allegorical. In part this is because public art often forces artists to think about the long-term relevance of their works; in Orozco's case, it was also due to his skepticism about all forms of ideology, while Siqueiros was negotiating even more tricky political terrain.

Orozco engaged the political climate of the time in several of his most famous murals. Upon his return from the United States, he completed a fresco in the Palacio de Bellas Artes (*Catharsis*, 1934) and then moved to Guadalajara, in his native state of Jalisco, where governor Everardo Topete commissioned three mural cycles of increasing complexity and extension.

In Guadalajara's Palacio de Gobierno (1936–37), an enormous portrait of Independence leader Miguel Hidalgo towers over the main stairway; holding a torch, he has returned from history to purge decadence and evil from a chaotic world. Orozco's greatest mural cycle was completed in the former chapel of the Hospicio Cabañas (1938–39), the orphanage designed by Manuel Tolsá. Here he refined his expressionist style on a vast scale, envisioning such historical figures as Cortés, Philip II, and an anonymous Franciscan as frightening prophets of unstoppable social transformations that culminate in humanity's immolation by fire. Several panels may refer to the parade grounds of Nuremberg. *Dive Bomber and Tank* (1940), a portable mural commissioned by the Museum of Modern Art in New York, obliquely references the Nazi blitzkrieg. In all of these furious attacks on the consequences of war in the machine age, Orozco avoided partisanship; instead, angered yet aloof, his ultimate concerns were the more general dangers of technology and mass organization.

Siqueiros, on the other hand, epitomized sectarianism in this fraught period. He returned to Mexico in 1939, down but not defeated after the fall of the Spanish Republic. Soon thereafter he accepted a commission from the radical Sindicato Mexicano de Electricistas (Mexican Electricians' Union) to paint a mural in their new functionalist headquarters (1936–41), designed by Enrique Yañez (1908–1990). Siqueiros again

196 José Clemente Orozco, *Hidalgo*, 1936–37.

In this mural, Hidalgo towers above a mass of struggling humanity. As one climbs the stairway, images to the left (*The Phantasms of Religion in Alliance with the Military*) and right (*The Carnival of Ideologies*) come into view. Hidalgo's pose echoes that of Jesus in Michelangelo's *Last Judgment* (1508–12), transforming him into an angry messiah.

assembled a team, including his longtime allies Luis Arenal and Antonio Pujol, and a recent exile, the Spanish artist Josep Renau (1907–1982), who had directed the Republic's propaganda efforts.

Although the mural is today known as *Portrait of the Bourgeoisie*, the artists originally focused on the separate themes of "Fascism," "War," and "the Electrical Industry." In the center, a machine controlled by capitalist-imperialist forces converts the blood of the working class into red-hot coins. This machine also operates a mechanical parrot-headed dictator, who rallies the masses and directs marching fascist soldiers; stencils were used to make each a perfect replica of the next. Amid scenes of total destruction, including burning buildings and gruesome corpses, a monumental proletarian soldier surges forth to save the day. Rendered in slick lacquer, much of the work is based on photographs—which Siqueiros believed were modern and objective substitutes for the traditional artist's sketch—lifted from the pages of the US magazines *Life* and *Look*, appropriating the capitalist mass media against the system itself.

The mural is also radical in terms of the relationship between imagery and architectural space. Rather than just "decorate" the three walls and ceiling, Siqueiros and Renau employed cinematic strategies, envisioning the work as a multi-screened projection of complicated montages, which denied the limits of the architecture (images move seamlessly across the corners of the stairwell). They also took into account the changing point of view of spectators as they moved up or down the stairwell. Siqueiros would use a similar strategy in many of his subsequent murals.

This mural was deeply implicated in the doctrinal shifts and vicious divisions that wracked the Left. The original concept included direct references to the victims of the Spanish Civil War, as well as to Mussolini; these were eliminated to bring the mural into compliance with official Communist policy that prohibited explicit attacks on the fascist regimes following the Nazi–Soviet Non-Aggression Pact of August 1939. The theme of the mural was then changed to "Monument to Capitalism." The mural was still unfinished in May 1940, when a team led by Siqueiros attempted to assassinate (or at least frighten) Trotsky, then living in Coyoacán. After a Stalinist agent murdered him that August (page 279), Siqueiros was arrested

197 David Alfaro Siqueiros, *Portrait of the Bourgeoisie* (detail), 1939–40.

The complex mural compositions by Siqueiros were particularly indebted to montage theory, an avant-garde strategy used by photographers and filmmakers, including Sergei Eisenstein. Disparate visual elements taken from various sources are seamlessly assembled on the flat surfaces of the wall. Meaning is generated by the individual visual elements as well as by their juxtaposition.

198 Rufino Tamayo, *Animals*, 1941.

The pointed ears and bony bodies of these dogs are derived from pre-Hispanic tomb sculptures from Colima, which Tamayo, Rivera, and many others avidly collected. Placed against a burning sky, however, these ancient forms are now re-envisioned as tropes for the modern victims of war.

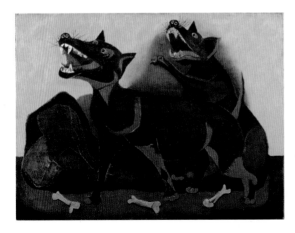

and exiled to Chile. Although unsuccessful, the first attack revealed the consequences of his activist-artist position taken to the extreme, and destroyed Siqueiros's reputation in the US for decades. Renau, meanwhile, completed the mural largely on his own.

Although it was geographically distant, World War II also affected many artists who were not principally engaged with public art, among them Tamayo, Antonio Ruiz (1892–1964), Juan Soriano (1920–2006), and others sympathetic to the ideas of the Contemporáneos, who had generally avoided political commentary in their work. They rejected the doctrinaire symbolism of the TGP or Siqueiros; rather than tanks or swastikas, they dealt with the war through metaphors of angst, suffering, and even guilt. Picasso's *Guernica* was a major source of inspiration, especially after a show of paintings and drawings related to this mural toured Mexico in 1944. Free of temporal specificity, without named victims or villains, Tamayo's images of barking dogs and other frightened animals of the 1940s, and the

non-sectarian allegories by Orozco, are the more lasting Mexican images of the greatest conflict of the century.

III. The Surrealist Knot

Of the European modernist currents that inspired Mexican painters in the 1930s and 1940s, none had as profound an effect as Surrealism, an aesthetic movement launched by the French poet André Breton in a manifesto of 1924 that called for a search for truth based more on Freud than Marx. In the 1920s, Breton and other Surrealists looked to Mexico as a source for inspiration, both as a mythical place in the imagination and an actual space for artistic practice. They were fascinated by the country's dense cultural history, including the pre-Hispanic past and surviving folk rituals. The Surrealists also saw Mexico as a place of greater freedom, in part because of the (easily romanticized) Mexican Revolution, in part because of their general (and often exaggerated) sense of the Americas as a realm of primitive psychic forces and beliefs.

Breton's theories appealed to several Mexican artists who were concerned with private rather than public issues. In the following discussion of the impact of this movement in Mexico, the uppercase "Surrealism" will be reserved for Breton and his immediate followers; the lowercase "surrealism" (or *sobre-realismo*, to use the Spanish equivalent common in the period) describes and contextualizes a less precise category of Mexican paintings and photographs, marked by uncanny juxtapositions and references to dreams and the subconscious, but not directly connected to Breton's specific aesthetic and political platform. These latter works often provide evidence of a shared artistic genealogy that included naïve painting, Symbolism, and Giorgio de Chirico, and a rejection of science and technology as paths to social perfection.

Even in the late 1930s, when Mexican artists were better informed about Surrealism, not all Mexican surrealists shared Breton's commitment to revolutionary politics, especially Trotskyism; indeed, some adopted surrealist effects as part of a more general rejection of political art. More importantly, Mexican surrealism often contains a nationalist and even religious component that would have been anathema to Breton and other leading Surrealists, who sought to create an internationalist force beyond the restrictive limits imposed by the state and the Church.

The first contacts between Mexican artists and the Surrealists were filtered through the pages of the magazine *Contemporáneos*. Surrealism offered an alternative to the nationalist muralist project, and justified an individual exploration of the psyche. Sympathetic poets, such as Jorge Cuesta, who had met Breton in Paris in 1928, published articles on the literary aspects of Surrealism, and the editors selected images by Joan Miró and Man Ray for publication. The magazine also illustrated works by De Chirico in 1928, probably through the intercession of Agustín Lazo, who had seen a major exhibition of metaphysical painting in Rome. The Italian's impact on Mexican art would be particularly strong, partly because his images of plazas, arcades, and monuments resonated with local architectural forms.

In the late 1920s, Rufino Tamayo and Manuel Álvarez Bravo incorporated Surrealist concepts in their works, which often show strangely juxtaposed objects, as well as explicit references to sleep and dreams (page 254). Álvarez Bravo read widely, and knew of the Surrealist interest in French photographer Eugène Atget, which probably shaped his own idiosyncratic vision of shop windows and architectural forms in Mexico City (page 259). When Álvarez Bravo's *Optical Parable* (1931) was erroneously printed in reverse, the photographer embraced this as a surrealist accident that confirmed how lenses and eyes invert reality; after 1935, he never again exhibited the photograph in its "correct" orientation.

Agustín Lazo had more direct connections to Europe in this period. While in Paris in the 1920s, he studied theater design at Charles Dullin's Théâtre de l'Atelier, where he probably met the Surrealist renegade Antonin Artaud; he was also a close friend of French poet Max Jacob. While still abroad he helped disseminate information on the European avant-garde in Mexico through articles and interviews; Lazo also lectured on Surrealism and published translations of Breton's writings in the late 1930s. Lazo created dreamlike landscapes featuring galloping horses and forlorn statues, some echoing the poems of his intimate friend, Xavier Villaurrutia. His collages of clipped engravings taken from illustrated magazines, directly inspired by Max Ernst, might be the most genuinely Surrealist images created by a Mexican artist in the decade.

In 1936, Artaud—who had broken with the Surrealist movement because of Breton's radical politics, but remained committed to its principles—arrived in Mexico to give a series

of lectures, sponsored in part by the Universidad Nacional. A poet associated with the Contemporáneos, Jaime Torres Bodet, provided diplomatic support. Artaud remained in the country for nine months, and published more than twenty articles in the local press, providing many in Mexico with their first direct contact with Surrealist theory. Less an anthropologist than a mystic, Artaud was searching for what he called the "Red Earth:" a fertile, spontaneous, even pure indigenous spirit, close to nature and free from the impact of European culture. (This, in fact, ran counter to contemporary *indigenista* politics, which sought the incorporation of Indians into the modern state.) His trip culminated in an expedition to the remote Sierra Tarahumara, where he discovered peyote (a native cactus that has mind-altering properties when ingested) long before the Beats.

Unkempt, penniless, and rambling in French, Artaud was an extreme character even for the bohemians of the Mexico City art world; he made few direct contacts other than the Guatemalan-born poet Luis Cardoza y Aragón (1901–1992), one of the only local critics who understood Surrealist theory. But he also met María Izquierdo, who offered the writer a room in her apartment in the colonial center. Tamayo's former partner, Izquierdo shared his interest in "pure art," emphasizing free and poetic expression rather than collective needs. Izquierdo was a rather prominent artist at the time of Artaud's arrival; in 1930, she was the first Mexican woman to have a one-person exhibition in New York, achieving success despite the trials of establishing an independent career as a woman in Mexico.

Around 1932, Izquierdo began working in gouache on paper, an economical strategy at a time when there were few private collectors. Her dreamlike landscapes, cosmic allegories, and stable and circus scenes are sophisticated compositions, informed by children's art, by Tamayo's own work, and by De Chirico and Surrealism—an expected influence, given that she too belonged to the Contemporáneos circle. Though their meanings are ambiguous, the gouaches frequently reference themes of entrapment, vulnerability, and escape, partly a commentary on the continuing restrictions faced by women in Mexican society.

Artaud embraced Izquierdo's gouaches, but read them completely differently, reminding us of how Mexican art has

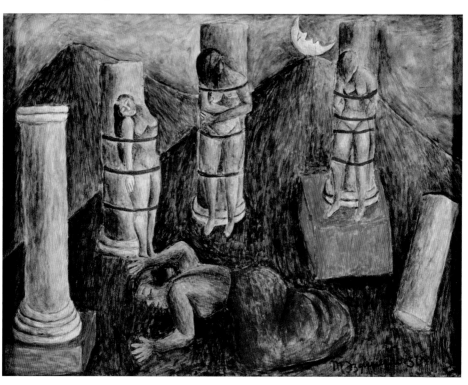

frequently been (mis)interpreted by outsiders. He knew they were "tainted" by her education, but to him they seemed expressive and terrifying confirmations of deep and ancient racial forces. That Izquierdo *looked* the part—she was a pioneer in adopting indigenous clothing, hairstyles, and jewelry that had nothing to do with her particular origins—facilitated Artaud's interpretation of her work as more authentic. Perhaps because she herself was living on the margins, Izquierdo welcomed Artaud's validation; he organized an exhibition of her gouaches in Paris in 1937 (two years before Kahlo made her splash in that same city). In later years, Izquierdo turned to more quaintly folkloric subjects, still lifes related to the altars of the Virgin of Sorrows, for example, or landscapes featuring peculiarly Mexican forms, such as indigenous granaries, in part to satisfy the demands of the art market.

In April 1938 Breton and his wife, Jacqueline Lamba, arrived in Mexico. He had both personal and political goals. Like Artaud he sought to experience firsthand a nation that figured in his imagination as the "surrealist place *par excellence*;" he also lectured and published articles during his visit in order to disseminate Surrealist doctrine. But Breton also met with Trotsky, and together they wrote a manifesto, "For An Independent Revolutionary Art," which advocated the artist's complete stylistic freedom in the face of totalitarian controls, especially Stalinist orthodoxy (the manifesto was co-signed by Diego Rivera, since Trotsky had promised the Cárdenas regime he would not engage in political activism).

Rivera, interested in establishing his avant-garde credentials and sympathetic to Breton's politics, offered the French couple lodgings in his San Ángel studio (page 261); Rivera, Trotsky, Breton, and their wives also traveled together to pre-Columbian sites and colonial towns across Central Mexico. Nevertheless, Breton endured intense criticism from artists and intellectuals affiliated with the Mexican Communist Party, which opposed his association with Trotsky; his lectures were boycotted and the Surrealist movement was savagely attacked in the press. As often happened in the 1930s, politics trumped aesthetic theories.

Mexico's connection to Surrealism intensified after Breton's visit. In 1939 he organized an exhibition entitled "Mexique" at the Galerie Renou et Colle in Paris, which featured works from his own collection, including pre-Hispanic sculptures, Huichol

201 Diego Rivera, cover of *Minotaure*, no. 13 (May 1939).

Edited by André Breton and Pierre Mabille, *Minotaure* (1933–39) was a luxurious publication sponsored by poet and Surrealist patron Edward James (page 309). Each cover was designed by a leading artist; Rivera's version of the mythical beast and the surrounding maze includes subtle references to pre-Hispanic art, also evident in the typography.

ceremonial objects, Day of the Dead toys, colonial ex-votos (page 115), and works by Álvarez Bravo, Kahlo, and Posada. Some were illustrated in an issue of the Surrealist magazine *Minotaure*, with a cover by Diego Rivera. For Breton, the strange imagery—strange at least to his outsider's eyes— in this assemblage of high and low materials confirmed the international reach and relevance of his theories, precisely at a moment that the Surrealist movement was fading in Europe. It also served to give Manuel Álvarez Bravo and Frida Kahlo an international legitimacy they would never lose; indeed, they were perhaps the first modern Mexican artists to break free from the narrow confines of the post-Revolutionary "renaissance."

IV. An Exhibition and an Invasion

Other connections between Mexican and European Surrealists emerged as a direct result of World War II, when several leading writers and painters moved to Mexico as part of a broader exodus of artists from Europe to the Americas that would send Miró to New York, Salvador Dalí to Hollywood, and Wifredo Lam back to Havana. When Austria was overrun by the Nazis, Austrian artist Wolfgang Paalen (1905–1959), together with his French wife, painter Alice Rahon (1904–1987),

and the Swiss photographer Eva Sulzer (1902–1990), were in British Columbia searching for totems; they decided to extend their fascination with New World ethnography by continuing on to Mexico. Over the next three years, they were followed by Spanish painter Remedios Varo (1908–1963) and her husband, French poet Benjamin Péret (1899–1959); a young English painter named Leonora Carrington (1917–2011); US artist Gordon Onslow-Ford (1912–2003) and his wife Jacqueline; the Chilean poet César Moro (1903–1956); and the Hungarian photographer Kati Horna (1912–2000) and her Spanish husband, artist José Horna (1909–1963). At least initially, this diverse international community remained somewhat aloof from the Mexican art world, perhaps because they were unsure of how long they would stay in the country.

With Breton advising from Paris, Wolfgang Paalen and César Moro signaled the expanded importance of Mexico City on the Surrealist map by organizing an International Surrealist Exhibition, to be held at the Galería de Arte Mexicano, the capital's most important commercial gallery, in January 1940. The show included works sent from Paris by European artists from Hans Arp to Raoul Ubac, some of whom—Picasso and Henry Moore, for example—were only tangentially connected to Surrealism. There were examples of automatism, drawings by the insane, pre-Hispanic ceramics from Rivera's collection, dance masks from Mexico and New Guinea, and even a sponge-covered umbrella made by Paalen (it absorbed rather than shed water). Modern Mexican artists with shared surrealist affinities were set apart in the catalogue, except for Álvarez Bravo and Kahlo, who had been featured in Breton's Paris show; Rivera pressured the organizers to be included in that privileged group. The opening was a major social event, but the show itself was not a critical success—perhaps because it seemed elitist or irrelevant to nationalist critics, perhaps because of the lingering taint of Breton's Trotskyism.

Many of the Mexican artists conceived works specifically for the exhibition: Rivera's impossibly titled landscape, *Minervegtanimortvida*, and Ruiz's *Dream of Malinche*, for example, both of 1939, reveal self-conscious efforts to create explicitly Surrealist paintings. Other artists, including Lazo and Guillermo Meza (1917–1997), submitted less overtly Mexican works that were more neoclassical than Surrealist. Surprisingly, Izquierdo, who had been anointed by Artaud, was not included and nor

202 Manuel Álvarez Bravo, *The Good Reputation Sleeping*, 1939.

In one of Álvarez Bravo's most Surrealist compositions, a studio model poses on a Mexico City rooftop, wrapped in medical bandages, and uncomfortably close to some spiny cactus pads. The overt eroticism of this image prevented its intended use on the cover of the International Surrealist Exhibition catalogue of 1940.

was Siqueiros, the one Mexican artist who had most successfully adopted Surrealist theories of automatism—perhaps for political reasons.

The works of Carlos Mérida and Frida Kahlo, both of whom were included in the show of 1940, reveal the broad range of Mexican surrealist practice at the time. While Kahlo represents the dominant strand, evidenced by her legible imagery and nationalist references, Mérida was inspired by the abstract biomorphism of Arp and Miró. In the mid-1930s Mérida created what might be the only fully non-representational paintings produced in Mexico at the time (though most of his images do reference the human figure in some way). His adventurous path would distance him from most critics until the 1950s; even Breton believed his work was too European.

In the early 1930s, Kahlo was already showing an aesthetic interest in dreams, memory, violence, and sacrifice, themes that resonated with the Surrealist movement. For example, as closely tied as her *Henry Ford Hospital* (page 275) is to the ex-voto tradition, it is hard not to find parallels to Dalí's *Persistence of Memory* of just a year before, a painting that also has specifically biographical references. Several other works,

203 Carlos Mérida, *Plastic Invention on the Theme of Love*, 1939.

including *What the Water Gave Me* (1938) and her famous diary, were probably directly inspired by Surrealist theory. Like Izquierdo, Kahlo was critically framed by Surrealism from an early stage; besides Rivera, her greatest champion was Breton, who called her work "a ribbon around a bomb." Although they were not unknown, her paintings were infrequently exhibited before 1938, when Breton convinced Julien Levy in New York to give her a one-person show; she attained additional fame after showing in Paris in 1939. Kahlo also willingly participated in the Surrealist Exhibition of 1940, submitting two large canvases, *The Two Fridas* and *The Wounded Table*, certainly to garner attention.

In an interview of 1938, however, Kahlo famously said, "I never knew I was a Surrealist until André Breton came to Mexico and told me I was one." And it is true that simply to label her work "surrealist" can obscure her many other sources, both local and international, ranging from Aztec manuscripts, provincial portraiture, the Escuelas de Pintura al Aire Libre, and Estridentismo, to Symbolism, German Neue Sachlichkeit, and even her father's obsession with photographic self-portraits. But Kahlo's disavowal must also be understood as a personal and political decision to distance herself from Breton, as well as a rejection of the attempt by a male critic to simplify and possess, if only semantically, her complex persona. Kahlo may not have been officially a Surrealist, but the movement liberated her to explore inner fears and desires; to explore personal rather than public issues; and to move beyond the rationalism of modern society that so profoundly shaped the work of her husband and many of the other muralists.

In *The Two Fridas*, the painter is literally beside herself, split into urban and rural, virginal and earthy, and European and mestizo identities: a shared circulatory system links the two parts. The format appropriates the composition and directness

204 Frida Kahlo, *The Two Fridas*, 1939.

Kahlo owned both costumes shown here: a white European dress and the short blouse and long skirt favored by indigenous women in Tehuantepec. The miniature portrait of Rivera she holds recalls lockets carried by women in eighteenth-century Novohispanic portraits.

of nineteenth-century marriage portraits by provincial painters, just then being rediscovered by artists and collectors, including Kahlo and Rivera. As in many of Kahlo's works, clothing is a crucial marker of identity, but the artist was no anthropological purist: she mixed and matched costumes from her collection as part of a theatrical performance in which she played many roles, but never presumed actual indigenous identity (most of her costumes resulted from mestizaje). Although she was not the first or only urban Mexican woman to wear ancient jade beads or folk dresses, Kahlo was more flamboyant than most—perhaps to conceal her middle-class urban origins, and the fact

that she was half German (Kahlo's father was not actually of Jewish descent, though she may have cultivated the idea). Once rather shocking, her cultural cross-dressing was widely adopted by elite Mexican women and US tourists from the late 1940s on, as evidenced by many of Rivera's own society portraits.

Kahlo's relentless pursuit of an artistic identity distinct from those of her generation has thoroughly captivated modern sensibilities, making her easily one of the most famous and recognizable twentieth-century artists from anywhere in the world. Her life and art have been thoroughly dissected and interpreted by biographers, feminists, Chicanos, and psychoanalysts; her paintings have been distorted by advertisers and invented by fakers. Working in a visual language that was profoundly inspired by Mexican culture, Frida Kahlo could be from no other place; her art seems uniquely her own. Yet her popularity resides largely in her arresting depiction of personal traumas that were usually hidden from view: the fragile body wounded in an accident that forced her to abandon her studies; the inability to have a child; the feeling of being overshadowed by a partner; and the sense of being torn between sexual, political, and cultural identities. Kahlo seems to tell us private stories with total honesty, as if we were her closest friends, but we should be wary of her claim that she merely "painted her own reality." She was above all an artist, and a skilled one at that. Her life and her art were the products

205 Frida Kahlo, diary pages, 1951.

Kahlo created her "Diary" between 1944 and 1953, though it is more of a note- and scrapbook than a chronological record. Many drawings use automatist techniques or allude to Surrealist icons, such as Janus and the Minotaur, seen here. Showing her fears and obsessions, but also her sharp wit, the final product was one of Kahlo's most fascinating endeavors.

of a meticulous process of self-invention that was only partly Surrealist, and maybe precociously postmodern; that is why she has inspired a host of contemporary artists, from gay neo-Mexicanists (page 382) to Kiki Smith.

The International Surrealist Exhibition of 1940 prompted a surge in dreamlike imagery in the work of Mexican artists. Guillermo Meza, Roberto Montenegro, and Juan Soriano, as well as Carlos Orozco Romero (1896–1984) and Manuel González Serrano (1917–1960), all practiced a very literal type of surrealist painting in the 1940s, with endless references to dreams and nightmares, violent dangers, strange and sometimes erotic juxtapositions of still-life elements, and references to ancient myth. Formally, these works are as much indebted to De Chirico as to any other artist, though Picasso and Dalí echo throughout. Even in political prints by Anguiano, Zalce, and others in the Taller de Gráfica Popular, one can trace the impact of Surrealism—though in the service of radical reform rather than poetic meditation.

At the same time, some Mexican paintings of this period might seem to be the product of dream imagery, but are actually rather ethnographic. Orozco Romero's *The Pledge* depicts a shrouded woman wearing a thorny cactus pad, typical of penitents at the pilgrimage center of San Juan de los Lagos, in Jalisco; Soriano's images of angelitos, or dead children laid out before burial, relate to Novohispanic precedents (page 131), as well as a photographic tradition that continued in the 1940s. Although either artist might have accepted the label, calling their works "surrealist" distracts us from the cultural practices they directly reference.

The Surrealist exile with the strongest presence in Mexico was Wolfgang Paalen, who had been a protégé of Breton in Paris in the 1930s. In Mexico City, Paalen published *Dyn* (six numbers were issued between 1942 and 1944), a multidisciplinary art magazine with texts in English and French (but not Spanish) that revealed his international focus; Mérida was one of the few local artists featured. Among the most important collaborators was Robert Motherwell, who had traveled to Mexico in 1941 together with Chilean painter Roberto Matta specifically to meet Paalen. Through *Dyn*, Paalen rejected Breton's dogmatic faith in dialectical materialism, and instead announced a new "ethical" aesthetic, based on the moral objectivity of the physical sciences as well as on

206 Carlos Orozco Romero,
The Pledge, 1942.

This painting was directly
appropriated from an image by
the renowned photojournalist
Enrique Díaz (1895–1961) that
illustrated an article on penitents
in the popular magazine *Hoy* in
1940. Orozco Romero held close
to the original, but eliminated the
woman's male companion and her
crown of thorns.

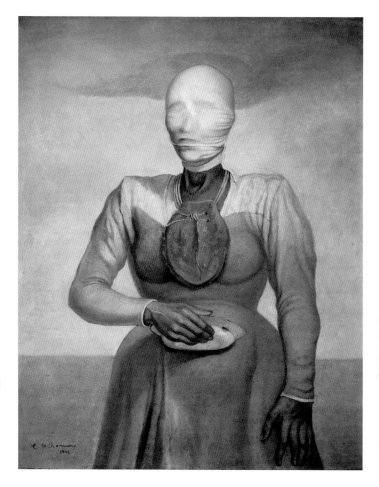

207 Juan Soriano, *The Dead
Girl*, 1944.

Like their viceregal counterparts,
several modern artists—including
Kahlo and Siqueiros—were
fascinated by the tragic theme of
the angelito. Soriano heightened
the contrast between the delicate
corpse and the ostentatious
display of flowers, leaving family
members in the shadows.

208 Wolfgang Paalen, *The Tarot's Aunt*, 1947.

As is the case with so many Surrealist works, the title here triggers speculation rather than limits interpretation, much like the use of tarot cards themselves. The isolated brushstrokes seem to reveal an anthropomorphic form with tiny head and broad shoulders, perhaps recalling an actual figure in the tarot deck.

emotions and rhythms taken from pre-modern cultures. And, at a time when totalitarian regimes had banned modern art, he declared that abstraction itself could be a political weapon. Some of Paalen's ideas were crucial to the later emergence of Abstract Expressionism in New York.

As painter, theorist, and collector, Paalen embodied the widespread Surrealist interest in the indigenous cultures of the Americas. By the mid-1940s, he had adopted a faceted style indebted to Analytical Cubism, in which isolated shapes evoke totemic figures, resembling the Northwest Coast masks in his collection. Whereas Siqueiros looked forward, using industrial materials to create an essentially proletarian art, Paalen looked back in time, sometimes painting on amate, the bark paper used by indigenous tlacuilos (page 28). These meditative works were Paalen's response to what he called the noisy "three-ring circus of politics, megalomania, and fake religion."

Paalen and Benjamin Péret, who was then translating Mexico's myths and legends into French, had a powerful impact on a young Mexican set designer and painter named Gunther Gerzso (1915–2000), who was educated in Europe and the US. Like Carlos Mérida, Gerzso also used pre-Hispanic forms, often taken from the Maya world, as springboards for the creation of abstract compositions. The complex armatures and spatial relationships in Gerzso's rigorously planned paintings draw on his own understanding of Analytical Cubism. His interest in non-Western art is indebted to Surrealism; the dark recesses and jagged edges in his paintings seem to reference themes of violence and sacrifice analyzed by such Surrealist writers as Bataille and Breton. After around 1953, when he began to dedicate himself full-time to painting, he distilled his visual language to fewer trapezoidal shapes, though still redolent with sinister forces. Along with Germán Cueto and Carlos Mérida, Gerzso was a precursor of the sharp-edged geometric abstraction that emerged in Mexico in the mid-1960s (page 360).

Most of the Surrealist exiles, on the other hand, created representational imagery with few if any references to Mexico; they also played a less public role in the art world than Paalen. Creating their own retreat-in-exile, Carrington and Varo

209 Gunther Gerzso, *Cenote*, 1947.

"Cenote" is the Maya word for a water-filled sinkhole in the limestone terrain of the Yucatán peninsula. The ancient Maya built cities near these natural wells, which were also used as sites for sacred offerings, including precious materials and human sacrifices.

shared a decaying Porfirian mansion on Gabino Barreda Street in the Colonia San Rafael. Finding a quiet space in Mexico after the turbulence of war, they invented arcane images in which alchemists, witches, and mythical beasts substitute for the insanity they had left behind in Europe. Carrington and Varo would not become well-known in Mexico until the 1950s, when they enjoyed greater critical acceptance—in part because of the rise of a more internationalist vision within the Mexican cultural bureaucracy, as well as an emergent commercial market. Yet, even then, their esoteric fantasy world had little impact or influence on local artists.

Unlike Luis Buñuel (1900–1983)—who became a leading director in Mexico's film industry after his arrival in 1946, and who helped introduce Surrealist imagery to a broader public—the English poet Edward James (1907–1984), a poet and patron of Dalí and Magritte, worked on his own Surrealist project somewhat in isolation. James also fled to the Americas during the war, and in the late 1940s he acquired a property called Las Pozas in the town of Xilitla, located in the remote Sierra Huasteca. Beginning around 1962, he designed fantastical constructions in poured concrete (often painted lurid colors) for this jungle retreat. James based his sculptures on ecumenical sources ranging from Hindu temples to Gaudí to Le Corbusier's

Chandigarh, but they also echo architectural forms in the uncanny landscapes of Carrington and Juan O'Gorman. As at the roughly contemporary Mexico City suburb of Jardines del Pedregal (page 317), modernism—albeit Surrealist rather than rationalist—was inserted into a wild natural setting.

At Xilitla, James created a truly "surrealist place *par excellence*," a physical embodiment of what Breton had only imagined. And there in the jungle, as in the galleries of Mexico City, Surrealism lived on long after Breton's death in 1966. Alongside Carrington and Varo, several younger Mexican artists created surrealist-inflected paintings—such as the obsessive self-portraits of Alfredo Castañeda (1939–2010)—and strange, unexpected objects—the wooden chairs shaped like human hands (1961) and anthropomorphic butterflies (1966) designed by Pedro Friedeberg (b. 1936), for example—until the end of the century, and even beyond.

210 Leonora Carrington, *The Temple of the Word*, 1954.

Carrington lived in France with Surrealist painter Max Ernst before the war; she arrived in Mexico in 1943. Her inventive subject matter draws on multiple sources, from Celtic mythology, Buddhism, and Jungian psychology, to alchemy and the tarot. In this painting, figures approach an oracle housed in a pseudo-Egyptian temple.

211 Edward James, Bamboo Palace, after 1962. Xilitla (San Luis Potosí).

James's project at Xilitla began around 1962, when a rare snowfall destroyed many of the tropical plants he had been collecting, prompting him to create a garden from concrete. These eccentric sculptures, along with structures with names like "Bamboo Palace" and "The Three-Story House that Might Have Five," are placed on paths above a stream with natural pools (or *pozas*).

Chapter 9 Construction and Rebellion (1946–68)

Mexican art and architecture of the postwar period was shaped by the government's enthusiastic embrace of social and economic development, and by artists' demands for greater inclusion in international circuits. Miguel Alemán, the first civilian post-Revolutionary president (1946–52), shifted the national focus from the progressive goals of the Constitution of 1917 to policies designed to improve industrial growth and agricultural production, including substantial investments in infrastructure, from highways to housing. This was extended by the subsequent leaders of the dominant Institutional Revolutionary Party (or PRI), the name of the official party after 1946. During this period of stability and growth, known as the "Mexican miracle," the country seemed to have escaped the political and social crises seen elsewhere in Latin America, among them the Cuban Revolution and the military dictatorships in South America. At the same time, the PRI faced few checks or balances, and tolerated little dissent while allowing ample opportunities for corruption.

The exponential population growth and industrialization of the postwar era created opportunities for a transformation of the capital never imagined by even the most visionary past reformers. Just as the government had used muralism in the 1920s to advance its agenda, now modern architectural projects—vast in scale and optimistic in their rhetoric—provided confirmation of a miracle that many desperately wanted to believe in. Like the embellishment of the Paseo de la Reforma during the late Porfiriato (page 212), or the widening of city streets in the colonial center in the 1930s, these projects expanded and transformed Mexico City. Fearing their possible irrelevancy, the muralists sought to participate in the construction of this new urban environment, theorizing a synthesis of painting, sculpture, and architecture known as *integración plástica*, a term loosely translated as "visual and structural integration." Many of the critical debates over the theory and practice of art in this period revolved around these projects, rather than painting exhibitions; Mexican architecture also garnered the lion's share of international critical attention.

Postwar prosperity also created an emergent art market, seen in an expanding network of commercial galleries, although many painters remained reliant on the state cultural system for patronage and exposure. Some, following Rufino Tamayo's lead, updated local imagery, translating time-honored subjects into more abstract visual languages. Several younger painters, however, rejected nationalist and populist art altogether, variously adopting non-representational styles or neo-figuration as possible alternatives. Although sometimes grouped together as a "generation of the *ruptura*," these artists were focused less on breaking with the past than on opening Mexican painting up to international currents, from lyrical abstraction to existentialism.

I. Developments, Urban and Suburban

Beginning in the late 1940s Mexico City was radically transformed from a compact and easily negotiated space into a complex and increasingly unwieldy megalopolis. The population doubled in size between 1940 (1.6 million inhabitants) and 1950 (more than 3 million), and then tripled by 1970 (9.1 million), mainly through migration from the countryside. As new arrivals crowded into older neighborhoods, including the colonial center, the middle and upper classes pushed the boundaries of the city farther to the west and south. The suburbanization of Mexico City, begun even before the Revolution, follows patterns established in Los Angeles—especially in the development of agricultural zones and the replacement of the trolley system with cars and buses. Up until the 1960s, works of modern architecture often seemed to rise from vast open spaces, something rarely seen in the congested city of today.

The first true skyscrapers, as well as swanky hotels and corporate offices, were built along the most glittering and modern axis of the city: Avenida Juárez, on the south side of Alameda Park, and its continuation west along the Paseo de la Reforma. Private development was emblematized by the Torre Latinoamericana (1948–56) by Augusto H. Álvarez (1914–1995), the tallest building in Latin America until 1979. Mimicking the profile of the Empire State Building, this glass-covered tower—an engineering marvel in a land of earthquakes—became a symbol of civic pride. Along Reforma, new architectural forms signified an equally new lifestyle of busy executives streaming

into their offices from elevators, and of well-to-do families living in light-filled condominiums typical of Manhattan, rather than in neo-colonial homes, as if Estridentista dreams had come to fruition, at least for the few.

Mexico City's expansion is a frequent theme in paintings, prints, and photographs of the 1940s and 1950s: like canaries in a coalmine, artists are often the first to sense dramatic social change. In Alfredo Zalce's exposé, produced in the Taller de Gráfica Popular, skyscrapers under construction overwhelm starving and homeless residents. Lola Álvarez Bravo (1903–1993) created more ambiguous photomontages that also deal with urban growth. One appeared in an official publication of 1946 praising Alemán's six-year term; the second, *Architectural Anarchy in Mexico City* (1954), shows the still-unfinished Torre Latinoamericana (to right of center) and the U-shaped Hotel Plaza (1945) by Mario Pani (1911–1993), in a dense array that dwarfs the Monument to Bolívar (1938). Both

212 Alfredo Zalce, *Mexico Is Transformed into a Great City*, 1947.

Artists associated with the TGP, including Alfredo Zalce and José Chávez Morado, were skeptical of the pro-development campaigns of the Alemán administration. In this print, the ironic title seems lifted from a political speech or real estate advertisement; most of the figures were based on Zalce's observations of life in the street.

México se transforma en una gran ciudad....

ALFREDO ZALCE 1947

213 Lola Álvarez Bravo, *Architectural Anarchy in Mexico City*, 1954.

Lola Álvarez Bravo first adopted photomontage as a political strategy in the mid-1930s, when she was a member of the LEAR. In the 1950s, she created several more complex photomontages that were enlarged to mural scale for public and corporate spaces. The former wife of Manuel Álvarez Bravo, she kept his name after their separation in 1935.

photomontages seem to laud the booming skyline, and perhaps this is why the latter was published in 1955 on the cover of Pani's *Arquitectura/México* (1946–78), the country's leading architecture magazine. The montage's current title, which implies a critique of development, may have been assigned later.

In the 1950s and 1960s, Lola Álvarez Bravo was the only female photojournalist in a competitive field that included Enrique Díaz, Héctor García (1923–2012), Nacho López (1923–1986), and the Hermanos Mayo, a collective of Spanish Civil War refugees who were the first to introduce 35mm photography to Mexico. In a variety of illustrated magazines modeled on *Life* and geared towards the emergent middle class—including *Hoy* (founded 1937), *Mañana* (1943) and *Siempre!* (1953)—the photoessay emerged as a key rhetorical device, reaching wider audiences than murals. Many

214 Héctor García, *Watching for the Future*, c. 1958.

Though less pamphleteering than Zalce, Héctor García also expressed sympathy for those caught in the race to modernity, such as this man—perhaps a market vendor or porter hauling goods—who cautiously negotiates traffic congestion.

photographers focused on former peasants trying to make their way in the metropolis, as well as the lives of those who benefited most from development. But it was Mexico's booming postwar film industry that most successfully portrayed the changed city, in laudatory comedies that used modern buildings as backdrops of sophistication, and in brutal critiques of impoverished neighborhoods, such as Luis Buñuel's "Los Olvidados" (1950), where highway overpasses and buildings under construction mark the divide between a regime catering to the aspirations of privileged sectors and the realities of life in the street.

Increasingly, the government focused on the needs and desires of an emergent middle class, including the civil servants, bureaucrats, and others who formed an essential part of the PRI machine, in which complicity was rewarded (and antagonists persuaded or bludgeoned). Their demands resulted in suburban developments in airy open spaces as well as dense housing projects in more urban areas. But these projects were not simply signs of a benevolent state taking care of its citizens. Alemán's regime promoted urban development in Mexico City to help forge alliances with local industrialists who had supported the opposition in the 1940 elections; the president also made a fortune through some of these same schemes.

The first two major urban projects of the postwar period were located in the Pedregal, a 2,000-year-old lava flow located in southern Mexico City near the towns of Coyoacán and San

Ángel. The extension of the city into this once-inhospitable wasteland was facilitated by an incipient automobile culture (Alemán's subsidies for the local automobile industry dovetailed with these projects), and also symbolized a new beginning: although it was the site of a pre-Hispanic city named Cuicuilco, this area was entirely free from the weight of Mexico's post-Conquest history. It was also conveniently distant ` from the center, which remained the locus of political rallies and marches.

The Jardines del Pedregal de San Ángel (Gardens of the Pedregal of San Ángel) was a subdivision of more than 1,200 lots covering about a square mile, first laid out in 1946 by architect Luis Barragán (1902–1988) and a team that included urban planner Carlos Contreras (1892–1970), son of the modernista sculptor. Barragán sought to integrate architecture, landscaping, and sculpture in a garden-style development modeled on earlier precedents in the US and England: it would be modern yet deeply rooted in the land. A savvy marketer, he commissioned black-and-white photographs from Armando Salas Portugal (1916–1995) that advertised an image of mystery, privacy, exclusivity, and safety, as well as the security of living on solid rock. In 1950, the Jardines del Pedregal was even the setting for one of Mexico's first weekly television shows.

The houses at the Jardines del Pedregal represent two different modernist options: one closer to nature and the other more rigidly industrial. Barragán, who collaborated with German-born architect Max Cetto (1903–1980) on a few of the earliest and most visually spectacular houses, had arrived in Mexico City in 1935; like many other important figures in the art world, he fled a sophisticated but provincial Guadalajara for the capital. Already established as an architect of elite residences, by the late 1940s Barragán abandoned functionalism for a local modernism of rough walls, wide-plank wood floors, and indirect lighting, inspired in part by viceregal monasteries and nineteenth-century haciendas. He would further refine his aesthetic in the interior of his own house-studio, begun in 1947 but much modified over time (page 344). Cetto, who in 1938 had left Germany already critical of the International Style, also promoted local materials—lava blocks and rich woods, for example—and handmade rather than industrial techniques (reflecting local supply networks), softening the modernist

This was one of two houses
Barragán and Cetto created on
speculation. Thick walls and heavy
stairs dominate the entrance
court. The house nestles within
the exposed lava flow, part of
which originally penetrated into
the living room.

vocabulary and visually uniting his houses with their
surrounding environment.

The houses designed by Francisco Artigas (1916–1998) for
this subdivision are more strictly industrial, like luxurious
versions of the experimental Case Study Houses in Los
Angeles, and ultimately more typical of what wealthy patrons
desired. Though also built directly into the lava flows, Artigas

used dramatic cantilevers and plate-glass windows to make these symbols of Mexico's modernity appear to float over a primeval past. In all of these homes, open plans and large gardens—often with pools—and interiors filled with Knoll furniture and zebra rugs revealed the embrace of an American (or at least Californian) way of life. By contrast, the haciendas and weekend retreats of these wealthy residents—which were sometimes designed by the same architects responsible for their Mexico City homes—invariably emphasized traditional vernacular forms and furnishings.

Fearful of the rampant development that had already begun to affect older neighborhoods, Barragán created zoning guidelines to guarantee that exclusively modernist homes would each be set on a large lot; however, economic limitations and new governmental regulations soon made it impossible to retain tight aesthetic control of the development. Many homes have been destroyed and their lots subdivided. The Jardines del Pedregal eventually suffered from the same urban pressures faced by much larger and poorer working-class districts, especially in the swampy terrain east of the colonial center.

Subtle nationalist flourishes in the Jardines del Pedregal, however, could not compete with those of another "house" being built on the same lava in nearby Coyoacán: Diego Rivera's Anahuacalli, which was designed in the mid-1940s to display his collection of more than 60,000 works of pre-Hispanic art; it also included an enormous studio. Using lava quarried from the surrounding area, the building's profiles and doorways echo

216 Francisco Artigas, House in Texcoco (Mexico), 1957.

For this sprawling weekend residence to the east of Mexico City, Artigas reduced neo-colonial forms—archways, fountains, ceramic tiling, metal grilles, and even allusions to Mudéjar design—to a bare minimum. The building appears anchored to the ground, unlike the architect's seemingly weightless houses in the Jardines del Pedregal.

217 Diego Rivera with Juan
O'Gorman, Heriberto Pagelson,
and Ruth Rivera, Museo
Anahuacalli, Mexico City,
1945–64.

Anahuacalli is a Nahuatl
neologism meaning "House in
Anahuac," using the Aztec name
for the Valley of Mexico. Rivera
conceived the museum as the
centerpiece of a City of the Arts,
with subsidiary buildings
surrounding a central plaza. Like
so many utopian projects, this
vision was never fully realized.

forms at the ancient cities of Teotihuacan and Palenque, a sort
of brutalist version of Frank Lloyd Wright's Maya Revival homes
of the 1920s. Rivera worked here in collaboration with Juan
O'Gorman, whose whimsical cave-like home covered in
neo-Aztec mosaics (1949–53), in the nearby district of San
Jerónimo, was also associated with the Pedregal. In such
buildings, O'Gorman rejected what he and others (including
Cetto) considered the soullessness of the International Style.
Perhaps not coincidentally, O'Gorman's dismissal of his own
modernist buildings of the 1930s echoes Rivera's earlier
rejection of Cubism.

The most ambitious monument of the Alemán
administration was the new campus for the Universidad
Nacional Autónoma de México (UNAM). In the 1940s, the
decision was made to relocate the University, then scattered
among antiquated buildings in the crowded historical center,

to a new Ciudad Universitaria (CU, or University City). This campus, originally designed for some 25,000 students, was set on 1,730 acres of the Pedregal, bisected by the Avenida de los Insurgentes, the city's main north–south axis. Post-Revolutionary regimes in Mexico had long emphasized education as a transformative force, but the new world for new Mexicans—only imagined in Rivera's SEP murals—was now becoming a spectacular reality.

The CU was a collaborative project involving more than a hundred architects, designers, and landscapists, led by Mario Pani, Enrique del Moral (1906–1987), and Carlos Lazo (1914–1955), the latter a key figure until his death. They developed an integrated master plan in which administrative and educational facilities, housing (never built), and sports facilities were placed in separate sectors, with transportation networks pushed to the margins. Though designed by different architects, the main buildings conform to International Style tenets, largely inspired by Le Corbusier: most are enormous light-filled structures consisting of vertical and horizontal blocks, sometimes perched on *pilotis* (ground-level supporting columns) above gardens. Yet while the CU boasted the most modern facilities possible, it also looked to the past; the central campus loosely refers to pre-Hispanic ceremonial centers, with major structures placed asymmetrically around a grand plaza. The Estadio Universitario (Augusto Pérez Palacios, Raúl Salinas, and Jorge Bravo, 1950–52), excavated out of the earth, resembles the volcanic-ash cones that rim the Valley of Mexico. Mainly, however, the CU represented a fresh start in a new architectural language, just as Tolsá's Palacio de Minería had, a century and a half before (page 146).

The massive investment drew the attention of the leading muralists, especially Rivera and Siqueiros, who surely felt destined to continue at the CU the work they had begun in the early 1920s (Orozco, who had created a semi-abstract mural for Pani's Escuela Nacional de Maestros, or National Teachers' College, in the mid-1940s, died in 1949). As Minister of Communications and Public Works, Lazo included murals by José Chávez Morado and others on his new headquarters building (1952), and brought yet more muralists to the University, assigning them prominent windowless areas of building facades that had not necessarily been designed for murals. At the CU, the muralists pursued diverse strategies in

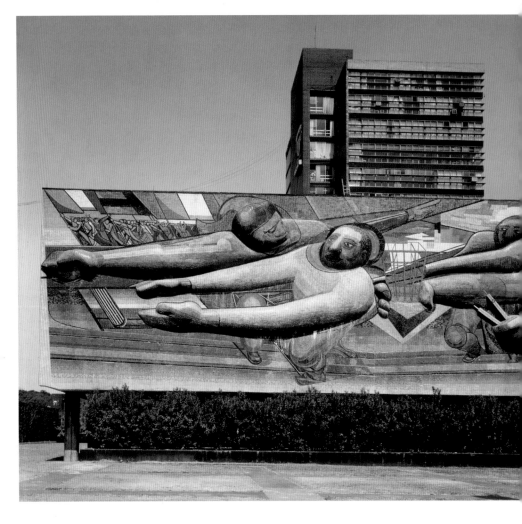

218 David Alfaro Siqueiros, *The People for the University, The University for the People,* 1952–56.

Siqueiros's tile-covered cement relief on the Torre de Rectoría (Mario Pani and Enrique del Moral, 1950–52) represents five male students empowered by the tools of knowledge they hold. Foreshortening was also used in the Sindicato de Electricistas mural (page 294), but here the wall was conceptualized as a billboard or movie screen visible from cars passing by, rather than spectators climbing stairs.

the attempt to integrate exterior murals—which Siqueiros had pioneered in Los Angeles (page 273)—with architecture, using materials resistant to the elements, and generally connecting their design motifs to each building's specific function. In the mid-1950s, these strategies were now theorized in terms of *integración plástica*, though the goal of relating murals with architecture has a far longer history.

As in the 1920s, many CU murals resulted from little if any dialogue or collaboration between painter and architect. Murals by Siqueiros and Chávez Morado resemble drive-in theater screens, projecting easily legible and nationalist messages that celebrate the "new Mexicans" being trained at the CU; at the medical school, Francisco Eppens (1913–1990) used bold graphic

elements to connect the Aztec past to modern disciplines. But O'Gorman and Rivera took a somewhat different approach. Building on their joint experience at Anahuacalli, they looked to pre-Hispanic building practices and employed stone mosaics for their murals on the Biblioteca Central and Estadio Universitario, respectively, which represent more successful attempts to integrate art and architecture with the specific site. This is most evident on the library, where historical and cosmological symbols (ancient and modern, local and international) fully cover the windowless block that protects the book stacks. Yet here too, O'Gorman's murals seem simply pasted over the walls of his own functionalist building, a costume as nationalist as the indigenous or peasant dresses worn by elite women in Rivera's contemporaneous portraits.

Exterior murals at the CU ameliorated the rigid, foreign, and alienating qualities of International Style architecture and provided the government with a highly visible and easily reproduced storyboard to illustrate its image of a modern nation with ties to the past. Still, as in politicians' speeches, nationalist rhetoric concealed underlying pragmatic and increasingly pro-capitalist policies: eager to continue their

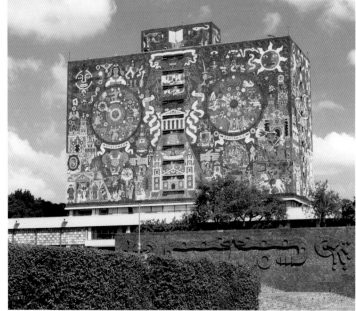

219 Juan O'Gorman, Gustavo M. Saavedra, and Juan Martínez Velasco, Biblioteca Central, Ciudad Universitaria, 1952.

The south wall of O'Gorman's mosaic mural, *Historical Representation of Culture*, features the colonial epoch. Eye-like circles depict the Ptolemean and Copernican models of the solar system; beneath the latter is a re-creation of the map of Tenochtitlan from 1524 (page 56).

220 Mario Pani, Centro Urbano Presidente Juárez, Mexico City, with panels by Carlos Mérida, 1950–52.

Mérida related each building's decoration to specific pre-Hispanic myths, but since no labels were applied it is unlikely that residents of the complex were conscious of the cultural or historical specificity of the designs.

relevance, leftist muralists had been fully co-opted by a regime that, despite its "revolutionary" name, was anything but. Some of the participating muralists admitted that their works had failed to advocate social change; other critics, including Cetto, attacked the use of figurative iconography as outdated.

None of the CU artists attained the level of *integración plástica* visible at the Centro Urbano Presidente Juárez (1950–52), a major housing project by Pani built on the former site of Vasconcelos's Estadio Nacional (1924) in the Colonia Roma. Working in close collaboration with the architect, Carlos Mérida returned to muralism for the first time since the 1920s, when he had worked briefly in the SEP. For this cluster of nineteen buildings, Mérida created more than 4,800 square yards of colored concrete reliefs, placed on the facades, stairways, and automotive underpasses of the buildings (it was the largest mural program ever carried out in Mexico). The murals depict human and animal forms, constructed from flat, abstracted shapes, and loosely derived from pre-Conquest and early colonial codices. Merida's program was not didactic, and the images distract less from the architecture than those at the CU, contributing to a kinetic experience in which viewers—whether climbing stairs or driving past in

cars—experience his murals as integral parts of a visual whole. Sadly, this entire project was razed after suffering partial damage in an earthquake that struck the city in 1985.

II. New Strategies for Artistic Integration

A more radical idea for the integration of art and architecture than that suggested by the muralists was proposed by the German-born artist Mathias Goeritz (1915–1990), who arrived in Mexico from Spain in 1949. Fleeing postwar Europe, he accepted an invitation to teach at the architecture school in Guadalajara before moving on to Mexico City. Like Mérida, Goeritz viewed *integración plástica* as requiring synthesis rather than just applied ornament, but he explored even more abstract modes of representation, thus creating new visual models for integrating art and architecture. His outsider status, international connections, and rejection of the political didacticism of the muralists, made him a controversial yet highly influential figure in the Mexican art world.

Although Goeritz collaborated with Barragán on a sculpture and plaza at the entrance to the Jardines del Pedregal, his first important project was the Museo Experimental El Eco (1952–53), built on a tight lot in the Colonia San Rafael, a residential neighborhood not far from the Monument to Cuauhtémoc. In this private commission to create a multiuse building with a bar, art gallery, and performance space, Goeritz combined diverse functions and media in an environment—partly inspired by his interest in the Bauhaus—in which architectural elements, paint color, furniture, and artworks would create a dynamic, energized space for experimental cultural projects. El Eco included a small mural by Mérida, and sculptures, "visual poems," and wooden chairs designed by Goeritz. A planned mural by Tamayo was never completed; instead, a sketch by Henry Moore of papier-mâché Judas figures in Rivera's San Ángel studio was enlarged and drawn on one wall.

In this discreet project, Goeritz rejected the architectural modalities then circulating in Mexico, from the megaprojects of Pani to the stony regionalism of O'Gorman. Instead, El Eco's closest equivalent (though the scales are entirely different) was Carlos Villanueva's mid-century modernist University City of Caracas, in Venezuela, which included non-objective murals and sculptures by local and international artists, including Alexander

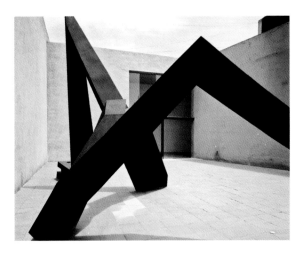

221 Mathias Goeritz, Museo Experimental El Eco (patio with *Serpent*; 1953), Mexico City, 1952–53.

For the patio of El Eco, Goeritz designed an angular sculpture of painted iron that would interact with the negative space. From some angles the object seems non-objective, but from others it clearly represents a serpent. Originally used as a prop in dance performances, it was later moved to the Museo de Arte Moderno.

222 Mathias Goeritz with Luis Barragán, Towers of Ciudad Satélite (State of Mexico), 1957–58.

Goeritz and Barragán originally shared credit for the Towers, although later writers sometimes assigned them to the architect alone. They are closely related to portable sculptures Goeritz created in the mid-1950s; Barragán certainly provided crucial technical expertise.

Calder, Fernand Léger, and Alejandro Otero. Goeritz's interdisciplinary space was barely inaugurated before the sudden death of his patron, Daniel Mont. The owner soon thereafter dismantled the sculptures and turned the building into a more commercial bar. In 2005, after years of neglect, the UNAM reopened El Eco, restored according to Goeritz's original vision.

Goeritz used El Eco to launch a movement he named Emotional Architecture. Building on the calls for a new spirituality following World War II, Goeritz sought to reinvest modern buildings—now devoid of explicit historicist references—with a spiritual and emotional charge, provoking responses of wonder and awe, as sacred buildings of the Gothic period had once done. The lack of right angles in El Eco, for example, underscored Goeritz's emphasis on expression over rationalism, and the materials used—as in Cetto and Barragán's houses in the Jardines del Pedregal—privileged tradition over industrial technology. A few years later, Barragán and Goeritz collaborated on another compact example of Emotional Architecture: the Convento de las Capuchinas Sacramentarias del Purísimo Corazón de María (1955–60), located in the south of Mexico City.

Goeritz faced the wrath of Rivera, Siqueiros, and other muralists in the press around the time El Eco opened, in part due to xenophobia, but more because he (unlike Mérida, who after all had been "one of them" back in the 1920s) signaled an internationalism—promoted not only in his art but also in his role as a teacher—that threatened to dislodge further the muralists' position in official culture. Goeritz's apparent spirituality, which was tied to his acceptance of several religious commissions, also irritated the radical artists (in 1948, Rivera had landed himself in trouble for painting "God does not exist" in a mural for the Hotel del Prado). Nevertheless, Goeritz had the active support of architects, including Barragán and Pani, who were shaping the new Mexico City in the 1950s and 1960s.

El Eco had been a short-lived experiment, but at Ciudad Satélite (Satellite City), a suburb about 10 miles northwest of

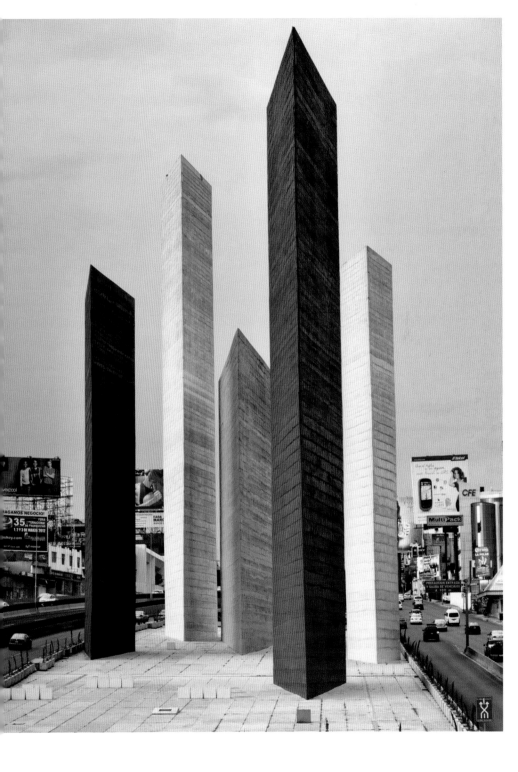

the Zócalo, Goeritz—working here too with Barragán—designed a soaring public icon for a metropolis where agricultural fields and historical monuments were increasingly being overwhelmed by urbanization. In 1954, Mario Pani began construction of a huge development with winding streets on 2,000 acres of ranchlands formerly owned by President Alemán. As in the Jardines del Pedregal, but now focused on a broader middle-class market, Ciudad Satélite reflected the aspirational desires of a burgeoning and politically powerful sector of the population.

For the entrance plaza, Goeritz created five hollow prisms of reinforced concrete, known as the Towers of Ciudad Satélite, ranging from 102 to 177 feet tall, placed on an island in the center of the main access highway. Although from a distance they look like sleek industrial structures, at close range their labor-intensive process of manufacture is evident, hardly concealed by layers of paint. Urban forms in a (once) rural setting, the Towers spoke to the inevitable shift in Mexico from country to city. The innovative and expressive use of reinforced concrete echoes contemporaneous, if more functional, buildings by Le Corbusier in France and Oscar Niemeyer in Brazil; and, in Mexico, by the Spanish exile Félix Candela (1910–1997), famous for his dramatic thin-shell vaults. The Towers' closest parallel in both purpose and meaning may be Eero Saarinen's Gateway Arch in St. Louis, Missouri, designed in 1947 but not completed until 1965: both projects use emotionally stirring abstract forms to announce confidence in an "American" future.

Although the Towers draw on urban imagery from San Gimignano to Manhattan, they were sited—as Siqueiros's CU mural was—to be seen mainly from speeding cars, and even today, though compromised by surrounding buildings and billboards, their scale and forms dramatically shift as one drives by, triggering an emotional response. In fact, they were Goeritz's most prominent example of Emotional Architecture, even if here the "buildings" were actually pure sculptures (he later called them "visual prayers"). Widely used in advertisements for Ciudad Satélite, they were also deployed as backdrops in futuristic ad campaigns featuring LPs and miniskirts. The Towers signaled a new direction for Mexican art, away from didactic muralism (as promoted at the CU) and towards a powerful and seemingly neutral form of public

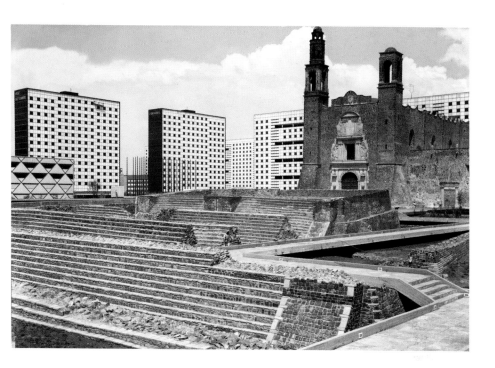

223 Mario Pani and associates, Conjunto Habitacional Nonoalco-Tlatelolco, Mexico City, 1960–64.

At the Plaza de las Tres Culturas, the sixteenth-century church of Santiago and its attached monastery, site of the Colegio de Santa Cruz, are framed by pre-Hispanic temples, Pani's apartment buildings, and (not visible here) the Secretaría de Relaciones Exteriores. The interior of the church was modernized by Goeritz and architect Ricardo de Robina (b. 1919) in the 1960s.

abstraction more amenable to politicians; in their idealized forms and utopian reach, however, perhaps they were not really so distant from Rivera's murals of the 1920s.

If Ciudad Satélite represented the ideal middle-class suburb, Pani's Conjunto Habitacional Nonoalco-Tlatelolco was the ultimate urban housing project, part of a massive building campaign initiated by President Adolfo López Mateos (1958–64). Pani transformed former railway yards and the old colonial center of Tlatelolco—within walking distance from downtown Mexico City—into a sprawling complex of 102 buildings, originally designed to house some 72,000 residents (mainly bureaucrats and other civil servants), as well as schools, clinics, museums, and sporting facilities. Although much compromised by subsequent renovations, partly the result of earthquake damage, the apartment blocks originally had the smoothest surfaces of any in Pani's housing projects: their broad exterior walls were covered with white Marcolite panels and Venetian tiles rather than murals or sculptures.

At Tlatelolco, Pani dramatically magnified the scale of his earlier projects, including the Centro Urbano Miguel Alemán (1947–49) and Centro Urbano Presidente Juárez. Tlatelolco

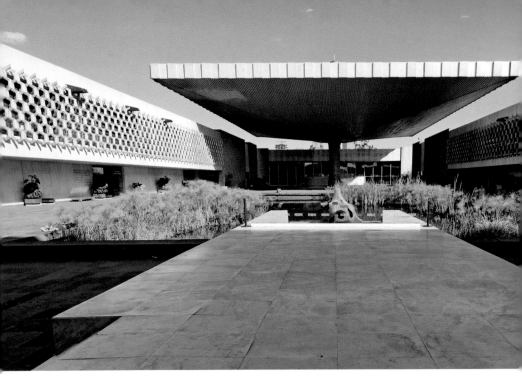

224 Pedro Ramírez Vázquez, Museo Nacional de Antropología, Mexico City, 1964.

Like the mural-filled galleries inside, the exterior of the museum integrates art and architecture. The monumental column supporting the cantilevered roof includes bronze reliefs by José Chávez Morado. The window screens on the second floor, inspired by the stone mosaics on Maya temples, were designed by sculptor Manuel Felguérez.

emerged like a gleaming phoenix—as promotional literature emphasized—not from nature or agricultural fields but from former slums. But what about *integración plástica*? Rather than murals, Tlatelolco has the Plaza de las Tres Culturas (Plaza of the Three Cultures), a theatrical juxtaposition of restored Aztec-era pyramids (one was even supposed to have an eternal flame burning at the top), the Franciscan mission church of Santiago, and a white marble Secretaría de Relaciones Exteriores (Ministry of Foreign Relations, 1965), designed by Pedro Ramírez Vázquez (1919–2013) (page 406). This union of indigenous, colonial, and modern referents in a single spectacular assemblage was a permanent declaration of the same cultural continuity being emphasized in contemporaneous exhibitions of Mexican art; in fact, the Plaza was designed as much to appear on postcards and travel posters as for daily use by residents.

The continuity between past, present, and future that was implied at the CU and made explicit at the Plaza de las Tres Culturas reached its architectural apogee in Ramírez Vázquez's new Museo Nacional de Antropología, inaugurated at the end of the López Mateos administration as part of a museum construction campaign that also included a new Museo de Arte

Moderno, designed by the same architect. The transfer of the state collections out of the historical center to Chapultepec Park further embodied the centrifugal forces that left the downtown neglected until the 1990s. These two structures also evidence the demise of official muralism as a contemporary artistic strategy. The *historical* museum placed murals by a wide array of artists, including recognized muralists (Chávez Morado and Zalce) and others who had not previously been much interested in this medium (Carrington, Goeritz), throughout its permanent collection galleries as decorative backdrops to exaggerate the sense of spectacle; the *art* museum, on the other hand, had no murals whatsoever.

Like the Plaza, the museums in Chapultepec Park were official declarations that Mexico was a unique and unified nation distinguished by extraordinary cultural achievements, and that the bloody sacrifices of the past had given way to a glorious and stable present. All too soon, however, these myths would be shattered by political and social realities that no party, however monolithic, could control.

III. Rupture or Aperture?

In 1947, as part of an expansion of the federal bureaucracy, the Alemán administration established the Instituto Nacional de Bellas Artes (INBA, or National Institute of Fine Arts), giving the government greater control over the cultural system, from art museums to the organization of biennials in Mexico and abroad. The INBA downplayed the acquisition or presentation of non-Mexican art, and its Salón de la Plástica Mexicana (founded in 1949), a non-profit sales gallery, long featured the work of its fifty-one original members, most of whom were associated with the "Mexican School." Muralism lingered as official state art beyond the CU, from Rivera's hymns to the pre-Hispanic past in the Palacio Nacional—left unfinished upon his death in 1957—to Siqueiros's allegory of the Mexican Revolution in the Castillo de Chapultepec (1957–66). Muralism survived even longer in the provinces, as José Chávez Morado, Alfredo Zalce, and others returned to their native states to create murals in government buildings.

In the 1950s, figuration and nationalism were far from dead and buried. Among easel painters, Surrealists Leonora Carrington and Remedios Varo remained highly visible, as did

many "Mexican School" painters, from Rivera to members of the subsequent generation, including Raúl Anguiano and Olga Costa (1913–1993). The Mexican government promoted figuration in influential exhibitions abroad, usually organized by Fernando Gamboa (1909–1990), a powerful museum director, curator, and installation designer. Gamboa's strategy was to highlight Mexico's cultural difference through a range of masterpieces that emphasized continuity over the centuries. Debates over the course of contemporary painting in Mexico thus frequently revolved around what type of art was being "exported" for international audiences.

Idealized canvases—for example, Costa's attention-grabbing *Fruit Seller*—reveal a sort of hyper-nationalism also present in commercial calendar art (page 10) and the melodramatic films directed by Emilio Fernández. The market stall here is really too good to be true. Equally prominent in the period was a streamlined or "modernized" Mexicanism that reduced traditional subjects down to basic outlines or

225 Olga Costa, *The Fruit Seller*, 1951.

This painting, commissioned by the government for a traveling show that opened to great acclaim in Paris in 1952, has been included in almost every major survey exhibition of Mexican art. Costa arrived in Mexico from Germany in 1925; she was the wife of painter José Chávez Morado.

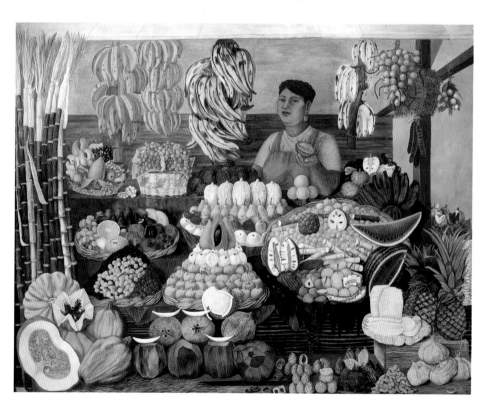

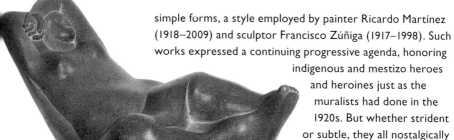

226 Francisco Zúñiga, *Woman in a Hammock*, 1957.

Born in Costa Rica, Francisco Zúñiga moved to Mexico in 1936, and assisted Oliverio Martínez on the sculptures atop the Monument to the Revolution. His images of traditionally dressed women, usually cast in bronze, were widely collected in the 1960s and 1970s.

simple forms, a style employed by painter Ricardo Martínez (1918–2009) and sculptor Francisco Zúñiga (1917–1998). Such works expressed a continuing progressive agenda, honoring indigenous and mestizo heroes and heroines just as the muralists had done in the 1920s. But whether strident or subtle, they all nostalgically referenced an old way of life under siege by urbanization and modernization, irrevocably transformed by migration to the cities and emigration to the United States.

Increasingly, however, such images were rejected by a younger generation that—above all—feared being labeled provincial. Influential critics, such as Luis Cardoza y Aragón, argued that no matter how great they had once been, muralism and the "Mexican School" were irrelevant modes given the new political and economic order. In this context, Rufino Tamayo emerged as the leading exponent of Mexican painting, partly because of his skilled self-construction as both national *and* international. In the late 1940s, having established his fame in New York and Paris, and fully cognizant of ongoing aesthetic battles between internationalism and provincialism, Tamayo turned his focus increasingly to Mexico; he was given a major retrospective there in 1948. He sought to stake a more public claim for his own approach to art, occupying a middle ground that would combine the long-standing local emphasis on figuration and the increasingly dominant trends in postwar abstraction.

From the 1950s on, Tamayo's easel paintings combined flattened and stylized forms derived from synthetic Cubism; gritty, richly worked surfaces inspired by French artist Jean Dubuffet's *Art Brut*; and bright colors that critics sometimes linked to his youthful days in the fruit markets of Oaxaca (though there is really nothing inherently Mexican about his palette). Except perhaps for red, white, and green slices of watermelon, a relatively common subject in his work, nationalist references are rare. Tamayo's paintings of this period more frequently allude to more universal concerns, such as postwar angst. He thus stood out as the Mexican painter who best embodied a broader cultural reality, in which

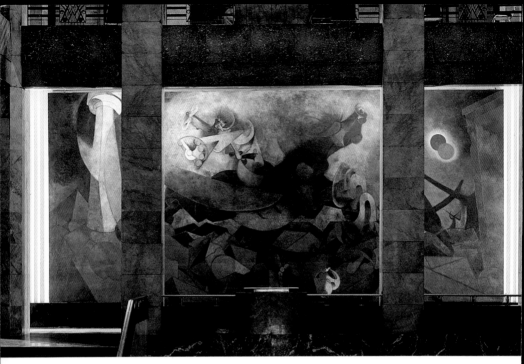

227 Rufino Tamayo, *Birth of Our Nationality*, 1952.

Like earlier muralists, Tamayo locates the origins of the Mexican nation in mestizaje. A mounted conquistador tramples indigenous civilization. The vertical column represents triumphant European culture. In the ruined landscape an Indian mother gives birth to a mestizo child.

Mexicans of many social classes were abandoning nationalist isolation for a sense of participation in an international—or at least, Euro-American—modernist project, though never denying their particular citizenship or traditions. Like Barragán, Tamayo sought to have his provincial *torta* and eat it too.

In 1952 Tamayo was commissioned to paint two murals in the Palacio de Bellas Artes; this symbolized the government's approval of abstraction at a site more prominent than the Centro Urbano Presidente Juárez, and confirmed Tamayo's canonization as a leading artist by cultural leaders within Mexico, as well as by critics and collectors abroad. He chose to paint on canvas rather than use fresco, as if to assert the primacy of easel painting, and tied the colors to the surrounding marble-covered walls. Tamayo strategically eschewed universal themes in favor of two nationalistic subjects that connect Mexico's pre-Columbian past and colonial-era mestizaje to contemporary realities, including the fears of living under the threat of nuclear war. In *The Birth of Our Nationality* (1952) and *Mexico Today* (1953), Tamayo took themes addressed in earlier murals but recast them in his mature style, distilling iconographic complexity and didacticism down into fewer and simpler figures; for many viewers, however, his abstractions

were more difficult to "read" than the murals by Rivera, Orozco, and Siqueiros on the floor above, not least because of their cramped location along a narrow corridor.

Though Tamayo's murals did not immediately lead to other commissions, they placed him on a par with the *tres grandes*. Yet Tamayo rejected Siqueiros's attempt in 1953 to enshrine him (or co-opt him) as the fourth *grande*: he was then publicly attacked by both Siqueiros and Rivera, who accused him of being apolitical, even derivative. To some extent this represents a continuation of the debates of the early 1930s between "pure" and "realist" art (page 279), but the more radical muralists were also responding to their contemporary context. As Alemán and his successors restricted the power of the Left in Mexico's unions (causing violent protests later in the decade, including the railway workers' strikes of 1958–59) in favor of accelerated economic development, the muralists were conflicted: they were unable to support the regime, but needed it if they were to create truly public murals. Moreover, Tamayo's success had proven wrong Siqueiros' famous declaration in 1945 that "there is no other path but ours." After Siqueiros died in 1974 Tamayo became the lone *grande*, a fact he underscored in the Museo de Arte Contemporáneo Internacional Rufino Tamayo, inaugurated in Chapultepec Park in 1981, where he was the only Mexican-born artist featured in the permanent collection of international modernism he and his wife Olga had formed.

Tamayo's position inspired other artists; in visual terms, his impact can be traced in the varied work of Pedro Coronel (1922–1985) and Rodolfo Nieto (1936–1985), among those who took the road between figuration and abstraction, never veering too far to either side, and usually paying more attention to color and surface than to content, as is especially evident in Coronel's

228 Pedro Coronel, *The Deluded Ones*, 1959.

Partly derived from folk art, the saturated colors in Pedro Coronel's paintings became omnipresent in Mexican interior design in the 1960s, as well as on the exteriors of modernist landmarks, such as the Hotel Camino Real (1968; page 353).

eye-popping canvases. In fact, there was little precedent in Mexico for a fully non-representational practice, other than the sculptures of Goeritz and a few experiments by Mérida. Throughout the 1950s, Mexican "abstraction" was rather tentative, often including stylized figurative elements or narrative references. As in New York, these semi-abstract painters maintained ties to late Surrealism, especially through Wolfgang Paalen, who remained a force on the Mexican scene until his death by suicide in 1959. Tamayo himself saw non-representational art as dehumanized and overly intellectual.

In the 1950s, the chauvinism of the INBA and the continuing dominance of Rivera and Siqueiros on the national stage stimulated increasing demands for greater critical attention by young artists (mostly born after 1930) for whom the Revolution was ancient history. They followed no single manifesto and adopted a variety of styles—including lyrical abstraction, informalism, neo-figuration, and, somewhat later, geometric abstraction—that the muralists disparagingly called "Paris-isms." Nevertheless, they have often been discussed together as the "generation of the *ruptura*" or rupture (the word "rupture" was taken from an essay Octavio Paz wrote on Tamayo in 1950), meaning they shared a desire to break with the legacy of state-funded muralism and the localized subject matter of the "Mexican School." Besides Tamayo, their models included Alfonso Michel (1897–1957), an early devotee of the School of Paris, and Juan Soriano, whose work became more abstract after he moved to Rome in 1952. Mainly, however, they wanted to be considered international rather than provincial painters, in Mexico as well as abroad.

Over the course of the decade, this generation coalesced around several shared positions, particularly a rejection of didactic and folkloric imagery in favor of formalist experimentation, dissatisfaction with a state cultural system that strangled individual expression, and a sense of alienation shaped by postwar existentialism. Unlike the muralists, however, few of these artists were confident in the power of art to effect social transformations, or believed strongly in the "brave new world" being built by modernist architects across Mexico City. But while they rejected didactic art, these younger artists nonetheless admired Orozco's humanist questioning of ideological certitudes and Siqueiros's formal experimentation, which he called "neo-realismo."

229 José Luis Cuevas, *Woman*, 1954.

Although the original title is given here, this work is also known as "Asylum Figure." Cuevas's brother was a psychiatrist, which allowed the artist direct access to inmates in the city's largest hospital for the mentally ill, La Castañeda.

Given their undeniable interest in abstract currents abroad, it might be best to think of this as a generation focused on opening up Mexican art to international currents: an *aperture* rather than a *rupture*. Whether preferring non-representation or neo-figuration (and they often fought over which of these two trends was superior), these young artists all sought attention in museum exhibitions, the annual or biennial salons launched by the INBA in 1957, and the commercial art galleries that proliferated in the trendy Zona Rosa district, such as Prisse (1952), Proteo (1954), and Antonio Souza (1956). Short- or long-lived, these galleries were sites for experimentation that also confirmed the increasing privatization of the art world, parallel to the new capitalist structures governing Mexican society (even if sales were few).

The first in this younger generation to gain local and international attention was José Luis Cuevas (b. 1934). From the time of his first one-man show in 1953, Cuevas emerged as a magisterial draftsman, focusing on anti-heroic characters drawn from the streets and madhouses, and creating endless self-portraits—often in the company of prostitutes and lovers. Cuevas embraced the human figure, but except for some anti-Franco images and anxious references to Kafka and Dostoevsky, his ink drawings lack overt references to any particular time or place. Cuevas insisted on his position as an artist in the European tradition: his works openly cite Goya and Picasso, though Orozco's "House of Tears" (page 231) also provided a crucial precedent.

A brilliant wit, Cuevas assumed the role of *enfant terrible*, successfully using the press—which in this period closely followed every artistic debate and scandal—to emerge as the spokesman of his generation. In 1958 Cuevas published an untitled ironic letter-cum-manifesto in a leading newspaper (an English translation appeared as "The Cactus Curtain" in 1959)

in which he called for a Mexican art world of "broad highways leading out to the rest of the world, rather than narrow trails connecting one adobe village with another." More than any other text or event, this essay asserted a "rupture" that was more rhetorical than actual; Cuevas defined himself by rejecting the by-then-exhausted tenets of the "Mexican School," echoing the false break the muralists had made with their own pre-Revolutionary academic training back in the early 1920s. Cuevas established alliances with José Gómez Sicre, the influential Cuban-born curator who ran the Visual Arts Unit at the Organization of American States (OAS) in Washington, D.C., and Colombian art critic Marta Traba, both opponents of Mexican muralism—which only further secured his fame and success, especially in the United States.

Though Cuevas held fast to figuration, other painters in the mid-1950s, among them Lilia Carrillo (1930–1974), Fernando García Ponce (1933–1987), and Manuel Felguérez (b. 1928), embraced non-representational painting. They looked mainly to Paris for models, in part because of Tamayo's links to that city, but also due to the Surrealist legacy of Buñuel and Paalen. As individuals and as a group, these young artists worked in a variety of personal styles, which also evolved over time. García Ponce loosely referenced Constructivism and Cubist collage in paintings that combined brightly colored geometric shapes with loose brushwork. Carrillo and Felguérez adopted an intuitive and expressionist mode of painting that lacked easily defined forms and was closely related to the varied forms of lyrical abstraction then common in several European art capitals (it was known in France as tachisme or art informel). None of the Mexican artists was much interested in the aggressive machismo of the New York School, partly because it too closely echoed that of the muralists.

In Carrillo's Noon (1957) the loose choreographic brushwork, mottled color, and emphasis on texture are hard to pin to any particular subject, other perhaps than midday heat. Works like this were the result of the same turn inwards that artists in Europe, from Jean Fautrier to Antoni Tàpies, were taking in those same years. In her later paintings, soft, cloudlike forms and disconnected shapes seem tentative, as if they are about to slip away. Carrillo intensely worked the surfaces of these paintings, adding tiny details that appear only on close inspection, or incising areas of paint with calligraphic lines, as

230 Lilia Carrillo, *Noon*, 1957.

Lilia Carrillo was the leading lyrical abstractionist in Mexico. She first studied under conservative artists at La Esmeralda, the INBA's art school, before enrolling in the Académie de la Grande Chaumière in Paris (1953–55). She married painter Manuel Felguérez in 1960.

the Surrealist émigré Alice Rahon had done in her own paintings of the 1940s.

Unlike the works by Cuevas, abstract paintings like these proposed a withdrawal from daily life, partly the result of that widespread existential crisis that affected so many in the postwar years (and that also informs Paz's *The Labyrinth of Solitude* of 1950, a meditation on the Mexican psyche). Supported by critic Juan García Ponce (the artist's brother), dealer Juan Martín (who opened a gallery in 1961), and theater director Juan José Gurrola, these abstract artists lived as if on a Parisian island set into a vast Mexican ocean, reading *Le Monde* or Salvador Elizondo's magazine *S.nob* (1962), the title of which said it all. Their non-figurative works presumed a highly informed audience; critics spun

poetic readings from their forms that could have described any number of paintings made elsewhere in the world at the time, and that was precisely the point. We can be anywhere, they said, even if our studios happen to be in Mexico.

IV. International Horizons

The diversity of the ruptura generation was more visible after 1957, when Miguel Salas Anzures became the head of the INBA and began promoting greater openness to abstraction in official curated exhibitions (that Rivera had died that year only made things easier). At the First Interamerican Biennial (1958), held in the Palacio de Bellas Artes, the past triumphed: the main prize went to *Tata Jesucristo* (1926), a solemn Day of the Dead scene by the seventy-six-year-old Francisco Goitia. Artists representing the United States, however—among them Philip Guston, Franz Kline, and Willem de Kooning—provided evidence of which way the wind was blowing; even Siqueiros accepted this reorientation towards expressive abstraction, though still in the context of left-wing practice. At the Second Biennial (1960), Tamayo won the "international prize" and Pedro Coronel took the national one. Pedro's brother Rafael Coronel (b. 1931), however, submitted *Rat in the Trash Heap* (1959), a metaphor for a political and cultural system many were questioning at the time. In fact, Cuevas and others boycotted the Second Biennial in solidarity with Siqueiros, who had been imprisoned for criticizing the regime (1960–64).

Cuevas's emphasis on figuration in the 1950s reminds us that some members of the so-called *ruptura* generation had remained fully invested in representation. In the later 1950s, leading figurative painters included Rafael Coronel and Alberto Gironella (1929–1999), one of the founders of the Galería Prisse, the first space to promote this generation of artists. Originally more interested in writing, when he turned to painting Gironella began a lifelong exploration of Spanish traditions, from bullfighting to Velázquez (or perhaps Velázquez as digested by Picasso). In the 1960s and 1970s, shuttling between Madrid, Paris, and Mexico, he increasingly inserted his expressionist paintings in large assemblages that included everything from citations of *Las Meninas* and

photographs of Zapata to bottle caps and sardine cans, with echoes of both Surrealism and Pop Art.

In 1961, Canadian-born artist Arnold Belkin (1930–1992) and Mexican Francisco Icaza (b. 1930) founded a short-lived movement, first exhibiting together under the name *Los Interioristas* (The Insiders), but eventually becoming better known as *Nueva Presencia* after an eponymous broadside-manifesto. Other artists exhibiting with the group included Cuevas, Francisco Corzas (1936–1983), Leonel Góngora (Colombian; 1932–1999), Spanish émigré Antonio Rodríguez Luna (1910–1985), photographer Nacho López, and (albeit briefly) Rafael Coronel.

The members of Nueva Presencia were troubled by the broadening acceptance of abstraction, as practiced by Carrillo, for example, which they labeled derivative and formulaic, distant from local realities, redolent of "good taste," dependent on the bourgeois market, and (perhaps) too closely tied to US-led initiatives to promote non-representational painting in Latin America during the Cold War. In response, they proposed a new mode of figuration (or "new presence") distinct from the polished surfaces of "Mexican School" paintings, such as Costa's *Fruit Seller* (page 332). They would instead use wiry expressionist brushwork and dark or muted colors to reflect the anxieties of modern life and address problems affecting contemporary society, including political and moral corruption, the intransigence of poverty and oppression in the face of urbanization, and the threat of nuclear war, though without ever engaging specific targets, for fear of falling into the trap of social realism.

Nueva Presencia was directly inspired by two books published abroad: British writer Colin Wilson's *The Outsider* (1956), a study of artistic alienation; and US writer Selden Rodman's *The Insiders* (1960), which criticized the Abstract Expressionists, instead praising such artists as Mauricio Lasansky, Rico Lebrun, and Ben Shahn, who he argued felt a responsibility to address social rather than exclusively personal issues in their work. And although Tamayo's isolated and anxious subjects of the 1950s and 1960s provided a crucial model, these artists were mainly indebted to Orozco's angry humanism. Parallels to this type of work can also be found across Europe and the Americas in this period, from Francis Bacon and Alberto Giacometti to the Argentinians Luis Felipe Noé and Jorge de la Vega.

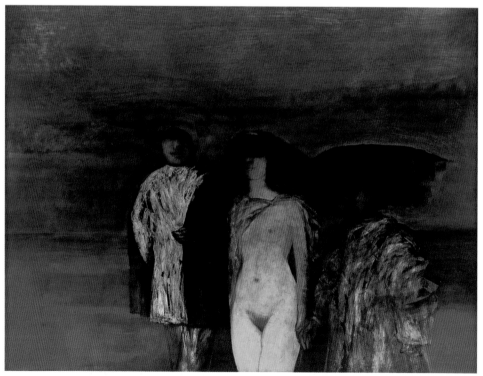

231 Arnoldo Belkin, *Man Does Have a Future*, 1963.

Of the artists associated with the ruptura, Belkin was the most closely affiliated with the New Left. He was one of several foreign artists who studied at Mexico City College and later trained with Siqueiros. Belkin was one of the last muralists to heroicize the Revolution, especially through the figure of Zapata.

232 Francisco Corzas, *The Poquianchis*, 1966.

In the 1960s and 1970s, urban intellectuals frequently saw rural Mexico as backward rather than noble. The Poquianchis, sisters who operated a bordello in a small town in Guanajuato, were astonishingly depraved kidnappers and mass-murderers. Their story inspired Corzas's painting and a later novel by Jorge Ibargüengoitia.

Images by Nueva Presencia artists tend to depict individuals, often isolated and anxious, who face grand yet unseen challenges—fear of nuclear annihilation, for instance—that admitted no easy solutions from either side of the political spectrum. As in works by Cuevas, the subjects of Corzas and Icaza are the prostitutes, madwomen, and clowns of the street, fools all, taking a painful stand against the indifference of the cosmos and the banalities of consumer culture. Belkin's paintings evidenced greater faith in solving the crises of contemporary society: in *Man Does Have a Future*, the figure strides forward with a confidence seen in many murals of the 1930s, and it is not surprising his palette is much more lively. Cuevas split with Nueva Presencia in 1962, partly to establish his own preeminence, but also because he sensed the lurking demon of social realism. Indeed, a concern for social problems and an emphasis on subjectivity were strange, and perhaps incompatible, bedfellows.

As he had in the field of architecture, Mathias Goeritz advocated an alternative path in painting and sculpture, beyond the quarrels between *informalistas* and *interioristas*. Although his sympathies lay more with the non-representational painters, his general discontent with the contemporary art scene—especially in Mexico City—prompted him to form a neo-Dada group called *Los Hartos* (The Fed-Up Ones). In several articles, Goeritz and art historian Ida Rodríguez Prampolini (his wife at the time) railed not against any particular figure but against spiritless and over-intellectualized painting, created by artists who were more concerned with market share and fame, or proving the "rightness" of their position, than the deeper meanings of their endeavor. His stance resembles that of neo-avant-garde artists in Europe, such as Yves Klein, who were also challenging the limitations of painting—abstract or figurative. Few younger artists in Mexico were willing to adopt such an adamant rejection of the commodification of art.

In 1961 Goeritz organized a parodic art exhibition, a happening, really, of Los Hartos at the Galería Antonio Souza, which included ironic contributions from Cuevas (a graphite square drawn on the white wall and entitled *Panoramic Vision of Art Today*), antiques dealer Jesús Reyes Ferreira (1882–1977), photographer Kati Horna, and Pedro Friedeberg; several non-artists also participated, including a housewife, Rodríguez Prampolini's seven-year-old son, and even a live chicken.

343

Goeritz exhibited a shimmering *Metachromatic Message*, a wooden panel covered in gold leaf made by a local artisan (and ordered by telephone, an idea that dates back to the *Dada Almanac* of 1920). Although Goeritz considered his *Messages* more design than "art," they reveal his ongoing effort, in painting and sculpture as well as architecture, to invest contemporary art with emotion and even spirituality. Some of his *Messages* are even pierced with nails, in direct allusion to Christian iconography. Though he rejected didactic and political strategies, Goeritz's idealistic belief that art was a service rather than a commodity recalls the declarations of the muralists in the early 1920s.

A student of Goeritz, Friedeberg proposed a more humorous attack on the pretentions of the art world, sparing neither his fellow artists, nor the intellectuals who controlled the scene in the Zona Rosa (the subject of *La Mafia*, a psychedelic narrative of 1967 by the Argentine-born writer Luis

233 Luis Barragán, Barragán House and Studio, Tacubaya, Mexico City, 1947–61.

At the top of the stairs in his own home, Barragán installed one of Mathias Goeritz's *Metachromatic Messages*, which were first exhibited at the Galería Antonio Souza in 1960. The handcrafted furniture was designed in collaboration with Cuban-born Clara Porset (1895–1981).

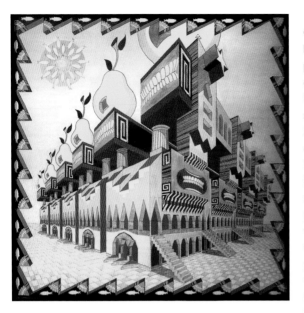

234 Pedro Friedeberg, *Gioconda Palace during Mona Lisa Week*, 1966.

Friedeberg's intricate drawings reveal the tricks of the trade he learned as an architecture student. They reference an encyclopedic array of sources, including Piranesi and Escher, Mannerist design manuals and Baroque theater sets, Art Nouveau and Surrealism, and contemporary currents in Pop and Op Art.

Guillermo Piazza), nor even the bourgeois collectors who eagerly purchased his work. Friedeberg's drawings of fantastically impossible buildings lampoon the soulless architecture of Mario Pani's housing projects. Instead of repetitive and logical units, Friedeberg's animated "Gioconda Palace" sprouts pear-shaped rooms and star-shaped projections, and is covered by toothy grimaces far less elusive than the Mona Lisa's smile. As prolific and ironic as his friend Cuevas, Friedeberg pushed harder against the mainstream in his own images, and was one of the few Mexican artists to wrestle—as did his Pop Art contemporaries elsewhere in the 1960s—with the avalanche of commercial culture. Not long after, other artists in Mexico could be found at this intersection of Pop Art, surrealism, and psychedelic art, including painters Arnaldo Coen (b. 1940) and Gelsen Gas (b. 1933), Canadian artist Alan Glass (b. 1932), and, on another register altogether, the pioneering video artist Pola Weiss (1947–1990).

Another manifestation of discontent with official institutions and bourgeois norms in Mexico was the loosely defined counterculture movement, marked by a turn inwards to new forms of spirituality and experience, from psychoanalysis to peyote to Zen, often from outside the Western tradition. In Mexico, this countercultural path had already been surveyed by Artaud in the 1930s, and later by members of the Beat Generation and other radical visitors in the 1950s and early 1960s. These included the US writer Margaret Randall, who, together with Mexican Sergio Mondragón, edited the bilingual journal *El Corno Emplumado/The Plumed Horn* (1962–69), and a number of artists from San Francisco: Bruce Conner briefly lived in Mexico City, and André VandenBroeck and Goldian "Gogo" Nesbit taught in the arts program at the recently established Universidad Iberoamericana (among their students was the young Friedeberg). Some younger rebels embraced the

235 Set for Alejandro Jodorowsky's *The Opera of Order*, Mexico, 1961. Photograph by Kati Horna.

Many artists, including Julio Castellanos and Agustín Lazo, were important costume and set designers in the Mexican theater. Jodorowsky's production of 1961, however, entailed far more experimental modes of collaboration. In this photograph, artists, actors, and musicians pose on a set decorated by Carrillo, Felguérez, Gironella, and Rojo, among others. The director hangs upside-down from the upper level.

liberating movements of the decade, traveling abroad, reading underground literature, listening to rock, and taking mind-altering trips; others—among them Gironella— remained more or less aloof from the "hippies," seeking instead affiliations with older Parisian luminaries, such as Buñuel and Breton.

One of the most influential and provocative countercultural figures in 1960s Mexico was Alejandro Jodorowsky (b. 1929), a Chilean avant-garde stage director who moved from Paris to Mexico in 1959. Extending and mixing ideas taken from Artaud, Beckett, and Ionesco, Jodorowsky challenged even the most tolerant bureaucrats in the INBA system. One of his avant-garde theater productions, "La ópera del órden" (The Opera of Order), done in collaboration with Juan José Gurrola, was shut down after its premiere in 1961—ostensibly for "ridiculing Catholicism," but surely because his radical project also undermined sexual and moral codes, as well as theatrical conventions. Unable to work in the traditional theater, Jodorowsky orchestrated outlandish single-day events that merged different media and disciplines, inciting terror and laughter. Jodorowsky called them "panic ephemerals," consciously alluding to the Greek god Pan; they were related to the happenings and situations taking place in other avant-garde circuits. One of the more ambitious events, held at the Deportivo Bahía, a private sports complex, in 1963, involved Jodorowsky descending into a swimming pool from a helicopter while reading Lautréamont; when the helicopter crashed during rehearsal, it was simply incorporated into the set.

Carrillo, Felguérez, Gironella, and Vicente Rojo (b. 1932) participated on the set design of "La ópera del órden" and several of the panic ephemerals. These events encouraged new forms of collective practice, and also prompted committed studio painters to consider non-painting strategies, first on and then off the stage. Jodorowsky's liberating influence is apparent in such works as Felguérez's mural of welded scrap metal for the Cine Diana in Mexico City (1962), and Gironella's theatrical installation of his paintings honoring Zapata alongside sacks of sugar hung from the ceiling in the Palacio de Bellas Artes (1972), both of which muddied the boundaries between life and art, between "real" materials and "false" representations.

Most of the visual iconography related to Jodorowsky's Panic Movement (co-founded with Roland Topor and Fernando

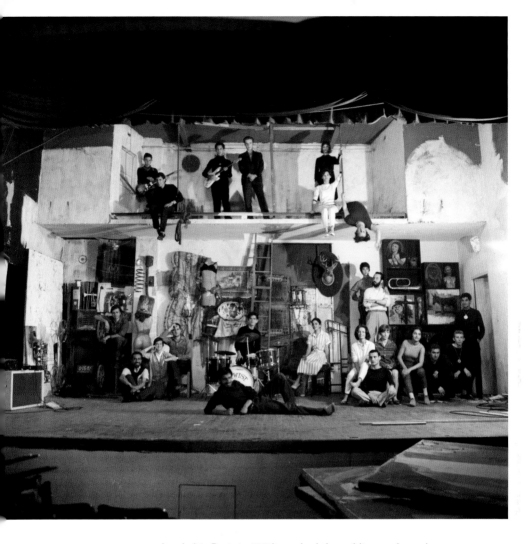

Arrabal in Paris in 1962) reached the public not through galleries or the stage, but through newsprint, even though the media remained controlled by the government, directly or by means of advertising. Jodorowsky's "Panic Fables" (1967–72) and the "Psychograms" (1967–68), illustrated by Felipe Ehrenberg (b. 1943) with texts by Colombian science-fiction writer and filmmaker René Rebetez (1933–1999), both appeared in the leading daily, *El Heráldo de México*. And for a brief moment, *Sucesos para todos* (1977), a tabloid parody edited by Jodorowsky with photographs by Pedro Meyer (b. 1935) and cartoons by Zalathiel Vargas (b. 1941), seemed to announce a new age of tolerance—until it too was censored.

236 Felipe Ehrenberg and René Rebetez, *Psychogram No. 1: Music and Machine*, from *El Heraldo de México*, no. 105 (November 12, 1967).

The "Psychograms" asserted a continuing need for spiritual development, while taking advantage of commercial publishing circuits and sophisticated color-separation techniques. Although Ehrenberg and Rebetez distanced themselves from hippie culture and synthetic rock music, the aesthetic parallels to psychedelic art are evident in this first installment.

In this period, avant-garde film also challenged the primacy of painting, theater, and performance, as in Gurrola's experimental film-portraits of Rojo, Cuevas, and Gironella (all 1965–67); Juan Ibañez's "Los Caifanes" (1966); Gelsen Gas's "Anticlimax" (1969); and Jodorowsky's irrational and neo-Baroque "El Topo" (1969) and "The Holy Mountain" (1972), all designed to provoke otherwise passive audiences. For the latter, Felguérez created abstract sculptures that incorporated living human bodies and a huge kinetic machine that was sexually activated by a naked actress (page 362): such works were reminders that boundaries of all sorts were increasingly fluid after the turbulent 1960s.

Notwithstanding these challenges, painting would reign supreme in official spaces throughout the 1970s. Tamayo and Siqueiros continued to lock horns in the press, and at large salon-type shows INBA directors and art critics attempted to mediate diverse artistic positions from abstract to figurative, though the "Mexican School" painters were increasingly marginalized. At the Concurso de Artistas Jóvenes de México in 1965—a competition to select young artists for a Latin

American exhibition at the OAS, and known as the Salón Esso, after its US sponsor—García Ponce and Carrillo took the top prizes in painting. "Confrontación 66," a more pluralistic exhibition that literally "confronted" abstraction with neo-figuration, but conferred no awards, triggered resentment on the part of the older figurative painters—mainly because those born before 1920 were not invited to participate.

Protests by Siqueiros, among others, prevented the younger generation from representing Mexico in the 1968 Venice Biennale: a solo show of Tamayo was sent instead. But in the late 1960s the ruptura artists were featured at other international venues, including Expo 67 in Montreal, the 1968 HemisFair in San Antonio, and Expo '70 in Osaka, where thirteen of them (including Carrillo, Corzas, Felguérez, and García Ponce) created mural-sized works for a U-shaped wall in the Mexican Pavilion. Yet if they were now winning battles, most painters had lost the proverbial war, for they remained committed to easel painting just as other trends—including minimalism, and performance, conceptual, and installation art—had begun to take precedence internationally, with artists from Andy Warhol to Joseph Kosuth rejecting the primacy of the handcrafted object and challenging official "systems" of display and promotion, both public and private. In retrospect, the artists of the so-called ruptura generation are perhaps less important for their paintings than for their attitude, which opened the way for the more diverse, radical, and internationalist discourses that would emerge in the 1970s and 1980s.

If any work of art of this period pointed the way to the future, while also remaining somewhat stuck in the present, it was Cuevas's *Ephemeral Mural*, inaugurated before a large crowd in the Zona Rosa in 1967. By placing a self-portrait and enormous signature on a billboard that would be changed after a month, Cuevas mocked the muralists' egocentrism and desires for permanence while simultaneously embracing commercial self-promotion as a valid strategy. Printed t-shirts and a documentary film produced at the time extended the work's visibility. Though the "mural" lacked the edge of similar events happening in Los Angeles, New York, and London, its public yet evanescent nature resonates with the temporary displays about to be installed across the city, as Mexico geared up for the 1968 Olympic Games.

Chapter 10 From the Olympics to Neo-Mexicanism (1968–94)

Transitions are rarely marked by single dates, but in the history of Mexican art and culture, as well as politics, October 1968 signaled both the apogee of the centralizing and often ruthless push towards economic development and internationalism begun under Miguel Alemán, and the beginning of the end of (almost) unchallenged rule by a single-party regime. Although the massacre of protesting students and workers at the Plaza de las Tres Culturas in Tlatelolco early in the month would dominate the national consciousness in subsequent years and even decades, it was framed by the decision in 1963 to name Mexico City—a compromise candidate selected in the context of Cold War polarities—as the site of the XIX Olympic Games, held from October 12 to 27, 1968.

The 1968 Olympics and the bloody repression of a student protest movement during the administration of Gustavo Díaz Ordaz (1964–70) placed the country front and center at a time of international unrest, from the civil rights movements in the US to revolutionary and guerilla struggles across Latin America. Yet, ironically, the PRI machine insulated Mexico from the even more brutal militarism that emerged elsewhere in the Americas. Despite—or because of—his links to the massacre of 1968, President Luis Echeverría (1970–76) turned the country to the left, at least rhetorically, welcoming leftist intellectuals fleeing Latin American dictatorships, sponsoring exchanges with other non-aligned nations, and even serving *aguas frescas* instead of whiskey and wearing guayaberas at state functions, though at the same time brutally suppressing urban and rural guerilla movements.

Much Mexican art from the late 1970s through the early 1990s was shaped by what historian Enrique Krauze has called the "decline of the system." The discovery of vast oil reserves in the early 1970s launched an economic boom that benefited many artists, particularly those represented by commercial galleries. Although the PRI initially expanded government services, its mismanagement of the economy plunged Mexico into crisis, marked by a major devaluation and the nationalization of the banking industry in 1982. The Mexico

City earthquake of 1985 revealed the fragility of the capital's modern infrastructure; the inability of the federal government to respond effectively to the crisis prompted the rise of independent civic organizations. The opposition believed that fraud committed during the 1988 elections guaranteed the PRI victory. The party's candidate, Carlos Salinas de Gortari, subsequently advanced a neo-liberal agenda that created new fortunes, but also increased social conflict. For many opponents of the PRI, both in and out of the art world, the political machine that had controlled Mexico for many decades had lost its legitimacy.

The most advanced Mexican artists of this period were engaged in the same trends being investigated by their colleagues elsewhere in Latin America, from viewer-activated kinetic art to neo-figurative painting. Many were trying to break free of a government-controlled system of arts patronage that increasingly limited free expression. The 1970s saw the rise of geometric abstraction in painting and sculpture, while members of emergent artists' collectives, known as the *Grupos*, rejected object-based practice in favor of installation, street performance, and other forms of political conceptualism. In the crisis-ridden 1980s, some painters, known as the neo-Mexicanists, again turned to local sources of inspiration, though now exploding nationalist myths and engaging with gender politics as the PRI system began to erode.

I. Glory and Tragedy in 1968

After facing international criticism that as a third-world nation Mexico was unprepared for the organizational challenge of hosting the Olympics, the federal government appointed architect Pedro Ramírez Vázquez head of the Organizing Committee in 1966. His track record had been proven by the Estadio Azteca (1966), the Museo Nacional de Antropología (page 330), and the Mexican Pavilions at the world's fairs in Brussels (1958), Seattle (1962), and New York (1964). Given a limited budget, however, the architect focused attention less on new facilities than on a design and publicity campaign directed by Eduardo Terrazas (b. 1936). A cascade of promotional materials was printed, and ephemeral urban installations unified dispersed sports facilities and concealed urban blight and underdevelopment. Terrazas saw this campaign as a matter of

national pride. Ramírez Vázquez also planned a yearlong Cultural Olympiad, a playing field where Mexico was far more competitive. Like the world's fair pavilions—though now on Mexican soil—the entire program projected Mexico's sophistication to outside audiences and turned local skeptics into enthusiasts.

Although primarily remembered abroad for the raised fists of US medalists Tommie Smith and John Carlos, a controversial display of Black Power, the 1968 Olympics were the first to have an integrated design program that encompassed all signage, printed material, souvenirs, and even the clothing of the young ushers or *edecanes*. Bright contrasts were selected with an eye to the television broadcast, the first ever of the Olympics in color. Like so many buildings and paintings of the period—including the new Hotel Camino Real by Ricardo Legorreta (1931–2011), constructed for VIP guests—the "Mexico 68" logo blended traditional and modernist forms, alluding to both Huichol yarn paintings and Op Art, which was then enjoying its heyday. The other major Olympic image was the silhouette of a dove, emblematizing Mexico's embrace of a peaceful "third way" at a time of frightening tensions between the Eastern and Western blocs.

Ramírez Vázquez named Mathias Goeritz, Mexico's most internationally connected artist of the time, head of international promotion for the Cultural Olympiad. Goeritz coordinated the Ruta Internacional de la Amistad (International Route of Friendship): nineteen painted-concrete sculptures by artists from aligned and non-aligned nations representing all five continents were placed along an eleven-mile-long stretch of new highway that connected the newly re-baptized Estadio Olímpico on the UNAM campus to the athletes' housing and other facilities. Three other modern sculptures, by Goeritz, Germán Cueto, and Alexander Calder, were commissioned for other sites (Calder's enormous stabile *The Red Sun* stands outside the Estadio Azteca).

For the Ruta, Goeritz chose artists who worked exclusively in non-objective styles. Not only did this confirm the international relevance of his own practice, but it also eliminated the risk of nationalist statements or political controversies that sometimes arise when artists employ figuration. *Gateway to the Wind*, by Helen Escobedo (1934–2010), is typical of the bright abstractions that suddenly appeared in what was then a rather rural zone; slum-dwellers adjacent to

237 Lance Wyman, art direction by Eduardo Terrazas and Pedro Ramírez Vázquez, *Mexico 68*, 1967.

This abstract design, in which lines radiate out from "Mexico 68" and the Olympic rings, is more memorable than many subsequent Olympic mascots. Although a collaborative effort, US graphic designer Lance Wyman (b. 1937) was mainly responsible for the final version. He also created pictographic signs for the stations in the Mexico City subway, or Metro, which opened in 1969.

238 Ricardo Legorreta, Hotel Camino Real, Mexico City, 1968.

Building on the legacy of Luis Barragán, Legorreta designed monumental buildings for the public and private sector, which were famous for their massive walls and voids, and striking use of color. Murals and sculptures by Tamayo, Friedeberg, Goeritz, and Alexander Calder were installed in the Camino Real's public spaces. The pink entrance screen is also by Goeritz.

239 Helen Escobedo, *Gateway to the Wind*, 1968.

Helen Escobedo studied with Germán Cueto before receiving her MFA from the Royal College of Art. She was one of three Mexican artists Goeritz selected to create a sculpture for the Ruta de la Amistad. Other participants included the Australian Clement Meadmore, the Austrian Herbert Bayer, and the Uruguayan Gonzalo Fonseca, the latter two artists living in the US at that time.

other Ruta sculptures were given leftover paint to make their surroundings more attractive to Olympic visitors. Like the Towers of Ciudad Satélite (page 327), the Ruta sculptures were prominent, media-friendly, and seemingly apolitical markers of modern sophistication, easily viewed by passing cars (many are now obscured by subsequent construction, and some have been moved). This was also a high-profile display of official patronage of foreign artists, rather rare in Mexico—though some US muralists had worked for the government in previous decades (page 282).

The Organizing Committee of the Cultural Program of the XIX Olympics, as it was formally known, also sponsored numerous exhibitions, from children's art to kinetic installations. The INBA organized a Festival Internacional de as Artes that brought Julio Le Parc, Jasper Johns, and Merce Cunningham, among others, to Mexico for shows and performances. In June, together with the INBA, the Committee co-sponsored an open call for a juried "Exposición Solar" to be held in the Palacio de Bellas Artes, where works were to have the Sun as a theme. Several of Mexico's leading artists, including Cuevas and Tamayo, dissatisfied with anachronistic juried exhibitions where anyone could enter and anyone could win, refused to participate unless the guidelines were modified; although the authorities acquiesced, the show was still partially boycotted in yet another challenge to the power of the government to set the rules of the cultural game.

Yet discontent with established institutions was brewing far beyond the parameters of any one exhibition, and would not be contained by Olympian calls for peace and solidarity. In the summer of 1968, students and teachers from Mexico's technical schools and the UNAM began organizing nonviolent demonstrations calling for an end to police violence, the release of political prisoners, and respect for the University's autonomy, among other concerns. Art students enrolled in the Escuela Nacional de Artes Plásticas (ENAP, which was now affiliated with the UNAM) and La Esmeralda (the INBA's Escuela Nacional de Pintura, Escultura y Gráfica) joined the propaganda brigades of the Consejo Nacional de Huelga (National Strike Committee), which organized and directed the student protests. Often working surreptitiously at night with their more radical professors, they created posters, banners, fliers, and other materials for diverse political uses. Not

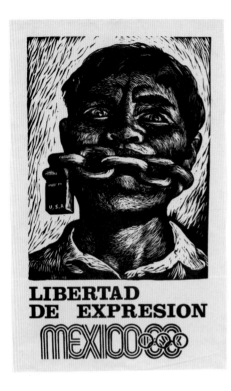

240 Adolfo Mexiac and anonymous students, *Freedom of Expression*, 1954/1968.

While a professor at the ENAP, Mexiac allowed his students to reuse a print he had produced in 1954 in the TGP supporting Guatemalan resistance to a CIA-led coup. In 1968, the image was ironically re-captioned with Olympic typography to condemn censorship of student voices.

surprisingly, credit was almost always anonymous. In their rapid and collective production, political vehemence, and even appropriation of popular imagery, these ephemeral images recall the work of Posada and the Taller de Gráfica Popular.

Some of the most radical and—in retrospect—influential developments in the visual arts were taking place in the street, on the UNAM campus, and in other spaces not directly controlled by the government. Even more established artists expressed their solidarity with the students, using collective strategies and politicized imagery absent in their individual work. In an exhibition at the Salón de la Plástica Mexicana that August, several prominent artists of the ruptura generation turned their paintings to face the wall to protest government repression. At the CU, José Luis Cuevas, Manuel Felguérez, Francisco Icaza, and Ricardo Rocha (1937–2008), among others, painted murals in support of the student movement on corrugated zinc panels covering a vandalized sculpture of Miguel Alemán. The narrow impact of these events, however, showed the limitations of traditional painting in the face of the new urban and media-based strategies being employed by the younger generation, which was far less tied to traditional institutions.

López Mateos had launched the construction of the Conjunto Habitacional Nonoalco-Tlatelolco by telling crowds that "a pacific revolution avoids the violent revolution." But on October 2, just ten days before the scheduled opening of the Olympics, government agents fired on students and workers peacefully assembled in the Plaza de las Tres Culturas, killing some three hundred people. Although the PRI had a violent history of repressing striking workers, this massacre was far bloodier and directly affected the middle class. Given government censorship, there are few visual records of the events of that day other than grainy photographs; Jodorowsky's film "The Holy Mountain" later alluded to the carnage in a scene where birds emerge from a murdered boy's body, but not

241 Various artists, untitled murals, 1968.

In 1952, a larger-than-life-size stone sculpture of Miguel Alemán dressed in academic robes, by Ignacio Asúnsolo (1890–1965), was installed to commemorate the patron of the CU. As a symbol of the ruling regime, it was attacked in 1960 and again in 1965, when it was irreparably damaged and concealed behind a corrugated metal fence. In the late 1960s, several artists painted murals on the fence, to express their support of the student movement. The statue and fence were removed by 1970.

until "Rojo Amanecer" (Red Dawn), a 1989 film by Jorge Fons (b. 1939), was the tragedy of October 1968 represented in full. Though radical artists generally avoided figurative references to the massacre, Tlatelolco shaped a generation: afterwards it would be impossible to ignore the fact that complicity with the regime was complicity with "evil."

For the history of Mexican art, perhaps the most important result of the summer of 1968 was the establishment of the Salón Independiente (SI), an idea launched by Felguérez, British-born artist Brian Nissen (b. 1939), and Japanese-Argentinian painter Kazuya Sakai (1927–2001). This artist-led initiative emerged in direct response to official control over shows like the "Exposición Solar," the lack of innovation at the Museo de Arte Moderno, and the demagogic promotion of past artistic splendors. Fundamentally, these artists wanted total independence from the system and the freedom to exhibit their own versions of international trends, particularly diverse forms of abstraction. The SI should also be seen in the context of related efforts by filmmakers, such as Arturo Ripstein (b. 1943), who were then trying to create an "independent cinema" equally free of government control.

The first Salón Independiente was planned for the Museo Universitario de Ciencias y Arte (MUCA), where Helen Escobedo was director. Since the army still occupied the UNAM campus, it opened instead at the Centro Cultural Isidro Fabela in San Ángel. Although inaugurated just two weeks after Tlatelolco, and involving some of the same artists who had

painted the "ephemeral murals," the SI kept its distance from politics—at least publically. Instead, organizers emphasized international openness and "free expression," and rejected prizes and media-specific categories. In keeping with international boycotts of the Venice and São Paulo biennials in the late 1960s, the participants agreed not to show their work in official exhibitions, though this was not rigorously followed.

The second (1969) and third and final (1970) incarnations of the Salón Independiente, both at the MUCA, entailed greater visual experimentation and openness to foreign artists, even if Mexicans remained dominant. In 1969, the SI took place in the wake of an almost-complete boycott by Mexican artists of the São Paulo Biennial to protest the Brazilian military dictatorship. The works exhibited, however, generally avoided explicit political positions in favor of hard-edged geometric abstraction, lingering forms of late Surrealism, and other diverse tendencies.

A lack of funding for the 1970 exhibition forced artists to improvise, and to adopt more conceptual and inventive strategies than they had previously. Rather than expensive mural-sized paintings, like those several ruptura artists sent to Osaka that same year, the SI artists created ephemeral, site-specific installations using cardboard (donated by a paper company), discarded newspapers, and other cheap materials. Cuevas promoted himself in an installation called *The World's Longest Drawing: 307 Meters*, but other works explicitly critiqued the national media and film industries. Felipe Ehrenberg sent his contribution from London via the postal system; mail art and other conceptual strategies increasingly offered artists a way of subverting commercial and political limits on free expression and even travel. Mail art was also a key way of sharing ideas with colleagues trapped by Latin American dictatorships. Didactic yet fragile, these works contradicted—by implication—the validity of "official" non-objective monuments, such as those recently sited along the Ruta de la Amistad.

Ehrenberg had taken up residence in London with Martha Hellion (b. 1937) in 1969, fleeing the repression that followed Tlatelolco. Like other voluntary exiles in Europe, including Ulises Carrión (1941–1989), Ehrenberg entered alternative networks of artistic production and distribution, and engaged in institutional critique. In his tape-recorded performance *A Date with Fate at the Tate* (1970), he entered the museum with

242 Felipe Ehrenberg, *Work Entitled Secretly Upwards and Onwards*, 1970.

This early example of Mexican mail art was an assemblage of apparently meaningless postcards, sent one-by-one from London to Mexico. When assembled at the Salón Independiente according to a pre-established grid, they formed a Pop Art image of a nude woman holding a soccer ball—playfully eroticizing the 1970 World Cup, held in Mexico City.

his head covered in a hood; when guards told him he had to remove it, he declared he was a work of art. Ehrenberg and Hellion established close ties with Fluxus and other avant-garde groups, and they, as well as Carrión, were key figures in the publication and dissemination of artists' books, mail art, and other conceptual practices that asserted that social communication, particularly when it negated or manipulated traditional institutions, was a liberating act.

II. Geometric Abstraction and Other Trends

As of 1972, Mexico City's Museo de Arte Moderno, led by Fernando Gamboa, was the official arbiter of national visual culture. It was now more open to international art, especially from Latin America, through exhibitions as well as the in-house magazine *Artes Visuales* (1973–81). In this decade, several stylistic options were in play, with varied forms of geometric abstraction emerging in an artistic landscape still to some extent dominated by Tamayo. Members of Nueva Presencia had gone their separate ways: Francisco Icaza turned to abstraction,

while Rafael Coronel pursued an ever more nostalgic realism. A few older artists and critics remained convinced of the need for state support, and sought to reform rather than avoid state institutions; their short-lived Congreso Nacional de Artes Plásticas (1972) desperately insisted—once again—that artists were crucial participants in the national project, from educational reform to urban beautification.

Among the dominant trends in Mexican painting and sculpture of the 1970s, geometric abstraction perhaps best reflected the new age promised by Mexico's oil-fueled economic miracle. Rational, clean, and ostensibly ahistorical and apolitical, non-objective paintings of hard-edged geometric forms appealed to government bureaucrats and capitalist elites alike. Artists saw their images as metaphors for progress and rational order, but, like the postwar housing projects, geometric abstraction was also a state-endorsed phenomenon that—whether seen in exhibitions or public parks—gave the authoritarian regime a crisp modernist facade. Geometric abstraction was also undeniably international; though some critics attempted to uncover allusions to pre-Hispanic architecture or identified colors as particularly Mexican, these were misplaced attempts to situate anti-nationalist works within a nationalist tradition.

In Mexico, the roots of geometric abstraction were shallow: though precedents can be found in the works of Mérida, Gerzso, and Goeritz, those images were more dependent on post-Cubism and late Surrealism than Constructivism or the Bauhaus. Josef Albers, while a frequent visitor to Mexico since the 1930s, seems not to have had much of an impact. Mérida almost never abandoned references to indigenismo, or at least human subjects (page 303), while both Gerzso (page 309) and Goeritz (page 326) tapped into irrational fears or spiritual emotions, rather than the cold well of reason. In the 1950s Mexican artists did not embrace the utopian Constructivist ideas then shaping Argentinian and Brazilian art during the developmentalist campaigns of those countries. From 1966 to the late 1970s, however, when hard-edged geometrism and related modalities, such as kineticism, were being featured in official and commercial spaces in Mexico, they too seemed evidence of the triumph of logic over political terror and social chaos.

In the late 1960s, several Mexican artists rejected the stasis of the traditional picture plane to explore theories of individual

perception and viewer participation. A very few played with dizzying Op Art patterns; more interesting are those who animated geometry itself in kinetic objects or environments that proposed a more "democratic" relationship with the audience. Siqueiros had been a pioneer in reconceptualizing three-dimensional mural space as early as the 1930s (page 294), culminating in his *March of Humanity* (1957–71) at the Foro Universal (later renamed the Polyforum Siqueiros), a cultural space on the Avenida de los Insurgentes. Goeritz had also created immersive "installations," including the patio of El Eco, which spoke of his internationalism (page 326). Nevertheless, compared to the Argentinian and Venezuelan artists who established important beachheads in Paris in the early sixties, Mexican artists were rather slow to adopt kineticism.

In 1968, however, Op Art and kinetic tendencies were evident in several shows organized around the Olympics, including a "Kineticism" exhibition held at the MUCA that summer, which invited audiences to experience an eclectic array of viewer-activated or electrified installations, by international artists ranging from Robert Morris (US) to Jesús Rafael Soto (Venezuela). The "Exposición Solar" also included

243 Ernesto Mallard, *Heliogony*, 1968.

Mallard was one of Mexico's leading kinetic artists. In *Heliogony*, circular bursts of precisely painted radiating lines covered by convex bubbles reference the origins of the universe. The freestanding format echoes the biombos of the viceregal period (page 134).

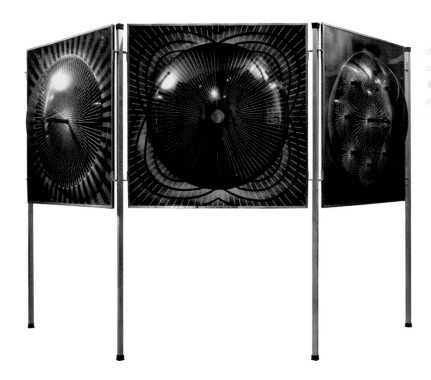

244 Manuel Felguérez,
Love Machine, 1972.

Several sculptures by Felguérez
appear in a sequence in
Jodorowsky's film that features
the "factory" of a wealthy art
dealer. This electric sculpture
opens out from a cube: curving
multicolored arms and fiber optic
"hair" anthropomorphize the
machine, which responds to the
stimulations of the dealer's lover,
played by the actress Re Debris.

kinetic works, some using industrial plastics or neon rather
than age-old materials, such as wood or bronze. These works
included space-age forms by Ernesto Mallard (b. 1932), and
a circular sculpture by Lorraine Pinto (b. 1933) called *Fifth
Dimension* (1968), which incorporated sound and light. The
most spectacular kinetic work created in Mexico was Felguérez's
huge *Love Machine* (1972), commissioned for the set of
Jodorowsky's "The Holy Mountain" but afterwards destroyed.

Another Mexican sculptor in tune with international
currents that engaged viewer perception phenomenologically
was Jesús Hernández Suárez, who adopted the name Hersúa
(b. 1940). Together with fellow ENAP graduates, including
Enrique Carbajal González (known as Sebastián; b. 1947), he
formed a collective called Arte Otro (Other Art) in 1968.
One of the first artists' groups to emerge from general
discontent with the academic system, Arte Otro created
installations combining light, color, architecture, and geometric
forms; in some, movable parts allowed viewers to activate
the space, freed from the hierarchical conventions of existing
institutions. Hersúa and Sebastián later collaborated with

a team of artists, including Goeritz, on the *Espacio Escultórico* (Sculptural Space), a UNAM commission, which brought some of the ideas of Arte Otro to more permanent form, though now with an emphasis on natural evolution and historical referents.

Several strands of geometric abstraction emerged in Mexico in the 1970s, some painterly and intuitive (García Ponce, Rojo), others industrial and analytical (Felguérez, Sakai). Some artists made rectangles to hang on the wall, while Francisco Moyao (1946–2008) created painted sculptures—or perhaps sculpted paintings—that leapt off the wall onto the floor. But one aspect that several painters shared was a concern for developing rule-based systems to generate their art, often as part of an attempt to negate the importance of personal style. In different series of works developed using mathematical frameworks, often accompanied by catalogues heavy with technical jargon, Arnaldo Coen, Gelsen Gas, and Manuel Felguérez situated themselves almost as scientists (and indeed, some held research positions at the UNAM).

245 Helen Escobedo, Manuel Felguérez, Mathias Goeritz, Hersúa, Sebastián, and Federico Silva, *Espacio Escultórico*, 1977–79.

This "sculptural space" on the UNAM campus consists of a circle of sixty-four isosceles triangles of hollow concrete, arrayed around a field of exposed lava. Openings to the four cardinal points connect abstract geometry to the cosmos and recall the gateways of the sacred center of Tenochtitlan, though the entire work looks more like a landing pad for a spaceship.

246 Manuel Felguérez,
The Aesthetic Machine, 1976.

In the 1970s Felguérez distilled
and sharpened the contours of
forms that appear in his gestural
abstractions of the 1960s. He
later abandoned this hard-edged
approach, returning again to
more spontaneous compositions,
now with the barest hints of
underlying geometric structures.

247 Kazuya Sakai, *Diachrony
(Mario Lavista)*, 1976.

Several of Sakai's paintings signal
the close relationship between
his compositions and music.
The title of this work references
Mexican composer Mario
Lavista's "Diacronía (String
Quartet) No. 1," composed in
1969. Sakai was also the graphic
designer of Octavio Paz's
magazine *Plural*.

In his *Multiple Space* (1973) and *Aesthetic Machine* (1975–76) series Felguérez fed a limited vocabulary of formal elements (the circle, the rectangle, etc.) into rather primitive computer programs (first at the UNAM, and then at Harvard) that generated innumerable permutations. The artist then intervened, selecting compositions based on aesthetic categories—balance, for example—and investing them with color. His process recalls Best Maugard's method of the 1920s (page 248), with the artist-inventor as catalyst rather than creator, though now elevating modernity and technology rather than traditional folk culture.

Like scientists who develop controls to guide laboratory experiments, other artists also restricted their pictorial options, allowing them to understand better the logical process behind the creative act. Coen worked with open cubes; Sakai, who arrived in Mexico from Argentina in 1960, developed a system of brightly colored looping lines and circles that cross the canvas like fragments of an infinite whole. Rojo, who had briefly flirted with lyrical abstraction but was more famous as a graphic designer, now emerged as an important painter. In a series he called *Negations*, each canvas had the same size and composition: a T-shape set within a square. After creating a work, he radically changed the brushwork and coloration of the next, thus "negating" the style of the previous one. Although Rojo hoped to contest clichés of authorship, in the end, his T-compositions were undeniably Rojos, as easily recognizable as Kenneth Nolands or Frank Stellas of the same years.

Geometric abstraction was perfectly suited for public spaces, already signaled by Goeritz's Towers and some works on the Ruta de la Amistad (page 355). Just as muralism had spread to provincial cities, so monumental sculptures, often painted vibrant colors, proliferated across Mexico from the 1970s, allowing regional politicians to show that they too were harbingers of modernity. Architect Fernando González Gortázar (b. 1942) provides an important link to the visual education programs instituted by Goeritz in the 1950s. Working especially in Guadalajara, he embedded dynamic concrete sculptures in parks and highway roundabouts, sometimes including fountains or elegant pedestrian overpasses. For one building (Edificio San Pedro, 1971), he commissioned Argentinian kinetic artist Luis Tomasello (b. 1915) to design an enormous wall relief. It was Sebastián,

however, who emerged as Mexico's most prominent public sculptor in the 1980s: his gigantic monochromatic steel forms, derived in part from folded paper sculptures he created in the early 1970s, were embraced by politicians across the country. The most famous of these is the bright yellow *Horse's Head* (1992), which towers (at nearly ninety-two feet) over the former site of Tolsá's Equestrian Monument to Charles IV (page 144).

III. The Grupos

In the 1970s, many younger Mexican artists chose to work outside the official and commercial networks of display that were then dominated by Tamayo and his followers, by the geometric abstractionists, and by surviving representatives of the "Mexican School." Some got lost along the spiritual avenues opened up in the 1960s by the countercultural movement. Others, many while still in art school, clustered into a dozen or more politically active *Grupos*, or collectives, that emerged in the mid-1970s at another moment of economic crisis. Working outside the mainstream, they took diverse approaches to the reasons for making "art."

These artists challenged the political system at a time of continuing PRI control in Mexico and military crackdowns throughout Latin America, and were inspired by broad-based social shifts, including the rise of the New Left and the anti-Vietnam War and civil rights movements. They also challenged the art world by rejecting the sanctity of the art object, the gallery wall, or even the identity of the artist him- or herself. The Grupos generally scorned traditional forms of painting and sculpture in favor of conceptual and critical modes of art-making: installation, performance, mail art, and environments, all practices that were surfacing in avant-garde circles across Europe and the Americas. They sought to engage new publics and to shock a complacent bourgeoisie, as had Jodorowsky before them, though in their own public events most of the Grupos avoided absurdity and bombast, and, despite certain charismatic leaders, tended to erase individual identity in favor of the collective.

The immediate origins of most of these collectives are to be found in the classrooms of the ENAP and La Esmeralda in the mid-1960s, where art students had grown tired of debates over

the validity of such stylistic categories as informalism, hard-edge abstraction, or figuration; Tamayo and Siqueiros seemed like quarrelsome grandparents who were better ignored. One of the first collectives, Grupo 65, consisted of students from the ENAP who rejected the status of the artist as genius and the preeminence of the art object. Arte Otro had also been an early manifestation of this collective urge. After moving to Mexico in 1971, the Peruvian-born critic Juan Acha became a principal theorist who inspired several of the Grupos through texts and seminars promoting collective organization and "non-objectual" art.

The student protest movement and continuing government repression of dissent in the early 1970s politicized the Grupos; though only a few of their members were old enough to have been active in the late 1960s, the sense that art could transform society by challenging tradition and official politics was in the air, partly informed by international developments in the art world. But the Grupos could also trace their roots—at least indirectly—to predecessors at home. From the muralists' union of the 1920s to the LEAR and TGP, there was a long tradition in Mexico of artists forming collectives in opposition to the status quo in contested public spaces, whether official institutions or the street. Even their non-objectual practice had precedents in Mexican art history, from the Estridentistas—though their cacophonous events were poorly remembered—to Los Hartos (page 343), and including the ongoing (and highly public) efforts by Cuevas, Goeritz, and Jodorowsky to *épater les bourgeois*, though the Grupos were motivated by a greater sense of political urgency.

Despite a shared commitment to self-critical collective work, and a rejection of authoritarian systems—cultural, educational, or social—the Grupos were less a movement than a phenomenon, marked by diverse approaches. Some used expected artistic strategies, such as street murals and installations, while others pushed into new territories. Grupo Março (1979–82) created urban interventions using texts rather than images, while No Grupo (1977–83; page 379) and Peyote y la Compañía (1978–84; page 380) engaged in performances that lampooned the solemnity of institutions and artists. Some of these collectives lasted for several years and produced sustained bodies of work, while others materialized for specific projects and quickly disbanded. Much of what they did was

ephemeral or printed on cheap paper, since the groups were poorly funded and neither collectors nor the state had any interest in their work; theoretical discussions or even socializing were often as important as actual production.

Some of the work of the Grupos circulated abroad through publications or exhibitions, but their primary audience was local. Given their need to operate outside—or in opposition to—official institutions, it is not surprising that much of their activity took place in the street, where they encountered new and diverse audiences. From Siqueiros to the TGP, getting images into public view had been a priority for activist artists, and, in fact, one of the calls of the 1972 Congreso Nacional de Artes Plásticas was "for an art of the streets." Some Grupos reinvented mural production in new contexts, parallel to the far more prolific Chicano mural movement in the US. Arte Acá, founded in 1973, created street murals intended to reactivate Tepito, a working-class neighborhood in downtown Mexico City. The Taller de Investigación Plástica (TIP; 1974–76), based in Morelia, worked on mural projects in rural communities. And at a time when museums and commercial galleries tended to ignore photography, Adolfo Patiño (1954–2005) founded Fotógrafos Independientes (1976–84), which set up impromptu shows on wires strung above Mexico City's sidewalks. These photographers challenged lingering ideas of transcendent "Mexicanness" with anti-aesthetic shots of urban residents and streetscapes.

For some Grupos, art production was secondary to specific political goals. Arte Acá was founded in resistance to an urban redevelopment project known as Plan Tepito, which would have drastically altered the traditional neighborhood. Other collectives were concerned with wider urban and even international problems. The Taller de Arte e Ideología (TAI; 1974), led by Alberto Híjar (b. 1935) of the UNAM's Faculty of Philosophy and Letters, staged plays and exhibitions in support of liberation movements in Asia and Latin America. Both Grupo Mira (founded in 1977 as a continuation of Grupo 65, and directly linked to the student brigades in 1968) and the much younger artists in Germinal (1979) created cheap prints, banners, and other displays that could be moved from neighborhood to neighborhood, highlighting data about violence and poverty in Mexico City (in the case of Mira) or working directly with unions and other social movements, even

248 Pedro Meyer, *Laundry Epic*, 1979. Photograph showing mural by Arte Acá, Tepito, Mexico City, c. 1973.

The leading muralist in Arte Acá was Daniel Manrique (b. 1939), who had studied at San Carlos. His murals, close in spirit to those by Siqueiros and the Chicano movement, were generated by dialogue with members of the community, rather than being imposed by outside institutions.

going to Nicaragua to give classes on popular murals and graphics to the members of the Sandinista resistance movement (TAI, Germinal). Some of this practice recalled the posters, banners, and floats produced in Siqueiros's Experimental Workshop back in 1936.

Of all the Grupos, Proceso Pentágono (1976–97) and Suma (1976–82) had a more lasting impact on the visual arts, in part because they were concerned with aesthetic problems as well as political engagement. Sculptor and MUCA director Helen Escobedo invited Pentágano and Suma, along with TAI and Tetraedro (led by Sebastián) to create collective works for the Tenth Paris Youth Biennial in 1977. No Grupo (page 379) also sent works to Paris, though as an unofficial and subversive act.

This was one of the most politicized Mexican exhibits of the period. Proceso Pentágono—whose members then included Felipe Ehrenberg and Víctor Muñoz (b. 1948)—built a freestanding pentagon-shaped room containing objects, images, and texts related to political repression in Latin America, including the Mexican government's dirty war against urban and rural guerillas; Suma created a complex tripartite "altarpiece" with collaged elements alluding to the López Portillo administration (1976–82). Both groups had a fluctuating

249 Proceso Pentágono, *Pentagon*, 1977.

The interior of this installation included furniture and pseudo-torture devices, as if it were a military installation that had been invaded by the public. In fact, the name of the group not only emphasized their collective process, but also co-opted the symbolic power of the Pentagon in Washington, D.C.

250 Grupo Suma, *The Unemployed Man*, 1978.

Led by Ricardo Rocha, Grupo Suma began as a Taller de Experimentación Visual y Pintura Mural (Workshop of Visual Experimentation and Mural Painting) in the ENAP. In several illicit actions, stencils were applied to walls, sidewalks, and other structures, at a time when graffiti in the central part of the city was almost absent.

membership: in fact, more than twenty artists were associated with Suma, including Oliverio Hinojosa (1953–2001), Gabriel Macotela (b. 1954), and Mario Rangel Faz (1956–2009). Suma also pioneered the use of "neo-gráfica" or new graphic technologies, using stencils, mimeographs, and other cheap forms of printing that could be posted on walls, somewhere between murals and graffiti.

In 1979, the antagonistic relationship between the Grupos and the Museo de Arte Moderno was underscored at the first and only Sección Annual de Experimentación (sometimes called the Salón de Experimentación) of the INBA's Salón Nacional de Artes Plásticas. The jury rejected Mira's neo-graphic project about violence in Mexico City, while Suma won an award but then graffitied its own work in protest. The Salón de Espacios Alternativos, organized by the INBA in 1981, 1984, and 1988, provided increasing legitimacy for the new forms of artistic practice first explored by the Grupos, including installation (these shows also allowed groups to get funding for their unmarketable art). By the 1980s, however, the heyday of the Grupos had passed; former members now turned to political activism, or pursued independent careers that showed a continuing commitment to non-traditional practice.

In both official and alternative spaces, explicitly feminist discourse had been rather tentative in the 1970s: in part, this is because the most politically active Grupos were focused on class rather than gender, and were led mostly by men. A late and explicitly feminist manifestation of the Grupo phenomenon was Polvo de la Gallina Negra (1983–93), named for a powder used to avert the evil eye, founded by Maris Bustamante (b. 1949) and Mónica Mayer (b. 1954). These two women played a pioneering role in the emergence of performance art in Mexico (Mayer had studied in the 1970s at the famous Women's Building in Los Angeles). Their neo-Dadaist performances highlighted serious issues, such as rape, or critiqued the media image of women; in 1987 they subverted a popular television show by convincing the male anchor to dress up as a pregnant woman and engage in a discussion about female archetypes.

Though Lourdes Grobet (b. 1940), a member of Proceso Pentágono, also pursued feminist issues, she rejected imported feminist theory as constraining. In *An Hour and a Half* (1975), members of the audience watched Grobet tear her way out of a foil-covered box, while a photographer recorded the

event; she then pretended to enlarge and develop the images, hanging them in the gallery-turned-darkroom. To the annoyance of people who had patiently waited ninety minutes to see the results, the unfixed almost life-size prints (which had actually been made before the happening) turned completely white when she turned on the light. In this and other works—such as *Striptease* (1983), where she showed photographs of herself stripping while remaining fully clothed—Grobet, inspired by Goeritz, her former teacher, mocked the seriousness of "art photography" (including the signed edition), while also asserting the right to control when, where, and how she was represented.

A feminist sensibility also shapes the work of Magali Lara (b. 1956) and Carla Rippey (b. 1950). While still in Grupo Março, Lara began creating artist's books about daily life and dreams; these text-based works later morphed into calligraphic paintings replete with botanical references.

251 Lourdes Grobet, *An Hour and a Half*, 1975.

Grobet's performance took place at the Casa del Lago, a small UNAM space in Chapultepec Park that was a key site for alternative practice in the 1970s. The photographs were taken by the artist's then-partner, Marcos Kurtycz.

252 Carla Rippey, cover of *La Regla Rota*, no. 3 (Spring 1985).

La Regla Rota (1984–87) was an experimental magazine that covered everything from rock concerts to the art world. Its title, "The Broken Rule," expressed its irreverent attitude.

In the 1980s, after leaving Peyote y la Compañía, Kansas-born Rippey began appropriating photographs found in archives and flea markets, exploring an intensely personal and outsider consciousness at a time of highly charged nationalism. In one drawing, Rippey's laughing protagonist—a stand-in for the artist—takes aim at Picasso's *Guernica* as a symbol not only of "high" art of noble purpose, but also of images—produced even by the Left—that made women victims rather than protagonists.

At a time when most of the innovative happenings and installations were being created by members or former members of the Grupos, one lone figure stood out—that is, when anyone stopped to notice him. Marcos Kurtycz (1934–1996), a Polish-born mechanical engineer, moved to Mexico via Cuba in 1968 and adopted graphic design as a way of earning a living. His personal work consisted of artist's books, mail art, and performances, some of which were frighteningly visceral or involved dangerous manipulations of his body: in *Passion and Death of a Printer* (1979), a complex action at the Salón de Experimentación, he ended up so bloodied that some spectators called the Red Cross.

Yet like most conceptual artists of the time, Kurtycz was generally ignored by the art establishment and critics, and had limited recognition beyond a few passionate followers and the shocked newspaper reporters who contributed to his almost mythical reputation. In fact, partly due to their evanescent nature, and partly to the continuing emphasis on such traditional formats as painting and sculpture in museums and traveling exhibitions, only recently have the performances and actions of the 1970s and 1980s received critical attention. Even as rumor and memory, however, these events provided a model

for theoretical and conceptual approaches to art-making that would reach fruition in the 1990s, earning greater international attention for a younger generation of artists.

IV. Mexicanism Redux

In the 1970s and 1980s, painting remained dominant in official salons and galleries: people needed something to decorate their homes and offices, after all. Works commonly seen included the late paintings of Tamayo and the geometrism, informalism, and Tamayesque abstractions of a younger generation, including Gabriel Macotela, Irma Palacios (b. 1943), and four brothers named Castro Leñero. Yet what stands out most clearly in retrospect, and what reveals more about changing political and cultural realities in the country, is the widespread resurgence of explicitly local subject matter. Rather than a continuation of the "Mexican School," this return to nationalist iconography typically entailed a critique of the post-Revolutionary myths those earlier painters had helped forge. Popular culture, Mexican history, and personal identity were now unpacked with greater critical distance, evident in the artists' heightened use of eroticism, irony, cynicism, and humor.

One of the earliest manifestations of this shift away from internationalism is evident in the work of Francisco Toledo (b. 1940), a painter born in Juchitán, on the Isthmus of Tehuantepec, but educated in Mexico City and in Paris, where he lived from 1960 to 1965. Toledo abandoned his youthful abstractions, typical of the ruptura generation, while still in Europe. He adopted peasant clothing—a Mexican hippie *avant la lettre*—and began creating ephemeral works using humble materials, such as seeds and mud, asserting a direct relationship between art and nature. Octavio Paz and others initially rejected Toledo as the avatar of a false neo-primitivism that went against their cherished idea of a sophisticated and international Mexico, but he had discovered a rich visual resource to mine for the rest of his career.

Beginning in the mid-1960s, Toledo invented a mythical bestiary where humans often seemed interlopers, rendered in a sophisticated figurative style with echoes of Tamayo and Marc Chagall. Designed to look naïve, resembling cave paintings or folk art, Toledo's images—like those of many Mexican artists of the 1920s and 1930s—are hardly innocent. Although triggered

253 Francisco Toledo, *Woman Attacked by Fish*, 1972.

Toledo works with an almost unlimited range of materials and media: oil paint mixed with sand, watercolor, ceramics, and even turtle shells and ostrich eggs. In the 1990s he began taking photographs, including some frankly erotic "self-portraits" that showed he could laugh at himself as well.

by ancient and contemporary Zapotec myths, they also reveal the artist's profound sensitivity to natural history and social anthropology, filtered through Surrealist dream theories. In *Woman Attacked by Fish*, the naked victim seems about to be inseminated by a swarm of phallic creatures: nature here is aggressive and unrelenting, but the image, in the end, is playful, even tongue-in-cheek. Toledo inspired many younger painters, loosely referred to as the "Oaxacan School," the leading exponent of which is Sergio Hernández (b. 1957).

Toledo's erotic wit distinguishes him from many of his generation—except, perhaps, Jodorowsky—but there is also a seriousness to his endeavor. Though his art is never didactic, Toledo is as much an activist as Rivera or Siqueiros had been. In 1972, he helped found the Casa de la Cultura del Istmo in Juchitán (a town with a long history of political dissidence), one of the first attempts to build a decentralized cultural network in Mexico. Since the 1980s, he has used his art to finance programs in Oaxaca City, supporting arts education, historic preservation,

and the recovery of local culture, challenging not only a monolithic "official" nationalism largely orchestrated from Mexico City, but also international corporations; in 2003, he prevented McDonalds from opening on the city's main square.

Several Mexican photographers working in the 1980s—including Mariana Yampolsky, a former member of the TGP—used a documentary mode to capture an idyllic rural world, often free of any evidence of modernity. Others, however, were taking a more critical stance, whether in the

254 Graciela Iturbide, *Lizard*, Juchitán, Oaxaca, 1986.

The pose of these two *tehuanas* is reminiscent of studio portraits. Iturbide set up the scene, but had not intended the hands holding the plexiglass sheet to appear in the frame. Yet she embraced the "error," reminding viewers of the constructed nature of all photographs.

countryside or the city. Since the 1970s, Graciela Iturbide (b. 1942), who studied under Manuel Álvarez Bravo, has captured the eccentric side of Mexican traditional culture in powerful black-and-white photographs that undermine any sense of unspoiled Mexican "authenticity," from sympathetic portraits of the tehuanas and *muxes* (openly gay, frequently cross-dressing men who are fully accepted in local society) of Juchitán, to brutal images of the annual slaughter of goats in Tehuacán, Puebla. Like her teacher, Iturbide often leaves open the question of whether her subjects have been found or posed.

Photographers across Mexico were also fighting for greater independence and institutional recognition in the 1970s and 1980s. The Consejo Mexicano de Fotografía, founded in 1977 by Grobet, Nacho López, Pedro Meyer (page 369), and others, promoted a new photography that focused more on social issues than aesthetics, sponsoring exhibitions and colloquia that brought together Latin American photographers. Turning away from the mythical countryside, Grobet documented the private and public side of professional wrestling (*lucha libre*); Pablo Ortiz Monasterio (b. 1952) created images of punk culture in the streets of poor Mexico City neighborhoods, such as Tepito. Photojournalists affiliated with an emergent oppositional press, including *Proceso* (founded in 1976), *Unomásuno* (1977), and *La Jornada* (1984), also captured the changing urban landscape and rise in social dissent, as well as revolutionary struggles in Central America. At the same time, this period marked the apogee of photography as an independent discipline defined by a noble pursuit of "truth." By the 1990s, as elsewhere, leading contemporary artists in Mexico City were embracing the medium—and especially new digital technologies—in ever greater numbers, but often more skeptically, constructing photographs in new ways without ever calling themselves "photographers."

Toledo, Iturbide, and Grobet were all linked to social movements calling for political change at a time when the PRI still maintained strict control. This distinguishes them from the neo-figurative painters of the 1980s, who generally disdained activism in favor of a more hermetic introspection, as if the answers were to be found in the self rather than the group, and at home rather than abroad. This generation was formed, in part, by a general malaise that extended across class lines. The political and economic situation limited international travel and

255 Enrique Guzmán, *Miraculous Image*, 1974.

The transparency of Jesus's body—a probable citation of paintings by René Magritte—underscores Guzmán's critique of religious doctrine. Though he found some critical success, Guzmán left Mexico City in 1979, and committed suicide a few years later.

exchange for many artists, some of whom were also rebelling against sexual and cultural restrictions—especially on women and gays—imposed by a relatively conservative society.

The most critical of these artists turned to the icons of Mexican culture—nopals and magueys; Ixtaccihuatl and Popocatepetl; folk art and calendar illustrations; the flag and other patriotic emblems; Aztec sculptures; the Virgin of Guadalupe; Revolutionary heroes and the recently rediscovered Frida Kahlo—not out of respect for the glories of the past, but as part of an ironic awareness, if not cynical disdain, for how those icons had been invented, manipulated, recycled, and distorted by the post-Revolutionary regimes, and especially the PRI, in the media, schools, and advertising. Their work has come to be known collectively as neo-Mexicanism or the "New Mexicanisms," but this was not simply a return to the local after the internationalism of the ruptura generation. From their postmodern position (though few yet used the term), these artists understood the "national" as a construction that was constraining more than liberating, and, as such, as something that could be demolished.

Besides images by Toledo and Iturbide, there were other precedents in the 1970s that inspired, directly or not, the neo-Mexicanists. These include the frequent references to Zapata in the works of Alberto Gironella, and the prescient imagery of Enrique Guzmán (1952–1986), a controversial painter who developed a crisp figurative style unlike anything else being done in the Mexican art world at the time. His most startling works—*Miraculous Image*, for example—recycle patriotic or religious icons, including Mexican flags and images of Jesus, in blasphemous, sometimes scatological compositions intended to scandalize a national audience made complacent by so many banal abstractions. Such attacks on religion had their limits in the Mexican context, however: a montage showing the Virgin of Guadalupe with the face and bared breasts of Marilyn Monroe, by a relatively unknown artist named Rolando de la Rosa, provoked a violent protest by irate religious activists when it was shown at the Salón de Espacios Alternativos in 1988.

In the late 1970s and early 1980s, some members of the Grupos were also exploring Mexican stereotypes critically. No Grupo—Maris Bustamante, Melquiades Herrera (1949–2003), Alfredo Nuñez (b. 1949), and Rubén Valencia (1950–1990)—undermined the cultural system in irreverent performances they called "stagings of visual moments." Less interested in pamphleteering than the other Grupos, No Grupo (the name itself signaled their difference) nonetheless spoke out against the folklore of the "Mexican School." Invited to contribute to a special number of the magazine *Artes Visuales* featuring the Grupos, No Grupo focused attention on Jesús Helguera (1910–1971), an academic illustrator whose melodramatic renditions of the Legend of the Volcanoes (page 220) were and remain common on calendars. The manifesto exposed Helguera's paintings as kitsch, and noted the complicity between art and advertising, an early manifestation of a neo-Mexican sensibility. In the late 1980s,

256 No Grupo, *Publicist or Artist?*, one-page contribution to *Artes Visuales*, no. 23 (January 1980).

Edited by Carla Stellweg (b. 1942) and designed by Vicente Rojo, *Artes Visuales* was published by the Museo de Arte Moderno during the directorship of Fernando Gamboa. The magazine signaled an increased opening up to alternative practices and international art, and provided a space for greater debate.

¿ PUBLICISTA O ARTISTA ;

DE ENERO A DICIEMBRE
HELGUERA PRESENTE !

Javier de la Garza (b. 1954) revisited Helguera's calendar art, as well as stills from famous Mexican films, in slick paintings that became emblematic of neo-Mexicanism.

Adolfo Patiño, founder of Peyote y la Compañía—besides Rippey, the group's members included Armando Cristeto (b. 1957) and Rogelio Villarreal (b. 1954)—was one of the most influential figures for the development of art in the 1980s and beyond. For the 1979 Salón de Experimentación, his group created an installation that resembled a Day of the Dead altar covered in references to Mexican popular culture and urban kitsch, culled from Patiño's childhood and flea market excursions (Patiño also invited Guzmán to participate). The group used nationalist icons as part of an explicit rejection of internationalist abstraction, of imperialism, and of US commercial culture. Patiño later condensed this idea in more intimate works that recall the surrealist boxes of US artist Joseph Cornell, and—closer to home—the assemblages of Gironella and Alan Glass. Glass-covered boxes protect delicate photographs, dried roses, *lotería* cards, and religious prints. Patiño's Polaroid self-portraits dressed as Frida Kahlo were among the first references to her paintings in contemporary Mexican art.

The diversity of neo-Mexicanist practice is evident on both formal and conceptual levels. A few painters, including de la Garza, worked in an academic style reliant on photographic sources, while others experimented with collage and montage, as if depicting the mess they had left after rummaging through once-sacrosanct national narratives. Most neo-Mexicanist

257 Adolfo Patiño, *Queen, Star, and Sacrifice*, 1985.

Like modern reliquaries, these boxes include varied references to the Virgin of Guadalupe, from the roses that miraculously appeared to Juan Diego (page 123) to Patrona brand vegetable oil. The portrait on the left is an old *fotoescultura*, a distinctive Mexican craft in which photographs are pasted to carved wooden supports to make them seem more real.

258 Germán Venegas, *Zapata Vivo*, 1984.

After his assassination in 1919, revolutionary leader Emiliano Zapata emerged as a mythic figure: idealized by such artists as Rivera and Belkin, viewed critically by Orozco and Gironella, and fictionalized in film. In this intentionally crude image, Venegas shows him as skeletal and destabilized, undermining the traditional cry of victory, "Viva Zapata!"

painters, however—among them Dulce María Núñez (b. 1950) and Germán Venegas (b. 1959)—employed loose brushwork, loud colors, and awkward draftsmanship to question national myths and histories, parallel with contemporary works by the German neo-expressionists. This visual aggression contradicted the smooth and trouble-free surfaces of established icons, from religious paintings and textbook covers to Diego Rivera's murals. José Clemente Orozco, admired for his expressionist brushwork and his cynical rejection of indigenismo and other totalizing ideologies, also provided an important, if often unstated, model.

There were several overlapping aspects to neo-Mexicanist practice. Some images are affirmative and even celebratory, and thus closer rhetorically to post-Revolutionary art. Successful "regional" painters, such as Rodolfo Morales (1925–2001), based in Ocotlán, Oaxaca, and Ismael Vargas (b. 1947), from Guadalajara, produced large, non-threatening paintings lauding folk culture almost to an extreme, waxing nostalgic for what was being lost in the pursuit of modernization and urbanization. However, as in some paintings of the "Mexican School" of the 1930s and 1940s, a melancholic spirit invades many of these works. This is clear in Morales's paintings, and in the later staged studio photographs of Gerardo Suter (b. 1957), which convert muscular nude models into Aztec gods as powerful as Vilar's *Tlahuicole* (page 171), while alluding to frightening primal forces. Other neo-Mexicanists, however, were more ironic and

259 Nahum B. Zenil, *With All Due Respect*, 1983.

In Mexico, interest in Frida Kahlo further increased after an exhibition organized by London's Whitechapel Art Gallery came to Mexico City in 1983. This drawing by Zenil references two Kahlo paintings, *The Bus* (1929) and *The Two Fridas* (1939), both included in that show.

even transgressive, exposing fictions and destroying myths, frequently using images of the body to dismantle traditional constructions of race, gender, and sexual identity.

The subtle differences among the varied strands of neo-Mexicanism might be clear through a comparison of self-portraits by Nahum B. Zenil (b. 1947) and Julio Galán (1958–2006), two of the most important Mexican painters of this period, and among the first to explore explicitly local themes in their figurative work. Both, not coincidentally, referenced Kahlo, who by the mid-1980s had emerged as a cult figure in Mexico and the US. Kahlo's heroic status derived as much from her biography as her work: her broken body, sexual ambiguity, and difficult relationship with Rivera resonated with the preoccupations of many neo-Mexicanists, especially women and gays. Yet Kahlo also provided a crucial professional model, as a painter of intimate confessions who challenged the rhetorical strategies of state-funded muralism.

Zenil's precisely rendered ink drawings often appropriate the format of ex-votos (pages 114–115). In several self-portraits, sometimes appearing with his partner Gerardo Vilchis, Zenil asserted his racial and sexual identity without emotion; these

260 Julio Galán, *I Want To Die*, 1986.

works often conceal more than they reveal, even when the artist appears naked, with heart exposed. In a respectful homage to Kahlo created the same year that Hayden Herrera published her groundbreaking biography, Zenil cites two of Kahlo's paintings. As in her *The Bus* (1929), we find ourselves inside the vehicle as if another passenger. The artist sits with his mother, Vilchis, and of course Kahlo; Zenil literally and figuratively embraces the "indigenous" half of *The Two Fridas* (page 304). His childhood home in rural Veracruz appears in the background. Here the gay man is no longer an isolated prowler, as in Manuel Rodríguez Lozano's portrait of Salvador Novo of 1924 (page 260), but part of a community and a tradition.

Where Zenil found strength in Mexican culture, Julio Galán found oppression. In the 1980s Galán was based primarily in Monterrey, where he felt distant from stereotypes of Mexican identity—tehuanas and *mariachis*, for example—none of which was native to his northern part of the country. One of the most influential and successful of the neo-Mexicanists, Galán explored far broader themes than many of his contemporaries, and he created an eccentric Warholian persona as he moved back and forth between Monterrey and New York. His early

works refer to a childhood in rural Coahuila, doted over by fussy aunts on a former hacienda, but many of his paintings embody the most critical, ironic, and pessimistic strain of neo-Mexicanism. In *I Want To Die*, Galán subverts the confident Mexicanism of Kahlo's self-portraits. Surrounded by a floral design taken from traditional lacquerware, the pallid figure, clearly of European descent, raises his arms in surrender, bound by chains that loosely reference Mexico's geographic borders. The paper banner, of a type used in fiestas, announces his dystopian wish: death rather than enslavement to national identity.

Although neo-Mexicanism's recycling of national symbols superficially resembles contemporaneous Chicano art in the US, the contexts were different, and direct contact was sporadic. Whereas in Mexico members of the mainstream deconstructed longstanding cultural myths and oppressive stereotypes, Chicano artists tended to elevate nationalist icons (from the Virgin of Guadalupe to Zapata and Kahlo) as a form of resistance to the oppressive mainstream. Chicano street muralists asserted Mexican cultural identity to empower communities, and rarely used humor or irony as discursive strategies (the members of Asco, a collective formed in 1972, were a notable exception to this rule).

Artists from Mexico City were, however, involved in promoting the US–Mexico border zone as an autonomous site for art production in the 1980s. This was spearheaded in South Texas by US artist Michael Tracy (b. 1943), who invited several collaborators up from the capital, and in the San Diego–Tijuana region by Mexican-born artist Guillermo Gómez-Peña (b. 1955; living in the US since 1978), and US artist David Avalos (b. 1947), members of the Border Art Workshop/Taller de Arte Fronterizo (founded 1984), which engaged in early critiques of violence and migration networks. Gómez-Peña later reinvented himself as the Border Brujo, a transnational shaman-performer who mixed cultural identities at multiple levels.

By the late 1980s, neo-Mexicanism dominated a now thriving local art market: galleries like Arte Actual in Monterrey (founded in 1972) and OMR in Mexico City (1983) relentlessly promoted this work to emergent collectors, many of whom were beneficiaries of the government's neoliberal economic policies. (A simultaneous international surge in collector and museum interest in modern Mexican art further fueled the demand for contemporary art with local references.)

Neo-Mexicanism was also widely seen in new private museums founded by corporations, with budgets that dwarfed those of the INBA museums: Televisa's Centro Cultural Arte Contemporáneo (1987–98) in Mexico City, and the Museo de Monterrey (1977–2000) and Museo de Arte Contemporáneo (1991 to present), both controlled by divisions of the Grupo Monterrey conglomerate. Ironically, or perhaps as a purposeful distraction (a sort of replay of Echeverría's nationalist ploys of the 1970s, page 350), the same media barons and industrialists who were inserting Mexico into a global economy—and thus eroding local and regional difference—were now filling their mansions and museums with bright assertions of traditional culture, by both "Mexican School" and neo-Mexicanist painters.

Overexposure rarely benefits a critical artistic movement, but for some artists and curators, an even more important concern was the incorporation of neo-Mexicanist work in exhibitions in the US supported by the Consejo Nacional para la Cultura y las Artes, a *de facto* cultural ministry created by the Salinas administration (1988–94) in 1988. For almost everyone in the Mexican art world, "Mexico: Splendors of Thirty Centuries," the traveling blockbuster exhibition of 1990— organized by New York's Metropolitan Museum of Art but mainly sponsored by the Mexican government and its corporate allies on the eve of the North American Free Trade Agreement (or NAFTA)—was a milestone event, to be embraced or reviled. Although that show excluded all post-1950 art, paintings by the neo-Mexicanists were featured in exhibitions and promotional materials connected to "Mexico: A Work of Art," an extensive program of related events held in other galleries and museums at the same time. Some of the neo-Mexicanists rejected this as an appropriation of their work by the PRI, or felt the commercializing of their practice distorted their original intentions; younger and more rebellious artists began taking off in new directions, even leaving Mexico altogether.

Although artists of the 1990s generally dismissed neo-Mexicanism, references to local history and tradition were hardly abandoned, though they were now filtered through the frameworks of conceptual or neo-conceptual art. One example is *The Middle of the Road*, a powerful installation by Silvia Gruner (b. 1959) on the fence—made of corrugated steel plates used in the Gulf War of 1991—dividing Mexico and the US, in a Tijuana neighborhood known as Colonia Libertad. Seated on

261 Silvia Gruner, *The Middle of the Road*, 1994.

As if forming an infinite line, the 111 sculptures in this installation were cheap replicas of a stone original in the collection of Dumbarton Oaks in Washington, D.C., now thought to be a nineteenth-century forgery. The replicas were soon stolen, making the work as fleeting as the migrants crossing the border.

metal stools welded to the wall, plaster casts of an Aztec sculpture of Tlazolteotl ("Eater of Sins") guarded a dangerous crossing point where migrant workers sought to evade the watchful eye of the US Border Patrol. Gruner appropriated this image of a woman grimacing in childbirth as a poignant symbol of sacrifice and penitence, rather than as an ironic critique of national identity.

The Middle of the Road—ephemeral, non-illustrative, and created in dialogue with the local community—was a form of public art about as far from the corridors of the SEP (page 240) as one could imagine, even if it too sought to draw attention to social problems. It was commissioned by InSite, an organization founded in 1992 that sponsored site-specific installations and other cultural projects in the Tijuana–San Diego region. This was just one of many biennials, directly or indirectly modeled on Venice and São Paulo, that proliferated across the globe in the early 1990s, part of an even wider expansion in the field of contemporary art in which more and more curators, working for all sorts of institutions, were searching for new ideas, especially on the former "periphery." All of this would dramatically expand the visibility of contemporary Mexican artists, who were increasingly players on an international, or perhaps post-national, stage.

The last gasp of official neo-Mexicanism is not to be found in painting or international exhibitions, but rather in architecture. In 1994, at the close of the Salinas presidency, the Centro Nacional de las Artes—a campus for the national art, dance, film, music, and theater schools—rose on the former film lot of Estudios Churubusco, site of the great productions from the Golden Age of Mexican cinema in the 1940s and 1950s. Although some of the structures—the Escuela Nacional de Danza by Enrique Norten (b. 1954), for example—were high-tech, the dominant cultural references in the complex were local. For the Escuela Superior de Música, Teodoro González de León (b. 1926) employed the large forms and hammered concrete surfaces reminiscent of pre-Columbian pyramids that have long distinguished his work; Legorreta's La Esmeralda included blue tiled domes and thick yellow walls. The entire project evoked, as at the CU, a brightly painted and theatrical reinvention of the Plaza de las Tres Culturas, at least in its allusions to cultural continuity across time. This was the last of the PRI's pharaonic displays of power through architecture, the true end of an era.

262 Teodoro González de León, Escuela Superior de Música (left) and Ricardo Legorreta, La Esmeralda (center), Centro Nacional de las Artes, Mexico City, 1993–94.

To foment interdisciplinary exchange, the Centro Nacional de las Artes (master plan by Legorreta Arquitectos) united the government's five visual and performing arts academies and four related research centers— designed by eight principal architects—on a single campus. This was the latest manifestation of a system of government patronage that dates back to the Academia Real de San Carlos.

Chapter 11 Contemporary Issues: Art in Mexico since 1990

Carlos Salinas's last year in office was a turbulent one. On January 1, 1994, the Zapatista Army of National Liberation launched a revolt in Chiapas that highlighted continuing social inequities, especially in southern Mexico. Later that year, brazen assassinations of PRI leaders, including presidential candidate Luis Donaldo Colosio, hinted at deep divisions within a decaying system. After taking office in December, Ernesto Zedillo (1994–2000) was forced to devalue the peso once again; in 1995 the economy began to stabilize, but the PRI's power was eroding. In July 1997 the Party of the Democratic Revolution (PRD)—a coalition of leftist forces, including the PRI's left wing, which had split off after the contested presidential election of 1988—was victorious in the first direct election of the Mexico City government. In 2000, the triumph of the National Action Party (PAN) under Vicente Fox ended more than seventy years of single-party control of the presidency (that is, until the PRI's resurgence in 2012).

Artists in Mexico born in the 1960s and early 1970s reacted to these changes with skepticism and distance. Literally shaken by the Mexico City earthquake in 1985, and growing up during one economic crisis after the other, they knew the fragility of modernism and development firsthand. This generation, even more than its predecessors, had little respect for the state's cultural infrastructure, including museums and art academies (even though some had studied at San Carlos and La Esmeralda), which they saw as overly conservative and out of touch with international artistic currents. Working with few resources, they created alternative networks for discussion, self-critique, and experimentation. At first operating on the margins of official culture, by the start of the new millennium they had become central players in Mexico's flourishing art world.

Summarizing contemporary art in Mexico over the past twenty years with any pretense to objectivity or historical perspective is an impossible task. Instead, this chapter focuses on a few artists who have captured the attention of critics and curators since the early 1990s, in Mexico as well as abroad, and whose works resonate with issues discussed elsewhere in this

263 Melanie Smith, *Orange Lush I*, 1995.

This work forms part of a series, including photographs and videos, in which the artist focused on a single, almost arbitrarily selected theme—the color orange—as a control mechanism allowing her to approach the complexity of Mexico City. In fact, loud colors are essential attention-grabbing devices in the chaotic metropolis, evident in commercial products, advertising, and even architecture (page 353).

book. All of these artists distanced themselves from flashy, market-oriented painting and what they believed were the simplistic identity politics of neo-Mexicanism. Inspired by Marcel Duchamp, Joseph Beuys, the Minimalists, and the Situationists, among other models, they developed art-making strategies that were more tentative than assertive, often focusing on surprising, dangerous, or even banal aspects of daily life on the streets of Mexico City. (Only a few of them had learned, from parents or teachers, about their conceptual forebears in the Grupos of the 1970s.) Their works were sometimes nonchalant and often witty: they observed and posed questions without ever really trying to provide answers.

It would be reductive to see any of these artists as brave pioneers escaping the legacy of muralism and the "Mexican School," or—at the opposite extreme—to interpret their work as determined by Mexican identity: some of them are not even Mexican. Instead, in the same way as the Contemporáneos, the Surrealists, and the artists of the ruptura generation, they were trying to forge an artistic identity that—like the location of their studios—was tied to Mexico only when it suited them. As throughout Mexican history, artists from abroad, whether temporary or permanent residents, still play a crucial role: for example, British-born artist Melanie Smith (b. 1965) represented Mexico at the 2011 Venice Biennale, something that would have been unimaginable in the 1950s. At the same time, like Lorenzo Rodríguez (page 98) or Mathias Goeritz (page 326) before them, these foreigners occasionally incited nationalist counter-reactions, often part of a more general critique of the dominance of post-conceptual art.

This new field of artists was already beginning to emerge in the late 1980s, clustered in discrete though overlapping and

sometimes competitive circles, loosely associated with different alternative spaces. The lack of a commercial market for their work stimulated even greater creativity. One contingent emerged around 1986 in the counterculture atmosphere of La Quiñonera, a suburban house in the shadow of Anahuacalli (page 320) that had been transformed into artists' studios, where curator Rubén Bautista organized shows of work by residents (among them Rubén Ortiz Torres; b. 1964) and non-residents alike. In 1987, Gabriel Orozco (b. 1962), just back from studies in Madrid, began a Friday afternoon seminar with disgruntled students from the ENAP, including Abraham Cruzvillegas (b. 1968) and Damián Ortega (b. 1967).

Meanwhile, several artists from abroad were also circulating in Mexico City. A few Cubans, including José Bedia (b. 1959) and Juan Francisco Elso (1956–1988), took advantage of relaxed visa requirements and moved to Mexico in 1986. Their use of natural materials and references to Cuban *santería* rituals inspired some local artists; by comparison, almost no one in Mexico City knew about the *Siluetas* and other performances Cuban-American artist Ana Mendieta (1948–1985) had devised in Oaxaca in the late 1970s. Things intensified at the end of the decade: US artist Jimmie Durham (b. 1940) was based in Cuernavaca from 1987 to 1994; Chilean-born artist Eugenia Vargas (b. 1949) was undertaking photographic projects that boldly used her own naked body as a site for ceremonial acts, exposing social and ecological traumas. Meanwhile, a young Belgian architect named Francis Alÿs (b. 1959), Texas-born Thomas Glassford (b. 1963), Silvia Gruner (who had recently returned to the city after completing her MFA in Boston), and Melanie Smith all set up studios in a couple of run-down apartment buildings in Mexico City's colonial center that soon became focal points for exhibition and debate.

Although Gabriel Orozco and Rubén Ortiz Torres both participated—albeit on two different collaborative projects—in the last Salón de Espacios Alternativos, held at the Museo de Arte Moderno in 1987, for the most part this generation of artists was showing its work in locales outside of the state cultural apparatus, assisted—though never controlled—by a new generation of independent curators and cultural promoters. Among the most important spaces of the early 1990s were Adolfo Patiño's La Agencia (1987–93); the Salon des Aztecas (1988–92); Curare (1991 to present), directed by critic

Olivier Debroise (1952–2008); and Temístocles 44 (1993–95), founded by Eduardo Abaroa (b. 1968), Abraham Cruzvillegas, and other artists, in an empty house in the upscale Polanco district. Dealer Benjamín Díaz showed some of this work at the Galería de Arte Contemporáneo (founded in 1982), and a few astute curators in government spaces—including the Secretaría de Hacienda's (Finance Ministry's) La Casona, and Ex-Teresa, an INBA gallery founded in a colonial church in 1993 and dedicated to performance, as well as the Museo de Arte Moderno—were also paying attention. This dizzying array of names and spaces gives some sense of a dynamic moment of tremendous possibility, akin to the excitement of the early 1920s.

Information about international contemporary art and theory was also circulating with greater intensity, well before the spread of the Internet. Curare invited guest speakers from abroad; the magazine Poliester (1992–2000) included reviews and essays on what was happening elsewhere in Latin America; new relationships were forged at InSite, the Havana Biennials, and other international events; the Centro Cultural Arte Contemporáneo and Museo de Monterrey expanded their exhibition program to include works of contemporary art (from Arte Povera to photographs by Robert Mapplethorpe) previously invisible in Mexico, except in books and magazines; and the FITAC, a symposium on art theory linked to Mexico's first art fair, was established in Guadalajara in 1991. All this was just the beginning of a boisterous conversation that made Mexico City an important hub in a now decentralized global art world. In fact, for the first time, Mexican artists sometimes became famous internationally before they were widely known at home—though the audiences for contemporary art in Mexico also exploded and diversified.

Chronology fails us in discussing contemporary art, since so many ideas overlap and collide in a short span of time, and projects—much less their makers—can rarely be pigeonholed into discrete categories. Although there were painters and sculptors who remained committed to traditional formats and media, many leading artists of the 1990s were engaged in a post-conceptual practice that privileged found objects or situations, removed from the markets and streets, reconfigured and recontextualized. Some artists employed specialized craftsmen (tapestry weavers, welders, even doormat fabricators) to create their work; others assembled precarious sculptures in their

264 Abraham Cruzvillegas, *Phlebitis*, 1995.

Wit and sarcasm were common strategies at a time when few had confidence in either the system or utopian alternatives. Like blood-red clots, the two fat punching bags in this sculpture are ironically branded "Delgado" (thin) after a Mexican boxer who won a gold medal at the 1968 Olympics.

studios; video and performance art were also increasingly widespread. Many—following in the footsteps of such scientist-artists as José María Velasco (page 184) and Manuel Felguérez (page 363)—were researchers and curators as much as "makers," and their inquiries stretched from the markets and workshops of Mexico City to the worlds of comics and UFOs, pornography and *telenovelas* (soap operas), Beat literature and car culture. Painting was even less a primary mode of self-expression or political communication for leading artists and their critics than it had been in the 1970s. Instead, along with sculpture, photography, and indeed the entire history of art, painting was just one of several potential weapons in an artist's arsenal.

I. Using the Found Object

One of the main art-making strategies of the 1990s was the appropriation of found objects, inspired by Duchamp's theory of the ready-made but tempered by Beuys's humanism, especially his concept of "social sculpture." Melanie Smith's *Orange Lush I* (1995) might serve as representative of some overarching concerns. The work is an assemblage of non-traditional materials, namely orange plastic objects found in wholesale shops in downtown Mexico City, from balloons to a bedpan, all disposable goods produced from oil. Here, Smith is less a "sculptor"—as is Cruzvillegas in his humorous juxtaposition of clunky shoes and punching bags—than a collector, investigator, anthropologist, and even curator. Whereas nationalist artists in the 1920s were drawn to rural folk arts as symbols of mestizaje, Smith relishes the diversity of industrial forms and textures, none of which is particularly Mexican, even if the overall composition might seem Baroque, or the title reminiscent of tropical excess. As in other works made in Mexico in the 1990s, the boundary between life and art is blurred: the result hovers somewhere between the display window and the trash bin.

In fact, *Orange Lush* refuses to be easily digested, and, most of all, avoids reaching for sublime meanings: instead, Smith seems merely to want us to share her surprise that so many orange things are out there in the modern city. Artists in the 1990s were particularly interested in popular culture and social

phenomena, especially in Mexico City, a simultaneously pre- and post-modern megalopolis that was dynamic, inexpensive, violent, majestic, and increasingly difficult to grasp, and where globalization was leading to all sorts of contradictions. This is evident in Smith's aerial photographs and airbrushed paintings of anonymous working-class neighborhoods in Mexico City's urban grid; these nondescript concrete buildings, devoid of any references to nature, could be almost anywhere, the complete opposite of Velasco's idealized representations of the Valley of Mexico (page 186). Only occasional pink gashes—the plastic sheeting covering the capital's famous *mercados sobre ruedas* (literally, markets on wheels)—ground us in a particular locale.

In much of his work, Gabriel Orozco has proposed a far quieter and more restrained strategy, distilling the complexity of the world down to elegant metaphors of ambiguous meaning. Some of his most poignant works are ephemeral "sculptures" or traces of actions—beach sand piled on a wooden table, circular tracks made by a bicycle, cans of cat food balanced on watermelons in a supermarket, a pile of wood scraps near the former World Trade Center in New York— that he made or just "discovered," by looking closely at what most of us rush by. These were recorded in color photographs sometimes reminiscent of the earlier, equally poetic, work of Manuel Álvarez Bravo. The empty shoebox Orozco exhibited on the floor at the Venice Biennale in 1993 was an eloquent statement: simultaneously modest and flamboyant, skeptical

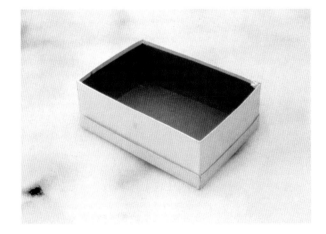

265 Gabriel Orozco, *Empty Shoe Box*, 1993.

In the competitive field of the Venice Biennale, artists often fight for the maximum possible area to display their works. Within a vast exhibition hall, Orozco's plain white shoebox drew attention by being purposefully discreet. The box echoes the forms of far weightier minimalist sculptures, and the "white cube" of the gallery itself.

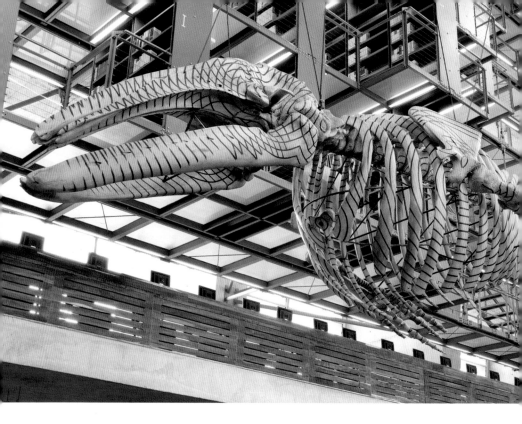

266 Gabriel Orozco, *Mobile Matrix*, 2006.

and humorous, a fragile container easily filled with contemporary art theory.

Critics embraced Orozco's post-minimalist Duchampian aesthetic as emblematic of the contemporary artist's global condition, linked simultaneously to the local *and* the international. For example, his *Black Kites* (1994), a human skull covered with a penciled checkerboard pattern, could be just as easily related to Dutch *vanitas* paintings or Op Art as to Day of the Dead broadsides by Posada (page 225). A far more spectacular project, entitled *Mobile Matrix* (2006), commissioned by the government for Mexico City's new Biblioteca José Vasconcelos (Alberto Kalach and team, 2006), employs the bones of a gray whale found on a beach in Baja California and enlivened by rhythmic graphite lines. Hanging in the lobby, the reassembled skeleton—which recalls the displays in natural history museums—is far more poignant than the abstract geometric sculptures installed in so many public buildings in the 1970s and 1980s.

II. The Art of the Copy

Mexico is a nation of tremendous originality, but also a place where innovation builds upon external models; since the early colonial period, there have always been skilled artisans ready to supply local markets with copies (licit or illicit) of whatever originals—religious sculptures, Kahlo paintings, new-release DVDs—are in short supply. It has thus followed that many contemporary artists have explored the conceptual problem of the copy itself. The reproductions of Tlazolteotl in Silvia Gruner's *The Middle of the Road* (page 387), for example, acknowledge Tijuana's tourist economy, filled with ersatz versions of everything from the Virgin of Guadalupe to black velvet paintings of Elvis to "zebras" that are actually donkeys with painted stripes.

Eduardo Abaroa's re-creation (at two-thirds the size) of Barnett Newman's *Broken Obelisk* (1963–67) replaces the original Cor-Ten steel with the plastic and metal used to create stands in Mexico's street markets. Abaroa's sculpture was first displayed in a show at Temístocles 44, and then re-erected for one day alongside a real market in the south of the city. The cheap collapsible frame and bright-pink color lampoon the solidity and solemnity of the original monument, designed as a memorial to Martin Luther King, Jr., by a US artist who embodied the *machismo* of the postwar New York School. Recalling the anonymous indigenous artist who dressed the Apollo Belvedere as Tlaloc (page 27), or Juan O'Gorman, who surrounded the modern Corbusian studio he built for Diego Rivera with a cactus fence (page 262), Abaroa took Newman's sculpture and "Mexicanized" it. In these and other cases, Mexican artists have challenged—on purpose or unintentionally—a history of art based solely on imported "originals."

Since the late 1980s, Francis Alÿs has kept his studio in the same few blocks of the colonial center of Mexico City that have served as his primary source of inspiration. But like many of his generation, he also operates internationally, orchestrating projects from Copenhagen to Patagonia to Afghanistan that oscillate between performance and documentation, often constructed around the simple act of walking. Alÿs has also been long fascinated by the problem of the copy. He has collected hundreds of amateur versions of Jean-Jacques

267 Eduardo Abaroa, *A Portable Broken Obelisk for Street Markets,* 1991–93.

Most urban monuments are permanently sited, and fade into the background of daily life; the Caballito (page 144) is a rare exception. Abaroa's monument, however, can be dismantled and re-erected, constantly engaging new viewers. At the same time he exposes the fact that high modernist sculptures, though popular with politicians, rarely address community needs.

Henner's lost painting *Fabiola* (1885), an imaginary portrait of an early Christian saint; his eponymous project, in which these flea-market finds are installed in museum settings, is a visual cacophony in which every copy, no matter the talent of the maker, energizes the missing original. In Mexico such a project resonates, of course, with the single most copied image in the country: the Virgin of Guadalupe.

Beginning in 1993, Alÿs began collaborating with sign painters (*rotulistas*); he asked these commercial artists, skilled in the use of airbrush, to create enlarged copies of small paintings. Like jazz musicians riffing on an original score, however, these artists were free to change colors, textures, and other details according to their own inspiration; Alÿs sometimes modified his own compositions to reflect their decisions. To subvert expectations about relative value, his diminutive "originals" and the larger, glossier "copies" were given equal prices. This mutual exchange may be reminiscent of the cross-cultural and cross-generational forces that shaped religious painting in Mexico City workshops in the seventeenth century, but here Alÿs specifically sought to challenge the traditional relationship between original and copy, between master and apprentice. Like other artists of the time, he also made transparent the process—and the sometimes collaborative labor—left hidden in many artistic endeavors.

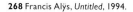

268 Francis Alÿs, *Untitled,* 1994.

In his "Sign Painting Project," Alÿs was inspired by professional artists in downtown Mexico City whose craft was threatened by the rise of industrially printed signs and billboards. In this example, consisting of his small "original" and two "copies," the tall, slender man is perhaps a stand-in for the artist himself, though his face is concealed by a wig.

III. New Modes of Social Critique

Curiously, though perhaps not surprisingly, several leading artists who emerged in this period were the children of 1960s radicals deeply committed to the development of a Latin American consciousness: Gabriel Orozco is unrelated to that other, more famous Orozco, but his father was an artist who worked closely with David Alfaro Siqueiros; Rubén Ortiz Torres's parents performed in the singing group Los Folkloristas; Laureana Toledo (b. 1970) and Jerónimo López (b. 1972, known as Dr. Lakra) are the children of painter Francisco Toledo; and the parents of Carlos Amorales (b. 1970) were both members of Proceso Pentágono. Perhaps in part to disentangle themselves from those bonds, most of these artists took up residence abroad, at least for a time. Ortiz Torres went to Los Angeles in 1989 and Orozco moved to New York the following year; Amorales and Dr. Lakra chose Europe.

Since the 1990s, mainly from the vantage point of Los Angeles, Ortiz Torres has rejected simplistic binaries that divide internationalism and nationalism, but not by searching for poetic ambiguity. Rather, his work opens a transcultural Pandora's Box, exposing the complexity and chaos that has resulted from appropriations and misinterpretations, particularly of US culture in Mexico and Mexican culture in the US. Ortiz Torres began as a neo-Mexicanist painter in the late 1980s and wrote his undergraduate thesis on postmodernism. While studying at the California Institute of the Arts (CalArts), he made "How to Read Macho Mouse" (1991), a frenetic video montage produced in collaboration with Aaron Anish. Accompanied by a soundtrack that mashes Herb Alpert's Tijuana Brass with Juan García Esquivel's lounge music, a cast of real and fictional characters—including Donald Duck, Emiliano Zapata, Speedy Gonzales, Frida Kahlo, Diego Rivera, tehuanas and trashy marionettes, noble campesinos and PRI politicians, and even Mexican gardeners in the US—are shown to be part of a messy field of myths and stereotypes that is impossible to resolve with such outdated concepts as mestizaje.

A similar sense of irony colors Ortiz Torres's more recent multidisciplinary practice—from collaborations with the designers of low-rider cars to garish photographs of examples of cultural hybridity in Mexico and the US (1940s murals

269 Rubén Ortiz Torres, *The Revolution Will Be Televised*, 1994.

In this print Ortiz Torres combined digital imagery (lifted from television) with a woodcut reminiscent of prints made in the Taller de Gráfica Popular. The artist recovers the lost dignity of the cartoon stereotype Speedy Gonzales, who is reborn here as Zapata. The title contradicts Gil Scott-Heron's anthem of the 1970s, "The Revolution Will Not Be Televised."

showing Walt Disney and César Augusto Sandino in a fancy Mexico City restaurant; the 1950s tourist trap known as "South of the Border" in Dillon, South Carolina) that have as many different "ancestral sources" as the offspring in casta paintings (page 116). Like several of his generation, including Abaroa (who directs an artist-run art school in Mexico City named SOMA), Ortiz Torres has also developed a career as critic, curator, and teacher alongside his studio work.

A Baroque aesthetic similar to that in Ortiz Torres's photographs informs the portraits of the young women in *Ricas y Famosas* (Rich and Famous), a photographic project that Daniela Rossell (b. 1973) began in 1994 and continued over several years. Taken mainly in domestic interiors, the images provide tantalizing insight into a *nouveau riche* culture concealed behind walls, protected by bodyguards, and marked by material excess. Her subjects—sometimes accompanied by household staff—are the beneficiaries of neoliberalism, but despite their cocky gestures and expressions they seem vulnerable, even ridiculous, as if the objects of a cruel anthropological study. Yet Rossell—who hails from the same social class—worked in complicity with them, and their artificial poses and settings are no less theatrical or socially constructed than those seen in *telenovelas* and newspaper society pages, Rivera's glamorous portraits of actresses and socialites, nineteenth-century genre paintings of saintly mothers (page 190), or images of viceregal aristocrats with prominent coats of arms (page 110).

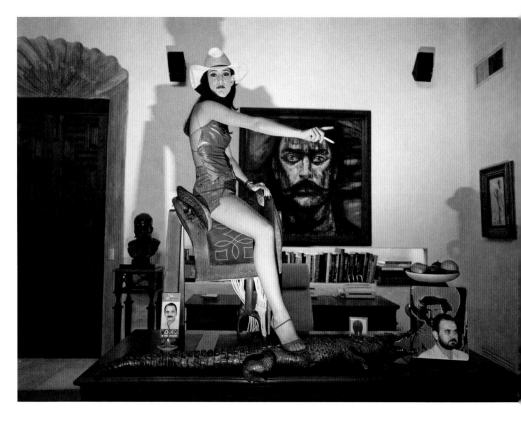

270 Daniela Rossell, *Untitled* (from the *Ricas y Famosas* series), 1999.

Captured with a harsh flash, a young woman poses in the manner of a sexy rodeo star, her foot placed on a stuffed alligator—a traditional symbol of America (page 86) but here just a silly prop. Her father's office is decorated with a bust and portrait of Zapata and contemporary political fliers, all of which she completely ignores.

Nevertheless, the publication of a book of these images caused a scandal in 2002, with some subjects threatening to sue the artist.

In fact, concerns about social class, crime, and power, more than the threadbare problem of national identity, can be detected in much of the art created in Mexico over the past fifteen years. Several artists have questioned the nation's political and economic system using various innovative modes of social critique, though generally avoiding the stridency or didacticism that prevailed in the 1930s or 1970s. Between 1995 and 1998, artist Vicente Razo (b. 1971) ran a "Museo Salinas" in the bathroom of his apartment, packed with dolls, masks, and other found parodies of the much-derided former president. Several of Alÿs's works comment on the fraility of nationalist or political rhetoric, as in his video showing people standing in the shadow of the flagpole in the Zócalo (page 16), or his *Housing for All* (1994), a temporary shelter made from plastic political campaign posters, inflated by the hot air flowing up from a subway grate. (The work was installed in front of the Palacio Nacional on the day of the election, when campaign materials are banned.)

Spanish artist Santiago Sierra (b. 1966) first arrived in Mexico City in 1995. In several challenging—and frequently controversial—performances and actions, recorded in photographs and videos, he used the human body as his medium, drawing attention to the power structures that shape daily life, including the economies and hypocrisies of the art world. To expose how labor is (de)valued in late capitalist society, he hired people to do inane tasks, such as hold up the detached wall of a gallery (*Acceso A*, Mexico City, 2000), or paid them to consent to unpleasant and sometimes permanent insults, including being tattooed.

In 2001, Sierra gave traditionally dressed Tzotzil women in Chiapas—who spoke only Maya—two dollars each to say, in Spanish, "I am being paid to say something, the meaning of which I do not know." Their statement might seem absurd, but it was intended, in part, to deflate romantic ideas about traditional culture, and especially how indigenous bodies and culture have been manipulated by elites. Like the Indians depicted in so many paintings of the "Mexican School," these women are trapped by poverty, revealed and reinforced by their lack of Spanish: Sierra makes this transparent. Though his sympathies clearly lay with the underdog, Sierra's actions reminded viewers that the utopian dreams of many a "revolutionary"—from Diego Rivera to the Zapatista leader Subcomandante Marcos—had not always changed much on the ground.

Of the alternative spaces of the late 1990s, the most important was La Panadería (1994–2002), founded by Miguel Calderón (b. 1971) and Yoshua Okón (b. 1970), young artists who had just returned from study abroad. Mixing music performances by rock, gore, and grunge bands with international contemporary art, La Panadería appealed to an ever-expanding streetwise audience. In their own work, executed collaboratively and individually, Calderón and Okón cultivated a sort of bad-boy aesthetic, though they themselves were from privileged backgrounds. Fearless and merciless, they engineered performances that

271 Santiago Sierra, *11 People Paid to Learn a Phrase*, Casa de la Cultura de Zinacatlán, Chiapas, March 2001.

Many of Sierra's works consist of very simple acts: tattooing a single straight line on a man's body; positioning a tractor-trailer to create a traffic jam; paying women to recite a straightforward phrase. Originally a sculptor, Sierra adopted the Minimalists' aesthetic of "less is more," but he has used this economy of means to draw attention to deeper social concerns.

272 Miguel Calderón, *Employee of the Month*, 1998

On the rooftop of the Museo Nacional de Arte, four employees mimic Gutiérrez's *Oath of Brutus* (1857; page 168). The museum guard brandishes his walkie-talkie instead of a knife. Calderón foregrounds individuals often pushed to the margins, but rejects the noble exaltations typical of leftist images of the working class in the 1930s.

exposed moral uncertainties in post-NAFTA Mexico, though with humor more than any reformist impulse.

In one video, made at a time when crime in Mexico City was on the rise, Calderón and Okón appear breaking into cars and stealing radios, later displayed in a faux-minimalist stack at La Panadería (*A propósito...*, 1996). Like so many thieves of the time, they were never caught (if in fact they had really stolen the radios in the first place). For an exhibit at the Museo Nacional de Arte, Calderón photographed museum workers posing in compositions derived from academic canvases in the permanent collection. Rather than demonstrating an interest in copies per se, Calderón was undermining the political and moral certitudes that shaped history painting in the Academia de San Carlos: he reminds us of its ridiculous artificiality, and draws attention to the distance between the ideal nation imagined by nineteenth-century intellectuals and contemporary reality.

IV. Sacrifice and Renewal in the New Millennium

After 2000, the Mexican economy continued its recovery under the National Action Party (PAN). This conservative party was less committed to funding national culture than the PRI had

been, but government support was becoming less crucial as Mexican artists were increasingly represented by commercial galleries in Europe and the US as well as Mexico; they and their works traveled international routes in order to participate in an endless variety of art fairs, biennials, and museum exhibitions. Private collecting expanded—in part inspired by the high-profile activities of Eugenio López Alonso, founder of the Fundación/ Colección Jumex (named for his family's juice company), which includes major works by national and international artists.

While Mexico City remains the country's dominant art capital, the system is no longer as centralized as it was even in the early 1990s, in part because neoliberalism weakened the state cultural apparatus while opening new avenues for private sponsorship. The UNAM's vast Museo Universitario de Arte Contemporáneo (MUAC), built by Teodoro González de León and inaugurated in 2008, quickly became a leading space for the presentation of contemporary art. INBA museums with dynamic directors, including the Museo Tamayo and Sala de Arte Público Siqueiros, have played a crucial role even when relatively underfunded. Commercial galleries, including kurimanzutto and Labor, bring international artists to Mexico City, rather than simply "exporting" Mexican art. The Fundación/ Colección Jumex commissioned a new museum (designed by David Chipperfield) in Mexico City, and the growth of private collecting, museums, and alternative exhibition spaces in provincial cities also proceeds apace, especially in Guadalajara, where Herzog and de Meuron were recently selected to design a new Museo de Arte Moderno y Contemporáneo. Whereas Mexican artists once feared complicity with the regime, today perhaps they need fear complicity with the demands of a market avid for anything new.

Though crime in Mexico City has declined in recent years, unbridled violence has increased elsewhere, largely because of a controversial militarized war against the drug cartels, unleashed in 2006 by the administration of Felipe Calderón (2006–12), that has led to tens of thousands of deaths. A rash of unsolved murders of women (many employed in *maquiladoras*, or assembly plants) and migrant workers along the border— most notoriously in Ciudad Juárez—has also exposed deep economic inequalities, as well as the weakness of national, state, and local police and judicial systems. It is difficult to approach such an historic situation with cynicism or indifference.

Since the early 1990s, Teresa Margolles (b. 1963) has been deeply engaged in an exploration of death and violence. Her career began as part of a collective named SEMEFO (an acronym for Servicio Médico Forense, the Mexican national forensic service), initially tied to urban subcultures, such as death metal rock and goth. SEMEFO soon began to allude to the darker side of neoliberalism in performances, videos, and macabre sculptural objects (one show featured installations involving horse carcasses) that were more visceral, perhaps, but no less irate than the images of man's violence to man in the murals of Orozco (page 292) and the prints of the TGP (page 286). As an independent artist, Margolles has created deeply moving works that combine minimalist aesthetics with morbid references: water used to clean corpses is transformed into bubbles, tattoos sliced from bodies in the morgue are converted into sculpture. Though such art materials seem horrific, they pale in comparison to the brutal impact of gangs and drugs on Mexico's streets.

In 2009, Margolles represented Mexico at the Venice Biennale, only the second time the country sponsored a national pavilion (the first, in 2007, featured work by Rafael Lozano-Hemmer; b. 1967). She filled a rented palazzo with references to the drive-by shootings that plague such cities as Juárez, including jewelry made from shattered automobile window glass. Cloths used to mop up bloody crime scenes were shipped surreptitiously to Europe; some were soaked in water, and people who knew murder victims mopped the floors with the rust-colored liquid. Stained fabrics were displayed on the walls, embroidered with the intimidating phrases assassins sometimes leave on corpses; another was installed as a flag outside the building. Margolles was redirecting attention to a war being fought on that same northern border where the Mexican Revolution had played out, almost a century before.

The apparition of blood was nothing new in Mexican art, whether evidence of personal suffering or public conflict. But Margolles had brought distant crime scenes to the Mexican pavilion, airing the nation's dirty laundry in front of world cultural elites. This was far from the glorious national identity heralded in the paintings by Rivera, Orozco, Siqueiros, and Tamayo that won accolades in Venice in 1950, and it was far less ambiguous than Gabriel Orozco's shoebox. Although she

273 Teresa Margolles, *What Else Could We Talk About? Cleaning*, 2009.

Viewers may have been appalled by the real blood Margolles used in Venice, but her work recalls the painted blood shown in many post-Revolutionary murals—whether falling from the wounds of historic martyrs in the SEP, or stolen from the veins of living workers and transformed into gold coins in the stairwell of the Sindicato de Electricistas (page 294).

was not censored, Margolles's rejection of the nationalism expected in a "Mexican pavilion" sent shock waves through a federal system that had sought to incorporate new artistic trends and forge alliances with the private sector, but still wanted to maintain control, especially over how Mexico is seen abroad.

Though Margolles takes a mournful approach to Mexico's ongoing tragedies, she is also one of many contemporary artists—among them Minerva Cuevas (b. 1975) and Betsabée Romero (b. 1963)—who have become involved in community activism, recalling that utopian drive to solve social problems through art so evident in the great murals of the 1920s and 1930s. Architects and urban planners have also sought to improve life in Mexico City, through dedicated bus lanes and bike stations, the revitalization and partial gentrification of the colonial Centro Histórico, and the restoration of the Monument to the Revolution and its surrounding plaza in 2010.

274 Alberto Kalach et al., *Lakes Project: The Islands*, 2001–3.

While artists now function independently of the official art system, architects remain bound to political and economic realities. In the early 2000s, this project to restore Lake Texcoco would have required an impossible level of cooperation and investment by three different bureaucracies and political parties: the Mexican nation (run by the PAN), the State of Mexico (PRI), and Mexico City (PRD).

The most utopian and ecologically focused of these was the *Lakes Project* (2001–ongoing), a carefully researched plan spearheaded by architect Alberto Kalach (b. 1960) and intended to improve drainage systems in the Valley of Mexico, revitalize Lake Texcoco, and create an entirely new urban environment around a desperately needed improved international airport. This was just the latest of many attempts to rationalize the city, from the traza of the 1520s and the urban reforms of the Bourbon viceroys and Emperor Maximilian, to seemingly endless attempts to ease congestion, including the so-called *ejes centrales* (central axes) of the 1970s and the elevated freeways built over the past decade. Unfortunately, political conflicts more than financial costs left Kalach's futuristic proposal on the drawing table.

A similarly idealistic impulse can be detected in one of the most recent and visible works of public art in Mexico City, Thomas Glassford's *Xipe Totec*, a site-specific light installation, partly covering Ramírez Vázquez's Secretaría de Relaciones Exteriores tower. Adjacent to the Plaza de las Tres Culturas at Tlatelolco (page 329), the Ministry was transformed in 2007 into

a cultural center operated by the UNAM, and includes a memorial to the massacre of protesters in 1968. Designed to commemorate the centennial of the 1910 foundation of the Universidad Nacional, Glassford's work consists of more than four miles of flexible PVC tubing containing red and blue LEDs, set into an aluminum frame, and arranged in an elegant geometric pattern that recalls the legacy of Mudéjar design in colonial Mexico (page 36). The title refers to an Aztec deity associated with fertility and renovation; Xipe Totec impersonators wore the flayed skins of captives until they dried and fell off, symbolizing the germination of maize. Glassford's choice of color directly recalls the veins and arteries of the human circulatory system. This was a powerful and multivalent metaphor for a cultural complex rising above a site of ancient and modern human sacrifice.

Unlike the costly Stela of Light erected on the Paseo de la Reforma to celebrate Mexico's 2010 Bicentennial (but not completed until 2012), Glassford's Xipe Totec is simultaneously delicate, historicist, and abstract without suffering from an elitism that too often leaves the general public—in whose interest public art is supposedly created—either mystified or indifferent. It is also the latest in a long line of commemorative monuments—from Tolsá's Caballito to Rivas Mercado's Column of Independence; from Obregón Santacilia's Monument to the Revolution to Goeritz's Towers of Ciudad Satélite—that have marked the passage of time in one of the cities with the densest history anywhere in the Americas.

As much as any recent work, Glassford's half-draped tower visualizes the tensions between the past and present, and between the local and international, which have continually shaped Mexican art and architecture from the Conquest to today. Its glowing network evokes the intersecting cultural forces, from every corner of the globe, that have complicated repeated attempts—by criollos, nationalists, revolutionaries, and modernists—to create a uniform Mexican national identity. And yet, like Renaissance facades attached to sixteenth-century churches, moralizing academic paintings designed to educate the citizenry, or the post-Revolutionary murals and housing projects, Xipe Totec reiterates that confidence—shared by so many of Mexico's artists, patrons, and intellectuals—that the visual arts command our attention not only because they resonate with history, but also because they help shape the future.

275 Thomas Glassford, *Xipe Totec*, 2010. Plaza de las Tres Culturas, Mexico City.

The geometric forms here are based on ordered configurations of tiles that cover planes with a non-repeating and non-symmetrical pattern, using a limited number of shapes. The design resembles Islamic tiling, developed according to similar mathematical principles.